Carpets of the Art Deco Era

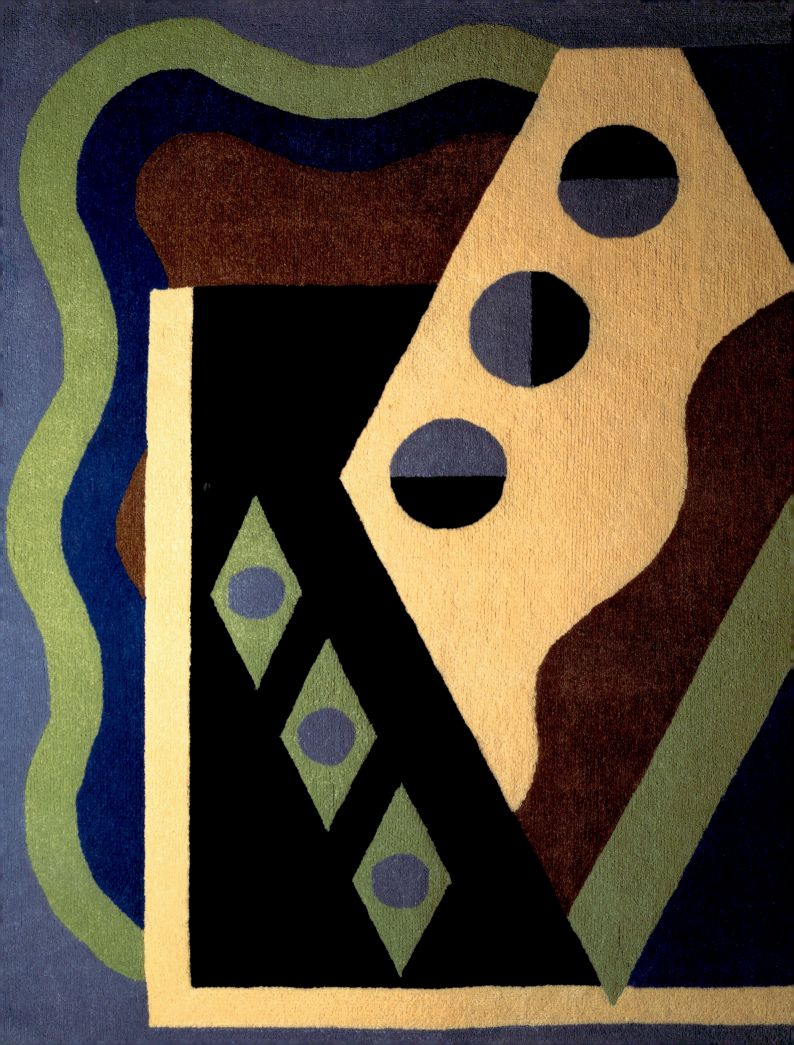

Carpets of the Art Deco Era

Susan Day

Preface by
Yves Mikaeloff

With 250 illustrations, 149 in colour

 Thames & Hudson

Cover
Sonia Delaunay, pile carpet in a Cubist design,
c. 1925, monogrammed. It was designed for
the living room of Dr Charles Viard, who was
Delaunay's own doctor and an avid art collector.
© Pracusa 2014067

Frontispiece
1 Georges Valmier, *Outremer (Overseas)* (detail),
wool, gun-tufted, 197 x 241 cm (77$5/8$ x 94$7/8$ in.).
This carpet was made from a stencil in the artist's
pattern book *Décors et Couleurs. Collections de
Georges Valmier. Album no. 1*, Paris, 1929–30.
It was issued for the first time in 1985 by the
Galerie Artcurial in a limited edition of 100,
and was woven by the Tapis de Cogolin.

First published in the United Kingdom in 2002
as *Art Deco and Modernist Carpets* by
Thames & Hudson Ltd, 181A High Holborn,
London WC1V 7QX

This compact edition published in 2015
as *Carpets of the Art Deco Era*

Art Deco and Modernist Carpets © 2002 Susan Day
Carpets of the Art Deco Era © 2015 Susan Day

British Library Cataloguing-in-Publication Data
A catalogue record for this book is available
from the British Library

ISBN 978-0-500-51795-6

Printed and bound in Malaysia by Infinity Press
Sdn Bhd

To find out about all our publications, please visit
www.thamesandhudson.com.
There you can subscribe to our e-newsletter,
browse or download our current catalogue,
and buy any titles that are in print.

CONTENTS

PREFACE BY YVES MIKAELOFF 7

INTRODUCTION

THE ROOTS OF MODERN STYLE 11

NEW TECHNIQUES, NEW MATERIALS 18

ART DECO: RISE OF THE DECORATIVE

JUGENDSTIL AND THE WIENER WERKSTÄTTE 27

FRENCH ART DECO: A RIOT OF FLOWERS AND COLOUR 34

CARPETS OF THE *COLORISTES* 35

THE ART DECO CARPET BETWEEN THE WARS 39

FLORAL AND CLASSICAL PATTERNS 42

GEOMETRIC AND ABSTRACT DESIGNS 54

IN A FIGURATIVE STYLE 58

A BOOM IN BELGIUM 63

BRITAIN AND THE OMEGA WORKSHOPS 67

DUTCH BATIK OR THE TUSCHINSKI STYLE 72

SCANDINAVIAN TRADITIONS REJUVENATED 76

MEDITERRANEAN DEVELOPMENTS: ITALY AND SPAIN 81

EASTERN EUROPE AND THE MODERN VERNACULAR 84

JAZZ MODERNE IN THE USA 87

THE MODERNIST CARPET:
ART MEETS INDUSTRY

THE BAUHAUS: CRUCIBLE OF MODERNISM 99

DESIGNING FOR INDUSTRY 106

ARTISTIC LEGACIES IN GERMANY, AUSTRIA AND SWITZERLAND 108

L'ART UTILE VERSUS *L'ART DÉCORATIF* 112

CHANGING TIMES, CHANGING TRENDS 120

CARPETS BY MODERN MASTERS 131

THE AESTHETICS OF TEXTURE 136

A BAS LE STYLE CLINIQUE 141

MODERNISM IN BELGIUM 149

BRITAIN ENDORSES PROGRESSIVE DESIGN 155

DE STIJL AND THE TRIUMPH OF NEO-PLASTICISM 163

SCANDINAVIAN MODERN 168

AMERICAN STREAMLINED 175

BIOGRAPHIES OF ARTISTS, MANUFACTURERS AND RETAILERS 183

SIGNATURES AND MONOGRAMS 205

GLOSSARY 210

SELECT BIBLIOGRAPHY 214

ACKNOWLEDGMENTS 217

PICTURE CREDITS 218

INDEX 221

PREFACE

I have always been fascinated by the debt we owe to William Morris. One of the most influential personalities on the British cultural stage in the second half of the 19th century, Morris was one of the first to consider the carpet as an art form, rather than merely as a floor covering. In lieu of a tapestry, he hung a 17th-century Persian Vase carpet on the dining-room wall of his London home. When Morris set up his own workshop in Hammersmith, Persian and Turkish carpets served as the source of inspiration for his own pattern designs. A connoisseur, Morris served as scientific advisor to the Victoria and Albert Museum when it extended its acquisitions policy to include oriental carpets in the 1870s. Visitors can still enjoy the collections of Islamic art on permanent display, including the Vase carpet acquired from Morris's widow after his death.

Similarly, it is not merely coincidence that Susan Day's book is the first to analyse the history of carpet production in the context of art and design between 1910 and 1945, an era when the decorative arts underwent a sea change owing to the debate on industrial design. Susan Day's background is rooted in the oriental carpet of the classical period of the 15th to 18th centuries and her thesis for the Ecole du Louvre was devoted to a catalogue of the collection of Turkish carpets in the Musée des Arts Décoratifs, Paris. In addition to oriental art, she has a passion for architecture and the decorative arts of the 20th century, and is the author of several monographs on the subject. She is thus in a privileged position, in being able to situate carpet design within a socio-historical context.

However, her study does not purport to be a systematic analysis of every aspect of carpet production during this period. Revival styles – Axminster, Savonnerie, Aubusson and oriental patterns – which continued, as in the past, to form a significant part of manufacturers' output are excluded. The aim of the book is to discuss the smaller but nonetheless significant proportion of carpet designs which reflect the influence of avant-garde trends in the plastic arts, a field of study neglected until now.

Attention is mainly focused on France, which nurtured many avant-garde movements in the first decades of the 20th century, coupled with a long-standing tradition of making luxury handwoven carpets; and Germany, whose strong scientific bias gave rise to the industrial aesthetic. Some regions have been treated in a briefer fashion or omitted entirely. For example, carpets have been woven for centuries in Spain, but with certain notable exceptions, modern production would appear to have been left relatively untouched by the events covered by this book. As for Scandinavia and Eastern Europe, the emphasis is laid on modern patterns, rather than those which do not greatly diverge from the folk rugs of previous centuries.

Susan Day is to be congratulated on undertaking this task, since the very nature of carpets makes a comprehensive survey rather daunting. Many of the carpets themselves have disappeared after years of wear. It is frequently impossible to determine which projects were executed and which never went beyond the drawing board, since the archives which aid in identification are either incomplete, imprecise, dispersed or, at worst, destroyed. As often as not, designers will neither sign nor date their work. Sometimes, recorded traces may exist, gleaned from black-and-white illustrations in period magazines, in which the item in question is photographed flat or partially hidden by furniture. Paradoxically, establishing the history of powerloom carpets is particularly difficult. A few institutions do try and achieve a balance between mechanized production and handweaving, but many do not, and examples of machine-made carpeting tend to be only sporadically conserved by official institutions which tend to lay disproportionate emphasis on conserving the handwoven items.

The downtrodden carpet suffers from its lowly and unjustified lack of status, especially when it is frequently the unifying element in a decorative scheme. In his history of the Axminster carpet, the historian Bertram Jacobs gave vent to his frustration: 'It is infuriating in reading the many books on the period to find gorgeous carpets illustrated, with absolutely no reference to them in the text. Alternatively, they may be given four or five words in passing and while immense detail is devoted to some spindly-legged bit of furniture or baroque mirror, the carpet, which is the main feature of the room, the basic setting upon which the whole furnishing scheme is built, is ignored.' The criticism remains valid for more recent publications.

Modern historians are privileged in having at their disposal a vast range of illustrated contemporary literature, which facilitates dating and identification. Alas, this material presents a trap for the unwary. Architects and interior decorators often commissioned their textiles and floor coverings from freelance designers, or acquired them from a retailer. The caption may identify the designer of the scheme, but not necessarily any other contributors. This has given rise to a great deal of confusion in recent publications, as all too often it is wrongly assumed that the designer has created every item in the scheme, when this may not be the case.

Carpets also pose specific authentication problems. In the normal course of events, the artist submits either a cartoon (a life-size drawing of the design on squared paper), or a small-scale design, or a section of it, generally painted in gouache or watercolour on graph paper, known as a point-paper, to the weaver or manufacturer. It may be woven only once, particularly in the case of a floor covering designed by an architect or decorator for a specific scheme. It may also be woven in a limited edition, commissioned by a retailer from a well-known artist or freelance designer. When interest in Art Deco and Modernism revived during the 1970s, manufacturers and retailers began reissuing designs, further complicating the task of attribution.

With the exception of mass-produced carpeting, the number of copies issued from any given design is difficult to assess, as this depends to a great extent on the manufacturer's

arrangement with the artist: Picasso, for example, limited the edition of his designs for the Maison Myrbor to a maximum of seven. The artist approves the choice of wools which best correspond to his design and oversees the final version. Finally, a carpet may not necessarily have been conceived as such at the outset, but may have been adapted from an existing work of art, with permission from the artist or his heirs. Unless otherwise specified, this book focuses only on designs expressly intended by the artist to serve as floor coverings, or interpreted in this medium with his or her approval, and not those adapted *post facto* to this medium. For example, neither Vasily Kandinsky, Mondrian nor Malevich designed carpets, but their works have since been reproduced as such.

Unlike the works by great masters of previous centuries, the abstract works of art characteristic of 20th-century painting adapt themselves well to floor coverings. This, coupled with access to coloured reproductions, has made it easy for designs to be plagiarized without the artist's consent or even his knowledge. Copyright infringement is a recent legal phenomenon and as a result, the pattern books commissioned by publishers which proliferated from 1856, when Owen Jones published the first edition of *The Grammar of Ornament*, now tend to be a thing of the past, owing to the payment of royalties by manufacturers.

Yves Mikaeloff

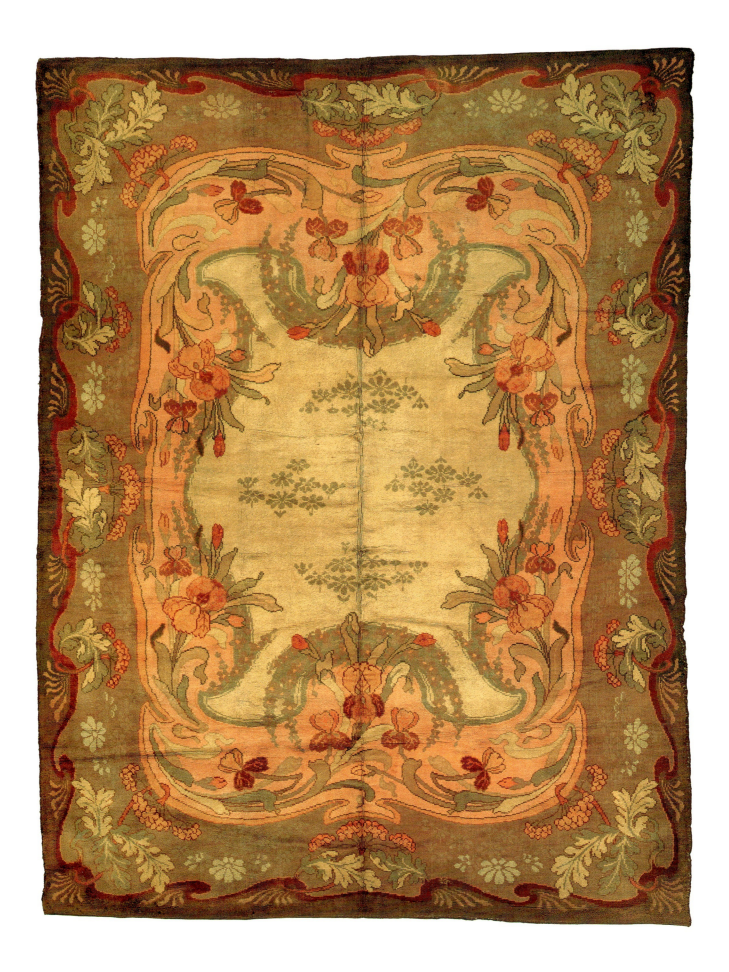

INTRODUCTION

THE ROOTS OF MODERN STYLE

The circumstances which gave rise to Art Deco and Modernism are rooted in the ideas and social idealism of 19th-century theorists. The philosophy of John Ruskin and William Morris led to an improvement in the status of the craftsman and the quality of industrial design and set in motion the debate on mechanization which came to figure prominently in many 20th-century manifestos on international art and design. Morris also advocated the 'total work of art', which extended from the design of a building down to the cutlery and floor coverings. A renewed interest in traditional crafts and the belief that a revival of the guild system offered a means of countering the evils of industrialization prompted many artists and designers to found their own craft workshops, several of which specialized in the production of textiles.

The Arts and Crafts movement became known throughout Europe through exhibitions and periodicals such as *The Studio, Kunst und Kunsthandwerk* and *L'Art Décoratif*, and personalities such as the architects Hermann Muthesius, Henry Van de Velde and Josef Hoffmann all became influential in instigating important reforms in their own countries. Each of the schools of Art Nouveau which developed in Europe between 1880 and 1910 – Jugendstil, Nieuwe Kunst, Stile Liberty – was rooted in the same philosophy.[1] The ornamental styles grouped under the name Art Nouveau stretched from the serpentine undulations of the 'whiplash style' favoured by the French (ill. 2) and Belgians to the rectilinear compositions endorsed by Josef Hoffmann and Koloman Moser's Wiener Werkstätte. In 1908 Adolf Loos penned a virulent denunciation of the Werkstätte in a tract entitled *Ornament and Crime,* which sounded the death knell of Art Nouveau and ultimately became the bible of the Modernists. It heralded a growing awareness that all designers who reject mechanical means of production are perforce restricting their output to luxury goods for the privileged few.

With a centuries-old tradition of fine craftsmanship behind them, French designers were initially slower to react to the Art Nouveau phenomenon than their cousins further north, but in 1901, the Société des Artistes-Décorateurs was founded with the intent of elevating decorative artists to the rank of fine artists. An elitist institution, the society successfully promoted the work of its members through the medium of annual Paris Salons. Meanwhile in Germany, the Werkbund or 'German Craft Union' was founded by Hermann Muthesius and Peter Behrens in 1907, with the objective of encouraging cooperative effort between artists and industry. Muthesius believed that the only way for art to reach the people was to improve

the quality and aesthetics of industrial production, which meant that the artist had to come to terms with the machine. The Werkbund successfully created a forum for debate, forging a link between artists, industrialists, teachers and politicians. The organization set an example on an international scale, and eventually resulted in the creation of schools of industrial design, such as the Bauhaus.

ART VERSUS INDUSTRY

In the first decade of the 20th century, Paris was the artistic centre of the avant-garde. Fauvism and Cubism, as well as the Italian Futurist movement, served as a springboard for many experimental movements elsewhere in Europe and America. The rejection of the academic tradition, coupled with scientific inventions such as photography, meant that artists began to question traditional picturemaking techniques and seek inspiration in other media. At the same time, this raised the vexed question of defining the difference between a work of art and a functional object, particularly in view of the fact that many academically trained artists had now turned to the crafts as a means of expression. Sonia Delaunay, Jean Arp and Ben Nicholson claimed they perceived no hiatus between their works of fine art and the design of functional objects, a view which sharply contrasts with that of Johannes Itten and Theo Van Doesburg, who both believed that a work of art is imbued with a spiritual essence which is in principle absent from a utilitarian object.[2]

Taking their cue from contemporary cultural developments, but also spurred on by their Austro-German rivals, French interior designers broke with the tenets of Art Nouveau to create a new style founded on tradition. Art Deco reached its fullest flowering at the 1925

3 Jean Arp, carpet design for the Maison Myrbor, *c*. 1928. The biomorphic motif reflects the influence of Surrealism. Arp was among those who participated in the first Surrealist exhibition, held in Paris in 1925. The Surrealists attempted to explore the imaginary and subconscious world and their work has a dream-like quality.

4 Sonia Delaunay, *Tondo*, carpet design, 1937, gouache. This study was originally done for the 1937 International Exhibition, but it remained unexecuted until 1989. The design embodies the theory of 'simultaneous contrasts' developed by Robert Delaunay.

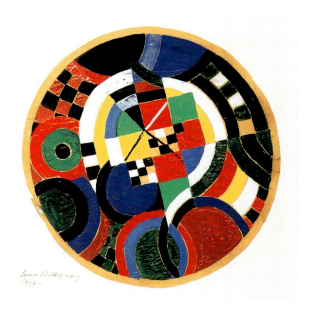

5 Carpet in a Constructivist design,
probably manufactured by the
Wilton Royal Carpet Factory,
c. 1930, wool pile, 187 x 240 cm
(73 ⅝ x 94 ½ in.). Constructivism
was an avant-garde art movement
which began in Russia but was
gradually taken up by artists across
Europe and in the United States.
Its followers sought to create an art
of order, rejecting the concerns of
the past and embracing modernity.
Constructivist art is abstract and
rarely emotional or subjective, with
forms often reduced to their most
basic elements.

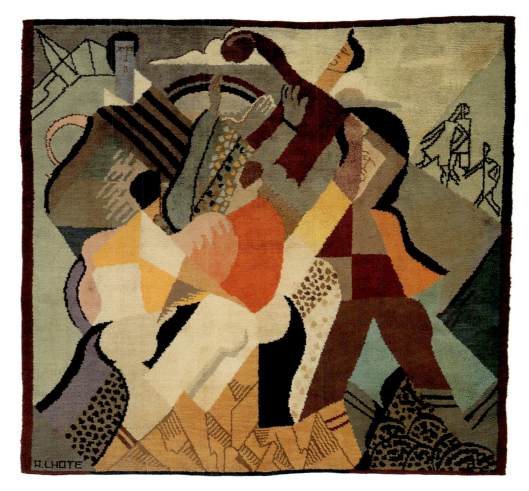

6 André Lhote, *Rugby*, hand-knotted
wool pile carpet, 208 x 217 cm
(81 ⅞ x 85 ⅜ in.), produced from
the 1917 painting in the Musée
d'Art Moderne de la Ville de Paris.
Lhote is reputed to have adapted
the Cubist canvas into a carpet
design himself at the request of the
painting's owner, a personal friend.

International Exhibition in Paris, and the supreme elegance of the custom-made interiors displayed at this event set an example for their peers the world over. Yet throughout the twenties and thirties, most established *artistes-décorateurs* in France remained hostile to the principle of industrial design. But with an increasing awareness of the need for organized professional bodies such as the Werkbund, the concept was eventually endorsed by the younger generation of French designers.

The functionalist doctrine originated in Germany at the Bauhaus, the first school of industrial design, founded in Weimar in 1919 by the architect Walter Gropius. The school maintained close ties with the international avant-garde and a number of contemporary artists, including Paul Klee, Johannes Itten and Vasily Kandinsky, joined the faculty. The Bauhaus ultimately succeeded in many of its aims, and the department which best achieved the transition from making traditional works of art to designing for industry was the weaving workshop. This example was a potent one, and although the Bauhaus experiment may have been short-lived, its spirit and teaching methods nevertheless lived on in the diaspora of its professors and students, and its influence was indelible and far-reaching.

Handmade tapestry-weave and knotted carpets were made in large quantities in Europe during the first half of the 20th century, particularly in France. Inspired by a new design aesthetic, designers, craftsmen and manufacturers across Europe and America produced a wide range of modern, innovative patterns. By the late twenties, the two most active centres of production were France and Germany, although their production methods were totally opposed; French manufacturers continued to make designer carpets by hand, while German output was concentrated on industrial mass production.

Critics of machine-made carpeting are legion, but some were quick to recognize that the more skilful manufacturers had placed beautiful carpets within the reach of even the most modest purse. In a 1927 issue of *Echos des Industries d'Art*, the critic René Chavance ventured to express the view that within the realm of the decorative arts, it was carpet production which had been the most successful in achieving some of the more visionary aims expressed during the 19th century. William Morris's aim of placing quality design within the reach of every budget had been achieved insofar as floor coverings were concerned.

MODERNISM TRIUMPHANT

The mass destruction of the First World War provoked an acute housing crisis and an awareness that custom-made interiors designed for the privileged few were an anachronism in a modern society. Le Corbusier published an indictment of modern decorative art to coincide with the 1925 International Exhibition, in which he roundly condemned the elitism of the Art Deco craftsmen and urged his peers to focus on the design of mass-produced housing and furnishings. Young architects and designers responded to the call by designing prefabricated housing, which was exhibited at the annual salons. Modernism gained further momentum

7 Paul Klee, *Blue-Red Abstraction (Abstraction Bleu-Rouge)*, *c*. 1930, hand-knotted wool, 150 x 195 cm (59 x 76 ¾ in.). Produced by the Maison Myrbor, a French retailer, this design was derived from Klee's colour theories.

8 Set for Marcel L'Herbier's film *Le Vertige*, designed by Robert Mallet-Stevens, with a carpet by Jean Lurçat.

9 Jean Lurçat, *La Sirène* (*Mermaid*), 1925, hand-knotted, wool pile, diameter 250 cm (98 ³⁄₈ in.). Made by the firm of Marcel Coupé for Pierre Chareau's hall-cum-library in the pavilion of the Société des Artistes-Décorateurs at the 1925 International Exhibition, Paris.

when the spending spree of the twenties was abruptly curtailed by the recession which spread worldwide in the wake of the Wall Street Crash of 1929. By the mid-thirties, custom-made luxury goods, including handmade carpets, had become virtually obsolete. Modernist dogma came to preeminence not simply for economic reasons, but also partly due to its unified theoretical base, which Art Deco had lacked.

The advent of Modernism caused a revolution in the design aesthetic coupled with a decline in production. The increased emphasis on home hygiene was translated into bare walls and simplified or even plain fabrics and carpeting, requiring little or no artistic intervention; even the most conservative designers dropped brightly coloured floral patterns for abstract designs in muted colour schemes. Taking their cue from the Bauhaus and Scandinavian weavings, European designers sought to achieve aesthetic effects through texture and technique rather than composition and colour which had prevailed until then. Lucien Lainé, director of the Manufacture Française de Tapis et de Couvertures, was quick to spot the significance of the upcoming Modernist Movement, and the threat posed to the textile industry by the diminishing role of textiles in the home. In an article which appeared in *La Renaissance de l'Art Français et des Industries de Luxe* in May 1929, Lainé noted that his countrymen had failed to respond to this movement, which the academies, force of inertia or adverse reactions were now powerless to stop.

The ripple effect of the American recession caused unemployment to reach record levels throughout Europe by the thirties, directly affecting the livelihood of thousands of craftsmen and designers. Afflicted by the economic crisis, few consumers could afford to indulge in luxury goods, and the decrease in demand implied a proportionate decrease in the

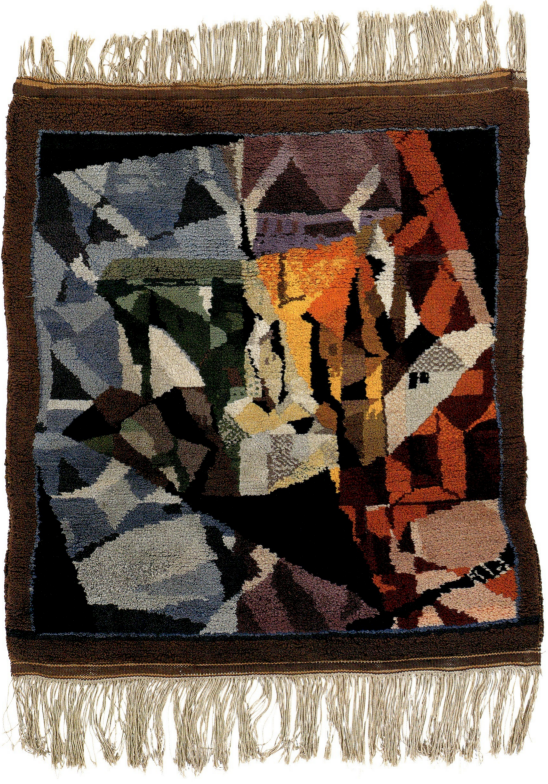

10 Jeanne Rij-Rousseau
(1870–1956), *La Cité Eclatée*,
1915–20, hand-knotted, wool,
127 x 107 cm (50 x 42⅛ in.).
A member of the Groupe de
Puteaux, she developed her
own version of Cubism named
'Vibrisme', based on visual
wave vibrations. She wove this
carpet as well as designing it.

11 Carpet based on *Composition* by Georges Braque (1882–1963), 415 x 280 cm (163 ³/₈ x 110 ¼ in.). This was one of three carpets made for the office of the president of the Chambre Syndicale de l'Alimentation Française at the International Exhibition, Paris, 1925.

12 Carpet based on a Cubist still life by Pablo Picasso, produced by the Maison Myrbor, *c.* 1928, hand-knotted wool pile, 205 x 118 cm (80 ³/₄ x 46 ½ in.). The original painting was formerly in the Paul Rosenberg collection. Helena Rubinstein was among the Maison Myrbor's clients and acquired an example of this design for the hallway of her New York apartment (ill. 182). The first painter to make a conscious break with traditional techniques of rendering distance and space, Picasso condensed natural motifs into geometric forms and attempted to represent perspective from several viewpoints, basing his canon on the flat planes of African sculpture.

production of handmade designer carpets, causing many manufacturers to founder. Nor did they revive after the Second World War. Improvements in living standards and the introduction of the welfare state after the war were concomitant with increased manufacturing costs. Economic imperatives became the deciding factor in the battle of the crafts versus the machine, and industry took up where art left off.

This study focuses principally on the carpets either designed by artists and designers active between the two World Wars or reproduced from their works with their permission, as well as designs taken from pattern books, possibly without the designer's knowledge, but with his or her implicit consent. A design by Edouard Bénédictus, for example, made by Templeton's of Glasgow, was probably taken from one of his pattern books. Some of the carpets taken from pattern books are not necessarily contemporary: over sixty years elapsed before one particular design from Georges Valmier's pattern book was produced in the gun-tufted technique by the Galerie Artcurial in 1985 (ill. 1). Also excluded from this study are designs adapted posthumously from pictures by artists; for instance the carpets made in Europe from abstract works of art by Mondrian or Kandinsky, and in Turkey from Picasso's Cubist portraits. During this period, carpet manufacturers often employed, as they still do, in-house designers whose work generally remains anonymous, and identifying the designer of a specific piece is not necessarily simple or even possible.

NEW TECHNIQUES, NEW MATERIALS

SYNTHETIC DYES, SYNTHETIC FIBRES

The first synthetic colourant, 'aniline purple' or mauve, was discovered in 1856 by British chemist William Perkin (1838–1907), based on research by the German chemist August Wilhelm Hofmann, who was the first to isolate benzene from coal tar, the raw material of aniline dyestuffs. Queen Victoria's favourite shade of violet was produced commercially by the Perkin family firm under the name Mauveine. Feverish activity by British, French and German scientists resulted in the rapid invention of a wide range of synthetic dyestuffs in other shades. As the new dyes did not require the complicated mordanting procedures of their predecessors, they quickly came to replace natural dyes. However, as the weaving industry quickly discovered, aniline dyes were not an unqualified success, as many of them proved fugitive when exposed to light or alkalis such as soap.

Meanwhile, research was directed towards determining the molecular structure of organic dyestuffs and synthesizing them. The first success was artificial alizarin, the red colouring in madder, obtained from coal-tar anthracene by Graebe and Liebermann in 1869. Indigotin, or artificial indigo, was discovered by Adolf von Baeyer in 1880, although the means for producing it commercially were not devised until 1897. Indanthrene Blue, the first synthetic vat dye, invented by René Bohn, was produced commercially from 1901. Colourless in the vat, the shades develop on exposure to light, which fixes the dye in the fibres by the same process as natural indigo. Limited at the outset to shades of blue, this group of dyes had by 1921 been developed to become particularly resistant to fading. Other important landmarks in the dyestuffs industry include the chrome and phthalocyanine dyes. Chrome dyes, which rival synthetic vat dyes for stability, are obtained by dipping the dyed fibre into a fixative of potassium bichromate. Metalliferous phthalocyanine dyes, discovered twice by chemists who failed to recognize their importance, were rediscovered by Scottish chemists in 1928. This group of dyes surpasses all others in stability and colour intensity, with the presence of metalliferous elements in the dyestuff serving the same function as the mordant in natural dyes.[3]

As so many of the pioneering chemists were of German origin, the industrial production of chemical dyestuffs developed there particularly rapidly. The break in the supply chain that resulted from the outbreak of hostilities in 1914 served to stimulate research elsewhere and the establishment of chemical industries like the British firm I.C.I. and the Swiss manufacturer CIBA-Geigy date from this time.

The first synthetic fibre, nitrocellulose rayon, made from cellulose derivatives, was invented by Hilaire de Chardonnet in 1884. Viscose, a fibre obtained by applying carbon disulphide to regenerated cellulose, was marketed by its inventors, English chemists Cross, Bevan and Beadle, once Topham had invented a spinning method in the late 1890s. Rayon obtained by the viscose process was initially spun from continuous filaments, but experiments

by French chemist Paul Girard in 1911 led to the discovery that rayon spun from short filaments, known as *fibranne*, was more resistant. Experimentation with rayon led to a vogue in the thirties for carpets in 'artificial silk', as it was then known, but the material proved less than satisfactory for floor coverings due to its poor wearing qualities. The first synthetic fibre made from entirely chemical sources, nylon, was invented by Wallace Hume Carothers and manufactured by the American firm of DuPont de Nemours from 1938. Apart from throw rugs made of 'artificial silk', synthetic fibres, with certain notable exceptions, are rarely used in knotted pile carpets prior to the Second World War, although rayon yarn may occasionally be used for the wefts.

HANDWEAVING TECHNIQUES

Not surprisingly, the best quality floor coverings made during the early 20th century continued, as in the past, to be made by hand. Napless fabrics include tapestry weave (or flatweave), embroidery, needlepoint and ingrain (also known as double- or triple-cloth). Piled fabrics include *moquette*, knotted pile, the hooked rug and the hand-tufted rug. Tapestry weave and pile carpets are the most commonly encountered handweaving techniques used in making floor coverings (ill. 13). Hooked rugs and rag rugs are the least common, as they tend to be folk crafts reserved for domestic consumption, although it should be noted that the former developed significantly as a cottage industry in North America. New techniques include the Cornély stitch, a semi-mechanized technique, and the hand-tufted carpet, both worked on an existing support rather than being woven.

From a structural viewpoint, flatweave and pile carpets made in the West are identical to their oriental counterparts. Famous since the fourteenth and fifteenth centuries for the quality of its fine tapestry, the French town of Aubusson has lent its name to a flatweave rug, first woven in the town in 1743. A napless fabric, the Aubusson carpet is woven on the same

13 Tapestry weave. The simplest form of weaving, the technique consists of threading the weft yarn under and over alternate warps.

The two most common types of knot:

14 the Turkish or symmetrical knot,

15 the Persian or asymmetrical knot.

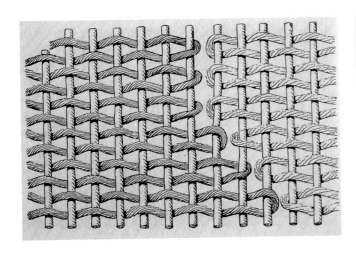
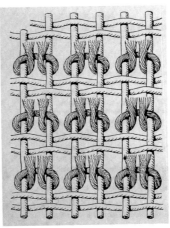
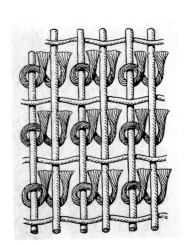

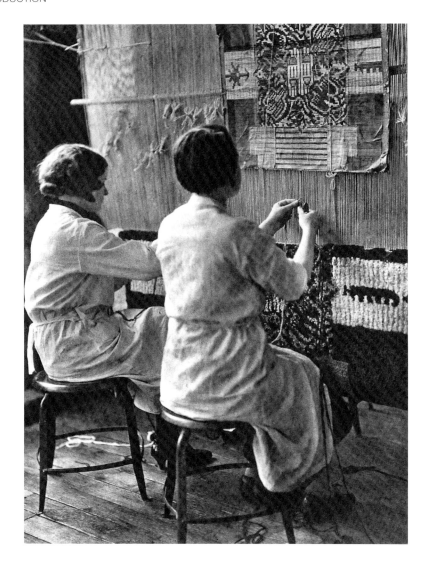

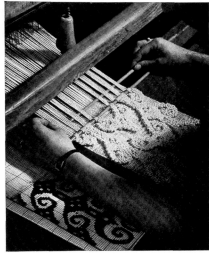

16　(left) Weaving a hand-knotted carpet on a vertical loom. Generally wrapped around two warps, the knots are tied and cut individually, secured with two or more rows of weft, or picks, and beaten down with a comb.

type of loom as fine tapestry, that is, a horizontal or low-warp loom. While it is coarser than fine tapestry, the weave tends on the whole to be finer than its oriental equivalent, the kilim.

On the other hand, the structure of the pile carpet of Western provenance tends to be a great deal coarser than the oriental product. The original drawing, or a section of it, is transferred onto graph paper, each square corresponding to a knot, hence the name 'point-paper'. Manufacturers often produce a design in more than one grade and one colourway, its quality dependent on the materials used and the density of the knot count. As in the oriental carpet, warp yarns may be in cotton or wool, but linen, hemp or jute may also be employed. As it is difficult to manipulate, linen is used infrequently in modern rugs, with the exception of those of Scandinavian or eastern European provenance. In modern carpets, good quality worsted wool imported from Australia or New Zealand is used for the pile in the finest grades. With the exception again of Scandinavian rugs, discussed in more detail in a later chapter, the number of shoots of weft between each row of knots rarely exceeds two.

Loom-woven pile rugs are made in two ways, either as *moquette* or as knotted pile. Made on a drawloom in a manner similar to velvet, *moquette* is a piled fabric formed by lifting

17　(above) Weaving *moquette* in the Studio de Saedeleer. A metered pile fabric, *moquette* is made by raising the warps into loops around rods introduced during the weaving process. When the rod is equipped with a shearing device at one end, it is known as the Wilton weave; when the loops are left uncut, as in this example, it is termed Brussels. Note the cartoon placed under the weave.

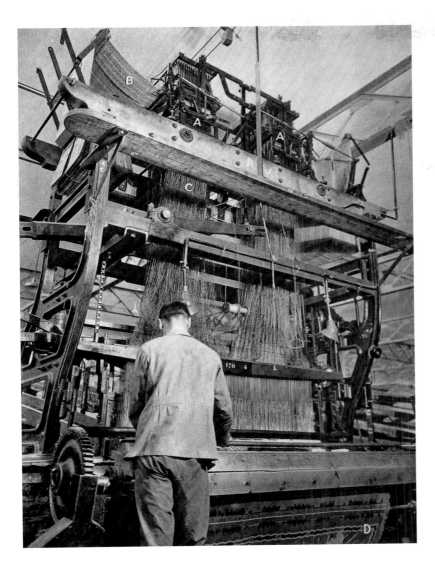

18 The Jacquard mechanism. Named after its inventor, the Lyons weaver Joseph-Marie Jacquard (1752–1834), the mechanism revolutionized the weaving of patterned textiles. The photograph was probably taken in the factory of the Manufacture de Tapis et de Couvertures, Beauvais, during the thirties.

supplementary warp threads into loops around rods inserted into the weave (ill. 17). The pile is formed when the rods are removed. When the loops remain uncut, it is known as Brussels. Made in rolls of standard width, strip carpeting is cut into lengths and is normally made up into wall-to-wall carpeting. It is probable that handwoven *moquette,* made in Flanders and the Netherlands, was made in Europe prior to the introduction of the oriental technique of hand-knotted pile.[4]

Executed on a high-warp or vertical loom, knotted pile rugs differ from the *moquette* technique in that the knots are tied and cut individually (ill. 16). European weavers tend to favour the symmetrical (Turkish) knot. While the asymmetrical (Persian) knot is less common, it is used by some Dutch and Belgian manufacturers (ill. 15). The knot count tends to be low, with the knotting density of carpets woven in the state-subsidized French Savonnerie workshop rarely exceeding 600 knots per sq. dm. This figure is inferior to most oriental rugs, but high compared with commercial products, the standard 'Savonnerie' grade woven in the Aubusson workshops having 400 knots per sq. dm and the 'point noué' grade even less. Similar criteria apply to other European rugs, from the so-called 'Smyrna' grade made in Germany, Austria and the Netherlands, to the British Axminster and Donegal qualities, the latter having rarely more than 400 knots per sq. dm.

Savonnerie weavers are credited with inventing a slight variant on the knotting technique derived from the *moquette* technique, named the *point de Savonnerie.* The yarn is looped around a rod with a cutting end placed in front of the weaving in the manner of *moquette.* Once pulled out, the rod cuts the pile, resulting in knots identical in appearance to the symmetrical knot.

The low density is partially compensated for by the number of strands of yarn used in each knot. Western weavers tend to use from six to ten strands, a great deal more than the two to three used by their oriental counterparts. Another feature particular to rugs of Western provenance is the technique known as *chiné,* which consists of plying several differently coloured yarns together in order to create nuances in the shading. The technique may have originated in the Gobelins tapestry workshop, renowned for the finesse of its colour shading. The art of bevelled contours may also come from the same workshop. Selvedges vary, but one mostly encounters the Turkish technique of weaving flat cords, as the work progresses.

The ends of the Western carpet may be decorated with fringes in the oriental manner, but it is more frequent for the extremities to be turned under and sewn to the back of the fabric.

NEW METHODS OF PRODUCTION

The 19th century witnessed the invention of a staggering range of new looms, tools and techniques for producing carpets. While the wealthy continued to furnish their homes with hand-made carpets, either imported or domestic, technological progress put woven floor coverings within the reach of a larger segment of society. The first handweaving techniques adapted to mechanical weaving were ingrain and *moquette*.[5] Other landmarks include the Jacquard mechanism, the powerloom, and a machine capable of producing mechanically knotted carpets virtually indistinguishable from their handwoven counterparts. These new production methods ensured the survival of some of the old craft workshops, which included England's Wilton Royal Carpet Factory and Holland's Deventer Tapijtfabriek.

The most significant event in the mechanization of the weaving process was the invention of the Jacquard attachment, which allowed the mechanical manufacture of patterned textiles. Named after its inventor, the weaver Joseph-Marie Jacquard (1752–1834) of Lyons, the loom incorporated and improved upon the work of earlier inventors (ill.18). The mechanism used to select the warp threads, which resembles the linked punched cards of a barrel organ, had been invented by Basile Bouchon as early as 1725 and the terminal for activating the cards placed above the loom by a maker of automata, Jacques de Vaucanson, in 1741. The number of holes in each punched card corresponds to the number of warps in the pattern unit which have to be raised in order to form a shed for the passage of the weft. When a series of punched cards has completed a revolution, the pattern unit is complete. Activated by a treadle, the Jacquard attachment consists of a metal bar with a row of hooks which moved forward to separate the warp threads and disengage them after the weft has been inserted into the shed. Having come across Vaucanson's model at the Conservatoire des Arts et Métiers, Jacquard succeeding in combining the elements into a working apparatus.[6]

The new drawloom won its inventor a medal when it was shown at the Industrial Exhibition held in Paris in 1801. Perfected three years later, the loom eliminated the need for drawboys. Seeing their livelihood endangered, the silk weavers of Lyons rioted and burned the loom, obliging Jacquard to flee the city in fear of his life. Within a decade, however, eleven thousand drawlooms of this type were in use in France. Not to be outdone by their French rivals, the British immediately set about inventing a similar apparatus, made operational in the cotton mills by 1810.[7] By 1825 the mechanism had been successfully adapted to the weaving of Brussels carpeting in Kidderminster, and it was adopted by French manufacturers of strip carpeting in Abbeville and Aubusson soon afterwards.

In about 1839, an American manufacturer, Erastus Brigham Bigelow, adapted a loom which wove ingrain, one of the simpler types of carpeting, to run on steam power. By 1846 the

same manufacturer had succeeded in adapting the Jacquard mechanism to Brussels and Wilton powerlooms. Other new mechanisms for making carpets include the so-called 'tapestry carpet' (also known as pre-printed or tinted-warp carpeting, and not to be confused with the ancient handweaving technique), patented by Richard Whytock of Edinburgh in 1832; and chenille carpeting (Patent Axminster), perfected in 1839 by the Scottish manufacturer James Templeton. Also worthy of mention are the Spool Axminster and Gripper Axminster looms developed by British and American carpet manufacturers. (See the glossary for more detailed explanations of these terms.[8])

According to some sources, the loom for weaving mechanically knotted carpets was invented by a French firm, the Manufacture du Renard of Saint-Lubin de Jonchères (Eure-et-Loire) in 1910.[9] However, archival sources reveal that a similar mechanism was patented in 1889 by the Aubusson manufacturer Sallandrouze Frères, and that this machine was itself an improvement on an earlier model.[10] Like most scientific inventions, these looms would undoubtedly have undergone successive improvements, each the subject of a patent. The fabric of a superior grade of mechanically knotted carpet is indistinguishable from a hand-knotted carpet; only the selvedge betrays its industrial origins. In an article on the Aubusson carpet-weaving industry, a journalist related an amusing anecdote about a rug in an oriental pattern made on this loom by Sallandrouze Frères. Loaned to an Austrian manufacturer, the rug was detained in customs upon its return to France, pending a visit to the factory by officials

19 Detail of a rug in the Cornély stitch by Ernest Boiceau. A semi-mechanized technique adapted from embroidery, the technique consisted of attaching tightly twisted yarns to a backing.

20 Hand-tufting a carpet in the V'Soske workshop in Puerto Rico. The workers insert loops of wool into a jute or cotton foundation which is stretched onto a frame from the back. Formerly, a small wooden tool resembling a crochet hook was used. Today hand-tufted rugs are made with a single-needle tufting gun resembling an electric drill.

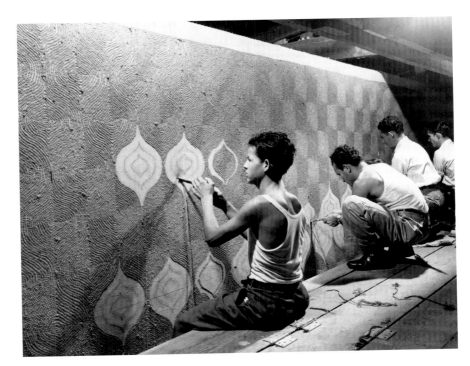

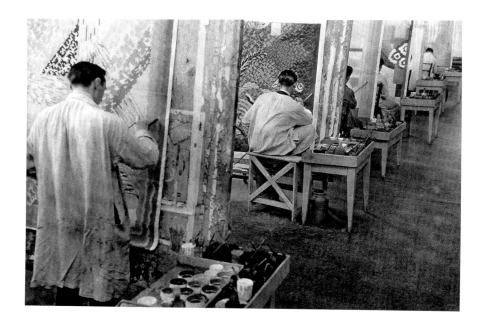

21 The design studio of a French manufacturer in the thirties, probably the Manufacture Française de Tapis et de Couvertures, Beauvais. The draughtsmen are working on carpet cartoons. Life-size cartoons of carpets are less commonly used than point-papers.

who were convinced that it was a foreign import subject to duty and refused to believe that it was a French product.[11]

Two significant new techniques for producing carpets were the Cornély stitch and the tufted rug, both made by attaching tufts of yarn to an existing canvas mounted on a frame rather then being woven on a loom. Invented in 1865 by the Frenchman Emile Cornély (1824–1913), the Cornély stitch is a semi-mechanized embroidery technique which consists of attaching tightly twisted yarn, juxtaposed in rows to form the pattern, to a fabric backing. It was adapted to carpet-making by Ernest Boiceau during the 1920s (ill. 19). Akin to the candlewick bedspread, the technique of hand-tufting was initially adapted to floor coverings, and in particular the bath mat, during the twenties.[12] To make a hand-tufted carpet, the weaver stands behind a jute or cotton foundation stretched onto a vertical frame and inserts loops of wool from the back, using a small wooden tool resembling a crochet hook (ill. 20). The American artist and manufacturer Stanislav V'Soske developed the hand-tufted technique, using different grades of needles to combine yarns of varying thicknesses and a hand-carving tool to create textural effects.[13] Hand-tufting is now semi-mechanized, the yarn inserted with a tufting gun which resembles an electric drill. Mechanical tufting was introduced into Europe from America during the 1950s. The first tufted carpets were sized to ensure stability; today they are coated with a latex backing.

NOTES

1 Robert Schmutzler, *Art Nouveau,* Harry N. Abrams, New York, 1962.

2 Theo Van Doesburg, 'Oude en Nieuwe Textiel-Kunst/L'Art Textile Jadis et Aujourd'hui', *Interieur* (Amsterdam), vol. 47, 1931.

3 For more detailed information on synthetic dyestuffs, see E. J. Holmyard, 'Dyestuffs in the Nineteenth Century', in *A History of Technology*, edited by Charles Singer, E. J. Holmyard, A. R. Hall and Trevor I. Williams, vol. IV, *The Late 19th Century*, Oxford, 1958, pp. 258–82; and 'Centenaire W. H. Perkin', *Cahiers CIBA*, no. 66, October 1956, pp. 2–49.

4 For more details, see Sarah B. Sherrill, *Carpets and Rugs of Europe and America,* Abbeville Press, New York and London, 1996, pp. 59–60.

5 Sherrill 1996, pp. 214–33.

6 Agnes Geiger, *A History of Textile Art. A Selective Account*, Sotheby Parke Bernet & Philip Wilson Publications, London, 1979, pp. 105–6.

7 W. English, 'The Textile Industry: Silk Production and Manufacture 1750–1900', in *A History of Technology,* edited by Charles Singer, E. J. Holmyard, A. R. Hall et al., vol. IV, *The Industrial Revolution, c. 1750–1850,* Oxford, 1958, pp. 316–19.

8 See also Sherrill 1996 for further information and diagrams of the techniques.

9 C. E. C. Tattersall, *A History of British Carpets*, 1934, revised by Stanley Reed, London, 1966, p. 77.

10 A document in the Archives Nationales, Paris, states that Sallandrouze Frères had 'amélioré une machine pour le point noué, dit d'Orient'. A.N. F12/8724.

11 A. Poisson, 'L'Industrie du Tapis à Aubusson', *Le Limousin de Paris,* 21 March 1937.

12 Sherrill 1996, pp. 251–52.

13 Jeanne G. Weeks, Donald Treganowan, *Rugs and Carpets of Europe and the Western World,* Chiltern Book Co., Philadelphia, 1969, p. 189; see also Joan Scobey, *Rugs and Wall Hangings. Period Designs and Contemporary Techniques*, Dial Press, New York, 1974, p. 141.

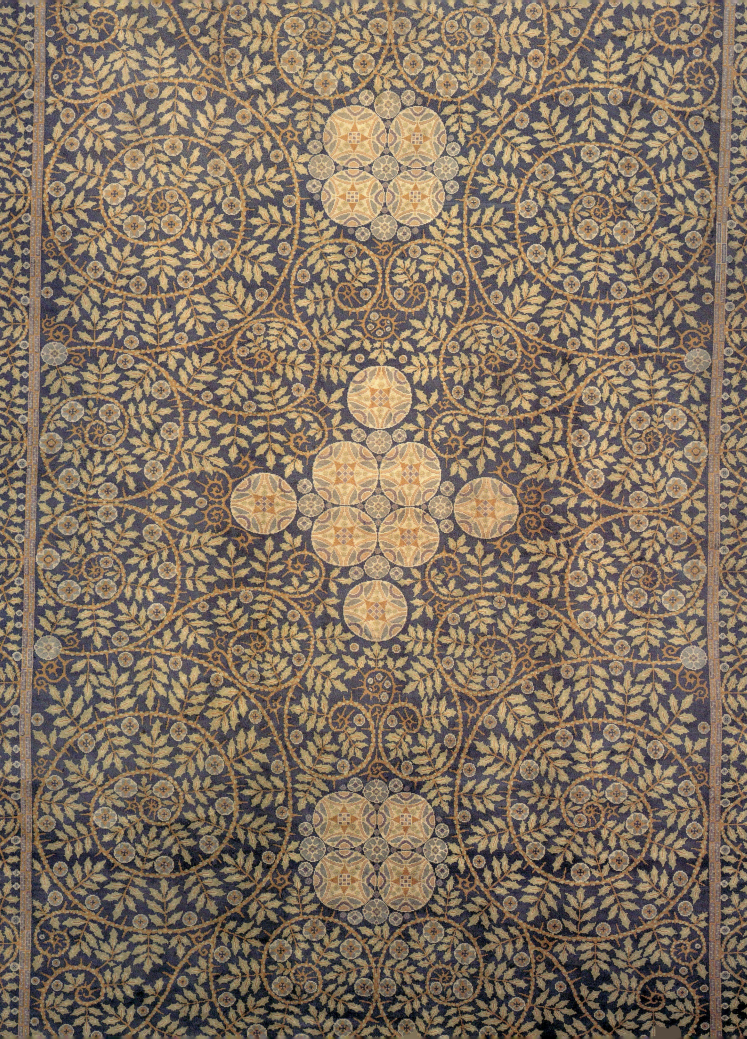

ART DECO:
RISE OF THE DECORATIVE

JUGENDSTIL AND THE WIENER WERKSTÄTTE

At the turn of the century, Vienna was the cultural hub of Europe. The work of Secessionstil designers matured into a decorative style which served as a link between Art Nouveau and Art Deco. Austrian design was dominated by the production of the Wiener Werkstätte, founded in 1903 by the architect Josef Hoffmann (1870–1956) and the painter Koloman Moser (1868–1916). The majority of the prominent Viennese designers had either been their students, collaborated with the Werkstätte at some point of their careers, or both. Some, like Dagobert Peche (1887–1923), Joseph Urban (1872–1933) and Paul T. Frankl (1887–1958), were particularly influential in disseminating Viennese design abroad.

A number of the hallmarks of Art Deco can be directly traced to the Viennese school. Hoffmann first used the oblique truncated arch in an exhibition of the Wiener Werkstätte's work held in Berlin in 1904 (ill. 23), and the motif was subsequently adapted to furniture and every type of object, from brooches to carpets, by designers the world over. Werkstätte designers began to soften the severe geometric repertoire that had been *de rigueur* at the outset. Linear rhythms, chequered and grid patterns remained a constant in carpet patterns, but a colourful note was introduced in the scattered floral motifs which overlaid them, inspired by Japanese textiles. The change in style may be attributed to the influence of Carl Otto Czeschka (1878–1960), who joined the workshops in 1905, and to the departure of Moser, who resigned two years later.

The year 1905 was a particularly significant one for the Wiener Werkstätte, as it marked the commencement of its most prestigious commission, the Palais Stoclet in Brussels. The client, Adolphe Stoclet, had for some years been a resident of Vienna. A landmark of 20th-century architecture and design, the mansion embodies the transition from Art Nouveau to Art Deco, and became a place of pilgrimage and a model for the avant-garde even before its completion in 1911.

The *pièce de résistance* was the dining room, adorned with mosaic decoration created by Gustav Klimt (ills 24, 25). The mansion was furnished with pile carpets in the main rooms and strip carpeting made by the firm of Backhausen und Söhne in the areas subject to heavy wear, such as the stairs and hallways. The Wilton carpeting laid in the stairway reveals Hoffmann's penchant for black-and-white grid patterns, here enlivened with blue and mauve campanula, which became one of his favourite motifs in later years (ill. 26). The same carpeting

23 Exhibition of the Wiener Werkstätte's work in Berlin, 1904, designed by Josef Hoffmann. The truncated arch became a familiar Art Deco motif.

22 Franz Delavilla, medallion carpet, 1909–10, hand-knotted, wool, 551 x 351 cm (217 x 138 ¼ in.), woven by Backhausen und Söhne, Vienna. Floral and medallion patterns made a comeback after 1910.

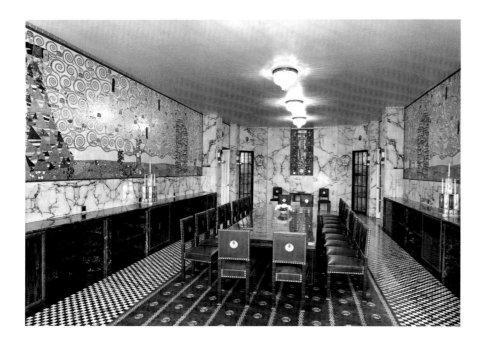

was used in other Werkstätte projects, such as the Villa d'Ast in Vienna and the Beer-Monti apartment. The pile carpet laid in the Stoclet dining room was decorated with diamond-patterned bands interspersed with rows of stylized plant motifs (ill. 25), recalling Klimt's Beethoven frieze in the Secession building. A surviving document reveals that C. O. Czeschka was closely involved in the design of the tapestries and carpet in at least one of the rooms, namely Mme Stoclet's boudoir.[1]

A change is also noticeable in the work of several designers whose repertoire had formerly been dominated by the rectilinear rhythms of the Werkstätte. A brightly coloured carpet designed by Leopold Bauer (1872–1938) in the Musée d'Orsay (ill. 28) recalls Klimt's mosaics in the Palais Stoclet, yet at the same time the theme of a central medallion on a field of scrolling arabesques and the red, yellow and blue colour scheme are taken from oriental carpets. Like the Germans, the French and the British, the Austrians had amassed impressive collections of Islamic art, brought to the public's attention via a series of major exhibitions.[2] Karl Witzmann (1883–1952), Otto Prutscher (1880–1949) (ill. 27) and Franz Delavilla (1884–1967) (ill. 22) likewise dropped grid layouts in favour of central medallion patterns reminiscent of Muslim manuscript illumination.

The work of the Austrian school attracted widespread admiration at home and abroad, but it did not lack detractors, the most strident of whom was Adolf Loos. Determined to prove the futility of ornament, the architect argued in *Ornament and Crime*, not without irony, that the decorative arts should be equated with the daubs of the savage, and drew the conclusion that

24 Dining room of the Palais Stoclet, Brussels, 1905–11, designed by the Wiener Werkstätte under the direction of Josef Hoffmann. The mosaics are by Gustav Klimt.

25 Study for the pile carpet for the dining room of the Palais Stoclet, designed by the Wiener Werkstätte, 1910, gouache on paper. The finished carpet was woven by Backhausen und Söhne, Vienna.

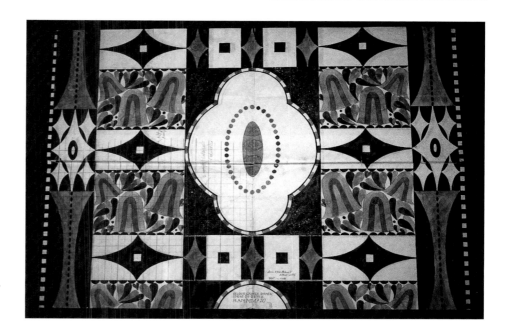

26　Josef Hoffmann, *Glockenblüme (Campanula)*, design for Wilton carpeting for the hallway of the Palais Stoclet, 1910.

27　Otto Prutscher, study for a circular carpet, 1910.

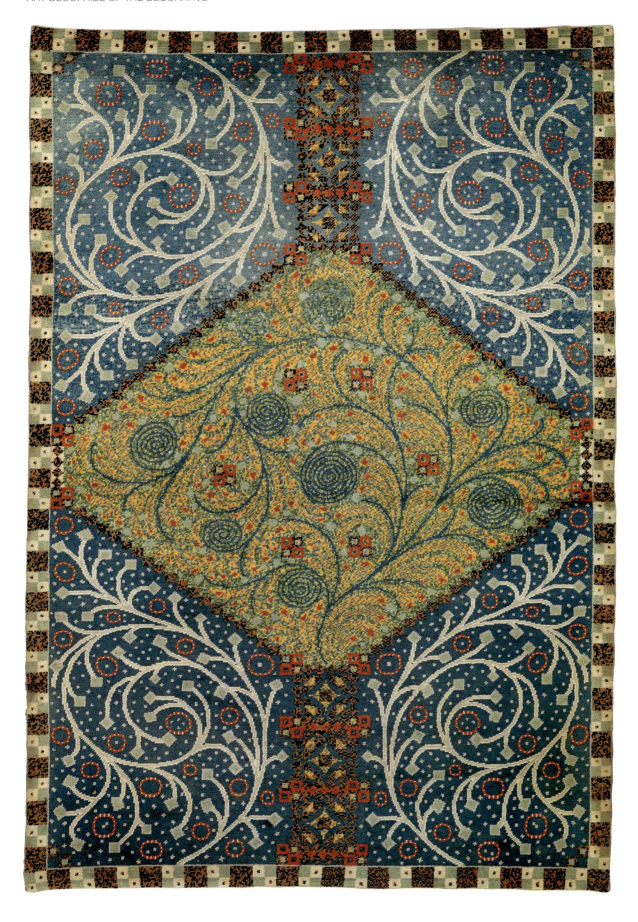

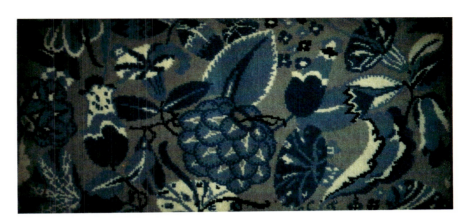

29 Josef Hoffmann, preparatory study of a pile
 carpet for the Villa Skywa, Vienna, 1913.

30 Dagobert Peche, fragment of Wilton
 carpeting, 1913, woven by Backhausen
 und Söhne, Vienna.

28 Leopold Bauer, carpet, c. 1905, hand-knotted,
 wool, 403 x 263 cm (158 ⅝ x 103 ½ in.),
 woven by Backhausen und Söhne, Vienna.
 The medallion and scroll design is borrowed
 from a Turkish carpet, enhanced by the spiral
 scrolls characteristic of Austrian Art Nouveau.

the Werkstätte's production was decadent and even that it posed a threat to the good name of Austria abroad.[3]

Other important Werkstätte projects in the period leading up to the war included the Villa d'Ast and the Villa Skywa, both in Vienna. Hoffmann remained faithful to the principle of chequered decoration, but began to handle it a little differently. Instead of serving as the ground, the geometric elements in the carpeting designed for the Villa Skywa in 1913 were transferred to the flowers, which are overlaid with areas of checked patterning (ill. 29). At the 1914 Werkbund exhibition held in Cologne, the Werkstätte showed an interior in which the Wilton carpeting in the boudoir was divided into squares containing broadly drawn leaves and flowers (ill. 31). It was executed by Backhausen from a drawing by a young newcomer, Dagobert Peche, who had studied in Paris (ill. 30). The following year, Peche joined the Werkstätte, and in 1917 was appointed director of the Zurich branch. Like Czeschka, Peche became a profound influence on the work of the other Werkstätte designers, including Hoffmann.

The German variant of Art Nouveau, Jugendstil, and particularly the work of designers attached to the Munich school, most of whom were members of the Werkbund, played a pivotal role in the genesis of Art Deco. The Werkbund sought to improve standards of design by encouraging the collaboration of artists and industry, by organizing production and distribution, by improving the quality of materials and through the establishment of standardized norms. Founded by Hermann Muthesius and Peter Behrens in 1907, the Werkbund membership was originally made up of twelve manufacturers and twelve artists. All of them, from Henry Van de Velde, Richard Riemerschmid, Josef Hoffmann, Bruno Paul and Max Laeuger to Josef Olbrich,[4] had been figures at the forefront of Art Nouveau. The Germans were particularly successful in implementing their theories, by allying their legendary sense of discipline with pragmatic solutions, and by using the medium of professional and educational bodies such as the Werkbund, and later the Bauhaus. Yet in spite of declaring war on the shoddy mass-produced goods which parodied Jugendstil models, the Werkbund never succeeded in

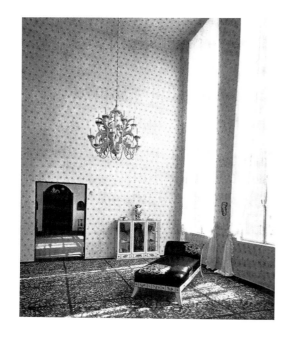

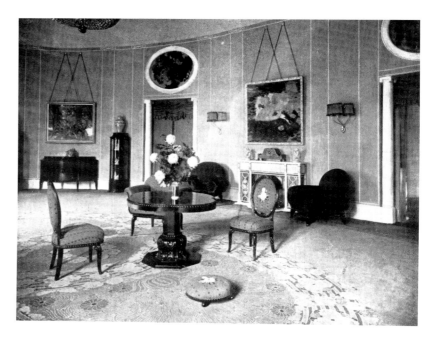

creating a homogeneous style of its own. Nevertheless, most established German designers became members.

Medallion designs made a comeback, owing to an increasing interest in Islamic art which culminated in a major exhibition held in Munich in 1910. One striking example is the pile rug designed by Richard Riemerschmid (1868–1957) and made by the Smyrna-Teppichfabrik in Cottbus (Lausitz) for the Thieme residence (ill. 33). Bruno Paul (1874–1968) also broke with the discreet squared-up patterning he had affected until then in exhibiting a medallion design at the Deutschen Kunstlerbundes exhibition held in Munich in 1904.[5] Rather than serving as an unobtrusive backdrop, the design has greater visual impact and forms the unifying element in the decorative scheme. Wilhelm Kreis, Robert Breuer, Hermann Billing, Margarethe Wiesemann and Thomas Theodor Heine were among the other German rug designers who broke with the Jugendstil tradition.

In 1910 the Munich branch of the Werkbund was invited to participate in the Salon d'Automne in Paris. Occupying eighteen rooms, their work was greeted with a mixture of admiration, jealousy and dismay by their French rivals. Carpets by Richard Riemerschmid, Karl Bertsch, Adelbert Niemeyer, Bruno Paul and Theodor Veil (ill. 32) were among those displayed on the stands. Notwithstanding the contempt for the *munichois* expressed in the Gallic press, which criticized the bulky volumes and strident contrasts of acidic colours, the show made French designers conscious of what could be achieved through disciplined collaborative effort.[6]

31 The Wiener Werkstätte stand at the Werkbund exhibition, Cologne, 1914. The stand was designed by Josef Hoffmann, with carpeting by Dagobert Peche.

32 Theodor Veil, reception room exhibited at the Salon d'Automne, Paris, 1910. Several French designers, including Maurice Dufrène, Paul Follot and André Groult, subsequently designed carpets with similar trellis and basketweave patterns, inspired by the Munich Werkstätte's contribution to this event.

33 Richard Riemerschmid, carpet for the Thieme residence, Munich, 1903, wool pile, 400 x 300 cm (157 ½ x 118 ⅛ in.). This striking design contrasts with the discreet squared-up patterns characteristic of Jugendstil carpets.

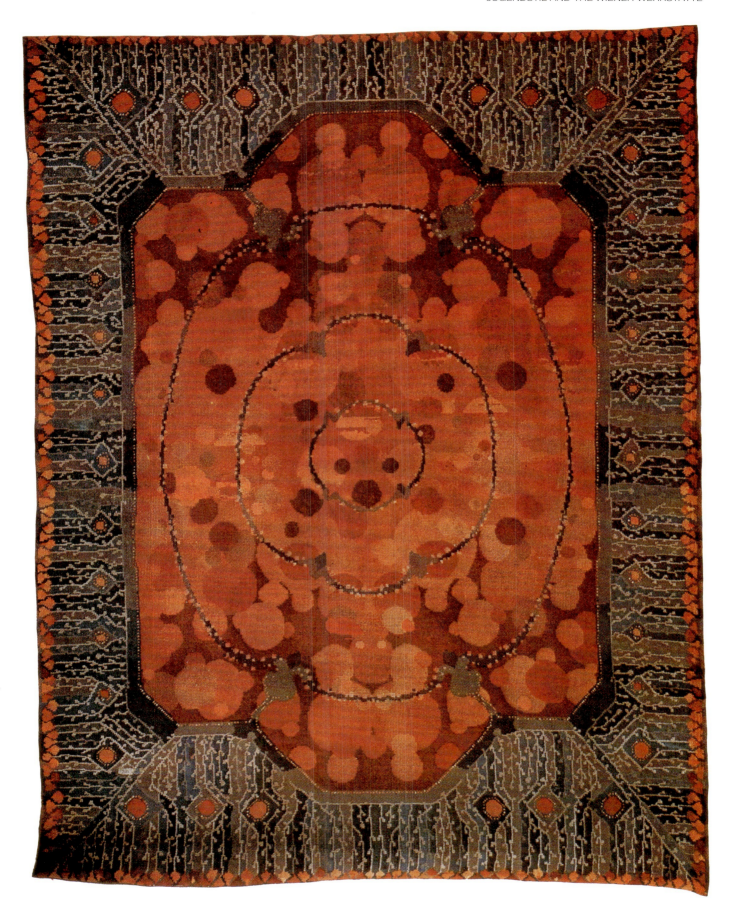

FRENCH ART DECO:
A RIOT OF FLOWERS AND COLOUR

France always has and still does lead the world in the production of luxury goods. This phenomenon was fostered by the Société des Artistes-Décorateurs, which sought to improve the status of the decorator. Its policy of defending solely the rights of interior designers ran counter to that of the Arts and Crafts society or the Werkbund. Manufacturers and artisans were only permitted associate membership and it was not compulsory to identify the manufacturers of objects displayed at the exhibitions organized by the society from 1906. The creation of the Salon d'Automne in 1903 further improved the status of the decorative arts, which accorded this section the same status as painting and sculpture in its exhibitions.

Although the sources of the Art Deco style are rooted in Austria and Germany, from 1910 the French again reasserted their superiority as designers. French Art Deco cannot be termed a movement, as it had no founders and no manifesto to speak of: its only *raison d'être*, crystallized by the privations of the First World War, was an unabashed indulgence in the production of luxury goods for the privileged. The style reached its peak at the first International Decorative Arts Exhibition held in Paris in 1925. The stands and pavilions at this event were dominated by the work of interior designers, the most famous of whom were Emile-Jacques Ruhlmann, Süe and Mare and the couturier Paul Poiret.

The aim of the new generation of interior designers was to create a new, purely French style, rooted in the classical tradition. The pastel shades and undulating curves of Art Nouveau were abandoned in favour of brightly coloured floral patterns and medallion compositions, frequently in the form of wreaths and floral swags, posies and baskets, motifs that had been used in carpet patterns for centuries. New life was infused into this traditional repertoire, combining trelliswork and chequered patterning with a fresh approach to the drawing of floral motifs, including the tightly budded so-called 'Cubist' rose. The term is misleading, however, since the roseball, a leitmotif of French Art Deco, owes nothing to the Cubist movement, as a preliminary sketch of the carpet laid in the dining room of the Palais Stoclet proves.[7] From a range of floral and geometric designs at its beginnings, Art Deco evolved in the late twenties into Modernist abstract and figurative patterns and then into muted, subdued neoclassical designs or textured surfaces in the thirties.

The majority of the carpets made during this period were either produced in small craft studios scattered all over France or were woven to order in the workshops of manufacturers. Firms which enjoyed a well-deserved reputation for the quality of their weavings included Lucien Bouix, Brunet-Meunié, the Maison Hamot, the Etablissements Lauer and Braquenié. Powerloom carpeting was mostly produced in the north, at Abbeville, Roubaix and Tourcoing although two Aubusson manufacturers, Sallandrouze Frères[8] and Croc & Jorrand, broke ranks and began producing strip carpeting in the late 1860s.[9] Few designer carpets made in

the Manufacture de la Savonnerie, a carpet-weaving workshop founded in Paris in the 17th century, have ever reached the market, but the prestige of the workshop meant that the terms Savonnerie and Aubusson used in the French trade denote a superior grade of pile and tapestry-weave carpets respectively, and not the place of origin.[10]

The Savonnerie weavers, like their peers in the Gobelins tapestry workshop with which it was merged in 1825, are justly famed for the high degree of realism achieved in their interpretations of plants, figures and architectural forms. Yet by the end of the 19th century, the production of the Savonnerie was confined mostly to weaving screens, wall-hangings and panels in the pile technique rather than carpets and had come under fire from reformers who followed the British example in advocating the use of flat patterns that were better suited, they claimed, to flat surfaces than attempts to represent relief. At one point it was suggested that the atelier be closed altogether.[11]

Research into dyestuffs was judged to be partly to blame. New mordants had multiplied the number of shades that could be obtained from any given natural dye, so that the weavers had in theory over 30,000 shades at their disposal. Many of them were created by Michel-Eugène Chevreul (1786–1889), chief chemist of the Gobelins dye laboratory.[12] Quick to realize that this number was unmanageable and therefore a handicap rather than an advantage, Chevreul then worked to reduce the number. By the time the scientist had developed his theory on colour contrasts, *La Loi du Contraste Simultané des Couleurs*, the number had been reduced by half, although this is still a sizeable figure when compared with the twenty shades or less used in the classical Persian carpet.

The Savonnerie nonetheless survived. The workshop and its annexe in Lodève still continue to produce small quantities of handwoven carpets destined to furnish state institutions or to serve as diplomatic gifts.

CARPETS OF THE *COLORISTES*

French designers rose to the occasion once the German and Austrian designers had thrown down the gauntlet at the 1910 Salon d'Automne. The German contingent was mostly made up of the members of the Munich Werkstätte, and *munichois* became a dismissive term to their French counterparts. Also present were members of Josef Hoffmann's Wiener Werkstätte, which was modelled along the lines of Arts and Crafts guilds. The Austro-German model served as an important stimulus in the development of the new style, but it was not the only one. The fact that colour became an important feature of French furniture and design may be attributed to developments in the arts closer to home. In addition to the Fauve movement, the colourful orientalist sets designed by Sergei Diaghilev for the Ballets Russes, first performed in Paris in 1909, had a particular impact.

34 Geometric ornament analysed by Eugène
 Grasset in *Méthode de Composition
 Ornementale,* a manual for students published in
 Paris in 1905. The vocabulary of early Art Deco
 often combines floral and geometric motifs.

While the impetus for the shift from curvilinear to rectilinear compositions could to a large extent be attributed to the Viennese school, another source were the new pattern books. Eugène Grasset, the author of *La Plante et Ses Applications Ornementales* (1896–99), a pattern book seminal in the diffusion of Art Nouveau, also published a manual for students entitled *Méthode de Composition Ornementale* in 1905. By analysing pre-Columbian pottery, Grasset created a new repertoire of geometric patterns and his compositions of assembled rectangles and triangles combined with half or quarter-circles were taken up by Art Deco designers the world over (ill. 34). A prolific designer of flat patterns, Emile-Alain Séguy brought out *Primavera,* probably for the Printemps department store; this was the first of a series of compilations of designs suitable for reproduction as wallpaper, fabrics and carpets in 1913. The many pattern books published during the twenties included those illustrated by Raoul Dufy, Edouard Bénédictus, Adam and M. P. Verneuil, Serge Gladky and the Cubist painter Georges Valmier (ill. 1). Manufacturers made ample use of these sources of modern design in an era when the concepts of royalties and reproduction rights were not yet protected by law.

The German and Austrian example caused some designers to revise their working methods. After a trip to Vienna, the couturier Paul Poiret (1879–1944) returned to Paris, where

he set up his own decorative arts school early in 1911. The Ecole Martine was named after Poiret's eldest daughter, and its students were trained to design fabrics, wallpaper and carpets which were sold in the Maison Martine, a shop on the rue du Faubourg Saint-Honoré, opened soon after the school. Poiret's designers were unlike any of their peers. Claiming that the Viennese workshops were too rigid in their approach, he preferred to train young girls aged between twelve and fourteen, unfettered by any formal training. He chose girls with a natural aptitude for drawing, and gave them close supervision. The 'Martines' were encouraged to work from nature and give free rein to their imaginations (ill. 35). Signing their creations in a childish hand, they worked in the attic of Poiret's couture house on the avenue d'Antin.[13] Six or seven were trained to weave carpets, probably by a professional manufacturer, and Poiret encouraged the girls to work directly at the loom in order to avoid the time-consuming preparation of point-papers.

A friend of Poiret's, the architect Louis Süe (1875–1969) had accompanied the couturier to Vienna. Upon his return, Süe established his own design studio, the Atelier Français, in 1912. Modelled on Viennese lines, the workshop collaborated with independent artists and decorators who included Paul and André Véra, Gustave Jaulmes (1873–1959) and André Mare (1885–1932). The intention of the workshop was to create a new style within a revitalized classical framework, aims expressed in a manifesto by André Véra, 'Le nouveau style', published in *L'Art Décoratif* the same year. Even before his visit to Vienna, Louis Süe had been one of the first to heed the call for a new decorative style. A carpet designed by the architect, shown on André Groult's stand at the 1911 Salon d'Automne, in a vibrant colour scheme of red, purple and blue, was decorated with four baskets linked by garlands of stylized roseballs, set off by a wide border of chequered patterning of Secessionist inspiration (ill. 36).

The painter André Mare caused a quite a stir when he exhibited the 'Maison Cubiste' at the 1912 Salon d'Automne, a collaborative effort in which thirteen artists participated, most of whom were, like Mare, members of the Groupe de Puteaux. The façade of the stand by Raymond Duchamp-Villon was designed in accordance with the principles of Analytical Cubism, yet it is difficult to detect any trace of the new school of painting in the busy flowered wallpapers and fabrics inside. The painter (and future Dadaist) Georges Ribemont-Dessaignes (1884–1974) designed a floral carpet with an oval medallion to

35 Ecole Martine, pile carpet showing a tree hung with magic lanterns, 230 x 187 cm (90 ½ x 73 ⅝ in.). The Ecole Martine's carpets were designed and woven by teenage girls in the attic of Paul Poiret's couture house. The designs were often inspired by nature, and Poiret even took his charges on trips to the botanical gardens in search of fresh ideas. This rug may commemorate his legendary party called the 1002nd Night, held in 1911.

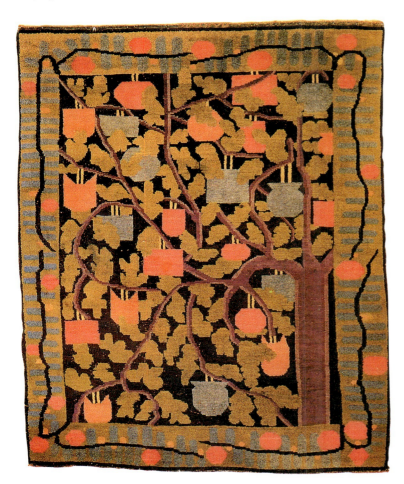

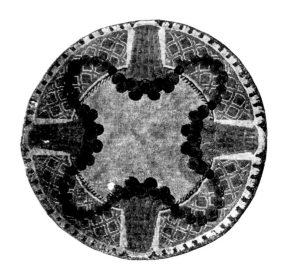

harmonize with the red, yellow and blue decoration in the bedroom.[14] The two pile carpets in the drawing room, from designs by the painter Marie-Thérèse Lanoa and Swiss artist Jean-Louis Gampert (1884–1943), were similarly ornamented with oval wreaths and floral baskets (ill. 37).[15] Another carpet designed by Mare in the period leading up to the war was woven in shades of sky blue, grey and white to match an accompanying set of furniture.

A sample of strip carpeting in the Secessionist style designed by Robert Mallet-Stevens (1886–1945) reveals the architect's familiarity with the interiors of the Palais Stoclet, owned by his uncle (ill. 38).[16] Austrian design also had an impact on the pre-war carpet designs of decorators Paul Follot (1877–1941) and Edouard Bénédictus (1878–1930). Follot exhibited a sumptuous dining room at the 1912 Salon d'Automne, and a carpet with an oval medallion and grid patterning offset by fruit baskets in the corners, designed to harmonize with the chairbacks and the chandelier. Gustave Jaulmes and André Groult (ill. 39) used a similar mix of roses, wreaths and trellises combined with geometric motifs in their carpets patterns. The work of these young designers, baptised the *Coloristes*, ushered in the Art Deco era.

In designing simple small-format scatter rugs virtually devoid of decorative motifs to serve as a discreet backdrop to his elegant custom-made furniture, Emile-Jacques Ruhlmann (1869–1933) proved the exception to the rule of sumptuous excess. One unusual example has a large diamond on a plain ground in the centre, set off by patterning which echoes the extremely long fringing at each end. The design was available in more than one colourway. Ruhlmann also made several embryonic sketches of rugs in his notebooks, some of which were developed by Henry Stéphany, a Studio Ruhlmann designer, after the war.[17]

36 Louis Süe, pile carpet produced by the firm of André Groult, Paris, and shown at the Salon d'Automne in 1911.

37 Interior of the *Maison Cubiste* presented by André Mare and Raymond Duchamp-Villon at the 1912 Salon d'Automne. The rugs are by Marie-Thérèse Lanoa (foreground) and Jean-Louis Gampert.

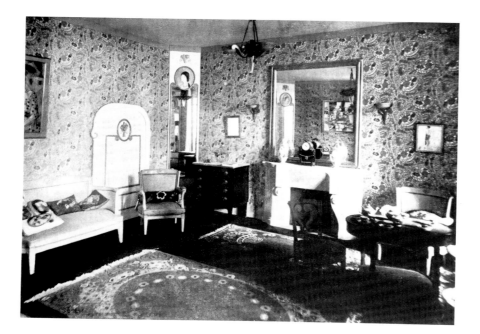

38 Robert Mallet-Stevens, sample of strip carpeting of Secessionist inspiration, made by the Laplante company and shown at the 1913 Salon d'Automne. The design reveals the architect's familiarity with the interiors of the Palais Stoclet, which was owned by his uncle.

39 André Groult, carpet exhibited at the Salon d'Automne, 1911. The design combines flower baskets and a central floral medallion over a diaper ornament.

Critics like Emile Sedeyn protested against the uncontrolled invasion of bouquets, garlands, baskets of fruit and red roses intruding upon carpets and furniture.[18] While some condoned the outburst of colour in the carpets, others thought that painting the furniture to match was sheer heresy. One commentator approvingly noted the carpet on Groult's stand at the 1911 Salon but in the next breath thoroughly condemned the polychrome dining room presented by Süe and Huillard on their own stand, having failed to realize that the interior intended for 'tasteless snobs'[19] was the work of the same designer. The renaissance of French carpet design was remarked upon by Maurice Verneuil, who singled out for special praise the attractive modern pile rugs and powerloom carpeting manufactured by Laplante.[20]

THE ART DECO CARPET BETWEEN THE WARS

The First World War ushered in a change of mentality in society at large. The mechanization of manual labour corresponded to an increase in leisure time, which meant that sport and cultural activities became more popular at all levels of society. Yet at the same time, the war provoked a rise in nationalism, and a desire to take refuge in traditional values, a desire manifest in the titles of magazines such as the *Renaissance de l'Art Français et des Industries de Luxe*, whose inaugural issue appeared in March 1918. French critics called for a 'return to order' and a truly national style free of any German influence. Most importantly, the deprivation of the war years reawakened a desire for consumer goods. By the mid-twenties, France had made a remark-able recovery, creating a prosperous middle class who could afford to invest in designer homes and luxurious custom-made rugs to furnish them.

In spite of the call to order, carpets made in the immediate post-war period reveal strong Germanic influence. A glance at the carpet displayed by Theodor Veil at the 1910 Salon d'Automne reveals that the floral style which typified French carpet design in the early twenties owed as much to the impact of the *Munichois* as it did to the Viennese.

40 Jeanne Lanvin's stand, the Pavillon de l'Elégance, at the 1925 International Exhibition, Paris.

41 Fur rug displayed on the couturier Jeanne Lanvin's stand at the 1925 International Exhibition, 154 x 154 cm (60 ⅝ x 60 ⅝ in.).

No longer simply a discreet complement to an interior, Art Deco carpets became the focal point of a room, and with the advent of Modernism often proved to be the only note enlivening an otherwise austere interior. At first, densely packed floral patterns in bright colours tended to predominate and every imaginable type of format was made, from the traditional rectangular and square to oval, round, octagonal and hexagonal shapes and the first irregular formats. Looser arrangements of roses and full-blown flowers or tropical vegetation were often juxtaposed with randomly placed geometric motifs. The designs were just as varied, ranging from floral and geometric patterns to reinterpretations of classical motifs, marine themes and figurative carpets. Fur throw rugs such as the one displayed in couturier Jeanne Lanvin's Pavillon de l'Elégance at the 1925 International Exhibition were also fashionable (ills 40, 41).

The floral designs and oriental motifs which had been a mainstay of carpet design until the twenties were now to a great extent effaced by other design criteria and the discovery of the arts and crafts of non-Western civilizations, particularly those colonized by European nations. Fauve and Cubist painters initiated the fad for collecting l'art nègre, and African influence on carpet design varied from a taste for exotic jungle plants or scenes drawn from African

life (ill. 42) to the intricate geometric patterns of Congolese textiles. North African carpets, particularly those of the Berber tribes, to a certain extent displaced the fashion for Persian and Turkish carpets. These had long, sometimes curly pile and were woven in undyed yarns or subdued earth tones, in which brick red, black, brown and ochre predominated. An exhibition of Moroccan art held at the Musée des Arts Décoratifs, Paris, in 1917 included Berber rugs and fostered a taste for carpets in simple geometric designs, of which Ivan Da Silva Bruhns was the greatest exponent. Interest in tribal crafts was further reinforced by the Colonial Exhibitions, the first of which was held in Marseilles in 1922. In the same year, Lord Carnarvon discovered Tutankhamun's tomb, which incited worldwide interest in the art of the pharaohs.

Interior decorators continued as in the past to design carpets coordinated with their interiors. The *artistes-décorateurs* who ran their own interior decoration studios, including Süe and Mare, Emile-Jacques Ruhlmann, Pierre Chareau and D.I.M. (Décoration Intérieure Moderne), owned by René Joubert and Philippe Petit, sold a wide selection of carpets from their own designs and sometimes used by freelance designers in their decorative schemes. D.I.M.'s varied from floral, abstract and figurative patterns to African and Islamic themes. Described as one of the most successful decorating firms of the time,[21] D.I.M. probably owed its success to the fact that it catered to all tastes. Designers such as Jules Coudyser continued the tradition of the *tapissier-décorateur*, specializing in wallpaper and textiles. The demand for designer carpets was such that a growing number of artists and designers including Eileen Gray and Evelyn Wyld, Gustave Fayet, Ernest Boiceau and Ivan Da Silva Bruhns founded workshops to produce their own.

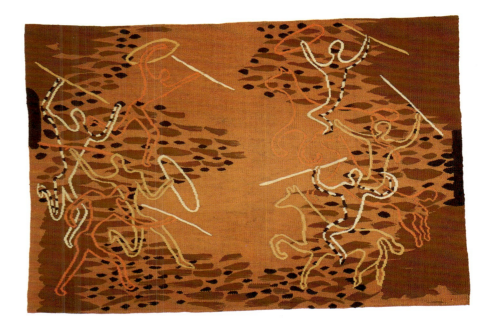

42 Flatweave carpet by an unknown designer, wool on cotton foundation, 220 x 150 cm (86 ⅝ x 59 in.). It depicts a battle between warriors on foot, armed with lances and shields, and their adversaries on horseback. The stick figures are reminiscent of the cave paintings at Tassili N'Ajjer, Algeria.

Most of the large department stores followed suit and opened their own interior design departments, appointing well-known designers as artistic directors. Printemps was the first to do so, in 1912. As hand-knotted rugs could then be made relatively cheaply in Aubusson,[22] the department stores played a significant role in making designer carpets available to the middle classes. While Primavera (the Printemps design department), La Maîtrise (at the Galeries Lafayette) and particularly Pomone (at Au Bon Marché) tended to cater to a conservative clientele, the Studium Louvre (Grands Magasins du Louvre) veered towards Modernism. By the late twenties, designer carpets had become so popular that they began to rival oriental carpets in the public's affections. In 1927, the Grands Magasins à la Place Clichy, a department store which until then had specialized in retailing oriental carpets, took the unprecedented step of issuing a collection of handwoven carpets by contemporary French designers, including Francis Jourdain, Yvonne Fourgeaud and Bénédictus.

FLORAL AND CLASSICAL PATTERNS

Variants on the floral carpet were legion. Many were created on a one-off basis, as part of an integral decorative scheme, as were for instance the rugs designed by Albert-Armand Rateau for Jeanne Lanvin's house in Le Vesinet. An even greater number were produced in limited editions or as Jacquards by decorators, *tapissiers-décorateurs* and manufacturers. Floral rugs were created by Pierre Bracquemond, Ernest Boiceau, Clément Mère, Gustave Jaulmes (ill. 43), Fernand Nathan (ill. 44), Jean Beaumont, Raoul Harang, Jacques Klein, Yvonne Fourgeaud, Camille Cless-Brothier (ill. 45), Jane Lévy, Paul Dumas (ill. 46) and Henry Stéphany. The chief exponents of the style were the Martines, Süe and Mare, Paul Follot, Maurice Dufrène, Emile Gaudissart, Jules Coudyser, Edouard Bénédictus and Gustave Fayet.

The cachet of Poiret's designs was dictated by the pre-war cultural ambience, namely a love of striking colours and floral patterns. As Paul Poiret took his charges on outings to the Jardin des Plantes, many rugs designed and made by the Martines were decorated with hothouse flowers. By the twenties, the Martines' work had matured into a unique, naively charming style of their own, based on loosely drawn open flowers and veined leaves in pinks, greens, mauves, oranges and blues (ill. 47).[23] A particular shade of bright pink, a favourite colour of Poiret's, is common to many of them. A critic remarked that this somewhat unorthodox approach had resulted in the 'most beautiful carpets of our epoch'.[24] Others were somewhat sceptical that young untrained girls could produce such charming compositions unaided. Rugs by the Martines were regularly shown on Poiret's stands at the annual salons and formed part of the furnishings of *Amours*, one of the three converted houseboats moored along the Seine which served as the couturier's showcase at the 1925 International Exhibition (ill. 48).

43 Gustave Jaulmes, section of a carpet design made by the Maison Hamot, 1925, gouache, 27.3 x 47.2 cm (10 ¾ x 18 ⅝ in.).

44 Fernand Nathan, carpet, *c.* 1925, hand-knotted, wool pile, 300 x 193 cm (118 ⅛ x 76 in.), monogrammed.

45 Camille Cless-
Brothier (attr.), pile
carpet, *c.* 1925,
348 x 249 cm
(137 x 98 in.).

46 Carpet designed
and/or produced
by Paul Dumas,
hand-knotted, wool,
400 x 480 cm
(157 ½ x 189 in.),
monogrammed.

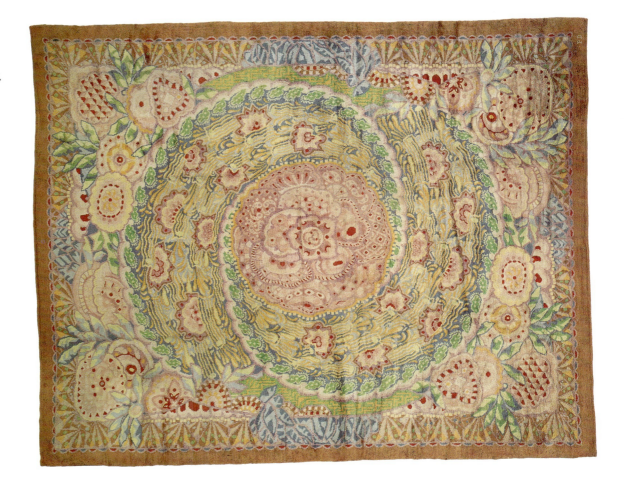

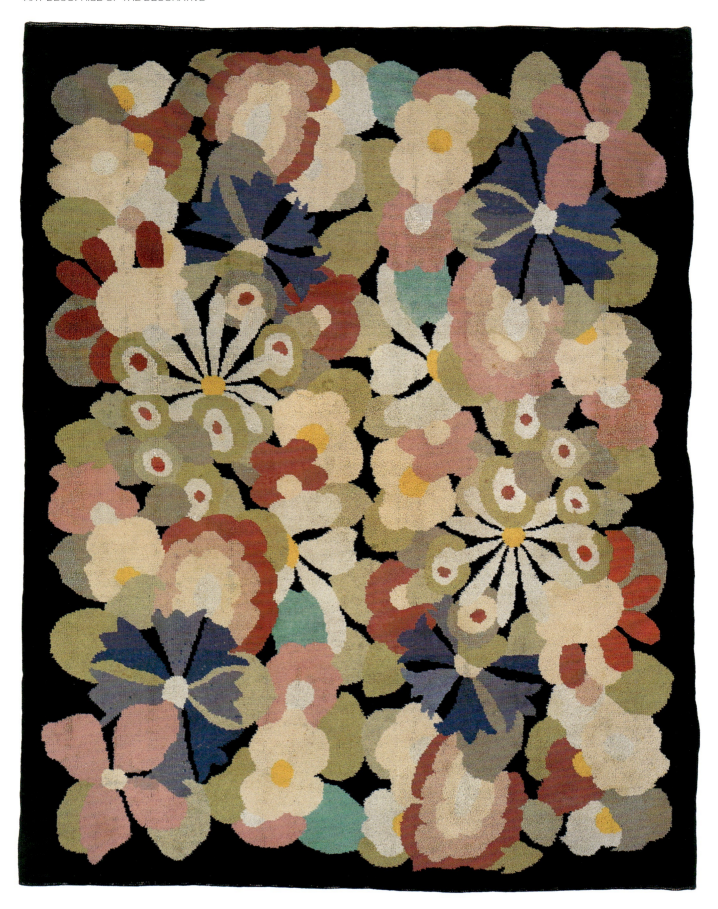

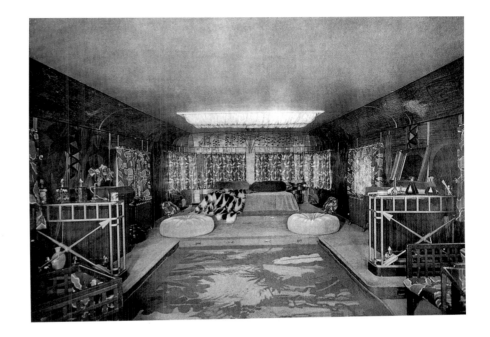

48 Bedroom on the barge *Amours*, decorated by the couturier Paul Poiret, 1925. This boat, together with *Délices* and *Orgues,* was moored on the banks of the Seine and served as Poiret's stand at the 1925 International Exhibition. The carpet was by the Ecole Martine and the curtains and fabrics by Raoul Dufy.

47 Pile carpet woven by the Ecole Martine, *c.* 1925, 457 x 255 cm (180 x 100 ⅛ in.). Naively drawn flower and leaf motifs are characteristic of Poiret's protegées.

After the war, Louis Süe formed a partnership with André Mare. Founded in 1919, their interior decoration studio, the Compagnie des Arts Français, had the aim of creating the 'total work of art' within a revitalized classical framework, with particular reference to the Louis Philippe period. Süe and Mare worked with some of the most prestigious artists of the era and along with Ruhlmann were the most sought-after decorators of the twenties. Their earliest carpet patterns use a classical vocabulary of posies, garlands, wreaths, festoons, floral swags and baskets, and medallions in symmetrical patterns. Their pre-war colour schemes were softened in favour of subtler harmonies in shades of green, blue, plum, soft yellow, brown and a particular shade of dusky rose. From 1921 new elements were introduced, namely looped ribbons, shells and palm fronds, framed by drapery or occasionally associated with areas of basketweave patterning (ills 49, 50, 51). Proportions were calculated using a module, in accordance with the principles of Vitruvian architectural theory.[25] Unlike many of their peers, Süe and Mare were not opposed to mass production, as long as it was of good quality. Carpeting and small Jacquard throw rugs, along with reasonably-priced lines of furniture, were sold by their Faubourg Saint-Honoré store.

Spectacular examples of Süe and Mare's work included the knotted carpets made for the drawing room of Jane Renouardt's villa in Saint Cloud (1924), and the twin pavilions they designed for the 1925 International Exhibition. The 'Musée d'Art Contemporain' pavilion served as a showcase for the work of the Compagnie des Arts Français, while its pendant was commissioned by the locksmiths Fontaine et Cie. Another exceptional commission was

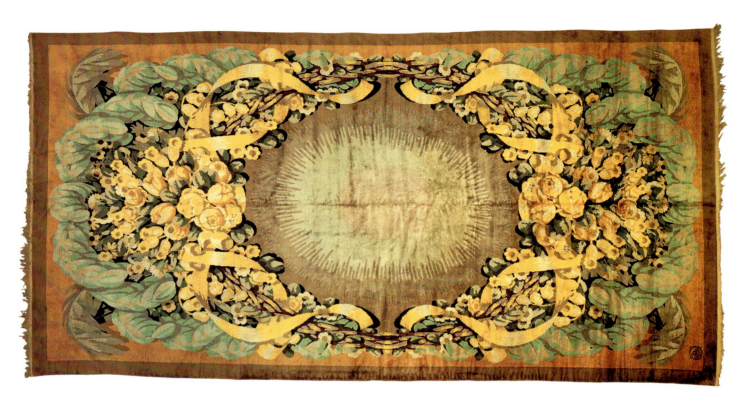

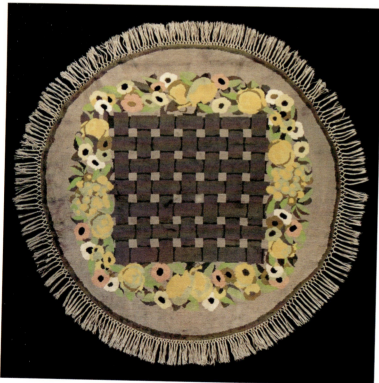

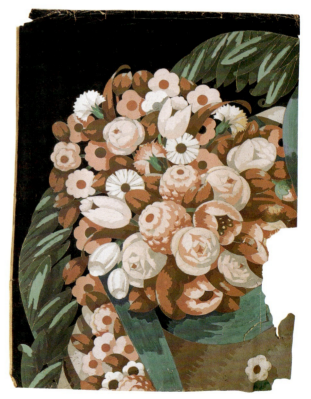

49 Süe et Mare Compagnie des Arts Français, carpet woven by the Maurice Lauer workshop, Aubusson, for the drawing room of Mme Gautrat de Lompré, Paris, 1924. Hand-knotted, wool, 490 x 260 cm (192 ⅞ x 102 ⅜ in.).

50 Süe et Mare Compagnie des Arts Français, circular carpet with a basketweave pattern set off by floral motifs, c. 1925, hand-knotted, wool, diameter 213 cm (84 in.), woven by the Maurice Lauer workshop, Aubusson.

51 André Mare, carpet design in gouache, c. 1925.

the first-class lounge on the liner *Ile-de-France*, laid with a vast carpet in a floral pattern enlaced with palm fronds and scallop shells. Surrounded by carpeting in a basketweave pattern, the rug was rolled back in the evenings to reveal a dance floor.[26]

An even more ardent defender of French classicism was Paul Follot (1877–1941). The decorator professed sympathy for contemporary trends like Cubism[27] but never diverged from his commitment to the French tradition. His early rug patterns stuck firmly to a repertoire of posies (ill. 52), fruit and flower baskets, wreaths, festoons, tassels and garlands, sometimes associated with a leafy trellis. One such piece was selected for a travelling exhibition of items shown at the Paris exhibition which toured the United States in 1926. Follot broadened his repertoire after he was appointed director of the Pomone design studio in 1923. A rug displayed on the firm's stand at the 1924 Salon des Artistes-Décorateurs was ornamented with a large central polylobed medallion, set off by pear-shaped floral *boteh*, and a border based on the same motif. Familiar from the Paisley shawl, the *boteh* appears in several other pieces. Follot also liked caisson arrangements and oriental motifs such as the lotus. He does not appear to have designed any carpeting, which is to be expected in view of his opposition to mass production. Working in a studio on the top floor of his house, Follot was also unusual in drawing life-size cartoons rather than the usual small-scale models and in selecting the wools himself.

The career of Maurice Dufrène (1876–1955) to some extent paralleled that of Follot. Both began their careers at the Maison Moderne, and both became directors of interior design studios run by department stores, in Dufrène's case, La Maîtrise at the Galeries Lafayette. Dufrène, however, was less bound to tradition than Follot, as he believed in mass production

52 Paul Follot, rug, 1920s, hand-knotted, wool pile, 116.2 x 185.5 cm (45 ¾ x 73 in.), signed.

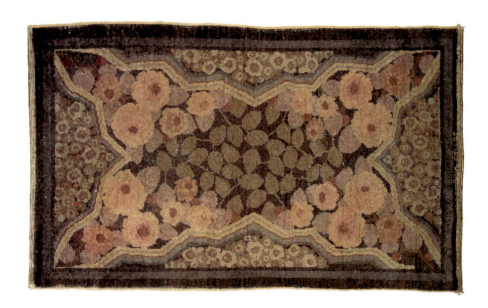

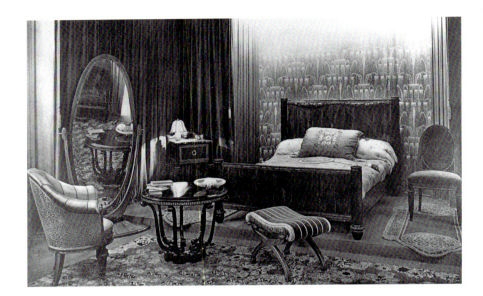

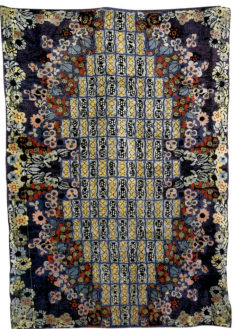

and was receptive to new techniques. La Maîtrise thus not only sold luxury pile carpets, but inexpensive lines of washable cotton and rayon throw rugs.

Affinities also exist between Follot's and Dufrène's early carpet designs. Dufrène also favoured trellis or chequered patterning, massed floral and leaf motifs and the ample use of roseballs, but his rugs tend to be less formal than those of Follot and often lack borders (ills 53, 54).[28] By the time of the 1925 exhibition, Dufrène had moved away from Viennese influence to create a forceful style of his own. A carpet named *Les Vosges en Automne*, woven by Schenk for the gentleman's study in the La Maîtrise pavilion at the 1925 exhibition, featured luxuriant tropical vegetation, tangled with overlapping forms and abstract motifs.[29]

One of Dufrène's most prestigious commissions was the design of powerloom carpeting for the monumental flight of stairs in the Elysée Palace, Paris, commissioned by the Mobilier National. Woven by the Manufacture Française de Tapis et de Couvertures, the strip carpeting had a repeating pattern of curved floral and leaf motifs framing the symbols of the French republic, the axe and lictor's fasces surmounted by a Phrygian cap.[30] Six more of Dufrène's rugs remain *in situ* in the dining room of a Belgian collector whose Brussels home (now the Van Buuren Museum) furnished by Dominique has been preserved intact. A former student of Dufrène, Suzanne Guiguichon (1901–85) designed a considerable number of carpets for La Maîtrise in a style which closely resembles that of her mentor (ill. 55).

A specialist textile designer, Emile Gaudissart (1872–1957) lent his collaboration to many designers and manufacturers, including the Beauvais and Gobelins tapestry workshops. His carpet repertoire varied from geometric to floral designs, many of which feature characteristic overlapping tongue-like motifs. The ones laid in Ruhlmann's sumptuous pavilion at the 1925 Paris exhibition are characteristic examples (ills 56, 57).

In designing and retailing furnishing fabrics and in providing advice on interior decoration to his clients, Jules Coudyser (1867–1931) perpetuated the tradition of the *tapissier-*

53 Maurice Dufrène, bedroom designed for La Maîtrise and exhibited at the Salon des Artistes-Décorateurs, Paris, 1923.

54 Maurice Dufrène, carpet produced by La Maîtrise, 1923, hand-knotted, wool, 290 x 205 cm (114 1/8 x 80 3/4 in.). Dufrène used many traditional motifs, but was open to mass production and new techniques.

55 Suzanne Guiguichon, carpet in the style of Maurice Dufrène, probably for La Maîtrise, *c.* 1925–27, hand-knotted, wool, 304.8 x 152.4 cm (120 x 60 in.), monogrammed. A former student of Dufrène, Guiguichon abandoned the floral patterns she designed for La Maîtrise in favour of a starker vocabulary after setting up her own interior design studio.

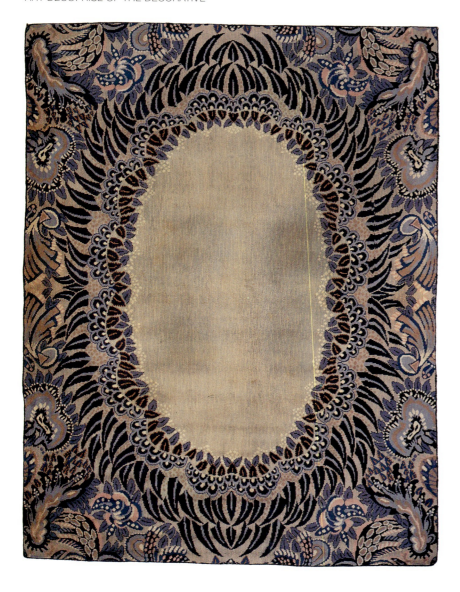

56 Emile Gaudissart, central fragment of the carpet from 'L'Hôtel du Collectionneur', a stand at the 1925 Paris International Exhibition. The fragment measures 405 x 301 cm (159 ½ x 118 ½ in.); the original carpet measured 650 x 750 cm (236 ¼ x 295 ¼ in.). Hand-knotted, wool pile.

57 'L'Hôtel du Collectionneur', a stand by Emile-Jacques Ruhlmann and Pierre Patout at the 1925 Paris exhibition. The carpet (1924–25) was made by Braquenié of Aubusson from a design by Emile Gaudissart, who also designed the tapestry used to upholster the seats.

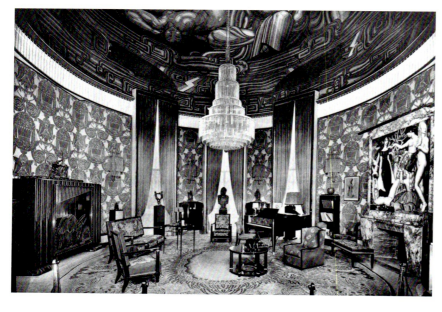

décorateur (ills 58, 59). Coudyser's shop on the rue du Bac, 'L'Art dans les Tapis et les Tissus', retailed a range of floral and medallion designs, somewhat disparagingly dismissed as conservative by the American photographer Thérèse Bonney (1894–1978) in her *Shopping Guide to Paris*.[31] Coudyser had a predilection for medallions, placed in spoke-like arrangements extending to the border or set off by a field of Secessionist-style tracery. The carpet named *Autumn Flowers*, laid in the Commissaire's pavilion at the 1925 exhibition, consisted of a floral medallion contained within bands resembling basket weave.[32]

Famous for his invention of Triplex shock-resistant glass, Edouard Bénédictus (1878–1930) was unusual in combining artistic and scientific talents.[33] At the start of his career, he made objects of inlaid leather, but soon turned to the two-dimensional art at which he excelled. Bénédictus published three pattern books and designed many beautiful fabrics, but according to the critic André Girodie, it was in the field of carpet design that he carved himself the most original place.[34] His floral trellis patterns and loosely drawn flowers are combined with ovoid and geometric shapes, including diamonds, squares and latticework in a subtle range of shades from soft to vibrant, such as greys and beiges with pinkish gold or violet, mixed with golden yellow or black (ill. 62). The most spectacular were displayed in the reception room in the pavilion of the Société des Artistes-Décorateurs at the 1925 Paris exhibition, furnished with textiles he designed for the Brunet-Meunié company and two carpets woven by the firm Aux Fabriques d'Aubusson (ills 60, 61).

Bénédictus's scientific background meant that he was one of the rare designers familiar with the technical aspects of production, and as a result manufacturers often sought his collaboration. He worked closely with the textile manufacturer Tassinari et Chatel, with a

58 An interior designed by Raymond Quibel for Mercier Frères at the 1925 International Exhibition, featuring glass by René Lalique, metalware by Jean Puiforcat and a carpet by Jules Coudyser.

59 Jules Coudyser, *Les Liserons (Convolvulus)*, carpet, *c*. 1925, hand-knotted, wool, 300 x 300 cm (118 ⅛ x 118 ⅛ in.), monogrammed.

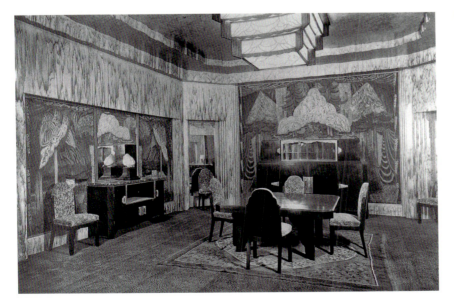

60 Edouard Bénédictus, pile carpet made by the firm Aux Fabriques d'Aubusson for 'Une Ambassade Française' (see below), c. 1925. Hand-knotted, wool, 830 x 435 cm (327 x 171 ¼ in.).

61 Henri Rapin and Pierre Selmersheim, reception room from 'Une Ambassade Française', the showcase of the S.A.D. (Société des Artistes-Décorateurs) at the 1925 International Exhibition. The carpet and wall fabric were by Edouard Bénédictus.

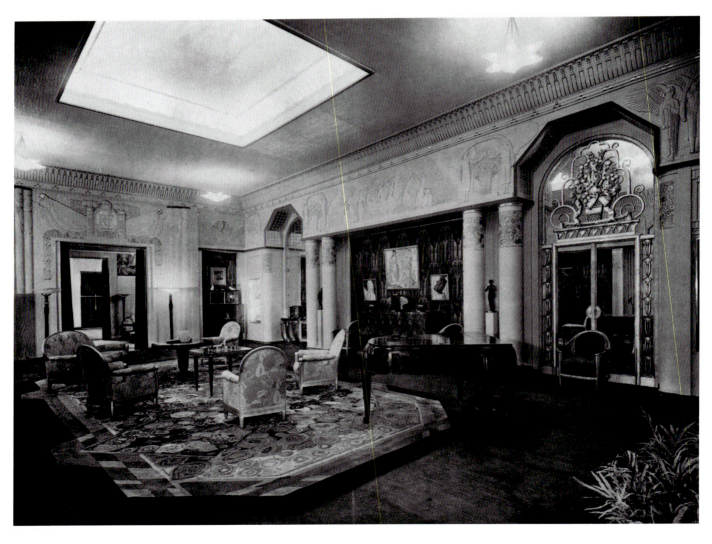

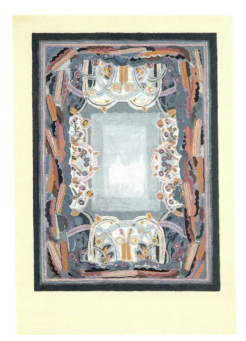

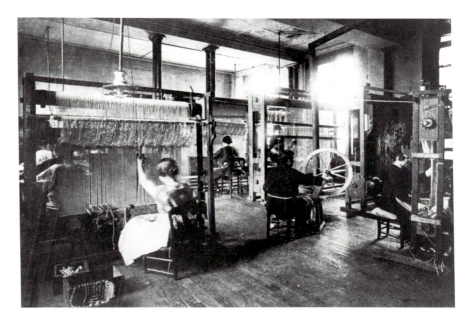

62 Edouard Bénédictus, carpet design, 1927,
gouache on paper, 49.5 x 35 cm (19 ½ x 13 ¾ in.).
The paired motifs at each end evoke
a flowing fountain, a favourite Art Deco motif.

63 The Atelier de la Dauphine in the early 1920s.
The workshop, on the rue Dauphine, Paris, was
run by Fernand Dumas and had the exclusive
rights to manufacture Gustave Fayet's carpets.

64 Gustave Fayet, pile carpet, c. 1920, hand-
knotted, wool, 163 x 128 cm (64 ⅛ x 50 ⅜ in.),
woven from a watercolour.

view to improving the quality of their rayons, and supplied many companies with patterns for strip carpeting. Notwithstanding this exemplary collaboration with industry and his belief in mass production, Bénédictus never adhered to Modernist doctrine in eschewing ornamentation.

The painter Gustave Fayet (1865–1925) became involved in the design and production of carpets relatively late in life. Through his work as curator of the Béziers Museum, Fayet met the painter Odilon Redon who urged him to take up painting. Fayet's watercolours of flowers and dream-like themes, painted on blotting paper, were woven as carpets from about 1920, when he formed a partnership with Mr and Mrs Fernand Dumas, who ran the Atelier de la Dauphine, a carpet-weaving workshop on the rue Dauphine in Paris (ill. 63). The couple had learned how to weave and dye their own wools in Kairouan and wove orientalist patterns until they decided to gear their production towards modern designs after seeing an exhibition of rugs by Pierre Bracquemond and Paul Follot.

Fayet's mature style owed much to the influence of marine life, with which he became familiar after acquiring a property at Cap Brun, near Toulon, directly overlooking the sea. The artist began incorporating forms resembling amoebae, algae and jellyfish into his carpet designs. The effect of seawater was obtained by mixing rows of knots in blues and blue-greens. Praised as a 'musicien de la couleur',[35] Fayet associated bright reds and blues with black and softer shades: grey, bistre, blue and pink with shades of aubergine, violet and purple (ill. 64). The delicate nuances in shade were achieved through the use of particularly silky wools and knotting in chiné yarns by weavers formerly employed by the Gobelins. Woollen and silk pile were occasionally mixed.

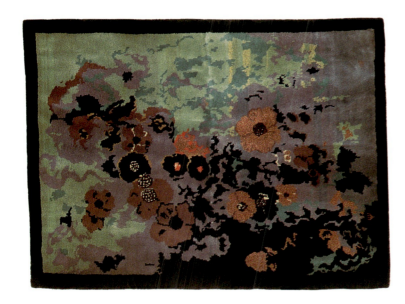

Floral patterns have been the most consistently popular ornamentation in carpet design over the centuries and the tradition is a tenacious one. But a change is perceptible after 1925, when the demand for floral patterns waned. Most of the designers who were still active during the thirties either completely abandoned floral motifs or adapted them to the new sobriety in design that was *de rigueur* from the late twenties.

GEOMETRIC AND ABSTRACT DESIGNS

As the crossing of the warps and wefts lends itself naturally to grid arrangements, repeating geometric ornaments, diaper and reticular motifs are hardly new features to carpet design. However, the range of geometric patterns which evolved during the twenties bears little or no relationship to the peasant rugs or geometric designs of previous eras (ill. 66). Geometric and abstract patterns were not specific to any particular group or movement: Ruhlmann, Paul Follot and Ernest Boiceau's design vocabulary was just as likely to be based on rationalist principles as that of Francis Jourdain or Djo-Bourgeois. Be that as it may, the influence of abstract painting is notably absent from the repertoire of the *arrière-garde*. The most prestigious *artistes-décorateurs*, among them Ruhlmann, Albert-Armand Rateau (ill. 67) and Jules Leleu, never subscribed to the tenets of the avant-garde, while the major exponent of the geometric style, Ivan Da Silva Bruhns, endorsed Cubism for only a relatively brief period.

Upon inheriting his father's prosperous contracting business, Ruhlmann created a decorating department as a sideline. He was among the few carpet designers not to receive an accolade from Thérèse Bonney, who warned potential buyers that the range was confusing and should be 'carefully handled'.[36] Intended to serve as a foil to his elegant custom-made furniture, the Studio Ruhlmann's range may best be defined as eclectic, varying from intricate floral and medallion patterns to geometric or linear designs or scrolling or vermicular ornamentation (ill. 68). The lack of a house style may be attributed to the number of in-house designers involved. The studio is known to have employed up to twenty designers at a time and also consulted freelance designers including Léon Voguet (born 1879) (ill. 65).[37] Henry-Jacques Le Même, Alfred Porteneuve and Henry Stéphany were among the many architects and designers employed by the firm.[38] Specializing in the design of flat patterns, Stéphany created many wallpapers, textiles and

65 Léon Voguet, carpet design for the Studio Ruhlmann, 1925, gouache on cardboard. This was one of two pile carpets he designed for the study in Ruhlmann and Patout's pavilion at the 1925 International Exhibition. The design could be said to prefigure the Abstract Expressionist school of painting.

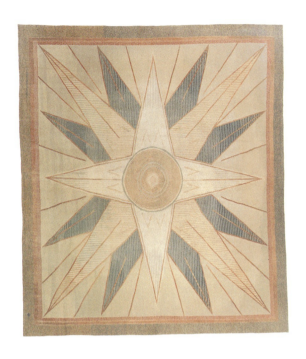

66 René Joubert (attr.), carpet designed for D.I.M., made in Aubusson, *c.* 1920, flatweave, wool, 376 x 320 cm (148 x 120 in.), monogrammed. Geometric patterns vied with floral designs for popularity.

67 Albert-Armand Rateau, carpet for the bedroom of Aline and Charles Liebman, New York, *c.* 1926, hand-knotted, wool pile, 414 x 346 cm (163 x 136 ¼ in.).

68 The Studio Ruhlmann, circular carpet with a vermicular pattern, *c.* 1920, hand-knotted, wool pile, diameter 360 cm (141 ½ in.).

69 Henry Stéphany (attr.), *Circles and Waves*,
 c. 1927, hand-knotted, wool pile, 534 x 414 cm
 (210 ¼ x 163 in.). This carpet was shown on the
 stand of the Studio Ruhlmann at the 1928 Salon
 des Artistes-Décorateurs.

70 Ivan Da Silva Bruhns, carpet with an African-
 inspired motif, *c.* 1920–25, hand-knotted,
 wool pile, 215 x 118 cm (84 ⅝ x 46 ½ in.).
 Before establishing his own workshop, Da Silva
 Bruhns had his rugs made on a piecework basis
 by a village weaver near Rheims.

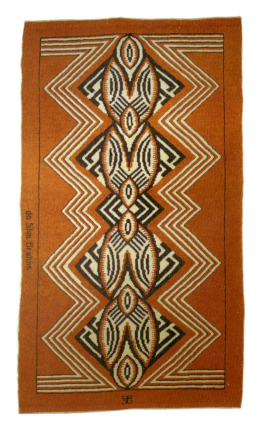

carpets for the studio. A carpet with a pattern of concentric circles presently in the Virginia Museum of Fine Arts, Richmond, Virginia, resembles a surviving design attributed to Henry Stéphany (ill. 69).[39]

The carpets of Ivan Da Silva Bruhns (1881–1980) are today among the most highly prized of French Art Deco carpets.[40] Born in Paris of Brazilian parents, Da Silva Bruhns initially studied medicine and painting before turning to carpet design. Invalided out of the army during the First World War, Da Silva taught himself to weave by unravelling oriental carpets. Presumably, he also took further professional instruction, as he used the Savonnerie technique and the structure of his carpets is typically French. Da Silva's first designs consisted of geometric or floral motifs outlined in black, on black, blue, bright green or yellow grounds. An early exhibition of his carpets was held at the Feuillets d'Art gallery, Paris, in 1919.

Da Silva's curiosity was aroused when he discovered Berber rugs at the exhibition of Moroccan art at the Musée des Arts Décoratifs, Paris, in 1917. His ensuing discovery of American Indian, African, Oceanic and particularly pre-Columbian art (hardly surprising, in view of his origins) enriched the repertoire of his 'Aztec' period, during which he designed symmetrical compositions using diamonds, triangles, meanders, serrated-edge, rectilinear scroll and chevron motifs (ill. 70). One circular design recalled the tortoiseshell filigree carving of Polynesia. Bright colours were replaced by subdued shades of garnet, rust or brick red, dull orange, brown, indigo, grey and black, highlighted with white. The range in any one carpet was generally limited to three or four shades (ill. 71).

By 1925 Da Silva's business had prospered sufficiently for him to found his own factory in the Paris suburbs, at Savigny-sur-Orge, with showrooms in Paris. Available in three grades, determined by the knotting density, carpets from his workshop are extremely well made, with luxuriantly thick pile in silky woollen yarn of good quality. They are also numerous, relatively speaking: in addition to enjoying remarkable longevity, Da Silva devoted his entire career to the

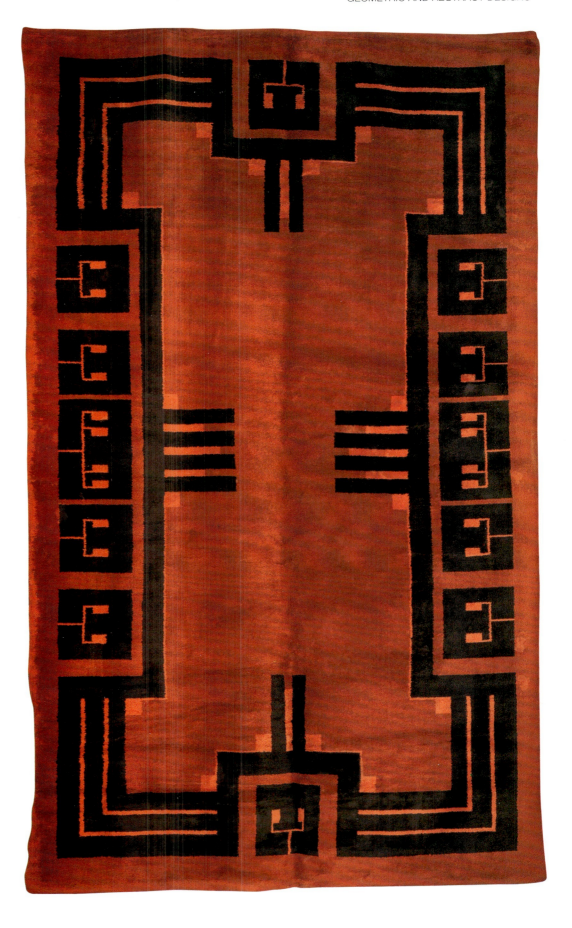

71 Ivan Da Silva Bruhns, carpet made at Da Silva Bruhns's workshop, the Manufacture de Savigny, at Savigny-sur-Orge, near Paris, *c.* 1927, hand-knotted, wool pile, 540 x 330 cm (212 ⅝ x 129 ⅞ in.). Da Silva Bruhns was the most prolific designer of carpets between the wars.

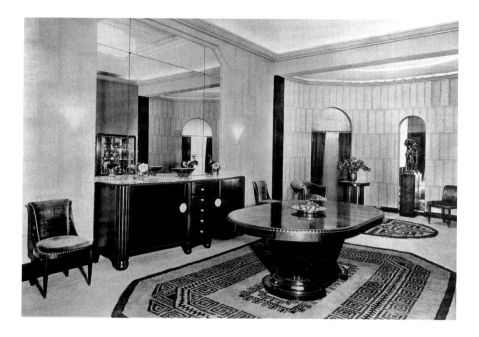

design and manufacture of carpets (ill. 73). His elegantly luxurious creations, regularly displayed on stands at the Société des Artistes-Décorateurs, served as a foil to Art Deco interiors designed by some of the most prestigious decorators of the era, including Ruhlmann and Jules Leleu, who regularly sought his collaboration (ill. 72).

IN A FIGURATIVE STYLE

Figurative carpets were less common than floral or abstract designs, but they nonetheless enjoyed marked popularity. The subject matter bore little or no relation to the figurative carpets of previous centuries, and instead reflected the preoccupations of the times, ranging from African themes to sports and leisure, animals, scientific inventions such as the aeroplane, and even esoteric subjects such as maps or plans of buildings and gardens. As a memorial to the war dead, the Mobilier National commissioned a design decorated with flags and grenades for the premises of the Ministry of War from the painter Robert Bonfils (1886–1971) (ill. 74).

Happily, the themes were in general more cheerful, corresponding to the newly found *joie de vivre* which followed the war's end. Pierre Leconte designed a carpet with young fruit-pickers climbing ladders into the branches for the La Maîtrise pavilion at the 1925 Paris exhibition (ill. 77). Marie Laurencin (1885–1956), whose graceful paintings of ethereal young women often enhance decorative schemes of the period, designed a similarly light-hearted piece for a friend. Laurencin's rug[41] was whimsically decorated with mermaids and sea monsters entwined with cooing doves and ribbons in her favourite shades of pastel pink and blue (ill. 75).

Manzana-Pissarro (1871–1961) initiated a fad for animal carpets. Born Georges Pissarro, son of the Impressionist painter, Manzana-Pissarro was first and foremost a painter of the Orientalist school. In 1913 he and his wife opened a weaving atelier in Paris and the following year, an exhibition of his tapestries and carpets was held at the Musée des Arts Décoratifs in Paris. His designs feature all kinds of fauna including rabbits,[42] peccaries, peacocks, ducks

72 Jules Leleu's stand at the 1925 International Exhibition. The carpet, with a repeating inlaid meander pattern, was designed by Ivan Da Silva Bruhns and made in his Savigny workshop, and was awarded first prize in the Textiles Section.

73 Ivan Da Silva Bruhns with a design in hand in front of one of his creations, *c.* 1930. Photograph by Thérèse Bonney.

74 Robert Bonfils, carpet commissioned by the Mobilier National for the French Ministry of War, 1922–24, hand-knotted, wool pile, 296 x 231 cm (116 ½ x 91 in.). Unusual in depicting the paraphernalia of war, the carpet includes names and dates which commemorate the major battles of the 1914–18 conflict. It was woven by the Manufacture de la Savonnerie, Paris, and was displayed on the Mobilier National stand at the 1925 International Exhibition.

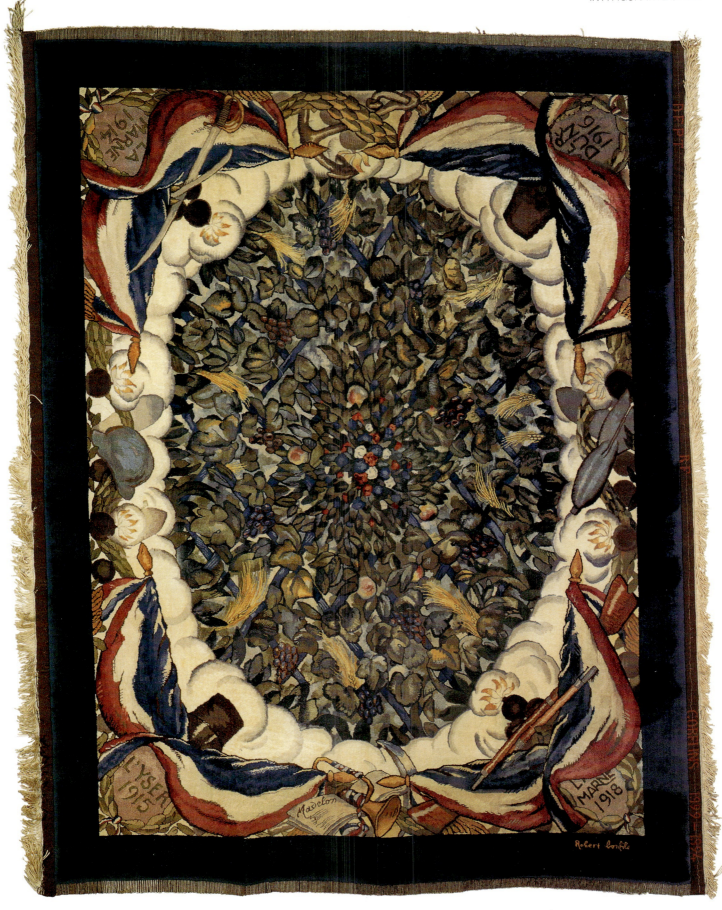

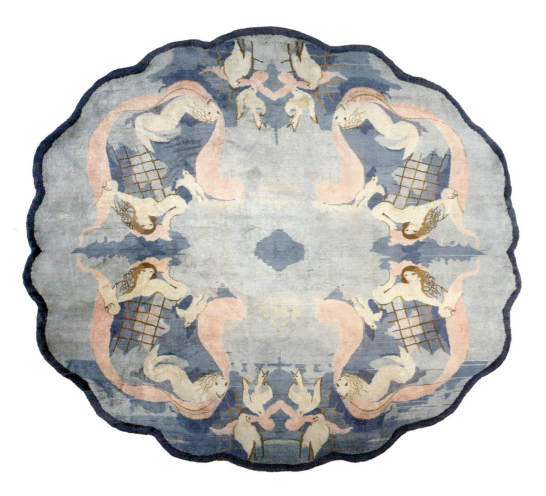

75 Marie Laurencin, carpet for the
 director of a Paris music salon, 1925,
 hand-knotted, wool pile, 325 x 350 cm
 (128 x 137 ¾ in.). In his diatribe
 against the prevailing Art Deco style,
 Le Corbusier decried carpets decorated
 with 'cooing doves'.

and chickens; the latter may be attributed to his unusual taste in pets, as he raised the
Faverolles and Padua breeds. Cockfights also feature frequently in both his paintings and
carpet designs.

Some rugs were in a light-hearted vein. The Martines once used a bowl of goldfish as
subject matter.[43] Painter and tapestry designer Jean Lurçat (1892–1966) drew a humorous rug
entitled *The Tiger*; the flayed pelt of the animal, complete with claws, was said to be a carica-
ture of his dealer.[44] Lurçat also produced a panoply of real and imaginary creatures sketched in
the linear style which appear in both his tapestries and carpets. Mermaids, naiads, centaurs,
winged horses and seahorses cavort over the surface of his rugs, which were sold by the
Boutique Pierre Chareau and the Maison Myrbor (ill. 76). Others feature friezes of mythical
beasts and riders that recall scenes depicted on ancient ritual Chinese bronzes. Helena Rubin-
stein acquired *Cavalcade*, decorated with a frieze of winged horses at each end, for her New
York apartment.

René Crevel and Vladimir Boberman (1897–1977) both looked to Africa for inspiration.
Wild animals from Noah's Ark parade around the border of one carpet designed by René

76 Carpet decorated with a galloping horse in
 the style of Jean Lurçat, woven by the Maison
 Myrbor, *c*. 1925–30, hand-knotted, wool pile,
 200 x 190 cm (78 ¾ x 74 ¾ in.).

77 Pierre Leconte, hand-knotted wool pile carpet, 1925, designed for La Maîtrise, the interior design department of the Galeries Lafayette department store, Paris, and shown in their pavilion at the 1925 International Exhibition. The fruit-picking scene expresses the newly rediscovered *joie de vivre* which followed the end of the First World War.

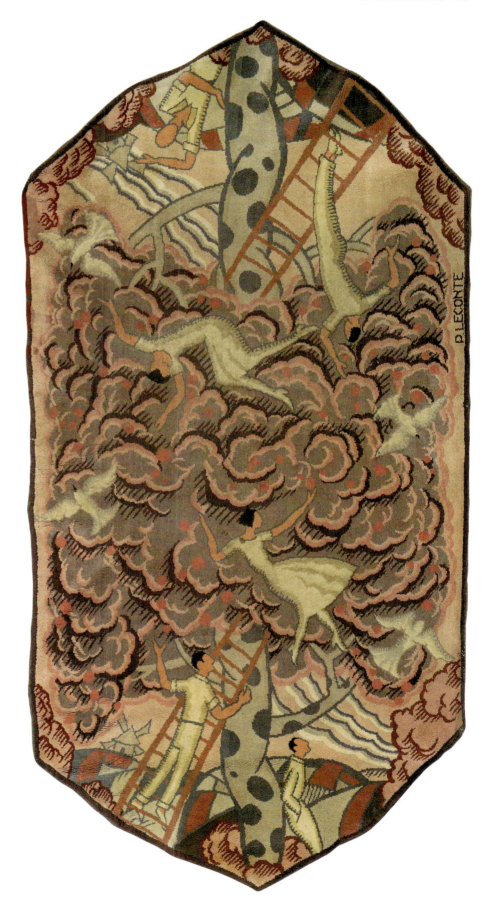

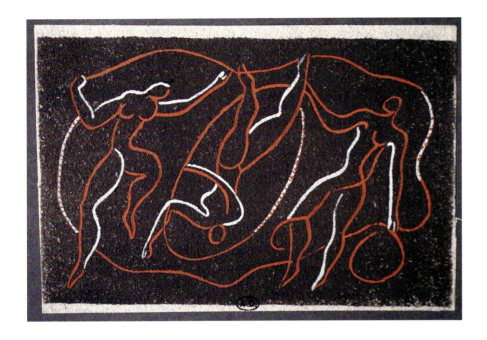

78 Vladimir Boberman, *The Three Graces*,
 carpet design for D.I.M. from an album
 published in 1928. The schematic drawing
 anticipates the Modernist aesthetic.
 An example of the finished rug is in the
 Victoria and Albert Museum, London.

Crevel, while Boberman's rugs are decorated with hunting scenes inspired by the Tassili cave paintings or a *caiman* (talisman) in the form of an alligator hide.[45]

A particularly versatile designer of Armenian origin, Boberman settled in Paris in 1923. He created a wide range of models, from abstract to figurative designs, for the D.I.M. studio. His favourite themes included leisure activities, such as the circus, sailboats and liners, or games in which leaping figures throw balls, dive into swimming pools, play tennis[46] or lounge on beaches. His figures were generally lightly sketched in silhouette form, in discreet shades of brick, grey, beige, slate blue, brown and black, occasionally enlivened with brighter colours. He often gave them allegorical names, like *The Three Graces*, a pile rug with a sporting theme, presently in the Victoria and Albert Museum (ill. 78).

By this time, however, the pendulum had swung in favour of the Modernists, who had gained the upper hand. The 1925 International Exhibition marked the peak of Art Deco, but also sounded its death knell. In his indictment entitled *L'art décoratif d'aujourd'hui*, Le Corbusier dismissed the work of the *artistes-décorateurs* as decadent and criticized the exhibition's brief, which had failed to respond to the needs of the socially deprived. Within a few years the Modern Movement ushered in the new era of functionalist design which triumphed during the thirties. The advent of Modernism caused a decline in the production of the designer carpet. Output dropped off sharply during the thirties and even the most conservative designers dropped brightly coloured floral patterns in favour of abstract designs in muted colour schemes.

A BOOM IN BELGIUM

By 1910, Brussels's lustre as one of the capitals of Art Nouveau had long since dimmed. Its chief protagonists, Henry Van de Velde, Paul Hankar and Victor Horta, had either disappeared from the scene or abandoned the style, leaving a void. However, the construction of the Palais Stoclet in the Belgian capital not surprisingly aroused excitement and controversy among the members of the architectural and decorating professions.

The architect Léon Sneyers (1877–1949) seized the occasion to open an interior decoration store named A l'Enseigne de Vienne et de l'Art pour Tous. The opening coincided with the completion of the mansion. Until then, Sneyers's architectural projects had been subject to the influence of the Arts and Crafts movement. A carpet design in the Archives d'Architecture Moderne in Brussels is decorated with Klimt-style arabesques, yet the firmly contoured motifs are unmistakably Art Deco (ill. 79). On the other hand, the rugs displayed at the Ideal Home Exhibition, London, in 1913 are more noticeably influenced by Hoffmann.

Initiatives like Sneyers's remained the exception rather than the rule until after the First World War, but the immediate post-war period saw the founding of several workshops specializing in the manufacture of handwoven carpets. The Ateliers Chaudoir in Brussels, the De Wit workshops in Malines, the Forces Nouvelles workshop in Tournai and the Studio de Saedeleer in Etikhove were founded with a view to infusing new life into a hackneyed commercial production, confined for the most part to copies of oriental and Savonnerie carpets.

Among these workshops, the Studio de Saedeleer achieved the most prominence. A leading figure of the Laethem school, Valérius de Saedeleer (1867–1942) had fled as a refugee to Britain during the First World War. Here the painter and his family met members of the Arts and Crafts movement, including William Morris's daughter, May. Valérius's daughter Elisabeth described the milieu as poetic, still subject to the influence of Ruskin, Burne-Jones and the Pre-Raphaelite painters.[47] When the family returned to Belgium after the war, Elisabeth de Saedeleer and her sisters, who had been trained as weavers by a former employee of Morris & Co., set up a workshop in the Villa Tynlon, at Etikhove, near Oudenaarde (ill. 80).[48] As a consequence, the studio was organized along lines directly derived from the Arts and Crafts movement. Initially, tapestries, table linen, clothing and furnishing fabrics were woven by the workshop, but by the early twenties, the pile

79 Léon Sneyers, fragment of a carpet design, c. 1910. The motif combines the influence of the Wiener Werkstätte with the firm contours of Art Deco.

80 The de Saedeleer sisters pictured in front of a high-warp loom, c. 1922–23. From left to right: Elisabeth, Marie-Jozef and Monique. Daughters of painter Valérius de Saedeleer, they founded a weaving workshop in Etikhove after the First World War.

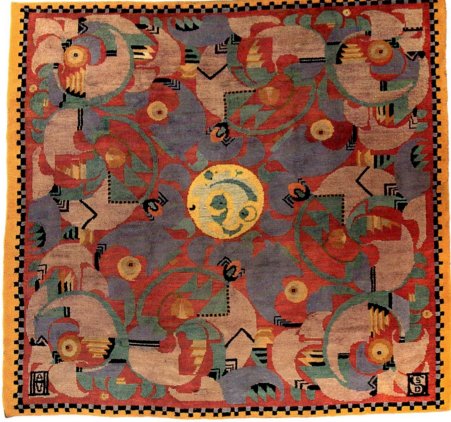

81 Albert Van Huffel, *Springtime*, carpet for the
 Van Gheluwe House, 1923, hand-knotted,
 wool pile, diameter 295 cm (116 ⅛ in.).
 Woven by the Studio de Saedeleer and
 monogrammed AVH and SDS.

82 Albert Van Huffel, carpet decorated with parrots,
 1923, hand-knotted, wool pile, 268 x 268 cm
 (105 x 105 in.), monogrammed AVH and SDS.
 Woven by the Studio de Saedeleer for the Van
 Gheluwe House.

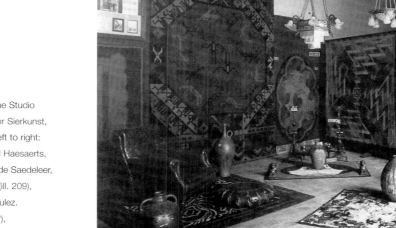

83 Exhibition of carpets woven by the Studio
 de Saedeleer at the Museum voor Sierkunst,
 Ghent, 1926. On the wall, from left to right:
 1. unidentified, 2. *Circus*, by Paul Haesaerts,
 3. untitled, attributed to Valérius de Saedeleer,
 4. *Remous*, by Albert Van Huffel (ill. 209),
 5. untitled, attributed to Jules Boulez.
 On the floor: 6. Charles Leplae (?),
 7. attributed to Jules Boulez, 8. unidentified.

carpets for which it is justly famed formed its major output. Several grades were available, the quality depending on the technique and materials used.[49]

Once established in Etikhove, artists and intellectuals such as Constantin Permeke, Edgard Tytgat, Ramah, the Haesaerts brothers and the sculptor Charles Leplae again gravitated around Valérius de Saedeleer. As a consequence, his daughters began to solicit designs from their father and his friends, including painter Gustave Van de Woestijne (1881–1947), their companion in exile.[50] The Etikhove group and the Studio de Saedeleer are credited with playing a vital role in the design revival which took place in Belgium between the wars.

The workshop also wove on commission for architects and decorators, and Albert Van Huffel (1877–1935) was one of their first clients. Van Huffel's name is principally associated with the Koekelberg Basilica, one of the largest buildings erected this century in Belgium. The architect was himself a talented carpet designer, and by the early 1920s had dropped the Arts and Crafts style for Art Deco (ills 81, 82). Two oval carpets designed for the Behn house in Ninove (1919–20), at the time of Van Huffel's collaboration with the interior decoration firm A.D.C.D. (Art Décoratif Céline Dangotte), display the floral and chequered patterns familiar from French design. The carpets are presently in the Museum voor Sierkunst, Ghent.

The superior quality of the rugs shown on the stand of Studio de Saedeleer at the 1925 International Exhibition reaped many new orders and to cope with the influx, the studio was reorganized. Renamed the Société des Tapis d'Art de Saedeleer, it was managed by Luc

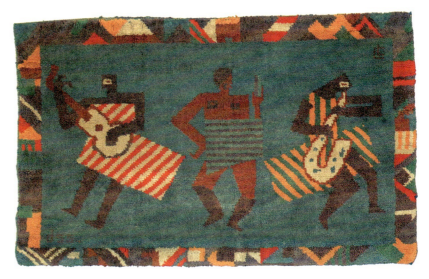

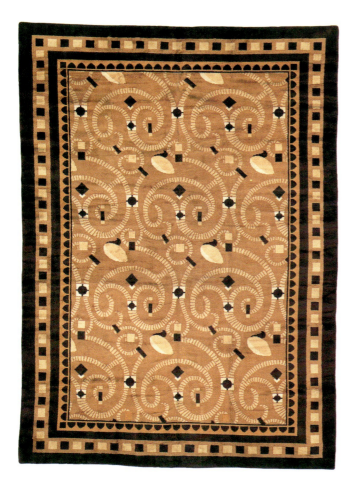

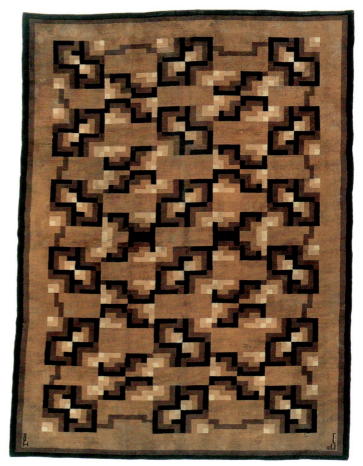

84 Edgard Tytgat, *The Hunt*, woven by the Studio
 de Saedeleer, *c*. 1925, hand-knotted, wool pile,
 260 x 260 cm (102 ⅜ x 102 ⅜ in.).

85 Charles Leplae, *Musicians*, *c*. 1928,
 hand-knotted, wool pile, 78 x 120 cm
 (31 ¼ x 48 in.), monogrammed.
 Woven by the Studio de Saedeleer.

86 Paul Haesaerts (attr.), carpet woven by the
 Studio de Saedeleer, *c*. 1925, hand-knotted,
 wool pile, 427 x 300 cm (158 ⅛ x 118 ⅛ in.).

87 Paul Haesaerts, carpet woven by the Studio de
 Saedeleer, *c*. 1925, hand-knotted, wool pile,
 350 x 255 cm (137 ¾ x 100 ⅜ in.).

Haesaerts, with his brother, the painter Paul Haesaerts, and Elisabeth de Saedeleer appointed joint artistic directors. Their work was shown at the Museum voor Sierkunst in Ghent (ill. 83), the Galerie du Centaure in Brussels and at many major international events.

The style of the carpets woven in the Studio de Saedeleer workshop tended to mirror contemporary French design. Whereas Gustave Van de Woestijne, Jules Boulez and Elisabeth de Saedeleer opted for brightly coloured floral patterns, Paul Haesaerts preferred African and leisure themes, while Charles Leplae (1903–61) decorated his with jazz musicians (ill. 85), ocean liners or ballet dancers. Gustave de Smet (1877–1943) based one of his, entitled *Window*, on the Queen of Hearts playing card. Edgard Tytgat preferred romantic subjects such as the *Fall of Eve*, or the gay romp entitled *The Hunt* (ill. 84).

In its heyday, the studio employed over twenty weavers. Proof of the workshop's vast output is revealed by a contemporary observer who witnessed an astonishing number of carpets on the looms during a visit in 1927. As well as works by the Belgian designers mentioned above, rugs by foreign artists such as Jan Sluyters, Maurice de Vlaminck, Yves Alix, André Favory and Ossip Zadkine were in the course of execution.[51] Designs were also commissioned from Marc Chagall and André Lhote.[52] 'What other European firm can boast of such a brilliant catalogue?' asked a contemporary critic.[53] The work of the studio ultimately received official approval when Henry Van de Velde invited Elisabeth de Saedeleer and Paul Haesaerts to teach at the La Cambre Institute of Decorative Arts in Brussels, of which he was by this time director.

The writer and film director Paul Haesaerts (1901–74) was probably the most prolific designer in the Studio de Saedeleer. He was unusual in taking an active interest in the technical aspects of weaving, seeking out new methods of spinning, dyeing and weaving, and even modifying designs once they were mounted on the loom on occasion, if he was dissatisfied. He showed a preference for flat linear patterns, dominated by small-scale abstract motifs or stick-like animal or human figures. The field is frequently divided up into compartments (ill. 87). Some of the compositions recall the Turkish kilim, while others have a pre-Columbian or African feel (ill. 86). *Circus*, the carpet shown on the de Saedeleer stand at the 1925 Paris exhibition, is typical of Haesaerts's repertoire.

BRITAIN AND THE OMEGA WORKSHOPS

Rarely an enthusiastic partner to events in continental Europe, the British prudishly rejected what they considered to be the vulgar and ostentatious displays of their immediate neighbours, whose interiors, some critics complained, suggested the boudoir of a courtesan. The Arts and Crafts movement continued to dominate the applied arts until well into the twenties and when its influence finally abated, it was succeeded by Modernism. Nevertheless, a few

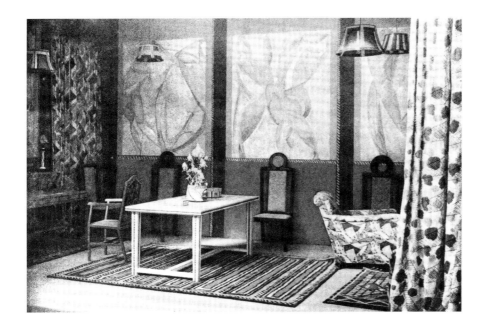

88 The Omega Workshops, Post-Impressionist
 room at the Ideal Home Exhibition, 1913.
 From *Illustrated London News*, 25 October 1913.
 The rugs are by Duncan Grant (left) and
 Frederick Etchells (right).

members of the avant-garde welcomed the new movements in painting and the applied arts which were developing across the channel. Notable among these were members of the Bloomsbury group.

In 1910, Roger Fry (1866–1934) mounted the first exhibition of Post-Impressionist painting at the Grafton Gallery, which enabled the British public to see the work of Cézanne and Van Gogh for the first time. Fry was also interested in the decorative arts and while he expressed respect for the ideals of the English guild system, the critic believed the aesthetics of the Arts and Crafts movement to be outdated. In 1913 he founded the Omega Workshops in collaboration with fellow members of the Bloomsbury Group: Duncan Grant (1885–1978), Clive and Vanessa Bell (1879–1961) (sister of Virginia Woolf), Wyndham Lewis, Frederick Etchells (1886–1973), William Wadsworth and Edward McKnight Kauffer (1890–1954).

The Omega Workshops' showrooms on Fitzroy Square in London were closely modelled on Poiret's Maison Martine, which Fry had visited a year previously. At the outset there was even talk of the two firms exchanging ideas and products.[54] Their range of goods included furniture, tableware, pottery, screens, fabrics and rugs. The work of the Omega group was met with incomprehension and even hostility from the public, which did not prevent their production from being copied.

The originality of the Omega workshops lay in their avowed intention to apply the principles of Post-Impressionist painting to designs for domestic interiors.[55] Fry and Grant were both aware of and deeply influenced by the French avant-garde. Parallels may be

89 Duncan Grant, carpet made by the Omega
 Workshops, 1913, hand-knotted, wool pile,
 174 x 116 cm (68 ½ x 45 ⅝ in.). The carpet
 used vibrant shades of green and yellow wool.

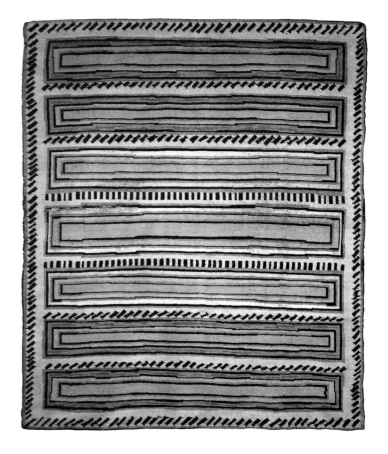

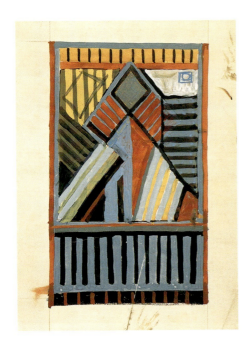

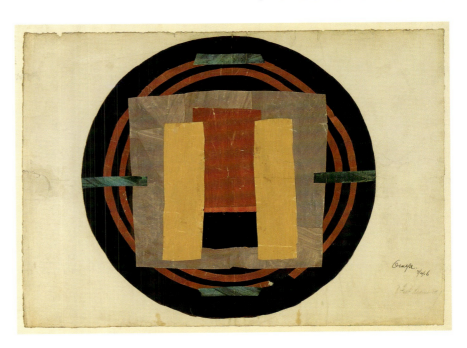

90 Frederick Etchells, carpet design bearing the
Omega monogram, shown at the Ideal Home
Exhibition, London, 1913, pencil, watercolour
and body colour, 44.5 x 40.6 cm (17 ½ x 16 in.).

91 Roger Fry, design of a circular rug for Arthur
Ruck, 1916, ink, gouache and *papier collé* on
paper, 43.2 x 60.6 cm (17 x 23 ⅞ in.). Fry and
his Omega colleagues were among the first to
adapt the artistic principles of the avant-garde
to the decorative arts.

drawn between Grant's paintings dating from 1913, such as *The Tub* (now in the Tate Gallery), influenced by Cézanne and Picasso, and his contemporary carpet designs (ills 88, 89). While Vanessa Bell's early work tended to be monastic in its simplicity, Fry, Grant, Etchells (ill. 90) and Roald Kristian (born 1893) made ample use of colour in their decorative schemes, again reflecting the influence of the Fauves and the *Coloristes*. In handling a 1916 carpet design for Arthur Ruck in the manner of Cubist collage (ill. 91), Roger Fry was even stealing a march on his peers across the channel. British manufacturers initially refused to execute these unorthodox patterns, so Fry arranged to have them made in France until the Wilton Royal Carpet Factory eventually acquiesced.

As a result of a quarrel with Fry over the presentation of a Post-Impressionist room at the Ideal Home Exhibition, Lewis, Etchells and Wadsworth left the Omega group to form the Vorticists, a movement whose doctrine resembled the Futurists, and a rival decorating firm, the short-lived Rebel Arts Centre. The Omega Workshops themselves were disbanded in 1919, the artists having been dispersed by the war.

Duncan Grant and Vanessa Bell continued to collaborate together on decorative schemes, but the early elan ran out of steam in later years (ills 92, 93). In contrast with the situation in France, the interior decorating professions were monopolized by a few large firms such as Heal's and Waring & Gillow. The British did contribute to the 1925 International Exhibition in Paris, with Edmund Hunter, Ethel Mairet, Jean Orage and Elizabeth Peacock showing handwoven fabrics, tapestries and rugs.[56] Still powerfully subject to the Arts and Crafts aesthetic, however, the British offering was dismissed as passé, particularly when compared with the blatant supremacy of contemporary French design.[57]

In their heyday, C. F. A. Voysey and Frank Brangwyn's work represented the epitome of the Arts and Crafts style. A prolific designer of wallpaper and textiles, Voysey produced carpets that differed little from those he designed at the turn of the century. Although he continued to use floral and animal motifs, those dating from the twenties tend to be more widely

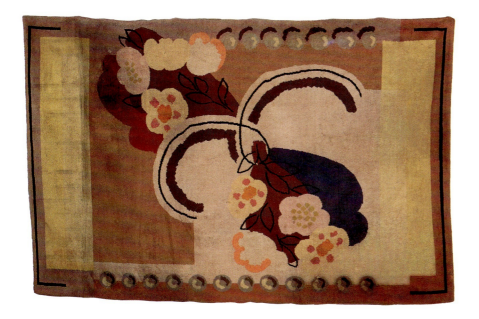

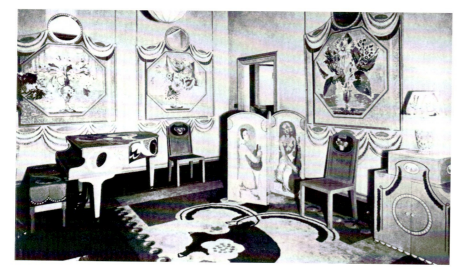

92 Vanessa Bell, carpet designed for the
'Music Room' at the Lefevre Gallery, 1932,
wool pile, 249.5 x 365.5 cm (98 ¼ x 143 ¾ in.).

93 Vanessa Bell and Duncan Grant, 'Music Room'
at the Lefevre Gallery, London, 1932–33. The
interior used exuberant shades of turquoise and
yellow, and the carpets were woven by Wilton
Royal Carpet Factory.

spaced, more sharply contrasted and frequently outlined in black. A show of Brangwyn's work at Pollard's in London in 1930 included handwoven Donegals and chenille carpets in floral designs, manufactured by Templeton's (ill. 94).

 Nonetheless, a few British designers did design rugs in the Art Deco style, among them Allan Walton (1891–1948), Sir William Nicholson (1872–1949) and George Sheringham (1884–1937). A painter renowned for his portraits of London society, Nicholson created a piece decorated with a central medallion, animal and fish symbols; made in a looped ribbon technique, *The Zodiac* is now in the Victoria and Albert Museum (ill. 95). George Sheringham, a designer for the Crossley carpet firm, showed a carpet with a similar theme at the exhibition of British Art in Industry held at the Royal Academy in 1934. On the whole, however, British designers tended to shy away from the more flamboyant aspects of Art Deco and these designs are few in number compared with stark Modernist patterns which by this time were coming off the drawing boards of the younger generation.

(opposite)

94 Frank Brangwyn, chenille Axminster carpet
manufactured by Templeton's of Glasgow,
1930, 270 x 367 cm (106 ¼ x 183 ⅞ in.),
monogrammed. Brangwyn was a major figure
in the Arts and Crafts movement, whose
influence is still visible in this design.

95 Sir William Nicholson and Elizabeth Drury,
The Zodiac, pile carpet made from looped
ribbon on a canvas backing, *c.* 1925,
278 x 227 cm (109 ½ x 89 ½ in.).

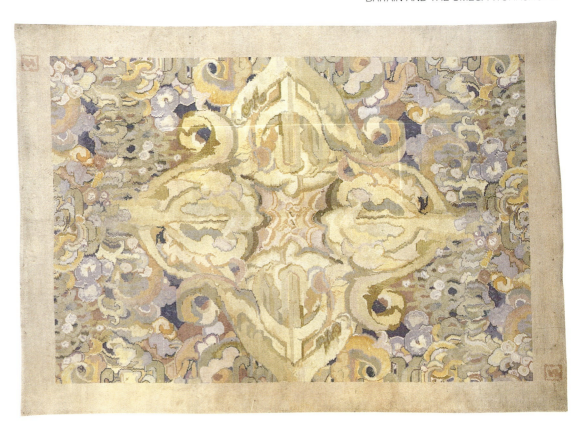

DUTCH BATIK OR THE TUSCHINSKI STYLE

At the turn of the century, architecture and design in Holland were dominated by Nieuwe Kunst, the Dutch variant of Art Nouveau. Subject to the influence of Expressionism, a new school developed after 1910, led by architects Michel de Klerk and Piet L. Kramer.[58] The mouthpiece of the Amsterdam School was the art magazine *Wendingen*, which examined contemporary trends in Dutch art and architecture and also published articles on Polynesian, African and Chinese art. The periodical also began to publish the work of foreign architects and designers including Frank Lloyd Wright, Eliel Saarinen, Josef Hoffmann and Eileen Gray. The Amsterdam School was unique in ensuring a smooth transition between Nieuwe Kunst and the rationalist school which came to prominence during the twenties.

One of the first craft workshops to weave designer carpets was the Kinheim company. Founded in Beverwijk in 1909 by Cornelia Polvliet van Hoogstraten (1882–1966), the firm at first limited its production to orientalist patterns designed by her husband. However, when Van Wisselingh, a leading interior decoration firm in Amsterdam, sent her one of Theodoor Nieuwenhuis's designs for execution, the firm changed its policy and geared its production to rugs by contemporary artists. Nieuwenhuis remained subject to the influence of the Arts and Crafts movement and faithfully observed their principles regarding flat patterns. Lightly traced in subdued shades, his carpets display polylobed and pole medallions set off by a light tracery of geometric and stylized floral motifs recalling Turkish and Persian textiles (ill. 96). The studio also wove rugs from designs by Carel-Adolph Lion Cachet (1864–1945) (ill. 97).

Dutch carpet design between the wars is unusual in being virtually free of the influence of Art Deco. A carpet designed by sculptor Hildo Krop (1884–1970) for the home of his sister Mrs Polak-Krop in 1915 is one of the exceptions to the rule. A central trapezoid motif, a common feature in decorative art of the Amsterdam school, is offset by sprays of floral motifs reminiscent of Art Deco (ill. 98). However, this lack of Art Deco design can be attributed to the dominance of the batik style during this period.

As its name implies, the invention of the batik style, attributed to Nieuwe Kunst designer Lion Cachet, was inspired by the traditional fabrics of Indonesia, formerly a Dutch colony. First used in carpet design at the beginning of the century by Theodoor C. A. Colen-

96 Theodoor Nieuwenhuis, carpet woven by Kinheim of Beverwijk, *c*. 1910–20, hand-knotted, wool pile, 244 x 140 cm (96 ⅛ x 55 ⅛ in.). The design obeys the Arts and Crafts guidelines on the construction of flat patterns.

97 (below left) Carel-Adolph Lion Cachet, carpet woven by Kinheim of Beverwijk, *c*. 1910–20, hand-knotted, wool pile, 170 x 115 cm (66 ⅞ x 45 ¼ in.).

(opposite)

98 Hildo Krop, machine-made carpet for the Polak-Krop house, 1915, wool pile, 254 x 320 cm (100 x 126 in.).

99 Jacob Van den Bosch, carpet woven for t'Binnenhuis by Kinheim of Beverwijk, 1924, hand-knotted, wool pile, 297 x 386 cm (116 ⅞ x 152 in.).

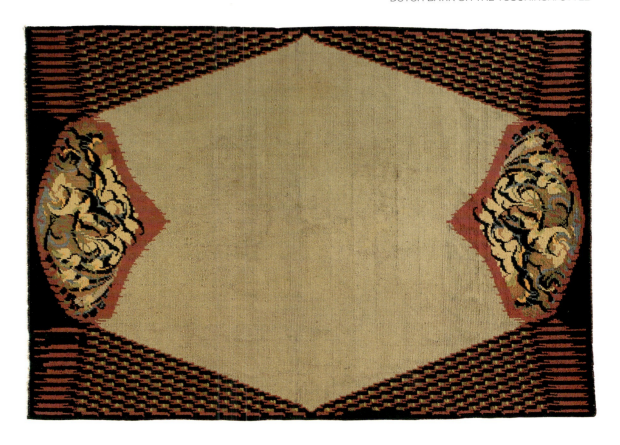

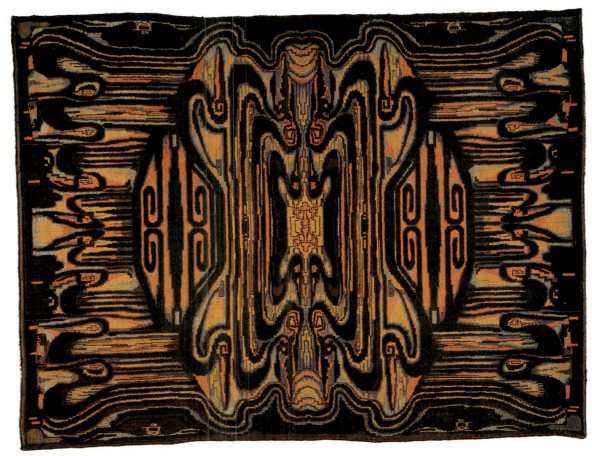

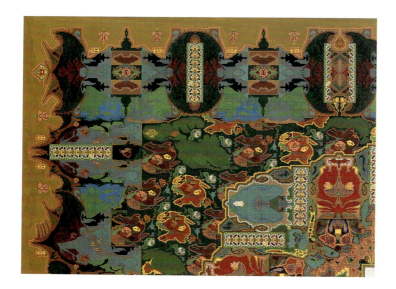

100 (left) T. C. A. Colenbrander, *Hovenierskunst (The Art of Gardening)*, detail of a carpet design in the batik style, dated 10 March 1910, gouache, 57 x 44 cm (22 ½ x 17 ⅜ in.). Artistic director of the KVT, Colenbrander drew freely on organic forms, oriental carpets and Javanese batik for inspiration.

101 (below left) R. N. Van Dael, carpet, *c.* 1930, wool pile, 282 x 195 cm (113 x 78 in.). Head of the KVT design studio, Van Dael created numerous designs for carpets and carpeting produced by the manufacturer between the wars.

102 (below right) Jaap Gidding, 'Tuschinski' carpet, woven by the KVT, *c.* 1920, wool pile, 138 x 74 cm (54 ⅜ x 29 ⅛ in.). Gidding was one of the best-known exponents of the batik style, dubbed the 'Tuschinski style' after the Amsterdam theatre.

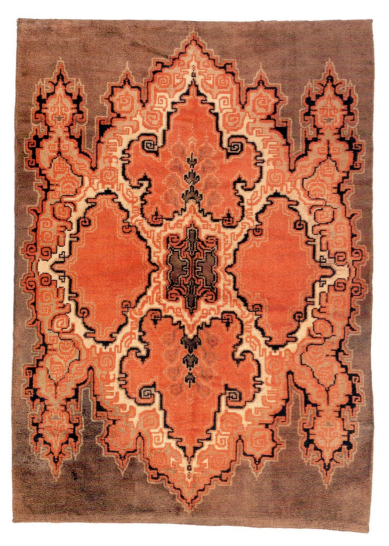

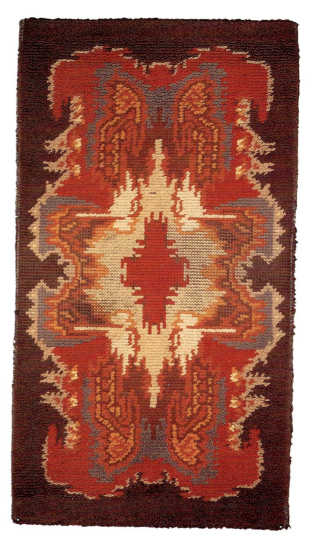

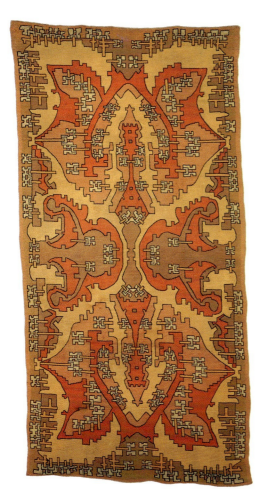

103 Carpet by an anonymous designer in the batik style, embroidered in wool on a cotton backing, *c.* 1900–25, 260 x 130 cm (102 ⅜ x 51 ⅛ in.).

104 The lobby of the Tuschinski Theatre, Amsterdam, 1918–21, designed by Jaap Gidding.

brander (1841–1930), the style is characterized by forceful designs and bold contrasting colours which conveniently adapt themselves to repeating patterns (ill. 100). Colenbrander gave up a career in architecture for the decorative arts and in addition to ceramics, specialized in designing carpet collections for the Koninklijke Verenigde Tapijtfabrieken (Royal United Carpet Factories), of which he was artistic director. Among the other designers who endorsed the batik style were Jacob Van den Bosch (1868–1948) (ill. 99), R. N. Van Dael (1880–1954) (ill. 101), Dirk Verstraten (1892–1946) and Jaap Gidding (1887–1955), the foremost Dutch carpet designer of the twenties (ill. 102).

Early in his career, Gidding had worked in Germany and his work was influenced by Expressionism. Singled out for attention by an official commentator at the 1925 Paris exhibition,[59] Gidding's highly individual colour schemes and designs found their most successful expression in the murals and carpets he created for the Tuschinski Theatre in Amsterdam (1918–21). Unusually baroque for Holland, the theatre's interiors rival some of the more flamboyant Art Deco cinemas built in America. The carpeting laid in the lobby is in the batik style, but at the same time recalls Caucasian dragon carpets of the 18th century (ill. 104). Woven by the KVT, a hand-knotted piece possibly made for the theatre is in the Stedelijk Museum, Amsterdam. Dutch textiles of the Amsterdam school are therefore dubbed the 'Tuschinski style' (ill. 103).

SCANDINAVIAN TRADITIONS REJUVENATED

Handweaving is rooted in the folk heritage of Scandinavia. A long-established cottage industry, peasant weavings include rag rugs, hooked rugs, flatweaves and pile rugs, popularly known today as *rya* or *ryijy*, usually woven on a linen foundation. More properly a bedcover, the term *rya* has only been applied to floor coverings since the twenties. Subject to the influence of John Ruskin and William Morris, the Scandinavian countries sought to organize the production of textiles along lines similar to the guilds advocated by British thinkers. This was achieved through the establishment of cooperatives which sprang up in great numbers from the late 19th century onwards and succeeded in reorganizing the production and distribution of domestic handicrafts.

Whether they worked from home or ran their own studios, the great majority of weavers and textile designers belonged to local cooperatives, which both sold and actively promoted handicrafts at home and abroad.[60] The activities of the cooperatives were for the most part beneficial, yet their influence could be a double-edged sword. As the traditional designs sold well, the more reactionary managers tended to discourage novelty. The 'imitation versus creation' debate remained a lively source of controversy. A contemporary critic summed up the dilemma facing designers by defending the principle of anonymity insofar as folk art is concerned, yet at the same time acknowledging that constant repetition inevitably becomes hackneyed.[61]

105 Ellen Ståhlbrand (1877–1958), flatweave carpet in a traditional design, *c.* 1900, wool, 249 x 388 cm (152 ¾ x 98 in.), monogrammed. Scandinavian weavers in the early 20th century began to look at folk heritage through fresh eyes and revitalize traditional motifs.

106 Eva Brummer, carpet, *c.* 1930, hand-knotted, wool pile, 269 x 208 cm (105 ⅞ x 81 ⅞ in.). The medallion-and-border layout is a traditional one, but the graphics and colour scheme reveal a shift towards the Modernist aesthetic.

Scandinavian peasant art consists of floral, geometric, bird and animal motifs, biblical scenes, wedding ceremonies or figures in pastoral scenes. Oriental motifs, particularly flower vases and the tree of life, are also common. Visible progress had been made in rejuvenating this vocabulary by the time the Scandinavian countries participated in the World's Fair held in Paris in 1900 (ill. 105). In the period between the wars, Finland, Sweden and, to a lesser extent, Denmark enjoyed a revival in the craft of rug-making.

In Finland, as elsewhere in Scandinavia, the revival of the craft of handweaving was largely due to the work of cooperatives such as the Friends of Finnish Handicraft, founded in 1879. The artist Akseli Gallen-Kallela, a collector and designer of *ryijy*, played a significant role in reviving interest in ethnic textiles at the turn of the century, as did Eliel Saarinen and Armas Lindgren. In claiming that textile design was an integral part of a modern interior, Saarinen and Lindgren espoused the theory of the *Gesamtkunstwerk*, the 'total work of art'. In 1918, the Finnish *ryijy* came to public attention when the Hörhammer Gallery in Helsinki organized an exhibition of historical pieces. The publication of a book by U. T. Sirelius in 1924 and regular design competitions organized by the Friends of Finnish Handicraft further stimulated public interest in peasant carpets. The design and weaving of *ryijy* was taught in Finnish art schools and remained a compulsory part of a student's diploma into the 1960s.[62]

Interest in folk rugs was further encouraged by the Marttajärjestö (Finnish Housewives' Association), which sponsored an exhibition of folk textiles in 1931. The *ryijy* were subdivided into several types: 'dense' *ryijy* used as floor coverings; bench *ryijy* used to drape over seating;

and a thinner type used for wall-hangings, which has since evolved into the art textiles of recent years. As well as copying traditional folk patterns, artists were hired by manufacturers to design new ones. Martta Taipale (1893–1906), Margareta Ahlstedt-Willandt (1889–1949), Impi Sotavalta (1885–1943), Laila Karttunen (1895–1981), Gurli Johansson, Arno Baeckman, Emil Danielsson (1882–1967), Eva Brummer (1901–2007) (ill. 106), Marianne Strengell, Hilma Aaltonen and A. W. Raito number among the artists who revitalized the *ryijy*. The craze led to the copying of antiques by professionals and amateurs alike and gave rise to a debate on the merits of borrowing cartoon images such as Snow White. Customers could order them in kits and weaving or hand-hooking a *ryijy* became a fashionable hobby until the outbreak of the Second World War when a shortage of materials brought demand to a halt.

Weaving has been a traditional domestic craft in Sweden since time immemorial and several types of floor coverings are made. They include flatweaves (*rölakan*), pile rugs, known either as *rya* (long pile), *flossa* (short pile) or *glesrya*. A variant on the *rya*, the *glesrya* is distinguished from other folk weavings by large number of shoots, generally ten to fifteen, between each row of knots.

The Swedes took second place only to the French in the number of prizes awarded in the textile section at the 1925 International Exhibition in Paris. Every local cooperative con-tributed tapestries and wall-hangings, furnishing fabrics, embroideries, table carpets and floor coverings made by their members, many of whom ran freelance studios. Among the master weavers who submitted carpets were Agda Österberg (1891–1987) (ill. 107), Annie Frykholm (1872–1955), Eva Nilsson, Maja Sjöstrom (1868–1961), Maja Andersson-Wirde (1873–1952), Karna Asker (1897–1989), Märta Gahn (1891–1973), Hildegard Dinclau (1890–1974), Ellen Ståhlbrand (1877–1958) (ill. 105) and Märta Måås-Fjetterström. The Nordiska Kompaniet, a Stockholm department store, showed a range of furnishing fabrics by talented modern designers, along with a room designed by the architect Carl Malmsten and laid with a carpet by Måås-Fjetterström.[63] Among the noteworthy interiors which reflect the spirit of Art Deco were the sophisticated ladies' *salon* laid with a circular carpet by Uno Ahrèn in 1925,[64] and the liner *Kungsholm* (1928), laid with Art Deco carpets in abstract designs by Maja Andersson-Wirde.

The quality of the carpets presented in the Swedish section and the favourable cover-age it received in the press incited the Musée des Arts Décoratifs to organize an exhibition of the rugs of northern Europe, held in Paris in 1927. Until then, Scandinavian rugs had been largely unknown to the general public. Most of the pieces on show were antique, with the exception of the Swedish contribution. Two long-established cooperatives, the Föreningen

107 Agda Österberg, carpet with a repeating tulip design, 1930, hand-knotted, wool pile, 495 x 380 cm (197 ⅞ x 149 ⅝ in.).

Handarbetets Vanner (Society of Manual Textile Art) and the Föreningen för Svensk Hemslöyd (Society of Swedish Homecraft), sent a selection of recent pieces made by Annie Frykholm, Maja Sjöström, Märta Gahn and Märta Määs-Fjetterström (ill. 108).[65] Unsurprisingly, all the pieces included in the show made references to folk heritage.

108 Märta Määs-Fjetterström, *Black Garden*, *c*. 1925, 340 x 221 cm (134 x 87 in.), monogrammed. This *flossa* or pile carpet was made in Määs-Fjetterström's workshop in Båstad. She broke with the tradition of making scatter rugs to weave large-format carpets on broadlooms.

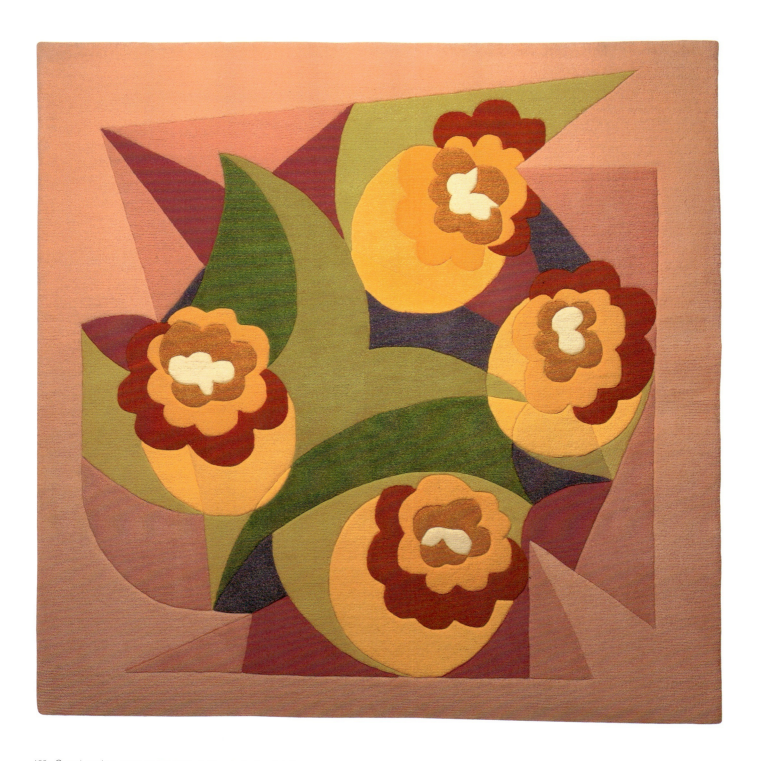

109 Carpet made c. 1990 by the Tapis de Cogolin for the Galerie Artcurial, Paris, from *Balfiore*, a design
 by Giacomo Balla dating from the 1920s. Gun-tufted, wool, 200 x 200 cm (78 ¾ x 78 ¾ in.).

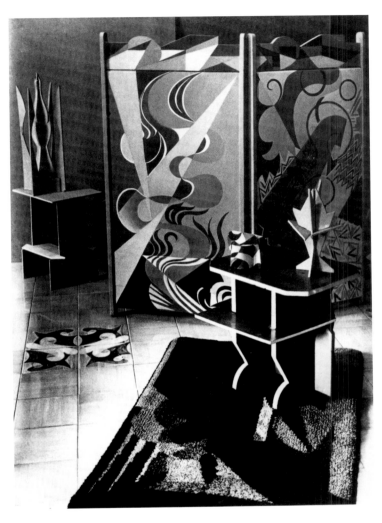

110 Giacomo Balla, Futurist interior, 1918.

MEDITERRANEAN DEVELOPMENTS: ITALY AND SPAIN

Peasant rugs have long been woven in certain areas of Italy, mainly for home consumption. Until the avant-garde imposed its credo between the wars, Italian textile art displayed few signs of innovation, remaining to a great extent subject to influences from abroad. The most important carpet designer in the immediate post-war period was Herta Ottolenghi Wedekind (1885–1948), a Genoese artist and weaver. She also made tapestries, embroidered panels and damasks using a repertoire of loosely drawn organic forms reminiscent of the batik style.

In an attempt to create utopian projects and to popularize the movement, the Futurists founded a series of *Case d'Arte*, craft centres inspired by the Parisian example, which sold their furnishings and accessories. The first Casa d'Arte was founded by Giacomo Balla (1871–1958) in Rome before the First World War (ills 109, 110). After the war, the art critic Mario Recchi and Enrico Prampolini (1894–1956), author of several Futurist manifestos, founded the Casa d'Arte Italiano (1918–21), also in Rome. A painter with international connections as well as a prolific writer, Prampolini wrote a manifesto on decorative art to coincide with the opening of the shop, which sold tapestries, cushions, screens, lampshades and carpets made from his own designs and those of other Futurist artists, including Giacomo Balla.

Similar initiatives followed at Rovereto, Florence, Imola and Palermo.[66] Futurist textiles were shown to the public at exhibitions organized in Italian cities by the Case d'Arte and at the major decorative arts exhibitions held in Paris and Monza.

The Futurists attempted to convey a sense of movement in their paintings through elliptic and diagonal 'force lines' and their textile designs were treated in a similar manner. Enrico Prampolini showed two such carpet designs in the Futurist section at the 1925 International Exhibition. A carpet entitled *Pesci (Fish)* attempted to represent the movement of a fish darting through water (ill. 111). Others were less schematic. Fascinated by the machinist aesthetic, Prampolini paid frequent homage to the aeroplane in his art, and resorted on occasion to a literal representation of this machine in his carpet designs. Pippo Rizzo, who directed the Casa d'Arte in Palermo, also used elliptical shapes in his patterns to suggest dynamism.[67]

Since the objects sold in the Case d'Arte were mostly handmade by the wives and daughters of the artists, the production methods of the Futurists would tend to belie their commitment to the machine. Yet a historian specializing in the Futurists' work has affirmed that Prampolini fully intended his carpets to be mass produced,[68] and that a fragment with a pattern of aeroplanes shown at the 1925 International Exhibition was not handwoven, as claimed at the time,[69] but machine-made.[70] Strongly nationalist, the Futurists eventually came to campaign for the values they had once rejected and in time received official sanction from the Fascist regime.

The international repercussions of the 1925 Paris exhibition meant that Italian interior designers began to endorse Art Deco. The Roman decorator Duilio Cambelotti (1876–1960) regularly showed his decorative schemes, which included carpets, at the Monza Biennale. Painter and decorator Enrico Paulucci (1901–99) displayed a rug at the 1933 Milan Triennale decorated with a flayed tiger's pelt (ill. 113). Giulio Rosso designed floral carpets; Francesco Da Cono and Gigi Chessa pictorial rugs. The Sicilian designer Paolo Bevilacqua (1894–1938) demonstrated particular flair. Some of his creations are Futurist (ill. 115) while others are closer to the spirit of French Art Deco, including the carpet decorated with pairs of wrestlers (ill. 114). Such frivolous themes were however less common than the floral or geometric patterns made in the workshops of Veroli, Pesaro, Prato and Rome.

Spain has a long history of weaving carpets, ever since the art of carpet knotting was first introduced in the 12th century by the Moors, the Muslim conquerors from North Africa.[71] Workshops located in Cuenca and Alcaraz in the south and later in Madrid, in factories granted a royal patent, tended to confine their production to traditional designs. As a result, information relevant to modern trends in Spanish carpet weaving is somewhat scanty.

Among the innovators was Tomàs Aymat (1892–1944), a painter and set designer who had learned weaving techniques in Paris. Upon his return to Catalonia, he founded a tapestry

111 Enrico Prampolini, two carpet fragments,
112 *c*. 1924. The designs are inspired by a fish darting through water.

113 Enrico Paulucci, *Tiger*, 1933, wool pile, 195 x 118 cm (76 ¾ x 46 ½ in.). Originally exhibited at the 1933 Milan Triennale.

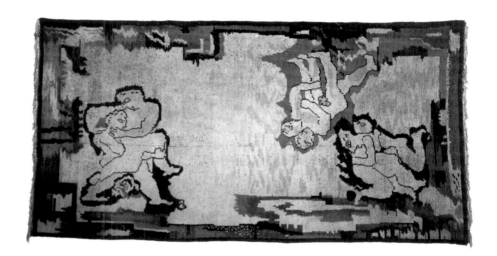

114 Paolo Bevilacqua, machine-made carpet
depicting wrestlers, produced by MITO,
Palermo, c. 1930.

115 The director's office at the Palazzo delle Poste
(Central Post Office), Palermo, with a rug by
Paolo Bevilacqua.

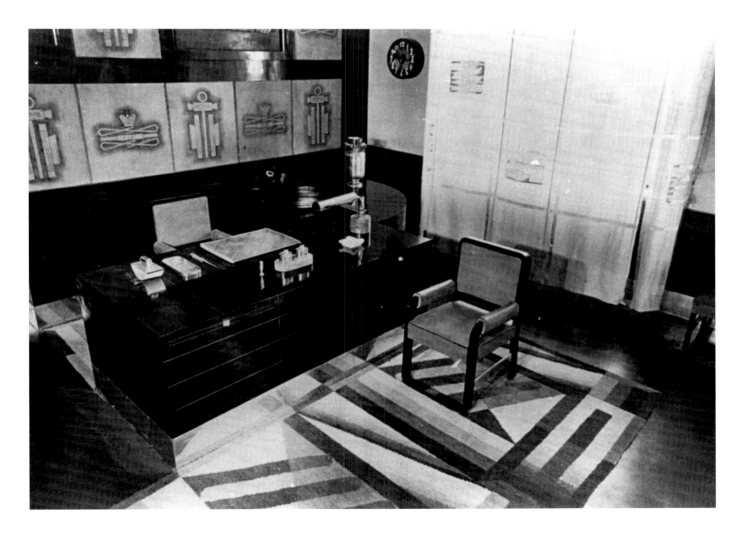

and carpet weaving factory in Sant Cugat del Vallès.[72] Aymat designed oriental-type patterns, but also a range of pictorial and geometric rugs, some of which recall tiled pavements. Two rugs, one depicting Diana the Huntress, presently conserved in a Spanish private collection (ill. 116), were shown in the Spanish section at the 1925 Paris exhibition.

EASTERN EUROPE
AND THE MODERN VERNACULAR

116 Tomàs Aymat, *Diana the Huntress*, 1924, wool pile, 252 x 232 cm (99 ¼ x 91 ⅜ in.). Designed and made in the artist's workshop at Sant Cugat del Vallès, and monogrammed in the top right-hand corner.

Like Scandinavia, the rugs of Eastern Europe, encompassing the countries of Poland, Czechoslovakia, Hungary and the Balkans, retain an ethnic flavour visible even to this day in modern production. Pride in ancestral origins, whether Magyar, Serb, Croat or Slav, allied to nationalist fervour is even now crucial to political life, and often takes precedence over national boundaries. The desire to create a national style was reflected in the teachings of the art schools and artistic communities founded at the end of the 19th century in the wake of the socialist ideals advocated by Ruskin and Morris, from those of Gödöllo in Hungary to the Ład Cooperative in Poland. The fall of the Habsburgs in 1918 liberated the countries formerly under the control of the Austro-German empire, but the Germanic culture continued even so to exert a more powerful and lasting hold on the cultural life of Eastern Europe than the French.

Situated at the confluence of eastern and western civilization, the Balkans, Poland, Czechoslovakia and Hungary all produce carpets strongly influenced by the Orient. Imported for centuries, oriental rugs, particularly kilims, have long formed a part of daily life in these regions and served as a source of inspiration for local weavers. The rugs of Eastern Europe exhibited at the exhibition at the Musée des Arts Décoratifs, Paris, in 1927 conform to the vernacular tradition. The tree of life is a recurring motif, and appears in both the kilims designed by Thérèse Paulic for the State Factory of Sarajevo and the pile rug by Yvan Gundrum woven by Djelo, the Society for the Promotion of the Decorative Arts in Zagreb (ill. 117).

After gaining its independence from the Austro-Hungarian empire in 1918, Czechoslovakia continued to remain an important centre of carpet manufacture, in touch with modern trends. The richly ornamented carpets designed by the artist Frantisek Kysela (1881–1941) would not have been out of place in a contemporary French or Austrian interior.[73] Kysela was also responsible for designing the carpets shown in the Czech section at the 1925 Paris Exhibition. They were woven by a Brno manufacturer, A. Klazar. A rival firm, Ginzkey, which has operated out of Maffersdorf, Bohemia (now Vratislavice) since the 19th century, commissioned cartoons from designers both at home and abroad.

The striking range of rugs designed by Lajos Kozma, decorated with staggered rows of geometrically patterned motifs, indicates that the Budapest-based designer was familiar with the weavings of the Bauhaus, as well as the work of his compatriot, the American émigrée

117 Yvan Gundrum, flatweave carpet woven by Djelo (Society for the Promotion of the Decorative Arts), Zagreb, 1927, wool, 142 x 186 cm (55 ⅞ x 73 ¼ in.), monogrammed.

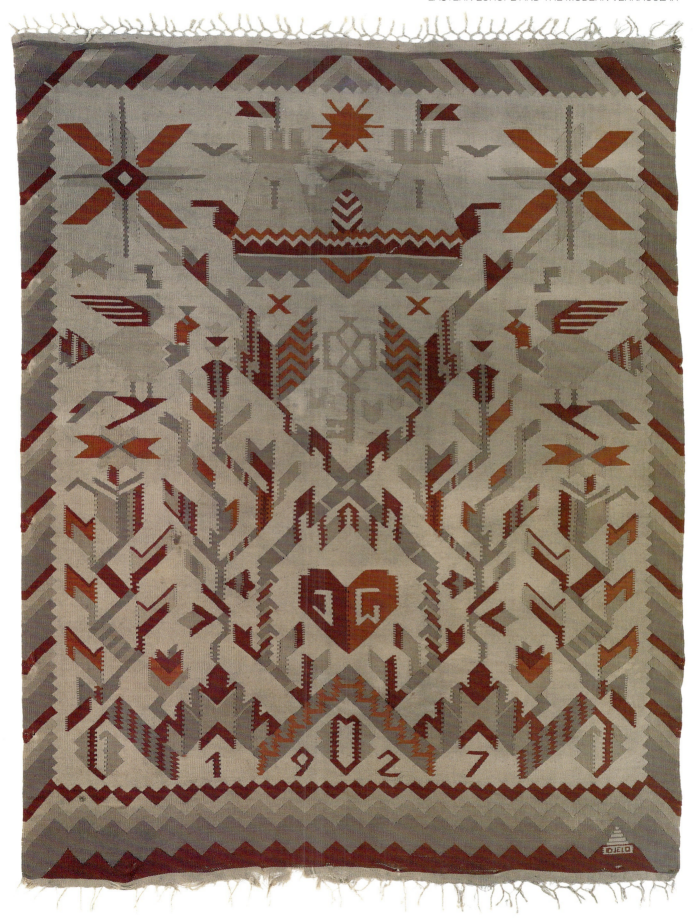

118 Flatweaves made by the Kilim Polski craft society, Warsaw, displayed in the Polish pavilion at the 1925 International Exhibition, Paris. In Poland, kilims function as both wall-hangings and floor coverings. On the walls: Bogdan Treter, Joseph Czajkowski and Bogdan Treter. Flatweaves by Wojciech Jastrzebowski (beneath table), Bogdan Treter (foreground) and a matching pair by Joseph Czajkowski lie on the floor.

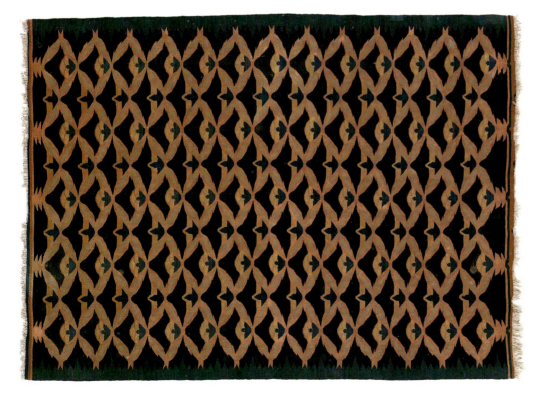

119 Edward Trojanowski, carpet made by the Kilim Polski craft society, 1925, flatweave, wool, 156 x 198 cm (61 ³/₈ x 78 in.). This carpet was also shown in the Polish pavilion at the 1925 Paris exhibition.

120 (opposite) Runner woven by the Kilim Polski workshop, Warsaw, flatweave, wool, 98 x 273 cm (38 ⁵/₈ x 107 ½ in.), monogrammed. The other monogram may be that of the architect Wojciech (or Adalbert) Jastrzebowski, who taught at the Academy of Fine Arts in Warsaw and designed the interiors of the Polish pavilion at the 1925 Paris exhibition.

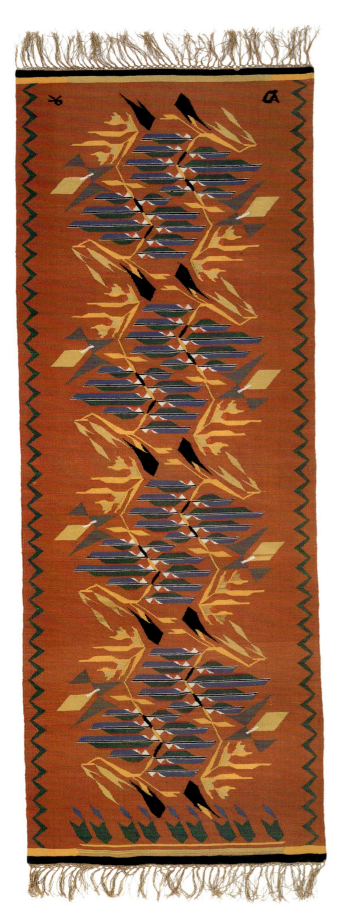

Ilonka Karasz. Kosma's highly stylized rows of trees and birds are an allusion to the weaving traditions of his country's past. The Czech designer Ludmila Kybalová (born 1905) and her husband Antonín Kybal (1901–71), who founded a weaving studio in Prague, were also followers of the rationalist aesthetic.[74]

It was Poland, however, which made the most striking contribution to the art of carpet weaving between the wars. Energetic efforts to revive traditional crafts were made by Towarzystwo Polska Sztuka Stosowana (the Polish Society of Applied Arts), founded in Krakow in 1901, and this boosted interest in the decorative arts. A series of craft workshops were founded, including Wanda Kossecka's Studio Tarkos in Zakopane, Jadwiga Handelsman's workshop in Warsaw and the Ład Artists' Cooperative, also in Warsaw, all important centres of rug production (ill. 120). The Ład ('harmony') workshops, founded in 1926 with a view to improving the modern interior, also designed furniture and objects for the home.[75] Other workshops, including the Warsztaty Kilimiarskie (Kilim Workshops) in Zacopane and Kilim Polski S.A. in Warsaw specialized in the manufacture of flatweaves, long used in Poland as both wall and floor coverings (ill. 118). Among the count-less Polish artists whose rugs were woven by these workshops were Kasimir Brzozowski (c. 1871–1945), Joseph Czajkowski, Karolina Bul-hakowa, Wojciech Jastrzebowski (1884–1963) (ill. 120), Edward Trojanowski (1873–1930) (ill. 119), Wladyslaw Skoczylas (1883–1934), Helena Bukowska, Zofia Stryjenska, Eleonora Plutynska (1886–1969) and Halina Karpinska (1902–69), among others.[76] By creating bold, simplified designs arranged in symmetrical compositions, these designers succeeded in rejuvenating the vernacular tradition without losing touch with it entirely. Of these, the architect and art historian Bogdan Treter (1886–1945) was the most prolific.

JAZZ MODERNE IN THE USA

Before the First World War, American artists and designers had begun to look to Europe for inspiration. Works by the Cubists exhibited at the Armory Show in New York in 1913 caused some of the more adventurous American artists to make the pilgrimage to the City of Light. This epoch also coincided with a first wave of European immigration. Joseph Urban and Paul T. Frankl were among the designers who opened interior decoration stores in New York, Urban on behalf of the Wiener Werkstätte. Notwithstanding such innovative

marvels as the skyscraper and jazz music, in matters of interior design, American designers tended to be overwhelmed by the European example. Officials even felt obliged to turn down the French invitation to participate in the 1925 Paris exhibition on the grounds that their designers and manufacturers failed to meet the criteria requiring 'modern' design. A glance at contemporary magazines reveals the truth of this statement; American interiors, like those in Britain, remained subject to the influence of the Arts and Crafts movement well into the twenties.

Frank Lloyd Wright (1867–1959) remained a singular exception to the rule. America's foremost architect had dominated the architectural scene since the end of the 19th century. In building homes for his clients for which he designed every aspect of the interiors, Wright served as a link between the Arts and Crafts movement and the Jazz, Zig-zag or Style Moderne, as it became known. He never swerved from his theories on organic design which echoed the geometric forms inherent in architecture. A surviving carpet from the Bogk Residence in Milwaukee in 1916 shows a pattern based on the square and the rectangle, similar to the exterior architecture of his earlier Midway Gardens in Chicago. His most important

121 Frank Lloyd Wright, pattern unit for the hand-knotted carpets made for the Banquet Hall of the Imperial Hotel, Tokyo, 1915, pencil and coloured pencil on tracing paper, 115 x 115 cm (45 ⅜ x 45 ⅜ in.). Over twelve hundred rugs made to order in China were pieced together as floor coverings and sewn around the columns and piers. The design has since been reissued as a fabric by the Frank Lloyd Wright Foundation and Schumacher Inc., New York.

122 Donald Deskey, *Seahorse, Starfish, Coral, Conch Shell and Jellyfish*, design for a bathroom mat with a marine theme, 1930–31, brush and gouache, graphite traces on grey paperboard, 25.9 x 25.8 cm (10 ¼ x 10 ¼ in.).

commission at the time was undoubtedly the Imperial Hotel in Tokyo (since demolished), for which over twelve hundred hand-woven carpets were made.[77] Wright himself owned a Tibetan pillar rug[78] and many of the carpets designed for the lobby were used in the same way; that is, they were sewn around the columns and piers. Some of the surviving drawings and a fragment of one of the original carpets are conserved in Frank Lloyd Wright's Taliesin Foundation in Scottsdale, Arizona. A repeating geometric pattern, based on a peacock fanning its tail feathers, is identified by Wright himself as the pattern unit of the rugs made for the Banquet Hall, woven in Beijing in 1917 (ill. 121).

The success of the 1925 Paris exhibition prompted New York's Metropolitan Museum of Art to organize a touring show of selected items shown at this event, purchased for their collection. Host to a subsequent series of exhibitions, including one devoted to rugs, the museum played a pivotal role in promoting consumer demand for progressive design. When American carpet manufacturers first responded to the demand for modern patterns, it was to shamelessly plagiarize foreign imports, to the extent that a curator of New York's Metropolitan Museum encountered a boycott on the part of their French counterparts during a research trip.[79]

Eager to jump on the 'Moderne' bandwagon, department stores such as Macy's and Lord and Taylor's organized promotional displays of French imports or copies of French imports, with a view to stimulating sales. American designers responded to the challenge and a first exhibition of their work was held in New York in the autumn of 1928. Top interior designers, including Gilbert Rohde, Eugene Schoen, Ely Jacques Kahn, Winold Reiss, Joseph Urban and Donald Deskey (ill. 122), tended to create rugs only sporadically, as one-off pieces to harmonize with their decorative schemes. American fine artists, who included painters Thomas Benton, Buk and Nura Ulreich, George Biddle, and the sculptor John Storrs, also designed carpets on an occasional basis. Marguerite Zorach, an American painter who made the pilgrimage to Paris after discovering Cubism at the Armory Show, created a series of hooked wall-hangings and carpets with pictorial themes (ill. 123).

In their predilection for combining highly coloured schematic representations of flora and fauna with repeating geometric motifs, American designers tended at first to emulate the French example. Hollywood extravaganzas produced by MGM and Cecil B. de Mille contributed in no small way to promoting Parisian chic, with the Art Deco interior as a backdrop. New sources of inspiration included the discovery of Tutankhamun's tomb in 1922, which gave rise to 'Egyptomania'. Like their European counterparts, American designers also sought

123 Marguerite Zorach, *Coral Seas*, cartoon sketch, 1942, watercolour on paper, 106 x 241 cm (41 ¾ x 94 ⅞ in.). The carpet was made in the tufted technique for the New York home of Sylvia Chandler by the V'Soske company of Grand Rapids, Michigan.

124 Loja Saarinen, carpet made for the headmistress's office at Kingswood School, Cranbrook, 1931, 262 x 204 cm (103 x 80 ½ in.). Made in Loja Saarinen's weaving studio, its design is based on the plan of a Mexican pyramid. The structure is typically Swedish, the wool pile being woven on a linen warp, shot with seven to eight shoots of wool weft between each row of knots.

125 Ruth Reeves, *Musical Instruments*, a design for Axminster carpeting decorated with musical instruments made for Radio City Music Hall, New York, 1932, brush and gouache, graphite traces on cream paper, 18.6 x 14.1 cm (7 ³⁄₈ x 5 ¹⁄₂ in.).

126 Donald Deskey, interior of the Radio City Music Hall, New York, *c.* 1931, with carpeting designed by Ruth Reeves and a sculpture by William Zorach.

inspiration in tribal cultures, but turned to sources closer to home, namely indigenous American Indian cultures, from Navajo rugs to the pre-Columbian art of Mexico and Central America. Frank Lloyd Wright designed carpets which mingled pre-Columbian references with circular forms, for his home in Taliesin in 1925. A ubiquitous motif, the Mexican pyramid became a hallmark of American Art Deco and featured in every type of design, from skyscrapers to the carpets designed by Loja Saarinen for the headmistress's office of Kingswood School at the Cranbrook Academy in Detroit (1931) (ill. 124). The most characteristic American Art Deco interior is the lobby of Radio City Music Hall, New York, designed by Donald Deskey and a team of artists and craftsmen in 1932. Even today, the Axminster carpeting by Ruth Reeves with a repeating pattern of clowns and musicians, one of several designs she produced for the project, continues to greet visitors (ills. 125, 126).

Founded in 1928, the Studio Loja Saarinen was attached to the campus of the Cranbrook Academy in Detroit, built and directed by her husband, the architect Eliel Saarinen. The studio made handwoven art fabrics, rugs and window hangings, products renowned for their superior quality. Loja Saarinen's staff consisted of professional weavers, hired in Scandinavia, who also taught at the Academy and Kingswood School; from 1929 to 1933 she was assisted by a Swede, Maja Andersson-Wirde (ills 127, 128). Saarinen imported the techniques of her native Finland; the rugs were woven in the traditional *rya* technique, on a linen foundation, with a large number of shoots between each row of knots. Her early pieces, some designed in

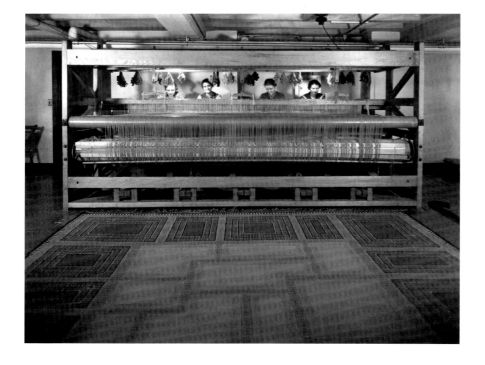

127 Weavers working on a broadloom in Loja Saarinen's weaving studio, Cranbrook School, May 1935.

(opposite)

128 Maja Andersson-Wirde, *Animal Carpet*, 1932, hand-knotted, wool pile, 385 x 274 cm (151 ½ x 108 in.), woven for the Cranbrook School, Detroit, in Loja Saarinen's studio.

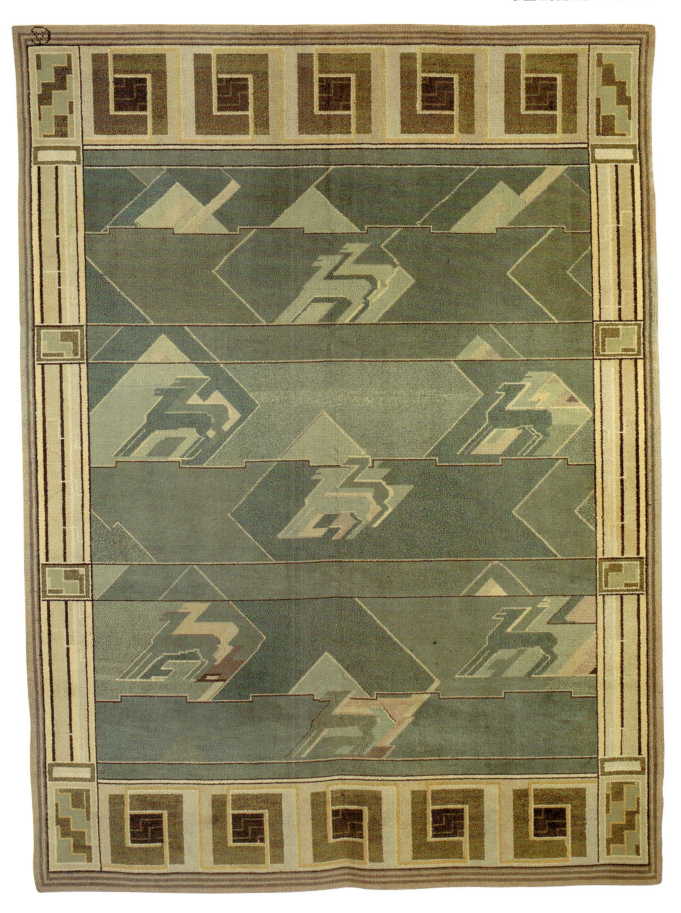

collaboration with her husband Eliel Saarinen, consist mostly of symmetrical compositions of stylized trees and affronted birds, harking back to the folk traditions of her homeland.

American carpet manufacturers on the whole lacked the skills to make carpets on handlooms, and as a result, designers who wished to have their carpets made by hand either had them executed abroad or gave the designs to small craft workshops or weaving guilds, which mostly specialized in the production of hooked rugs. Donald Deskey and Jules Bouy had theirs woven by the New England Guild in Portland, Maine, which made machine-hooked rugs. Several more, including the New Age Artists and Workers Association and the Ralph Pearson Studios, were located in New York City.

The demand for handwoven rugs caused a fully-fledged industry to develop in China. Several large factories were located in Beijing and Tientsin, some of which were run by Americans. Painter and ceramicist Henry Varnum Poor (1887–1970) had his rugs made by Elbrook Inc. in Tientsin. Shortly after her arrival in Beijing with her husband in 1919, Helen Fetté set up a business in partnership with a Chinese weaver, Li Meng Shu. Their carpets were created by a team of designers, supervised by Fetté. Taken from Chinese brocades and embroidery, the designs were Chinese in inspiration and included traditional motifs, such the flaming dragon and Buddhist symbols. Some, however, bear the unmistakeable stamp of Art Deco (ill. 129).[80]

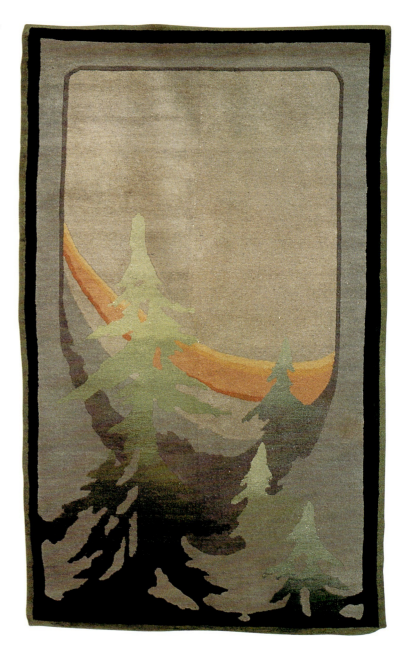

129 Carpet designed and executed by the Fetté-Li Co., Beijing, c. 1930. The Fetté-Li workshop produced both designs based on traditional Chinese motifs and Art Deco patterns.

NOTES

1 Eduard F. Sekler, *Josef Hoffmann, the Architectural Work*, Princeton University Press, Princeton, N.J., 1985, p. 89.

2 Medallion carpets by Prutscher and Delavilla were exhibited at the Handelsmuseum (now the Österreichisches Museum für angewandte Kunst), Vienna, in 1910. See *Deutsche Kunst und Dekoration*, vol. 25, 1909–10.

3 Adolf Loos, 'Ornament and Crime', trans. Harold Meek, in Ludwig Münz and Gustav Künstler, *Adolf Loos, Pioneer of Modern Architecture*, Thames & Hudson, London, 1966, pp. 226–31.

4 The others were Fritz Schumacher, Adelbert Niemeyer, Paul Schulze-Naumberg, J. J. Scharvogel, Wilhelm Kreis and Theodor Fischer.

5 Illustrated in *Dekorative Kunst*, 1904, p. 481.

6 The Germans were banned from participating in the 1925 Paris exhibition, due to sentiments stemming from the war. Had they been allowed to do so, it is interesting to speculate that the course of the French decorative arts might have been different.

7 In the Backhausen archives, Vienna, no. 1236. The roseball reached France via a circuitous route, the Austrians having borrowed the motif from the Glasgow School.

8 The firm run by Charles Sallandrouze Le Moullec and his brother Théophile Sallandrouze, not to be confused with the Sallandrouze de La Mornaix firm run by another branch of the family.

9 Archives Nationales F12/8724 and F12/5117.

10 Theoretically, the statutes of the Savonnerie workshops neither prohibit the sale of weavings nor the principle of private commissions but in practice, the traditional methods of craftmanship employed mean that a carpet may take years to execute, making it virtually inaccessible to the average purse.

11 Chantal Gastinel-Coural, *La Manufacture des Gobelins au XIXe siècle*, Administration Générale du Mobilier National, Paris, 1996, p. 19 (exhibition catalogue).

12 Jean Coural, 'Les Manufactures Royales', *Monuments Historiques*, no. 4, 1975, p. 65.

13 Poiret's daughter, Perrine Poiret de Wilde, recalls that two of these girls were named Alice Routy and Gabrielle Rousselin. I am indebted to Mme de Wilde for sharing her knowledge of the Ecole Martine with me.

14 Gustave Khan, 'La Réalisation d'un Ensemble d'Architecture et de Décoration', *L'Art Décoratif*, vol. 29, 1913, pp. 89–102; Marie-Noëlle Pradelle, 'La Maison Cubiste en 1912', *Art de France*, 1961, pp. 177–86.

15 For more textile designs by Gampert, see *Art et Décoration*, January 1914, p. 23; *L'Art Décoratif*, vol. 31, January–June 1914, p. 59.

16 Illustrated in M. P. Verneuil, 'L'Ameublement au Salon d'Automne', *Art et Décoration*, vol. 35, January 1914, p. 8.

17 Compare the pencilled scroll design in Ruhlmann's *Notebook 6* (Musée des Arts Décoratifs, Paris) with the design by Stéphany illustrated in Luc-Benoist, *Les Tissus, la Tapisserie, les Tapis*, Rieder, Paris, 1926, pl. VII.

18 Emile Sedeyn, 'L'Art Appliqué', *Art et Décoration*, 1913, p. 197.

19 M. P. Verneuil, 'Le Salon d'Automne', *Art et Décoration*, vol. 28, 1910, p. 156. The carpet was produced by André Groult and Verneuil was then unaware of the identity of the designer. The error was rectified by André Véra in 'Le Nouveau Style', *L'Art Décoratif*, no. 163, 1912, p. 23.

20 Verneuil 1914, p. 26.

21 Thérèse and Louise Bonney, *A Shopping Guide to Paris*, Robert McBride, New York, 1929, p. 180. An American photographer based in Paris, Thérèse Bonney gave important coverage to modern carpet production in her book.

22 Bonney 1929, p. 199. The Bonney sisters report that Aubusson rugs could then be made for $20 a square metre. This compares with $1,600 to $2,000 a square metre for a Savonnerie carpet, $2,000 for a Beauvais tapestry and $60 to $80 for an Aubusson tapestry.

23 As the signature clearly indicates, a carpet illustrated in Jacques Sirat and Françoise Siriex, *Tapis Français du XXe Siècle*, Editions de l'Amateur, Paris, 1993, p. 40, is the work of the Atelier Martine and not the Atelier Pomone as suggested by the authors.

24 Luc-Benoist, *Les Tissus, la Tapisserie, les Tapis*, Rieder, Paris, 1926, p. 45.

25 Léandre Vaillat and Louis Süe, *Le Rythme de l'Architecture*, F. Bernouard, Paris, 1923. A carpet is illustrated on page 66.

26 A drawing of the carpet as it was executed was published in *La Renaissance de l'Art*, 1928, p. 88. A similar but not identical carpet was sold by the Compagnie Générale Transatlantique in 1974 as a relic from the *Normandie*. Louis-René Vian (*Arts Décoratifs à Bord des Paquebots Français*, Fonmare, Paris, 1992, p. 80) has plausibly suggested that it may have been a spare carpet for the *Ile-de-France*. However, Florence Camard (*Süe et Mare et la Compagnie des Arts Français*, Editions de l'Amateur, Paris, 1993, p. 231) has pointed out that this carpet, measuring 1200 x 600 cm (39 x 19 ft), does not figure in the firm's inventory, unlike the rug executed for the liner. As a

carpet drawn by Louis Süe for the Mobilier National in 1937 is handled in a similar manner to the disputed carpet, he may well be the designer. If so, its destination remains a mystery, as the dimensions of the carpet in question far exceed those of the luxury stateroom *Deauville*, which Süe designed for the *Normandie*.

27 Léon Riotor, *Paul Follot*, Editions La Connaissance, Paris, 1923, p. 42.

28 The carpet in ill. 54, wrongly attributed to the Atelier Martine in Sirat and Siriex 1993, p. 32, is by Maurice Dufrène.

29 Illustrated in Maurice Dufrène, *Ensembles Mobiliers*, Eds. Charles Moreau, Paris, n.d., vol. 2, pl. 30, and Roberto Papini, *Le Arti d'oggi. Architettura et arti decorative in Europa*, Bestetti e Tuminelli, Milan and Rome, n.d. (1930), pl. CXXXII, fig. 203.

30 Henri Clouzot, 'Le Tapis Moderne', *La Renaissance*, April 1928, p. 164.

31 Bonney 1929, p. 198.

32 Illustrated in Gaston Quénioux, *Les Arts Décoratifs Modernes (France)*, Librairie Larousse, Paris, 1925, p. 302.

33 Marie-Noëlle de Gary, *Rythme et Couleur de l'Art Déco. Edouard Bénédictus*, Musée des Arts Décoratifs, Paris (exhibition catalogue), 1986, p. 9.

34 G. A. (André Girodie), 'Un tapis d'Edouard Bénédictus', *L'Art Vivant*, vol. 4, 15 February 1928, p. 134.

35 Tristan Klingsor, 'Les tapis de Gustave Fayet', *L'Art et les Artistes*, vol. 18, n.s., November 1923, no. 41, p. 114.

36 Bonney 1929, p. 199.

37 This carpet has been attributed to Eugène Printz and more recently to Ruhlmann himself. The attribution to Voguet is based on the exhibition's *Catalogue Général Officiel*, Paris, 1925, p. 81.

38 Jean Badovici, *'Harmonies': Intérieurs de Ruhlmann*, Editions Albert Morancé, Paris, n.d., p. 16. The architects Baudrier and Morel and designers Huet, Bougenot, Picaud, Lardin, Lautelin and Denise Nolin were among the other designers employed by the firm.

39 See Florence Camard, *Ruhlmann: Master of Art Deco*, Thames & Hudson, London, 1984, p. 240.

40 Susan Day, 'Art Deco Masterworks: The Carpets of Ivan Da Silva Bruhns', *Hali*, no. 99, July–August 1999, pp. 78–81.

41 The manufacturer remains unidentified. Laurencin is also reputed to have designed a flatweave carpet in a floral pattern, executed in Faureau's workshop in Aubusson in about 1938; see Amedée Carriat, *Dictionnaire Bio-Bibliographique des Auteurs du Pays Creusois et des Ecrits les Concernant des Origines à Nos Jours* (supplement), Société des Sciences Naturelles et Archéologiques de la Creuse, Guéret, 1976, p. 693.

42 Jacques Doucet acquired a Manzana-Pissarro carpet decorated with rabbits. See Arsène Alexandre (preface), *Exposition des Oeuvres de Manzana-Pissarro*, Musée des Arts Décoratifs, Paris (exhibition catalogue), n.d. (1914), no. 11. Doucet is famous for having auctioned his collection of 18th-century art in order to acquire contemporary art and design.

43 Shown at the exhibition 'Le Vingtième Siècle au Tapis', organized by the Musée de la Tapisserie, Aubusson, 1991.

44 The carpet calls to mind a Tibetan rug, but this must be purely coincidental, Tiger rugs having only become known to the West in 1979.

45 Illustrated in Raymond Cogniat, 'Technique et Esthétique des Tapis Nouveau', *Art et Décoration*, October 1931, p. 114; and *ABC Artistique et Littéraire*, 15 July 1931, no. 79.

46 Illustrated in 'Le Tapis', special issue of *Ce Temps-Ci: Cahiers d'Art Contemporain*, no. 6, October 1929, p. 161.

47 Elisabeth de Saedeleer, *Le Tissage à la Main*, Atelier d'Art Elisabeth de Saedeleer, Brussels, n.d., p. 6.

48 Marie de Saedeleer ceased weaving after an early marriage. I am grateful to Godelief de Saedeleer for providing me with invaluable insights into her family's workshop during an interview on 30 May 1991.

49 A small oval mat woven from a design by the painter Jules Boulez in the Museum voor Sierkunst, Ghent, has 16 x 16 Turkish knots per sq. dm, whereas another piece in the same museum, woven from one of Van Huffel's designs, is a superior grade, with 20 x 20 Persian knots per sq. dm. Both are woven with jute warps and wefts and bear the studio's monogram.

50 S. V. (Sibylle Valcke), 'Le Studio de Saedeleer', *Art Déco Belgique 1920–1940*, catalogue of the exhibition organized by Pierre Loze and Dominique Vautier at the Musée d'Ixelles, 1988, p. 214.

51 Jean Teugels, 'Les Tapis Modernes', *L'Art Vivant*, vol. 3, October 1927, p. 812.

52 Georges Marlier, 'Le Studio de Saedeleer', *Art et Décoration*, September 1928, p. 84.

53 Marlier 1928.

54 The possibility is mentioned in a letter Fry wrote to George Bernard Shaw in December 1912. See Isabelle Anscombe, *Omega and After: Bloomsbury and the Decorative Arts*, Thames & Hudson, London, 1981, p. 15.

55 Judith Collins, *The Omega Workshops*, Secker & Warburg, London, 1984, p. 39.

56 Department of Overseas Trade, *International Exhibition of Modern Decorative and Industrial Art, Paris. British Section*, organized by the Department of Overseas Trade, April–October 1925, pp. 75–76, 122–24, 211.

57 Stella Beddoe, 'L'Art Déco en Grande Bretagne: Une occasion manquée', in *L'Art Déco en Europe*, Palais des Beaux Arts, Brussels (exhibition catalogue), 1989, p. 199.

58 Marjan Groot, 'Amsterdam School and Expressionism 1910–1930', in *Avant-Garde Design: Dutch Decorative Arts 1880–1940*, V + K Publishing, Bussum and Philip Wilson, London, 1997, pp. 78–132.

59 Paul Léon, *Exposition Internationale des Arts Décoratifs et Industriels dans la Vie Moderne, Paris 1925. Rapport Général*, Larousse, Paris, 1927–31, vol. IV, p. 50.

60 There were thirty associations of this type in Sweden alone. See Nils G. Wollin, *Svenska Textilier 1930. Swedish Textiles 1930. Textiles suédois 1930*, Utställningsförlaget, Stockholm, 1930, p. 18.

61 Wollin 1930, p. 19.

62 Leena Svinhufvud, 'Finnish Textiles en Route to Modernity', in *Finnish Modern Design*, eds. Marianne Aav and Nina Stritzler-Levine, Yale University Press, New Haven, 1998, p. 194–95.

63 *Exposition Internationale des Arts Décoratifs et Industriels Modernes à Paris, 1925. Section de la Suède. Guide illustré*, Imprimerie Bröderna Lagerström, Stockholm, n.d., pp. 33, 44–46, 56, 57, 61, 114.

64 Helena Dahlbäck-Luttemann, 'L'Art Déco en Suède: arrière-plan et tonalité', in *L'Art Déco en Europe*, 1989, p. 241.

65 R. Stornsen, *Tapis de Finlande, Norvège, Suède*, Paris, Henri Ernst, n.d. (1927), pls 19–26.

66 Anna Maria Ruta, *Arredi Futuristi*, Novecento, Palermo, 1985, p. 39.

67 Ruta 1985, pp. 98–99, 102.

68 Anna Maria Ruta, in correspondence, 4 May 1992.

69 M. P. Verneuil, *Etoffes et tapis étrangers*, Eds. A. Lévy, Paris, n.d. (1925), pl. 22.

70 Ruta 1985, p. 206.

71 Sarah Sherrill, *Carpets and Rugs of Europe and America*, Abbeville Press, New York, 1996, pp. 29–55.

72 I am indebted to Mercé Viñas de Samaranch for providing me with information on the Aymat factory.

73 See the examples illustrated in Alena Adlerová, *Ceské Uzité Umení 1918–1938*, Odeon, Prague, 1983, pp. 38, 76.

74 A rug by Antonín Kybal is illustrated in Adlerová 1983, p. 130.

75 David Crowley, *National Style and Nation State: Design in Poland from the Vernacular Revival to the International Style*, Manchester University Press, Manchester, 1992, pp. 103–5.

76 For further information, see *Tapis de Pologne, de Lithuanie et de Yougoslavie*, Ernst, Paris, n.d. (1927); and Jerzy Warchalowski, *Polska sztuka dekoracyjna. L'Art Décoratif Moderne en Pologne*, J. Mortkowicz, Warsaw, 1928.

77 Bruce Brooks Pfeiffer, *Masterworks from the Frank Lloyd Wright Archives*, Harry N. Abrams, New York, in association with the Frank Lloyd Wright Foundation and the Phoenix Art Museum, 1990, pp. 281–82.

78 Illustrated by David Hanks, *The Decorative Designs of Frank Lloyd Wright*, Dutton, New York, 1979, p. 18.

79 Alastair Duncan, *American Art Deco*, Thames & Hudson, London, 1999, p. 139.

80 Margaret Setton, 'Chinese Rugs: The Fetté-Li Company'. *Oriental Rug Review*, vol. 11, December–January 1991, no. 2, pp. 18, 20–21.

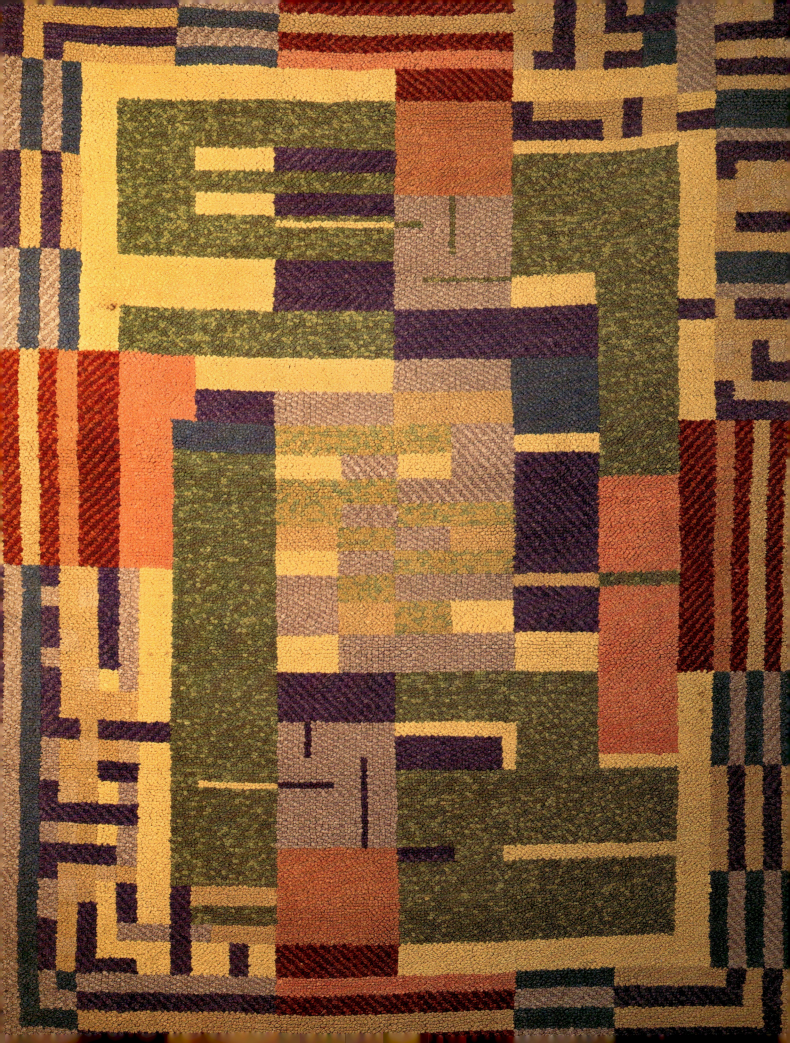

THE MODERNIST CARPET: ART MEETS INDUSTRY

THE BAUHAUS: CRUCIBLE OF MODERNISM

130 Benita Otte, carpet inspired by the work of
De Stijl painter Vilmos Huszár, 1923, wool pile.

The Germans were major contributors to Modernism and the industrial aesthetic, even though this was not achieved without a certain amount of strife. One of the problems on the agenda at the Werkbund's first annual meeting held in Munich in 1907 was finding a means of collaborating with the highly progressive German chemical industry, which was at the forefront of the research into synthetic dyes, with a view to developing standardized colours and fast dyes. Proof of the success of this venture is offered in the carpets displayed at the major exhibition organized by the Werkbund in Cologne in 1914.[1] More than a dozen carpet manufacturers who were either members or supporters of the Werkbund displayed their wares, dyed with guaranteed unfadeable dyes manufactured by two chemical giants, the Badische Anilin- und Soda-Fabrik and the Friedrich Bayer company.[2]

However, the 1914 exhibition was marred by internal tensions between the Werkbund members. A staunch believer in the need for standardization, Hermann Muthesius came into open conflict with Henry Van de Velde, who, as a defender of artistic freedom and individuality, represented the opposing view that the Werkbund had shifted too far in favour of industry. Those who sided with Van de Velde saw looming on the horizon a return to the bad old days when pattern draughtsmen had been exploited by industrialists. The conflict between art and industry continued to divide Werkbund members as it did the staff and students of the Bauhaus.

The Bauhaus is chiefly known as the place where the Functionalist school of architecture was born. The institution was initially created with a view to uniting all the crafts associated with building under one roof, hence the name 'House of Building'. The pedagogical theory of the Bauhaus was conceived by Henry Van de Velde and from 1919, when the school was officially founded, by the architect Walter Gropius, an active member of the Werkbund. Gropius shared Van de Velde's conviction that training in the arts should start with a period of apprenticeship, and that all craftsmen would cooperate on an equal footing, according to the ideals of Ruskin and Morris. Unlike the English theorists, Gropius recognized the need for a technical institution capable of collaborating with industry. The curriculum was based on the principle of joint instruction by a *Formmeister*, who taught theory, and a *Lehrmeister* or professional craftsman, in charge of the practical aspects.

The departments included metalwork, bookbinding, pottery, glass, sculpture, printing and weaving workshops. The curriculum for the textile workshop included training on various

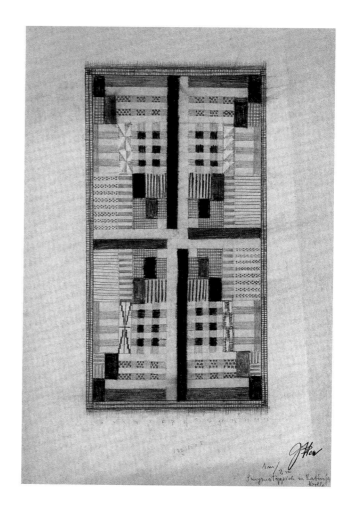

types of loom, the skills required to set them up, materials, weaving techniques and courses in management.[3] During its fourteen-year history, the workshop evolved from creating picturesque works of art to fabricating industrial prototypes in an experimental laboratory which advised the textile industry. It was moreover the only one to achieve the aims originally outlined in the school's brief. The number of carpets produced in the Bauhaus textile workshop was relatively few in comparison to other fabrics, but the school's theoretical approach and experiments with materials and techniques were of paramount importance in the evolution of the textile and carpet industry as a whole.

During the first three years of its existence, the Bauhaus functioned as a school of handicrafts, whose curriculum reflected the avant-garde ideology of the faculty. Paradoxically these were all artists rather than craftsmen, but they were united in their common opposition to academic teaching methods. Among them were Lionel Feininger, Oskar Schlemmer and several painters affiliated with the Expressionist movement, including Johannes Itten (1888–1967), Paul Klee (1879–1940) and Vasily Kandinsky (1866–1944). Particular importance was attached to the theory and science of colours, and spatial, visual and sensory perception. The *Vorkurs* or preparatory courses were at first taught by Itten, assisted by Georg Muche, and from 1923 by László Moholy-Nagy (1895–1946) and former student Josef Albers. Kandinsky and Klee taught the advanced courses in formal analysis. Both Itten and Klee were closely involved with the weaving workshop, and not surprisingly their influence was especially profound on the weavers.

The first 'master craftsman' appointed to the weaving workshop was Helene Börner, assisted by Li Thorn in the technique of carpet knotting.[4] The students learned all the tasks involved in weaving, from the preparatory drawings to final execution, on the principle that mastery of the tools and materials would give them the necessary skills to design for mass production. The reliance on traditional techniques meant that some of the early weavings, with animal and tree motifs woven by Ruth Valentin, Gunta Stölzl (1897–1983) and Ida Kerkovius (1879–1970), have a decidedly ethnic air.

Attendance at Itten's *Vorkurs* was compulsory for all students. A Swiss artist whose pictures reveal his familiarity with the work of the Cubists and Robert Delaunay, Itten endorsed the teaching methods of reformers Johann Heinrich Pestalozzi and Maria Montessori, who believed in liberating the creative imagination. Itten was also appointed *Formmeister* of the weaving workshop (ill. 131). A mystic and convert to Mazdaznan, a Zoroastrian sect, Itten favoured teaching methods that were for the time somewhat unorthodox. He sought to develop his students' potential through rhythm, sound, light and colour and taught that all natural forms could be broken down into three primary elements; that is, the square, the

131 Johannes Itten, point-paper for a carpet, *c.* 1923. The painter taught theory at the Bauhaus as well as designing and occasionally weaving himself.

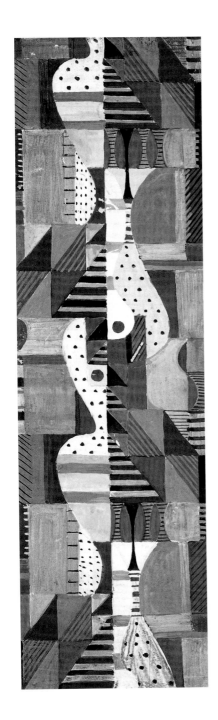

triangle and the circle, shapes which he equated with the primary colours. In order to improve the students' sensory perception of materials, he had them handle yarns, fabrics and pelts with their eyes closed. Afterwards they sketched these or made collages, in which they were expected to bring out the visual and tactile qualities of the materials and the contrasts between hard/soft, dull/shiny, thick/thin, rough/smooth, and so on.

Based on square, rectangular, triangular and cross shapes, the first carpet designs by weavers Benita Otte (1892–1970), Martha Erps (1902–77), Gunta Stölzl (ill. 132), Ida Kerkovius and Mila Hoffmannlederer demonstrate the influence of Itten's teachings. Ida Kerkovius sought to make practical use of her newly acquired knowledge by creating rugs with designs woven in contrasting fibres or knotted in pile so as to stand out in relief on a flatweave ground (ill. 133). Itten's courses were clearly a fundamental stimulus for research into textured fabrics.

Paul Klee began teaching at the Bauhaus in 1921 and after Muche's departure in 1927 he became particularly involved with the weaving workshop. Klee's theories were based on the importance of movement and the dynamic relationship between colours. Drawing on the theories of Philipp Otto von Runge, Eugène Delacroix and particularly Robert Delaunay, Klee analysed the relative strengths of opposing and complementary colour pairs in relation to elements of the composition. He also devised a chromatic code close in spirit to the helix developed some fifteen years earlier by Robert Delaunay. It took the form of a circle, in which the

132 Gunta Stölzl, study for a runner, 1923, gouache on paper, 12 x 41.8 cm (4¾ x 16½ in.). The artist, then a student, hand-knotted the carpet herself.

133 Ida Kerkovius, *Animal Carpet*, 1923, woven in a composite technique, partly in weft-faced plain weave and partly in relief. Like their Swedish counterparts of the time, the Bauhaus weavers began to focus their work on effects achieved through contrasts in texture.

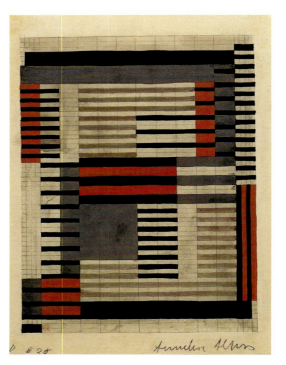

secondary colours were placed between their primary components; violet between red and blue, and so on. Grey, a uniform colour obtained by mixing any two secondary colours, was placed as a common denominator in the centre.[5] A work by Klee entitled *Abstraction Bleu-Rouge* and derived from his theories on colour was issued in carpet form by the Maison Myrbor (ill. 7), although it is unclear whether the design was commissioned, or if the retailers had it woven from a painting in their collection.

Klee enjoyed an exceptionally good rapport with the weavers, probably due to the fact that he equated the art of weaving with music. Anneliese (Anni) Fleischmann (1899–1994), who later married fellow student Josef Albers, even declared that for a time Klee was 'her God'. Carpets by Benita Otte and Grete Reichardt (1907–84) recall Klee's paintings (ill. 134). Klee himself must have felt that Ida Kerkovius had admirably responded to his teachings, as he purchased a carpet (or wall-hanging) from her. Otte, Reichardt and particularly Gertrud Arndt were among those who interpreted the painter's 'magic squares' in carpet form. In delicate shades of transparent watercolour in superimposed layers, they were extremely difficult to translate into textile form, but Arndt admirably surmounted the difficulties in a woven rug which must have pleased Gropius, as it lay on the floor in his office (ills 136, 137).

The Bauhaus had hardly been founded when the school came seriously under fire from critics within and without. The old demon of elitism had again raised its head, with a group of artists in Weimar pressing for the creation of a high-level school of painting within the school. The dissent was in part due to a clash between Gropius and Itten. The Swiss painter believed in the primacy of art and categorically refused to equate the fine and the applied arts. The situ-

134 Grete Reichardt, flatweave carpet design for a child's room, *c.* 1928, watercolour over pencil with collage elements. Under the influence of painters Paul Klee and Johannes Itten, the Bauhaus weavers evolved rapidly from work based on folk traditions to designs inspired by avant-garde trends in the arts.

135 Anni Albers, design for a pile rug, 1925, watercolour, gouache and graphite on paper, 20.6 x 16.7 cm (8 ⅛ x 6 ½ in.).

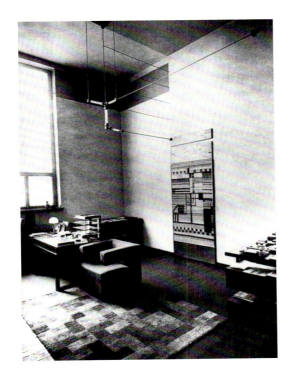 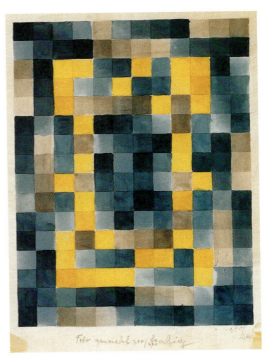

136 Walter Gropius's office at the Bauhaus, Weimar, 1923, featuring a carpet designed and woven by Gertrud Hantschk-Arndt, and a wall-hanging attributed to Else Mögelin.

137 Gertrud Hantschk-Arndt, design for a carpet, c. 1923, watercolour on paper. The design recalls Paul Klee's 'magic squares'.

ation worsened when De Stijl painter Theo Van Doesburg installed himself in Weimar. In 1922, the artist published a blistering attack of the school in an issue of *De Stijl* magazine, accusing the school of expressionist hysteria mixed with half-understood mysticism made into dogma. His criticism did not extend to the weaving workshop, however, which he singled out for praise in a series of articles on innovative modern textiles written in the early thirties.[6] The weavers responded in kind by creating textiles inspired by the graphic work of the Neo-plasticists. Surviving pieces include a carpet by Benita Otte in the Kunstsammlung in Weimar (ill. 130) and a design by Anni Albers in the Museum of Modern Art in New York (ill. 135).

Critics declared that Bauhaus teaching was based on a paradox, claiming to seek collaboration with industry, yet at the same time basing its methods on outdated craft practices. The malaise, Le Corbusier argued, was due to the fact that students learned to create superfluous objects like sculptures and tapestries, when they would be better served by a training in industrial standards. Towards the end of 1922, the school's brief was reorganized in accordance with objectives outlined by Gropius in a memo entitled 'Art and Technique: a New Unity'. Teaching was to be assimilated with industrial production techniques and the design of prototypes for industry. Gropius sought to respond to the call for a change in direction by recruiting the Hungarian artist László Moholy-Nagy, a Constructivist whose ideals corresponded to his own. The faculty found itself divided into two camps, with Lionel Feininger, Vasily Kandinsky and Georg Muche defending the primacy of art, opposing the group which endorsed the industrial aesthetic defended by Gropius, Oskar Schlemmer and Moholy-Nagy.

Criticism of the school did not abate. On the contrary, it was subject to increasingly vituperative attacks in the press, the work of right-wing extremists. Relations worsened with the local council of Thuringia, which financed the institution, and it became necessary for the school to seek alternative sources of income. In 1923, an exhibition of the students' work was organized, with a view to obtaining contracts from industrial firms. The exhibition took the form of a model home, the 'Haus am Horn', designed by Georg Muche, who had replaced Itten as head of the weaving workshop after the Swiss painter's resignation. It was furnished with handmade carpets by Ida Kerkovius, Gunta Stölzl, Agnes Roghé (1901–27) and Martha Erps, later wife of fellow student and architect Marcel Breuer (ills 138, 139). The exhibition attracted wide press coverage, but few contracts.

Pressured by local craftsmen who felt that the new technological orientation threatened their livelihood, the town council drastically slashed the school's budget, forcing its closure. In the spring of 1925, Gropius accepted an invitation from mayor Fritz Hesse and the Bauhaus reopened in Dessau. The move to Dessau brought about a number of fundamental changes. The bookbinding, pottery, painting on glass and sculpture workshops were dropped and the principle of separate theoretical and practical instruction was abandoned. The workshops were henceforth to be headed by former students who were able to teach both theory and craftmanship. In order to attract contracts from industrial firms, Gropius requested the heads of the remaining workshops to set up research laboratories.

138 A room in the Haus am Horn, the house designed by Georg Muche for an exhibition on the model home, Weimar, 1923. The carpet is the work of Martha Erps, wife of the architect Marcel Breuer.

139 Martha Erps, carpet for the living room of the Haus am Horn, 1923, wool pile.

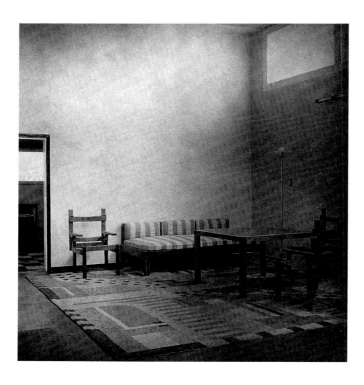

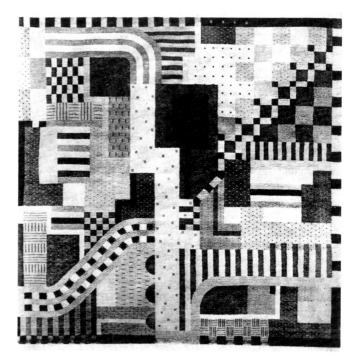

140 Students in the Bauhaus weaving workshop,
Dessau. Back row, from left to right: unidentified,
Margarete Heymann, Gertrud Hanschk-Arndt,
Kurt Wanke (technical advisor), Gunta Stölzl,
Gertrud Preiswerk-Dirks. Middle row: three
unidentified students, Léna Meyer-Bergner,
Lis Beyer-Volger, unidentified. Foreground:
Ruth Hollós-Consemüller, Grete Reichardt,
Anni Fleischmann-Albers.

Gunta Stölzl replaced Helene Börner as head of the weaving workshop (ill. 140). Stölzl had supplemented her training at the Bauhaus with courses on dyestuffs at the Färberei Fachschule in Krefeld, and advanced silk-weaving techniques at the Preussische Höhere Fachschule für Textil-Industrie, also in Krefeld. She reorganized the curriculum, set up a workshop devoted to experimental techniques and a dye laboratory, managed by Lis Beyer-Volger (1906–73). Synthetic fibres had already been used at Weimar, but the new orientation encouraged experimentation in earnest, particularly with cellulose derivatives such as acetate, rayon and even cellophane. Apart from testing materials for durability and resistance to light and washing, experiments were done with textiles that could function as light reflectors and as acoustic protection.[7]

Gunta Stölzl later acknowledged her debt to Itten, whose courses had stimulated her aesthetic pleasure in the textile medium and her taste for creating tactile effects by combining unusual materials.[8] To achieve this, Stölzl and her students experimented with combinations of different materials, yarns of varying thicknesses and mixtures of natural and synthetic fibres. In one of her most famous works, a tapestry woven in 1926–27, Stölzl achieved remarkable textural effects by mixing silk, linen and woollen chenille in a composite technique.[9] Otti Berger used yarn of uneven thicknesses for the wefts of a flatweave rug (ill. 141); by alternating these with woollen wefts of normal thickness, she created a wavy surface effect.[10] Margaret Leischner (1907–70) and Dutch student Kitty Van der Mijll-Dekker (born 1908) also experimented with the textural effects. The increased stress on technique also corresponded to a change in style, namely a trend towards a simplified geometric repertoire, visible in Stölzl's and Albers's creations (ills. 142, 143).

141 Otti Berger, flatweave carpet, c. 1930, woven in
yarn of uneven thickness on a hemp foundation.
The rug was exhibited at the Museum of Modern
Art, New York, in 1938.

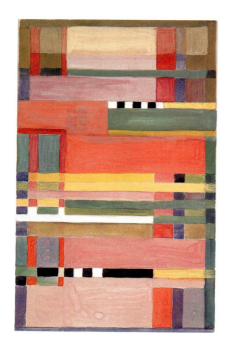 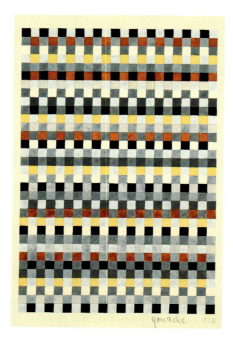

142 Gunta Stölzl, carpet design, 1926, watercolour and gouache on cardboard.

143 Anni Albers, rug design for a child's room, 1928, gouache on paper, 34.1 x 26.5 cm (13 ⅞ x 10 ½ in.).

Gropius, on the other hand, felt that the production of the workshop still lagged behind the programme outlined in the school's brief, namely the design of prototypes for industry. But Stölzl's main interests lay in experimental research and the weaving of works of art, to which she accorded the same aesthetic value as the fine arts: 'A Rembrandt and a beautiful Persian carpet have equal artistic merit...'.[11] Claiming she was not hostile to mechanization, she argued that textile manufacturers developed their products on handlooms, and that the complicated procedures involved in setting up mechanical looms were only worthwhile when large quantities were involved.

DESIGNING FOR INDUSTRY

Stölzl's management came in for a rebuke when Gropius wrote a directive on 21 January 1926, stating that the school's original objective was being ignored by the weavers. He suggested they prepare model books with proposed colourways to be shown to potential clients and initiated contacts with a number of textile firms in the Gera region, including the carpet manufacturers Hartwig und Posner, Erdmann, and Kreuse und Poser. It would seem that nothing came of these contacts.

After Gropius resigned in 1928, Stölzl's management of the workshop came in for more serious criticism by the new director, the architect Hannes Meyer, who succeeded in imposing

functionalist doctrine on the school. Stölzl also came under fire from her students, who believed that handweaving had become an anachronism, in particular Anni Albers, Otti Berger and Léna Bergner (1906–81), later Meyer's wife. Berger admitted that the production of metered fabrics and powerloom carpeting was an idea more easily endorsed by the younger students.[12]

Stölzl's technical expertise was however limited to handloom weaving, and specific technical problems had to be resolved by her assistant, master weaver Kurt Wanke. Léna Meyer-Bergner revealed that the students learned how to use the Jacquard loom, but that apart from this, their practical experience was limited and they were not conversant with the techniques involved in mass production. Feeling that she no longer enjoyed the support of either her students or the faculty, Stölzl resigned on 30 September 1931.

Dictated by functionalist criteria, the textiles and carpets made during the last period of the Bauhaus could all be described as austere, and none of the textiles succeeded in escaping from the inexorable grid plan imposed by the weave. In spite of press criticism of the school's new direction, the weavings being described as 'devoid of decorative or aesthetic value',[13] functionalism continued apace under Meyer's leadership. Otti Berger in particular collaborated closely with several textile manufacturers and a large number of samples of this work, including fragments of powerloom carpeting, are today conserved in the Busch-Reisinger Museum at Harvard University. Anni Albers also designed prototypes for industry, examples of which can be found at the Anni and Josef Albers Foundation in Bethany, Connecticut, and the Museum of Modern Art, New York.[14] The Bauhaus in Dessau conserves some carpet designs by Grete Reichardt (ill. 144) and Franz Ehrlich, some of which may have been intended for

144 Grete Reichardt, pattern unit for carpeting, *c.* 1930, watercolour over pencil, 12.1 x 9.2 cm (4 ¾ x 3 ⅝ in.).

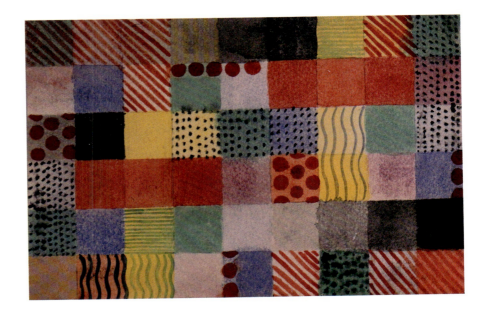

industrial production, but surviving samples of powerloom carpeting are otherwise rare. The Bauhaus Archive also holds working drawings by Léna Meyer-Bergner and Bella Broner Ullmann, although it is not clear whether these were intended to be woven by hand or by machine.

An admitted Marxist, Meyer was forced to resign in the summer of 1930. The Bauhaus had by this time become chiefly an architectural school and with the appointment of Ludwig Mies Van der Rohe as director, the workshops became subordinate to this department. After Stölzl's departure, Anni Albers was appointed manager of the weaving workshop until the arrival in January 1932 of Lilly Reich (1885–1947). The first woman to be named to the executive committee of the Werkbund, Reich had collaborated with the Wiener Werkstätte and Mies Van der Rohe. An interior designer, Reich had little technical knowledge of weaving and so was assisted by Otti Berger.

In spite of the fact that Mies kept a relatively low political profile, the school became a target of the National Socialists, who considered it a hotbed of 'cultural Bolshevism'. It was closed in the summer of 1932, but reopened briefly in Berlin as a private school headed by Mies Van der Rohe. Reich followed the architect to Berlin where she taught until 11 April 1933, when the building was stormed by Nazi paratroopers and the police. Otti Berger was less fortunate: she died in a concentration camp. The spirit of the Bauhaus nevertheless lived on in the diaspora of its professors and students.

ARTISTIC LEGACIES IN GERMANY, AUSTRIA AND SWITZERLAND

Fascination with the Bauhaus has tended to eclipse achievements elsewhere in Germany during the twenties and thirties. Output in Germany was indeed concentrated on the mass production of abstract Modernist designs and it has to be admitted that the fears voiced by Van de Velde were partly justified, as the bulk of these patterns were, as in the past, the work of in-house designers who remained anonymous.[15] Among the manufacturers who did continue to identify their artists were the Deutsche Textil Kunst in Leipzig, the Wurzener Teppichfabrik and the firm of Gustav Karl Lehmann in Cologne, which issued designs by Wilhelm Poetter, the Austrian architect Emmanuel Margold and H. Wandel, respectively.

Small craft workshops did not entirely disappear either: Greta Banzer in Osnabrück, Ilse Becher in Hagen, Louise Pollitzer in Munich, Franz Ulbrich in Bruneck-in-Tirol, Wenzel Hablik and Elisabeth Lindemann in Itzehoe and Alen Müller-Hellwig in Lübeck ran independent weaving studios.

A painter whose utopian architectural drawings particularly influenced the Expressionists, Wenzel Hablik (1881–1934) and his wife Elisabeth Lindemann (1879–1960), a designer

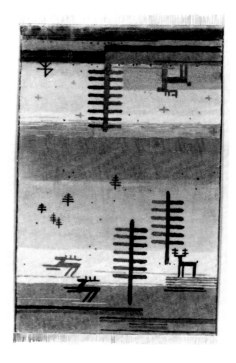

145 Wenzel Hablik, carpet design, 1932, tempera and watercolour on Chinese rice paper, 23.6 x 15 cm (9 $\frac{1}{4}$ x 5 $\frac{7}{8}$ in.). Made for the Hablik-Lindemann workshop in Itzehoe, the design uses adapted versions of traditional folk motifs in shades of brown with grey, white, blue and red.

and master weaver, founded their weaving workshop in 1917. The studio wove furnishing fabrics, wall-hangings, cushions, table linen and carpets (ill. 145), which used traditional folk patterns interpreted in a modern idiom, as well as themes drawn from modern life. Hablik also supplied carpet manufacturers with patterns.

Trained at the Kunstgewerbeschule in Hamburg, Alen Müller-Hellwig (1902–93) was the first textile artist to completely reject dyed yarns. Initially based in Lübeck, Müller-Hellwig professed admiration for the textured weavings made by the Scandinavians and focused her research on the effects which could be achieved with natural, undyed handspun wools and bouclé yarns in natural shades of black, white, grey and brown (ill. 146). When they were displayed at the Leipzig Fair in 1927, Müller-Hellwig's weavings attracted the attention of architects including Hugo Häring and Mies Van der Rohe (ill. 147). She designed and wove several carpets for Mies's projects, including one for the model home shown at the 1929 International Exhibition in Barcelona, for which she was awarded a gold medal.[16]

After the dismemberment of the Austro-Hungarian empire in 1918, Austria suffered an identity crisis and economic decline. Klimt, Wagner, Moser and the painter Egon Schiele, all giants of the previous era, died within months of each other. Meanwhile, Viennese designers continued to focus their attention on the creation of quality goods aimed at an ever-diminishing clientele. In spite of the objectives outlined in the Wiener Werkstätte's brief, Hoffmann and Peche remained adamantly opposed to the principle of mass-produced furniture and remained oblivious to the strident warnings of prophets of doom like Adolf Loos. With certain notable exceptions, Austrian design had lost most of its verve by the time of the 1925 Interna-

146 Alen Müller-Hellwig, *Kleine Mühle (Little Mill)*, flatweave rug woven in natural undyed wools, 1928.

147 Ludwig Mies Van der Rohe, interior of the Tugendhat House in Brno, Czechoslovakia, 1929. The carpets were woven in Alen Müller-Hellwig's Lübeck studio.

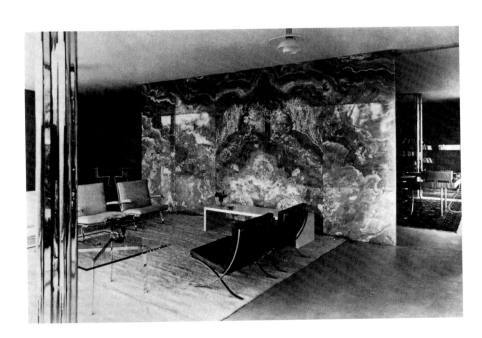

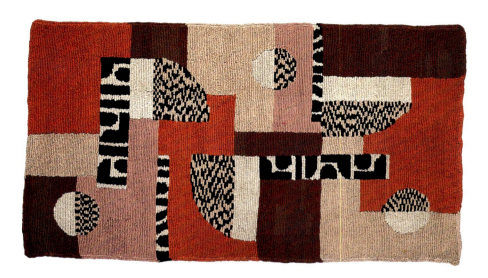

tional Exhibition in Paris. When the Wiener Werkstätte went into liquidation in 1932, it symbol-ized the loss of Austria's hegemony over the applied arts

Austrian carpet design from this period tends to reflect this loss of vigour. Few new names came to the fore, although designers Lois Resch and Josef Frank were among the exceptions. Working from her craft workshop in Schwertberg, Resch's repertoire included traditional and Modernist designs (ill. 150). A line of Modernist rugs from designs by Eduard Josef Wimmer-Wisgrill (1882–1961) and Josef Frank (1885–1967) was issued by Backhausen during the late twenties. Director of the fashion department at the Wiener Werkstätte and professor at the School of Decorative Arts in Vienna, Wimmer-Wisgrill also supplied the manufacturer Philipp Haas with patterns. He also taught some gifted students. Friedrich von Berzeviczy-Pallavicini (1909–89) designed several carpets, including one displayed in the 'lady's boudoir' at the exhibition to celebrate the school's jubilee in 1929. Representing an unusual variant on the pile carpet, it was executed in the weft loop technique, using rayon gros-grain ribbon, by Anna Truxas (ills 148, 149).

Switzerland, meanwhile, has never traditionally had a major carpet industry, and in comparison with other European countries, it housed few craft workshops which produced handwoven textiles. However, two major Swiss artists were instrumental in promoting modern textile art. Johannes Itten and Sophie Taeuber-Arp (1889–1943) shared a number of traits in common: both were artists and members of the avant-garde, both were influential teachers who used innovative teaching methods, and both spent a major part of their lives away from their homelands.

On leaving the Bauhaus, Itten joined the Mazdaznan sect at Herrliberg-Zurich, where he founded the short-lived Ontos weaving workshop with the aid of two of his former students, Gunta Stölzl and Mila Hoffmannlederer (1902–93). A carpet woven by Hoffmannlederer from a design by Itten was awarded a Gold Medal at the 1925 Paris exhibition (ill. 151). Another rug woven by Itten himself is in the Musée Bellerive in Zurich. Stölzl returned to the Bauhaus and Hoffmannlederer managed the workshop for a short time before Itten left to set up his own

148 Friedrich von Berzeviczy-Pallavicini, pile rug made by Anna Truxas in looped rayon ribbon, 1929, 96 x 171 cm (37 ¾ x 67 ⅜ in.).

149 Friedrich von Berzeviczy-Pallavicini, lady's boudoir shown at an exhibition commemorating the 60th anniversary of the Kunstgewerbeschule, Vienna, 1929.

school in Berlin. He joined the Swiss Werkbund, became closely involved with the textile industry and ran schools of textile design in Germany and Switzerland.

Taeuber-Arp headed the weaving department of Zurich's Decorative Arts School between 1916 and 1929. She had recently met her future husband, Jean Arp and through him was involved in most of the avant-garde art movements between the wars, from Dadaism to Abstraction-Création. Through her influence, Arp began experimenting with the textile medium, and both began to create abstract collages, embroideries and wall-hangings in austere geometric forms and bright colours which they claimed as an art form in its own right. Taeuber exhibited a flatweave carpet in an abstract design similar to early Bauhaus work alongside the embroidered cushions, lace and beadwork she contributed to the Swiss Werkbund's section at the 1925 Paris exhibition.[17] An oval mat in the form of an abstract collage was illustrated to accompany Theo Van Doesburg's article on textiles, but compared with her tapestries and embroideries, Taeuber designed few rugs.[18] Like Itten, she reformed traditional teaching methods by seeking to stimulate students' creative responses rather than concentrating solely on practical work at the loom.

Her best-known student, Elsi Giauque (1900–90), founded the Atelier de Recherches Textiles in her home in Ligerz in 1925. Working closely with architects, Giauque created tex-

150 Lois Resch, carpet, *c.* 1930, hand-knotted, wool pile, 213.4 x 123.2 cm (84 x 48 ½ in.), signed. Resch's Schwertberg workshop was one of the small craft workshops that perpetuated the folk traditions which coexisted with the up-and-coming functionalist trend in textiles.

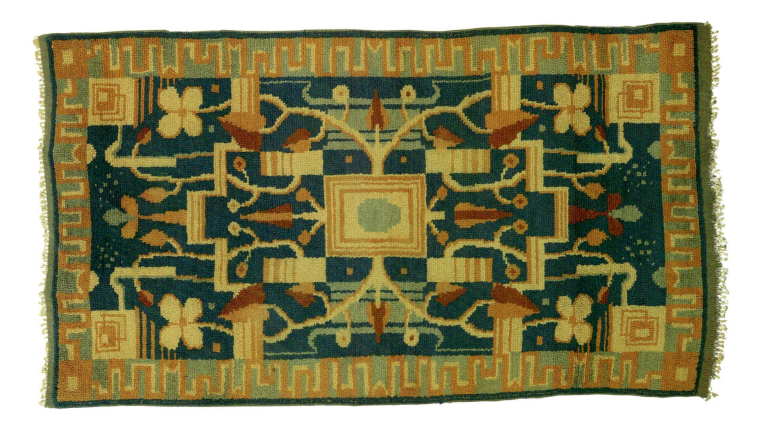

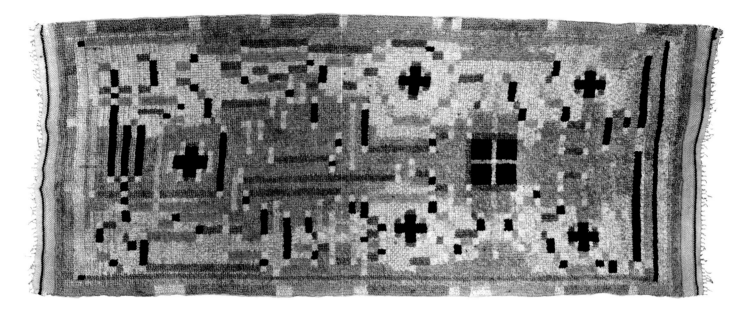

tiles, including carpets in bold abstract patterns, for numerous churches, schools, theatres and private homes. Renowned for her transparent tapestries, Giauque taught experimental weaving at the Decorative Arts School in Zurich, and also designed for industry.

151 Pile carpet woven by Mila Hoffmannlederer from a design by Johannes Itten. The work was awarded a Gold Medal when it was shown at the International Decorative Arts Exhibition held in Paris in 1925.

L'ART UTILE VERSUS L'ART DÉCORATIF

Along with Germany, France was to play a pivotal role in the development of the Modern Movement, spearheaded by the Swiss architect Le Corbusier (1887–1965) and his friend, painter Amedée Ozenfant. After settling in Paris in 1917, the architect assured himself a position in the vanguard of modern art and architecture. Irritated by what they thought was the Cubists' over-decorative approach to painting, Le Corbusier and Ozenfant developed a theory called Purism, in *Après le Cubisme* (1918). The Purist manifesto was followed by another joint effort, the magazine *L'Esprit Nouveau*, which served as a platform for their ideology and was founded on rationalist principles.

A fierce advocate of the principle of mass production, Le Corbusier was determined to wipe the slate clean and do away with traditional academic teaching methods, and was convinced that architectural students would be better served by training in engineering techniques and progressive design. Claiming that the house was 'a machine for living in',[19] Le Corbusier argued that housing should be designed using standardized norms. He was also the first to urge the industrialization of building techniques and mass-produced furniture as a solution to the housing crisis provoked by the First World War. In penning tracts with titles such as 'Cannons, munitions, no thanks! Housing please', he could even be described as an early master of the soundbite. The pavilion named *L'Esprit Nouveau* erected by Le Corbusier and Pierre Jeanneret at the 1925 International Exhibition in Paris, which took the form of a prototype for modern housing, received wide press coverage, even if this was mostly negative.

Le Corbusier's views on interior design were just as forcefully expressed, and Adolf Loos's essay *Ornament and Crime* became a key text in the functionalist debate. With a view to improving hygiene, Le Corbusier advocated that kitchens and bathrooms should resemble laboratories, that clutter and knick-knacks should be eliminated and that furnishing fabrics and floor coverings should be reduced to a bare minimum. The designs for housing and interiors which came off the drawing boards of his young followers were snootily dismissed as 'le style clinique' by the establishment. The Functionalists directed their design concepts more towards the design of space and the first open-plan homes date from this time. Within a few years the exuberant, chaotically crowded interiors of the early twenties made way for wide expanses of undecorated surfaces. Plain carpeting and rugs with a sparse scattering of motifs in light pastel or subdued shades replaced the fashion for bright shades and riotous patterns of a few years previously.

Le Corbusier himself did design one carpet. It was, to say the least, a startling piece, featuring two naturalistic sedentary lions posed back-to-back, surrounded by an array of tigers' pelts.[20] To judge from a contemporary description, it would seem that the carpet, shown on the U.A.M. stand at a 1931 exhibition in Cologne, was made up of several small Jacquard throw rugs sewn together. A derisory gesture, the architect was determined to thumb his nose at German Werkbund designers, whose work, exhibited at the Salon de Artistes-Décorateurs, had caused a stir in the design world some months previously. Designer Charlotte Perriand, Le Corbusier's associate at the time, recalled that she had presented the piece 'with a straight face and great deference, to the consternation of all...'.[21]

The Modernist credo had already made important inroads by the time of the 1925 International Exhibition. With his usual talent for picturesque metaphor, Le Corbusier equated the event with a fresh young girl in a cretonne dress, degraded into a slattern when surrounded by 'Renaissance salamanders, Turkish smoking tables, Japanese parasols and rugs decorated with flower baskets and cooing doves...',[22] a snide dig at a rug designed by Marie Laurencin. The designer Francis Jourdain was equally dismissive: 'the exhibition neither resolves nor even poses any problem. At best it has allowed us to ponder whether the basket of fruit constitutes more modern ornamentation than the chestnut leaf in 1900...'. He loftily concluded that his sleep remained 'undisturbed by such trivia'.[23]

It was through the Purist movement that French architects and designers became familiar with Cubism, which had until then had few repercussions on design. In the interim, Picasso and Braque had evolved from Analytical Cubism, in which the subject matter is distilled into facets, towards Synthetic Cubism and the concept of overlapping planes, and on to collage, a technique which involved incorporating foreign matter such as newsprint or paper cut-outs and fabric into their canvases. By the time the war was over, the movement had split into several offshoots. One of these was the Groupe de Puteaux, also known as the Section d'Or, which felt itself to be estranged from the painterly obsessions of Braque and

Picasso, whom they felt overlooked the dynamics of modern existence. This group, centred around painters Jacques Villon and Marcel Duchamp, shared ideals similar to those of the Futurists. They believed that advances in technology – speed, communications, electricity and machines – should be incorporated into modern art, and their interpretation of Cubism became highly influential in the French decorative arts scene. Members of the Groupe de Puteaux included Albert Gleizes, Marie Laurencin, Fernand Léger, Louis Marcoussis, André Mare, and Robert Delaunay.

Delaunay had discovered the rich palette of the Fauves and like the Futurists, sought to convey a sense of speed and movement in his paintings. Excited by the discovery of Chevreul's theory of colour contrasts, which he read in 1907, Delaunay had begun to experiment with the representation of light in his work. As white light is composed of a coloured spectrum and under certain conditions some chromatic values predominate over others, the painter sought to interpret the dyer's scientific findings in a series of abstract paintings, some of which recall a helix in motion. He baptised his work Simultaneism, although the poet Apollinaire preferred the term 'Orphic Cubism'.[24] Delaunay next proceeded to develop a theory of rhythm, claiming that a strict series of measurements based on the circle, in contrasting colours, would create a sense of rhythm and introduce a notion of time into the work.[25] He worked in symbiosis with his wife, Sonia Delaunay-Terk (1885–1979), a textile designer, interior decorator and highly innovative artist in her own right.

The blurring of distinctions between art and design meant that many artists began to express themselves through other media, including textiles. In creating an appliqué bedcover for her son in 1909 (Musée National d'Art Moderne, Paris), Sonia Delaunay was the first to adapt the principles of Analytical Cubism and collage to textile design. Endorsing her husband's theories on simultaneous contrasts, she claimed that she perceived no 'hiatus between her painting and her so-called decorative work'.[26] Her vibrant fabrics, sold in the boutique on the Boulevard Malesherbes which she shared with the couturier Jacques Heim, did indeed revolutionize haute couture design.

Sonia Delaunay's carpet designs closely resemble her fabrics (ill. 4), and included a rug in a swastika pattern for her Paris home, woven in an African palette of black, brown and cream.[27] Some of her designs were composed of interpenetrating blocks of colour which recall the work of the De Stijl movement, while others are closer to synthetic Cubist concepts like the piece she designed in 1925 for the home of Dr Viard (ill. 152). An interior she designed as a foil for her husband's famous painting *Hommage à Blériot* featured a carpet in a 'simultaneous contrast' pattern (ill. 153), and was praised by Theo Van Doesburg for the harmony achieved between the monumental painting and its environment.[28]

The 'simultaneous contrast' theory was endorsed by other artists in the Delaunays' circle, including Jean Arp and his wife Sophie Taeuber,[29] as well as many other designers in France and abroad. Marguerite Dubuisson (ill. 154), Eric Bagge, D.I.M., Jacques Adnet,

152 Sonia Delaunay, pile carpet in a Cubist design, *c*. 1925, monogrammed. It was designed for the living room of Dr Charles Viard, who was Delaunay's own doctor and an avid art collector.

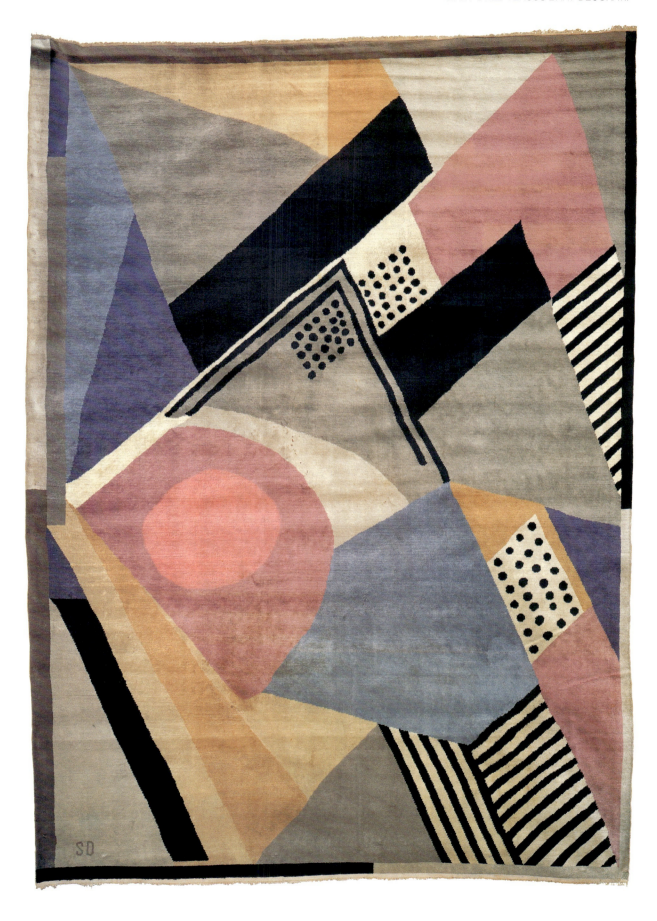

Yvonne Parigot, André Groult and British Modernist Serge Chermayeff were just a few of the many decorative artists who designed carpets in colourful rainbow hues.

The designer Eileen Gray (1878–1976) was also closely involved with the avant-garde. A friend of the architect Jean Badovici, she maintained close relations with Fernand Léger, Le Corbusier, Amedée Ozenfant and met members of the De Stijl group, whose work she became familiar with when it was shown in Paris in 1923. Some of her poetically named designs, such as *Brentano* and *Bobadilla*,[30] reveal her fascination for the work of the Russian Suprematist Malevich. Irish by birth, Gray initially designed lacquered furniture and carpets prior to taking up architecture. She and a young musician, Evelyn Wyld (1882–1973), learned the rudiments of weaving from Moroccan women and learned to dye wools with natural dyes during a trip to North Africa. Wyld took further training in weaving techniques in England, and after returning to Paris in 1910, the pair opened a craft studio in the rue Visconti, in the building where Balzac's printing workshop was once housed. Gray took a great interest in the technical aspects, as her notes attest, but it was Wyld who converted the designs onto point-paper and supervised the weaving.[31] The structure of one carpet, now in a private collection, with its twisted pile and unusually high number of ten weft picks and relatively low knot count (108 symmetrical knots per sq. dm), shows the influence of traditional Moroccan weaving techniques. Gray's carpets and furniture were sold in her shop, the Jean Désert Gallery on the rue du Faubourg Saint-Honoré in Paris.

The date at which Gray first adapted Cubist principles to carpet design is unclear. The oldest examples date from the early twenties, when she adapted the collage technique to a

153 Sonia Delaunay, interior shown at the U.A.M. (Union des Artistes Modernes) exhibition at the Musée des Arts Décoratifs, Paris, 1930. Hanging on the wall is Robert Delaunay's painting *Hommage à Blériot* (1914).

154 Marguerite Dubuisson, carpet in a 'simultaneous' design of chromatic contrasts, *c.* 1930, wool pile, 358 x 270 cm (141 x 106 ¼ in.).

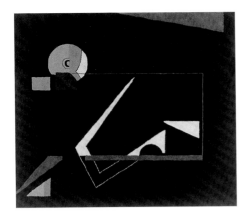

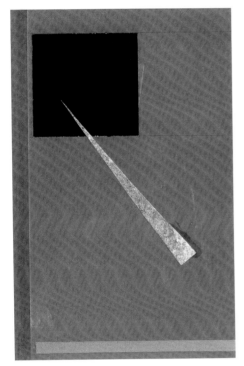

155 (above) Eileen Gray, *Black Magic*, 280 x 225 cm (110 ¼ x 88 ⅝ in.). First made for the 1923 Paris salon, this carpet is a recent reissue in the tufted technique by Ecart International, Paris.

156 (below) Eileen Gray, study for a carpet, *c*. 1922, gouache and collage on cardboard, 19.1 x 9.2 cm (7 ½ x 3 ½ in.). Gray also designed several rugs whose formalism echoes that of the De Stijl movement.

157 (right) Eileen Gray, 'Monte Carlo Room', a bedroom design shown at the Salon des Artistes-Décorateurs, Paris, 1923, featuring the carpet *Black Magic*.

series of carpets made for the apartment (1919–22) she designed for Mme Mathieu-Lévy, owner of Suzanne Talbot couture. Gray made collages from paper cut-outs, cardboard and fragments of textiles such as linen (ill. 156). A drawing similar to the design executed for Mme Mathieu-Lévy is in the Victoria and Albert Museum; the undyed wools used in the rug, in shades of ivory, black and grey-brown, reflect the natural colours of the drawing. The interior displayed at the 1923 salon of the Société des Artistes-Décorateurs (ills 155, 157) prompted the critic René Chavance to remark in the June 1923 issue of *Beaux Arts* magazine that her work displayed 'regrettable experiments with disquieting Cubism... which nevertheless... represent a curious harmony'.[32]

Another precursor was the artist Jean Lurçat, who designed fabrics, wallpapers and carpets for the Boutique Pierre Chareau and the Maison Myrbor. His designs are closely related to his oeuvre as a Cubist painter. A celebrated piece was the circular rug decorated with a mermaid, made for Pierre Chareau's hall-cum-library in the pavilion of the Société des Artistes-Décorateurs at the 1925 Exhibition (ill. 9). Treated collage-fashion, the figure was lightly traced in black on an orange ground, overlaid by two lime-green rectangles. Lurçat liked compact, centralized motifs, composed of irregularly shaped blocks of colour combined with chequered or spotted patterning, generally set off by bands of a different colour at either end of the field, in place of the traditional border.

A Cubist carpet by Lurçat entitled *Garden*, together with a rug by the artist Louis Marcoussis (1883–1941), were acquired by the couturier Jacques Doucet, a patron of modern art and design, for the hall of his Neuilly studio (1926–29) (ills 158–161). The studio

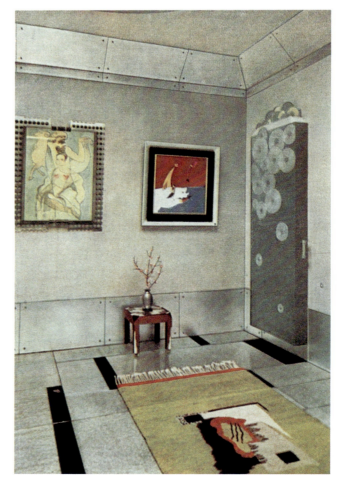

158 (top left) The staircase in Jacques Doucet's studio, *c.* 1926–29.
The banisters are by Joseph Csáky and the rug by Louis Marcoussis.

159 (top right) Louis Marcoussis, carpet woven by the Maison Myrbor, *c.* 1926,
wool pile, 253 x 140 cm (99 ⁵⁄₈ x 55 ¹⁄₈ in.). Marcoussis was a Cubist painter
and designer of Polish origin.

160 (above) Jean Lurçat, *Garden,* 1925, carpet design, woven in the Maison
Myrbor's Algerian workshop. Myrbor rugs were made in limited editions and
available in several colourways. Copies of this design were acquired by Jacques
Doucet for his Neuilly studio and by Helena Rubinstein for her New York
apartment (see ill. 182).

161 (right) The hallway of Jacques Doucet's studio in Neuilly-sur-Seine.
The rug is *Garden* by Jean Lurçat, the paintings are by Francis Picabia
and Joan Miró, and the low table is by Jean-Charles Moreux.

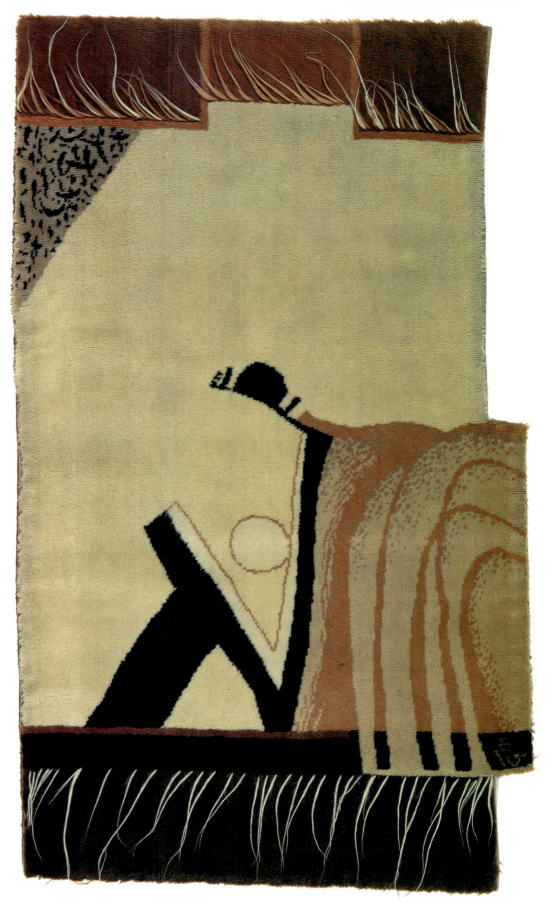

162 Gustave Miklos, 'collage' rug in an irregular format made for the drawing room of Jacques Doucet's home, c. 1925, hand-knotted, wool pile, 144 x 85 cm (56 ¾ x 33 ½ in.). After the death of his wife, Doucet auctioned his collection of 18th-century works of art and began collecting contemporary art. The furniture for his home was commissioned from avant-garde designers.

was a microcosm of French Art Deco: designed by the architect Paul Ruaud, hung with paint-ings by modern masters, and furnished by the best up-and-coming young designers. The rugs in the hall harmonized perfectly with the flat planes of the banister designed by Joseph Csáky (ill. 158). Three more carpets were designed by the sculptor Gustave Miklos for the drawing room (ill. 163); one of these uses the collage principle in such a literal fashion that the cut-out shapes overlap the border, creating an irregular format (ill. 162).

Another architectural landmark, albeit of the kind only the wealthy could afford, was the villa built by Robert Mallet-Stevens for the Vicomte Charles de Noailles in Hyères, com-pleted in 1928. Mallet-Stevens invited his friends Pierre Chareau, Djo-Bourgeois, Gabriel Guévrékian and the De Stijl architects Van Doesburg and Sybold Van Ravesteyn to take part in the interior and garden design. The carpets used in the house, like the façades and the inte-riors, were austere and included a piece by D.I.M., decorated simply with a Greek meander border around a plain field. Other rooms were furnished with rugs by Elise Djo-Bourgeois and Eileen Gray.[33]

CHANGING TIMES, CHANGING TRENDS

Gray and Georges Djo-Bourgeois belonged to a group which in 1929 broke away from the Société des Artistes-Décorateurs to form the U.A.M. (Union des Artistes Modernes). Claiming to reject the elitist principles of the *artistes-décorateurs*, members of the U.A.M. advocated mass production and logical, functional design. Unlike the Société des Artistes-Décorateurs, membership was open to other professions, including industrial designers and town planners. Charter members of the U.A.M. included René Herbst, Francis Jourdain, Robert Mallet-Stevens, Charlotte Perriand, Jean Burkhalter, Jean Lurçat and Eileen Gray. Le Corbusier joined soon after, as did Sonia Delaunay and master weaver Hélène Henry. To commemorate the birth of the U.A.M., Gray created a carpet bearing the group's initials,[34] and Sonia Delaunay published *Tapis et Tissus*, a compilation of works by the international avant-garde.

Along with printed fabrics and wallpaper by the Constructivists Popova and Stepanova, Delaunay's album contained weavings by Bauhaus members Gunta Stölzl, Martha Erps, Anni Albers and Hedwig Jungnickel.[35] The French contingent was represented by Francis Jourdain, Eileen Gray, Evelyn Wyld, Louis Marcoussis, Jean Lurçat and René Herbst in addition to Delaunay herself. In the preface to the album, she theorized that the renaissance in the field of textile and carpet design was the direct result of new developments in modern art. Unrelieved by decoration, the large plain surfaces of modern architecture called for an element of fantasy that paintings, contained within small frames, could no longer provide.[36] The work of these designers reflected the new austerity in textile design, as with the exception of Maurice Dufrène's contribution, floral designs are notably absent.

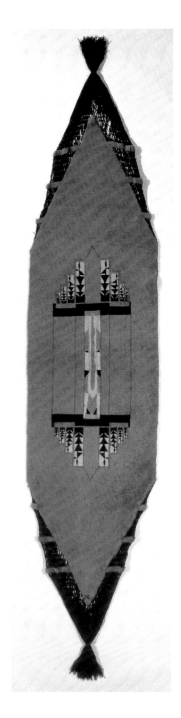

163 Gustave Miklos, carpet made in 1928 from an earlier design, for the drawing room of Doucet's studio, hand-knotted wool pile and metallic thread, 190 x 81 cm (74 ¾ x 31 ⅞ in.). The woven area is hexagonal in shape, with a central medallion of African inspiration. The rectangular format is re-established by the black warps bunched at each end.

Yet the album also reveals a degree of incoherence in the U.A.M.'s stance on mass pro-duction, at least as far as floor coverings were concerned. The printed fabrics and wall-papers contributed by the Constructivists were of course machine-made, but with one possible excep-tion, all the rugs were made by hand. Most of the Modernists, including Sonia Delaunay, Francis Jourdain, Eileen Gray and even Le Corbusier continued to furnish their projects with handwoven carpets. Le Corbusier's stand at the 1925 International Exhibition, the 'Pavillon de l'Esprit Nouveau', was meant to be a model of what prefabricated housing could be and featured mass-produced furniture, but the floor coverings were handwoven Berber rugs. A guiding force in the U.A.M., René Herbst (1891–1982) later invested a lot of time and effort in designing and distributing mass-produced furniture using new materials, but nonetheless continued to furnish his interiors with handmade carpets. Their decorative motifs sometimes echo the curved forms of his tubular metal furniture (ill. 164).

Delaunay's album was one of a series of pattern books of Modernist designs suitable for two-dimensional use published in 1928 and 1929. Along with Georges Valmier and Vladimir Boberman, Maurice Matet (born 1903) also published a compendium which reflected the diversity of contemporary carpet design. Matet was an interior decorator and co-director of the Studium Louvre (the interior design department of the Grands Magasins du Louvre depart-ment store), and his album was devoted solely to carpets by the best French designers.

Few carpets can be attributed with any certainty to the architect and interior decorator Pierre Chareau (1883–1950), who designed the Maison de Verre, an archetypal Modernist

164 René Herbst, furniture and pile carpet, photographed by Thérèse Bonney, *c.* 1929. Herbst's carpet designs reflect the tubular shapes of his furniture.

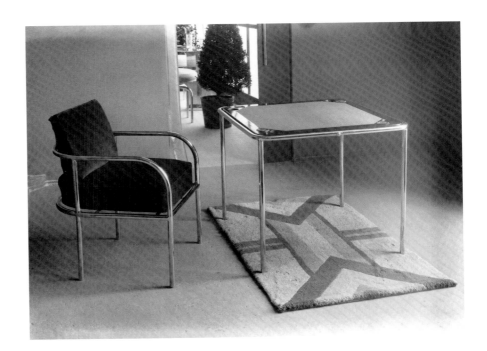

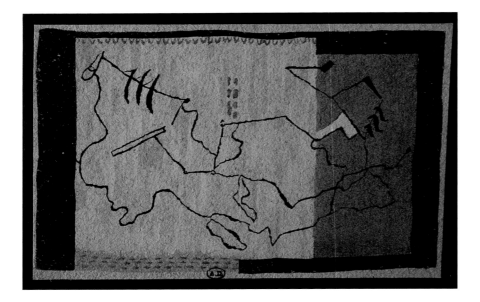

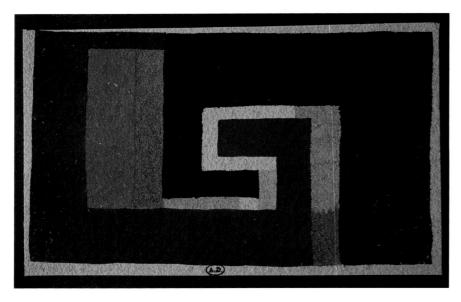

165　Philippe Hosiasson, carpet design for the
　　　Boutique Pierre Chareau, *c*. 1930.

166　Elise Djo-Bourgeois, carpet design, *c*. 1928.
　　　Its rectilinear pattern is strongly influenced by
　　　the Neo-plasticist movement.

Paris townhouse built in collaboration with Dutch architect Bernard Bijvoët. We know from
Thérèse Bonney that Chareau did sometimes design his own rugs, even if she is reticent about
his style.[37] He may be the author of some rainbow-patterned rugs or circular pieces crossed by
a single speckled stripe, such as the one shown on his stand at the 1926 Salon d'Automne,[38]
but the attribution remains uncertain. For his most prestigious commissions, Chareau tended
to call upon designers in his circle, particularly Hélène Henry, Jean Lurçat and Philippe Hosiasson
(ill. 165). The carpets in the Maison de Verre were the work of Lurçat and Burkhalter.

An architect and interior decorator, Jean Burkhalter (1885–1984) had learned tapestry
and weaving techniques from Jules Coudyser, who hired him at the beginning of his career.
Burkhalter's designs are abstract, many with blurred marbled and speckled effects, such as
the carpets in an irregular curvilinear format created for Hélène Bernheim's apartment, designed
by Pierre Chareau in 1927. These contrast with the Cubist carpet he designed for Robert

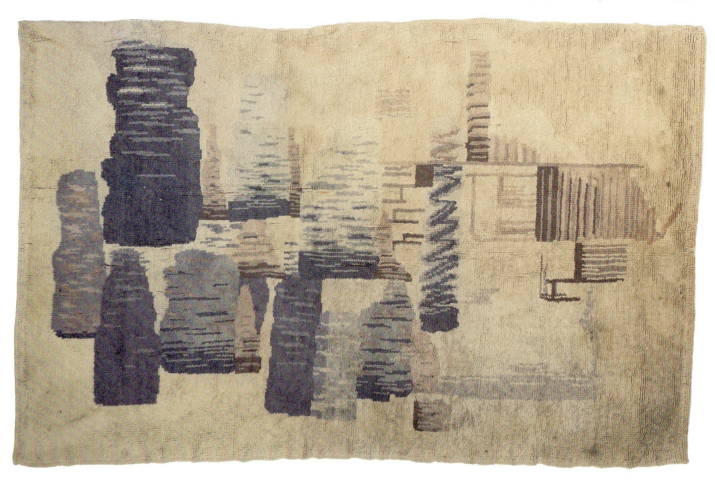

167 Jean Burkhalter, *Les Dalles*, carpet, *c.* 1930,
 hand-knotted, wool pile, 215 x 147 cm
 (84 ⅝ x 57 ⅞ in.). The original watercolour
 design is in the Neue Sammlung, Munich.

Mallet-Stevens's Paris townhouse, presently in the Musée des Arts Décoratifs in Paris,[39] and a range of rugs in loose abstract designs which resemble the strokes of a paintbrush (ill. 167).

A student of Mallet-Stevens, Georges Bourgeois (1898–1937), known professionally as Djo-Bourgeois, was closely involved with the U.A.M. without actually being a member. The architect created airy spacious interiors, using plate glass and tubular metal furniture which was set off by furnishing fabrics and carpets in rectilinear patterns, designed by his wife, Elise Djo-Bourgeois, in their Paris studio (ill. 166). Composed of symmetrically arranged blocks of colour, the rugs displayed a Neo-plasticist rigour, which the Bonney sisters felt revealed 'a pleasing austerity, almost monastic, heightened by colour...'.[40]

The interior designers who endorsed the progressive aesthetic are legion. Eric Bagge, D.I.M. (Joubert and Petit), René Prou, Renée Kinsbourg, Francis Jourdain (ill. 169) and Eugène Printz ran their own studios. Others either directed or worked for design departments run by the department stores. Jacques Adnet joined the Compagnie des Arts Français; Solange Patry-Bié and Max Vibert were associated with the Studium Louvre, Eric Bagge with Mercier Frères' Palais de Marbre. Designers specializing in functional textiles included Vladimir Boberman, and Evelyn Wyld and Hélène Henry, both of whom ran their own workshops. Fernand Windels (ill. 168) worked as a designer for the Manufacture Française de Tapis et de Couvertures before setting up his own firm in Bourganeuf (Creuse). He sold his own designs and wove works by other Modernist designers including Jean Goulden (1878–1946) (ill. 170).

168 (left) Fernand Windels, carpet, 1928, wool pile,
 170.2 x 256.5 cm (67 x 101 in.), monogrammed.

169 (above) Francis Jourdain, carpet design, c. 1928.

170 (below left) Jean Goulden, textured carpet,
 c. 1930, wool pile, 250 x 170 cm (98 ⅜ x
 66 ⅞ in.). Made by the Industrie du Tapis,
 Bourganeuf (Creuse), and bearing the
 monograms of the designer and manufacturer.

The fate of the Compagnie des Arts Français was symbolic of the changing spirit of the times. Faced with bankruptcy, Süe and Mare had been bought out by the Galeries Lafayette and replaced by a protégé of Dufrène, Jacques Adnet (1900–84), in 1928. The young designer completely overhauled the Compagnie des Arts Français, embracing progressive design and introducing a streamlined Modernist look.[41] The C.A.F. marketed carpets by Adnet (ill. 171) and his twin brother Jean, as well as designs by Lurçat, Kinoshita, Francis Jourdain and the ceramicist Marianne Clouzot, and a more conservative range of floral patterns by Dufrène, Guiguichon and Paul Pouchol. The Adnet brothers' designs were either strictly geometric, like the carpet decorated with a regular pattern of interlocking triangles and rectangles in the Neue Sammlung in Munich, or reflected the Neo-plasticist aesthetic.

An interior architect who designed many stands at the 1925 International Exhibition, Eric Bagge (1890–1978) was director of the Palais de Marbre, a furniture shop on the Champs Elysées. Bagge also created ranges of silks and other metered fabrics, carpeting and hand-woven rugs for various manufacturers (ill. 172). His mature style consists of abstract patterns

171 Jacques Adnet, circular rug in a Modernist design, *c.* 1930, hand-knotted, wool pile, diameter 220 cm (86 ⅝ in.), monogrammed.

172 Eric Bagge (attr.), carpet, *c.* 1930, hand-knotted,
wool pile, 300 x 205 cm (118 ⅛ x 80 ¾ in.).

made up of symmetrically arranged blocks of colour, concentric quarter- and half-circles, in patterns reminiscent of Robert Delaunay's paintings. Bagge also liked to experiment with materials and invented a technique for obtaining nuances in the shading of his fabrics and carpets by spraying the design onto the material with a vaporizer.[42]

The interior decorator Renée Kinsbourg (ill. 173) described herself as a 'Modernist'[43] and several of her designs do in fact fit this label. The Bonney sisters aptly summed up her work as a peculiar combination of the modern built on the old.[44] While some of her carpets are close to floral Art Deco, others are vaguely figurative, treated in the manner of an abstract painting. They all share a free, loosely drawn treatment of the motifs with visible 'brushstrokes', a feature which recalls Burkhalter's work. Kinsbourg even liked to include her paintbrushes in the design; they are often tucked away in a corner.

Ivan Da Silva Bruhns was among several designers who enjoyed a flirtation with Cubism. The dense overall patterning of his earlier carpets gave way to larger-scale motifs,

173 Renée Kinsbourg, carpet, *c.* 1925–30,
hand-knotted, wool pile, 295 x 195 cm
(116 ⅛ x 76 ¾ in.).

174 Ivan Da Silva Bruhns, carpet in a Cubist design woven for the palace of the Maharaja of Indore, 1933, hand-knotted, wool pile, 345 x 250 cm (135 $\frac{7}{8}$ x 98 $\frac{3}{8}$ in.). The proportions of the woven rug differ slightly from the design, signed by Da Silva Bruhns and dated 1931, formerly in the Maharaja's collection.

175 Eckhart Muthesius, foyer of the Palace of the Maharaja of Indore, 1933. The portrait of the Maharaja is by Bernard Boutet de Monvel, the carpets by Ivan Da Silva Bruhns.

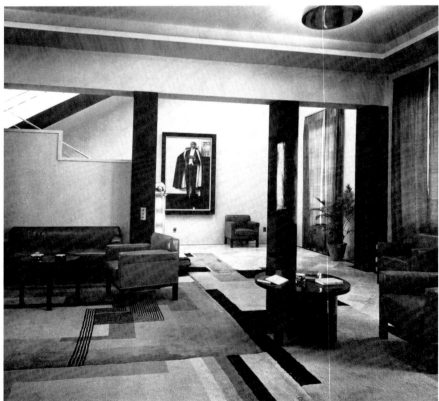

massed or overlaid in the Synthetic Cubist fashion, and asymmetrical compositions, often without borders. Sometimes the cut-outs themselves were patterned, or overlaid with spots, zig-zags or other shapes. A series of carpets designed in 1931 for the Maharaja of Indore's palace, built to the north of Bombay by Eckhart Muthesius, are typical of this Cubist period (ills 174, 175).

In around 1927, Evelyn Wyld and Eileen Gray separated, and Wyld formed a new partnership with Elisabeth de Lanux, known professionally as Eyre de Lanux, an American journalist with a flair for decorating. After their separation, Gray moved her share of the looms into the basement of the Galerie Jean Désert, while Wyld retained the rue Visconti premises. Wyld had by this time begun designing her own pieces, and became the workshop's chief designer. Two were woven from photographs by Man Ray, whom Eyre de Lanux knew socially.[45] In neutral tones, Wyld's uncomplicated abstract or stylized figurative patterns served as an unobtrusive backdrop to the new streamlined interior. Even so, she continued to exploit Gray's work, much to the discomfiture of the latter.[46] Wyld's carpets were particularly favoured by the decorator Eugène Printz (1889–1948), who used them on his stands at the annual salons and also in interiors he designed for the Princesse de Wagram[47] and the Chateau de Grosbois, home of the Princesse de la Tour d'Auvergne.[48]

In the interim, Gray had embarked on a new career as an architect and in 1929 had built a villa named 'E1027' at Roquebrune on the Mediterranean, now considered an archetype of Modernist architecture. As no self-respecting architect at the time would believe that it

176 Eileen Gray, Jean Badovici, living room of E1027, a villa built at Roquebrune, France, 1929. On the left, the rug *Centimetre*. The Metropolitan Museum, New York, owns the design of the rug on the right, a collage in linen pasted on cardboard.

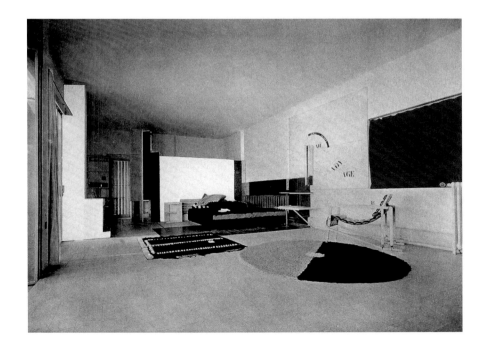

177 Eileen Gray, design for *Centimetre,* first woven
 in pile for the living room of E1027, 1926–29,
 gouache on paper, 17.8 x 15.5 cm (6 ⅛ x 7 in.).
 The design was reissued in the tufted technique
 by Ecart International in 1980.

was the work of a woman, it was initially deemed to be the work of the architect Jean Badovici
or Le Corbusier. As Gray's work took on a significant architectural dimension, so did her rug
designs, which were conceived in terms of constructive elements. She created a considerable
number for the house (ill. 176).[49] The living room boasted a circular carpet executed from a
collage of cut and pasted linen and cardboard, now in the Metropolitan Museum in New York.
A second rug named *Centimetre*, decorated with three rows of ruler measurements, reflects
her passion for her new-found profession (ill. 177).[50] In shades of blue, black and white, *Marine
d'Abord*, laid on the terrace, reflected the nautical style of the house, befitting its location. Both
Centimetre and *Marine d'Abord* bore the figure ten, representing the initial of her friend Jean
Badovici.[51] The curving lines of a fourth design, now in the Victoria and Albert Museum, echo
the quarter-circle symbolizing barometric pressure drawn on the marine map hung on the
living room wall; the same design was also woven for the guest room in shades of blue, white
and grey. In the 1929 issue of *L'Architecture Vivante* devoted to the house, Badovici com-
mented that 'like the carpets, the house evokes far-off shores, and gives rise to reverie'. Gray
is reported to have noted, somewhat tartly, on her own copy of the magazine that the colours
chosen for reproduction bore no relation to reality.[52]

CARPETS BY MODERN MASTERS

The Maison Myrbor was the first gallery to specialize in limited editions of carpets woven from works by the great masters of 20th-century painting, including Picasso, Léger, Miró, Calder, Klee and Ernst. The driving force behind Myrbor was Marie Cuttoli (1879–1973), née Bordes, patron and friend of a bevy of avant-garde artists. Many of the works formerly in her collection have since been donated to the Musée d'Art Moderne de la Ville de Paris. Although Cuttoli is known primarily for her role in reviving the moribund Aubusson tapestry industry during the thirties, her interests originally lay in revitalizing the carpet production of her native Algeria. In 1920, she installed two looms in her home in Algiers, hired four local weavers and soon afterwards established a workshop in Sétif. Married to a French senator, Cuttoli divided her time between Paris and Algiers, which motivated her to gauge her workshop's production to modern French taste.

Determined to re-educate her weavers, whose repertoire ran the gamut of kitschy images of camels in garish colour schemes, Cuttoli asked them to weave a carpet in plain white wool, entirely devoid of any decoration. Faced with a delegation of angry mothers, outraged by this insult to their daughters' talents, Cuttoli calmed them by having them weave rugs from designs by the then-unknown Jean Lurçat.[53] One was a plain design with green and yellow markings, acquired by the Japanese ambassador; the other was *Garden*, bought by Doucet after he saw it displayed on the Myrbor stand at the 1925 International Exhibition.

178 André Lurçat, advertising poster designed for the opening of the Maison Myrbor, 9 December 1926.

179 Interior of the Maison Myrbor, rue Vignon, Paris, designed by André Lurçat. The gallery was the first to weave rugs in limited editions from works by modern masters. On display are rugs woven from works by Jean Lurçat, Louis Marcoussis and Pablo Picasso.

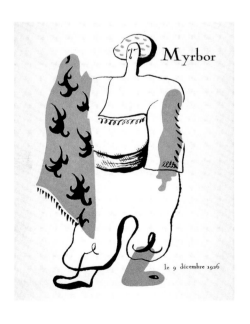

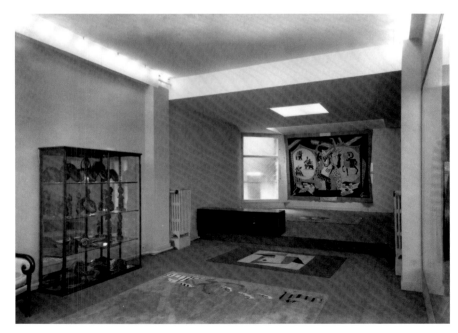

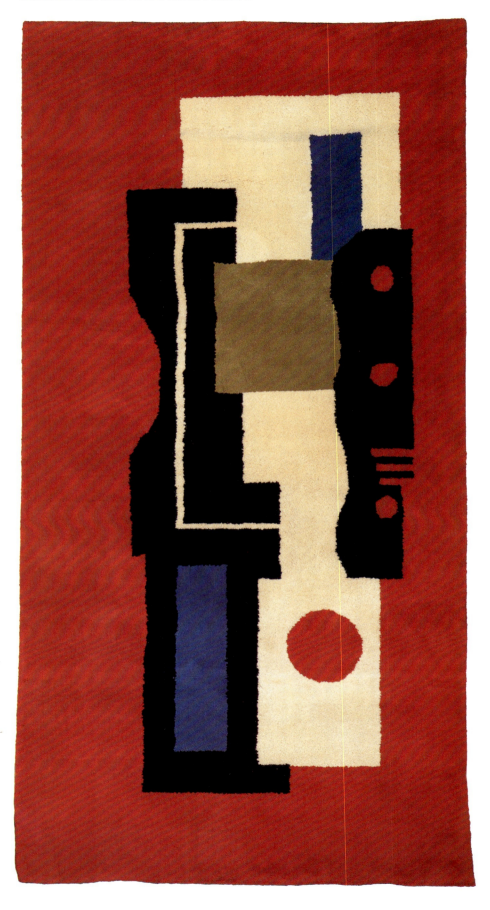

180 Fernand Léger, *Red*, carpet woven by the Maison Myrbor, *c.* 1927, hand-knotted wool pile, 230 x 115 cm (90 ½ x 45 ¼ in.). Léger produced several different collage designs for the gallery, devised according to the principles of Purism. Resembling collages, their names were determined by the colour of the grounds: *White*, *Yellow 1* (also known as *Yellow 9*), *Green*, and so forth. Thus the same design was issued as *Yellow 2* and *Brown*.

181 Robert Mallet-Stevens, interior of the architect's
home on the rue Mallet-Stevens, Paris.
The fabrics are by Hélène Henry, and the
carpet by Fernand Léger.

182 Donald Deskey, hall of Helena Rubinstein's
apartment, New York, c. 1935, furnished with
two carpets made by the Maison Myrbor.
Lurçat's *Garden*, in the foreground, was also
acquired by Jacques Doucet; in the rear is the
first of many carpets by Picasso made by the
Maison Myrbor.

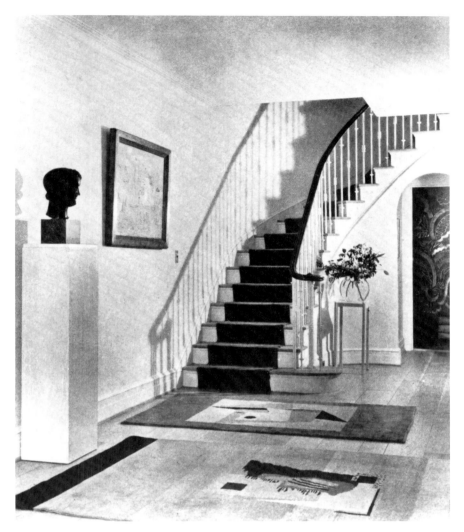

Encouraged by this success, Cuttoli opened the Maison Myrbor, a gallery on the rue
Vignon near the Champs Elysées, with showrooms designed by André Lurçat, Jean's younger
brother (ills 178, 179). As well as rugs and paintings, Myrbor sold fashions, supplied many
haute-couture houses with embroideries, and ran an interior decoration department. At the
inaugural exhibition held in December 1926, Cuttoli displayed her art collection alongside rugs
designed by Jean Lurçat, Louis Marcoussis (1883–1941) and Fernand Léger (1881–1955)
(ills 180, 181). The first in a series of carpets by Picasso, taken from a still life (formerly in the
Paul Rosenberg collection), was issued by the Maison Myrbor in around 1928 (ill. 12).[54] Helena
Rubinstein acquired one for her New York apartment, decorated by Donald Deskey, where it
lay in the hall next to an example of Lurçat's *Garden* (ill. 182). Cuttoli subsequently persuaded
Jean Arp, Giorgio de Chirico, Raoul Dufy, Max Ernst, Jean-François Laglenne (1899–1962),
Joseph Csáky and Joan Miró to design rugs for her. Rugs by Paul Klee (ill. 7) and André Derain
were added to the catalogue, probably during the thirties. An advertisement published in the
first issue of *Cahiers d'Art* in 1929 states that the designs were a registered trademark.

The rug collection of the Maison Myrbor was warmly praised by Thérèse Bonney in her
Shopping Guide to Paris: 'The artists, all painters, have given them the painting quality. They

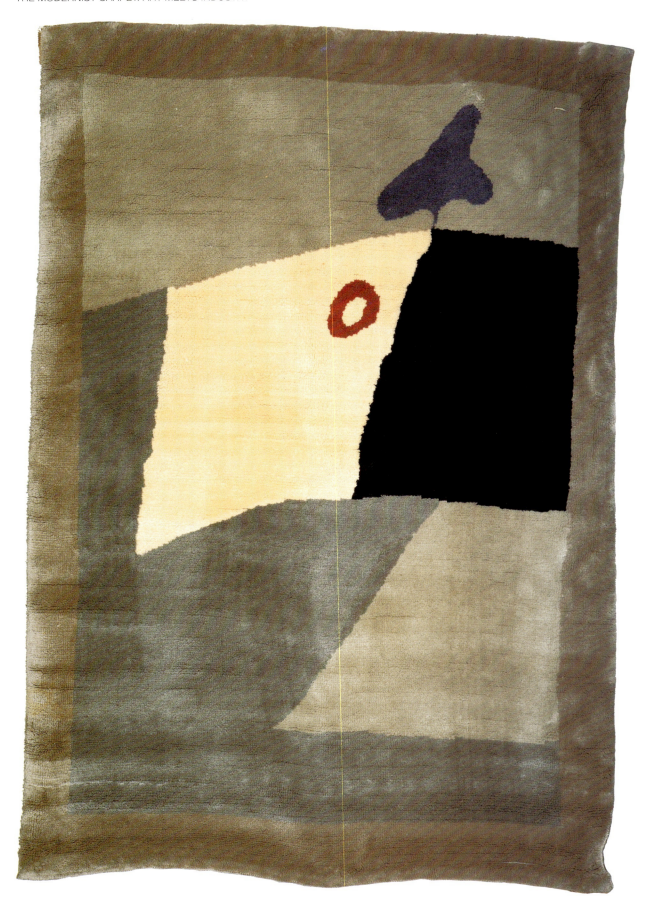

183 (opposite) Jean Arp, *Red Circle*, carpet woven in the workshops of the Maison Myrbor in Sétif, Algeria, *c*. 1930, wool pile, 200 x 155 cm (75 ¾ x 61 in.).

184 (right) Joan Miró, *Spanish Dancer*, carpet designed *c*. 1930 for the Maison Myrbor, reissued in the 1980s. Wool pile, 200 x 155 cm (75 ¾ x 61 in.).

are personality rugs, dominating most interiors, and properly used are a great asset to a modern room.' Yet her praise was not unreserved: 'The colours are from the palettes of the modernist, not always acceptable to the average American taste. Much chartreuse green, flame, brilliant blue, purple, yellow...'.[55] The pictorial quality of the rugs, Bonney noted, meant that they could equally well serve as wall-hangings. These words must have sounded like music to Cuttoli's ears, since the collector was determined to abolish the distinctions between the art of fine tapestry and the knotted-pile carpet, an aim she vigorously promoted in the catalogue for one of her gallery's many exhibitions.[56] Persuading so many of the great modern masters to design rugs for her was deemed by Bonney to be Cuttoli's most original contribution to the Modern movement.[57]

A former Dadaist, Jean Arp (1886–1966) incorporated everyday objects such as shirt fronts or ties into his paintings. Two early acquisitions, entitled *Red Circle* and *Ace of Spades*, were produced by Myrbor, one of which was acquired by the Neue Sammlung museum in Munich in 1930 (ill. 183).[58] Three more were added to the catalogue during the thirties; they echo the curved vaguely organic shapes of his sculptures (ill. 3). Arp's undulating biomorphic shapes influenced the work of his fellow Surrealists Miró (ill. 184) and Calder and ultimately had great impact on the movement known as Organic or Biomorphic Modernism.[59]

As a follower of the industrial aesthetic, Fernand Léger believed that decoration should be an extension of its architectural framework and his rug designs closely parallel the murals

and mosaics he created during the twenties. Robert Mallet-Stevens acquired *White* for his Paris home in 1927,[60] while *Yellow 1* was displayed on Pierre Barbe's stand at the 1928 Salon des Artistes-Décorateurs.

Like many former Cubists, Henri Laurens (1885–1954) returned to a form of figurative art after a period of total abstraction. In 1932 he began to create the bronze sculptures of supine female forms which made his reputation. A series of rugs decorated with nudes issued by Myrbor show the rosy brown and ivory shades of the red chalk technique he used in his drawing. They were given similarly seductive names: *Nymphe*, *Femme*, *Odalisque* (ill. 185). Four were displayed on the gallery's stand at the 1939 San Francisco exhibition. After the Second World War, Cuttoli formed a partnership with Lucie Weill, and several more works by Picasso were added to the catalogue, along with rugs by Alexander Calder, André Derain, Roger Bissière, Jean Cocteau, Maria Elena Vieira Da Silva and Ben Nicholson.

185　Interior designed by Pierre Chareau, 1938, with a tapestry by Joan Miró and *Odalisque*, a carpet by Henri Laurens.

THE AESTHETICS OF TEXTURE

The increasing importance of technology was tangibly reflected in carpet design, as textured effects began to take precedence over colour or pattern. Reflecting contemporary research into architecture, effects aimed at creating surface and volume became a feature of rug design from this time onwards. This was attained through contrasts of light and shadow, by using different yarn thicknesses and lengths, as well as shaggy, looped or bevelled pile. Marguerite de La Tour Périgot, Eugène Printz, Louis Sognot, Charlotte Alix and René Prou were among the designers who experimented with texture as a means of expression. The most innovative pieces were those created by Eileen Gray, Evelyn Wyld, Hélène Henry and Germaine Montereau. By the mid-thirties, manufacturers had responded to demand by marketing lines of textured carpets and carpeting, ranging from shag rugs and half-pile carpets to floor coverings in composite techniques.

The focus on experimental research into dyes and fibres at the Bauhaus and the technically innovative work shown by Scandinavian weavers at the 1925 International Exhibition were of primary importance in this shift in direction. Interest in Scandinavian weaving was further spurred by a show devoted to carpets of the northern hemisphere, held at the Musée des Arts Décoratifs, Paris, in 1927 and by the decorative and industrial arts exhibition held in Stockholm in 1930. Noting that the mechanization of production methods had not killed off inspiration, the author of an article on the Stockholm exhibition congratulated the designers of the models on display, describing them as the most beautiful of modern carpets.[61]

Eileen Gray and Evelyn Wyld were probably the first to experiment with natural undyed wools, uneven pile lengths and juxtaposed plied and unplied yarns in the pile. This was undoubtedly due to the influence of their trip to Morocco, home of Berber carpets and the half-pile 'Hambil' rugs made in Salé and Rabat. Gray was among the pioneers in adapting the collage technique to textile form by varying the lengths of the pile.[62] A pile rug designed by Jean Dunand in 1927 for the apartment of the couturier Madame Agnès may have been woven in Wyld's atelier, as she is known to have woven other pieces for the lacquer artist.[63] A Cubist design, the nuances in the shading were achieved by juxtaposing areas of straight ivory and twisted natural brown yarn with shades of brownish-orange and light rust.

Wyld explored the idea of rugs in 'natural' fibres to match the 'textured' furniture in natural woods and materials such as pony-skin, cow-hide, and leather designed by her new partner, Eyre de Lanux. De Lanux designed a few carpets herself, but most were the work of Wyld. The idea of natural materials was not new: Gray had been experimenting with natural wood in her furniture for some years prior to this, and as previously indicated, her carpet designs had been executed in natural undyed yarns in the Visconti atelier since shortly after

186 Hélène Henry, textured carpet with mixed straight and bouclé yarns in monochrome wool, made in her Paris workshop, *c.* 1930, 500 x 600 cm (197 x 236 in.), signed.

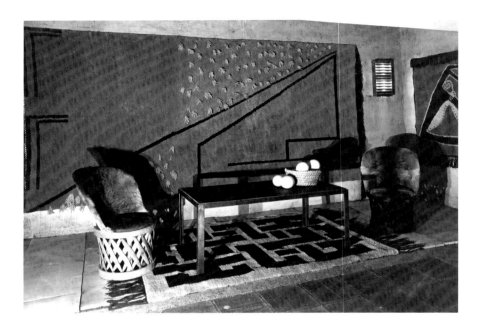

the war. Wyld expanded on the idea by varying the lengths of the pile, and adding decorative tufts and fringes. In one, entitled *Storm*, shown on her stand at the 1929 Salon des Artistes-Décorateurs, the driving rain was represented by extra long tufts of white wool standing out in relief on a sand-coloured ground traversed by brown lines (ills 187, 188). Another piece shown at the Salon d'Automne a few months later was entirely monochrome, the design based solely on the effects of light and shadow achieved with the half-pile technique.[64] The rugs stirred considerable international interest in Britain and America.[65]

Two other master weavers, Hélène Henry and Germaine Montereau (1892–1959) could also stake a claim to be the first to weave half-pile carpets in one shade of yarn, although it is difficult to pinpoint a precise date at which they began doing so. Having launched their own workshops in the early twenties, both were recognized for their innovative textured fabrics and rugs and their research into the possibilities afforded by new fibres. Half-pile or voided-pile rugs were effectively a novelty, but the technique itself is an ancient one, used in the manufacture of Genoese velvets as well as Scandinavian folk weavings.

Eileen Gray proved herself to be particularly inventive in this field. A carpet recalling a collage by De Stijl architect Vordemberge-Gildewart [66] was interpreted texturally, the circular 'collage' knotted in twisted yarn so as to stand out from the tapestry technique used in the rest of the carpet. The design was available in shades of blue and white or pale yellow. Another rug, a runner in an abstract design made by the Maison Myrbor, was woven in an unusual combination of knotted wool and weft-attached looped sisal pile in the chenille technique (ill. 189). The carpet was woven in 1927 or earlier and formed part of the furnishings for the E1027 villa.[67]

187 Evelyn Wyld and Eyre de Lanux, stand at the
 Salon des Artistes-Décorateurs, Paris, 1929.
 The carpets on display are *Romana* (on the floor),
 Storm (on the wall behind) and *Antennae*
 (on wall to right).

188 Evelyn Wyld, design for *Storm*, 1929. The carpet
 was made in wool pile with tufts of varying
 lengths standing out in relief to represent rain.

189 Eileen Gray, runner in hand-knotted wool
 and sisal pile in the chenille technique,
 c. 1927, 90 x 289 cm (35 ³⁄₈ x 113 ³⁄₄ in.).
 Made for the E1027 villa.

190 Eugène Printz, wool pile carpet
 in a bevelled design made by the
 Tapis de Cogolin, *c.* 1930–35,
 365 x 215 cm (143 ³⁄₄ x 84 ¹⁄₄ in.),
 monogrammed.

Like her architecture, Gray's carpet designs were uncompromisingly original, but she worked in isolation and her commissions were few. Hélène Henry (1891–1965), on the other hand, had a natural gift for cooperating with her fellow designers and her fabrics and carpets often formed an unobtrusive backdrop for Modernist interiors. Henry, who claimed to be one of the first weavers to experiment with rayon fibres,[68] opened a weaving workshop in Paris at the beginning of the twenties. In 1923 she showed samples of her table linen to Francis Jourdain, who, struck by the parallel between the simplified purity of her designs and his own, introduced her to his Modernist friends. Henry formed professional relationships and friendships with René Herbst, Pierre Chareau, Robert Mallet-Stevens and Louis Sognot and also joined the U.A.M. Henry's pile carpets were made in traditional woollen yarn on a cotton foundation, but as with her fabrics, she attempted to achieve maximum effect through weave and materials rather than patterning. She used very few colours, rarely more than two or three at a time, and frequently only one. By combining cut and twisted pile, she achieved slight nuances in shade, an illusion created by the degree of absorption of light (ill. 186).

Montereau, who ran her own weaving studio at Beaugency in the Loire Valley, wove half-pile, looped or mixed-technique rugs, and likewise restricted her colour schemes to shades of white, grey, brown and black. Louis Sognot and Charlotte Alix, whose speciality was rugs with widely spaced rows of shaggy pile, used both of these workshops. A Corsica-based designer, Marguerite de La Tour Périgot, sought to highlight the dark tones of the wools by interspersing areas of pile with made-to-order aluminium threads that would catch the light.

Eugène Printz (1889–1948) originally furnished his decorative schemes with rugs by other designers, but from 1930 he began creating his own. Like Wyld and Henry, he preferred

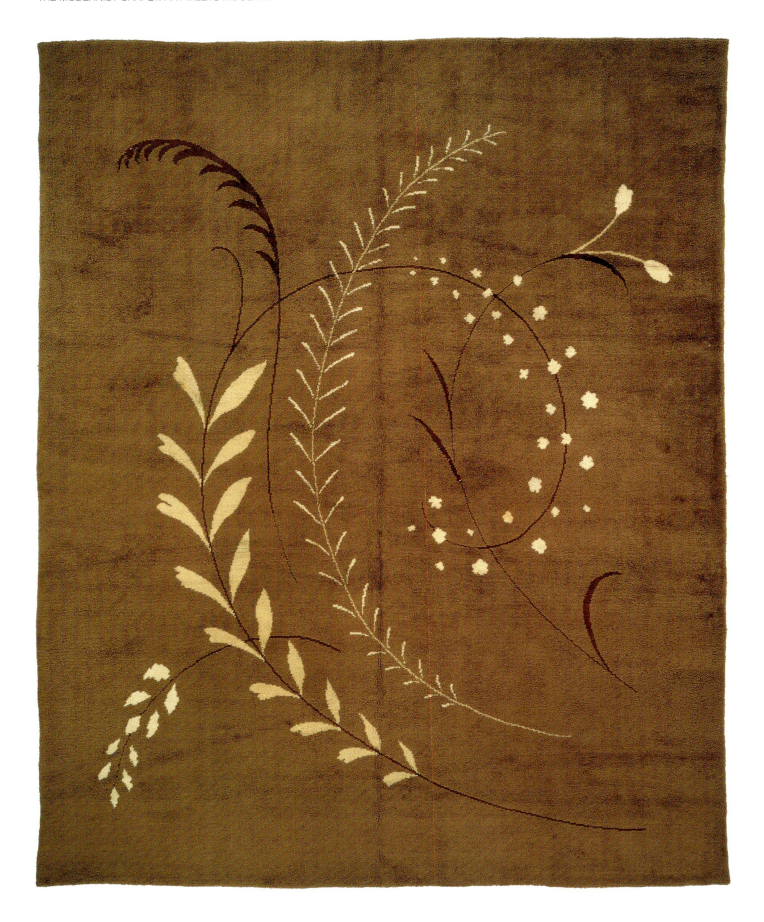

modest geometric patterns in monochrome or bicoloured yarns. A textured effect was achieved through subtle bevelling of the pile, a technique at which the manufacturer, the Ets. Maurice Lauer, Cogolin, excelled (ill. 190). Several were displayed in the drawing room of the pavilion of the Société des Artistes-Décorateurs at the 1937 International Exhibition.

A BAS LE STYLE CLINIQUE

The Modernist carpet with its limited range of decorative motifs and colour schemes mirrors the evolution in public taste during the thirties. This could be construed as a reaction against the exuberant designs and colour schemes of the previous decade but may also have been part of the trend towards functionalist interiors. Increasing public acceptance of the new stark interiors with mass-produced furniture, set off by plain carpeting requiring little or no artistic input, resulted in high unemployment in the textile trade, which was exacerbated by the recession.

Threatened by the spectre of a diminishing clientele, the artistes-décorateurs fought back. Paul Iribe initiated a campaign against the style clinique in the French press, and spoke out in defence of traditional French craftmanship as opposed to mass production. He was joined by the critic Waldemar-George, an eloquent spokesman who tirelessly called for a 'return to order', and by Louis Süe, who spoke out vehemently against the 'machine for living'.[69] Few members of the younger generation espoused their cause, however, one of the rare exceptions being the designer André Arbus (1903–69), who objected to 'fashionable homes which resemble operating theatres, cabin cruisers or model prisons'.[70]

The protagonists squared off into two opposing camps and articles debating the pros and cons of decoration and craftmanship versus mass production grew ever more prevalent in the press. Typical among these was a debate entitled 'Evolution or death of ornament?', in which Waldemar-George and his followers held aloft the traditionalist banner in a face-off with the Modernists whose spokesman was Amédée Ozenfant.[71] In a nutshell, the artistes-décorateurs claimed that a wealthy elite is unavoidable, whether a nation is ruled by a monarch or governed by the state. The privileged few set standards for the rest of society and the luxury items created for them function as prototypes for mass production. To deprive the French economy of its skilled craftsmen, who relied on the luxury goods trade, would, they claimed, result in massive unemployment and serve nobody.

From an aesthetic point of view, the designer carpet of the thirties is the total antithesis of those of a few years previously. The pendulum swings wildly from patterns featuring an austere range of linear motifs, often sparsely scattered on a plain field, to deliberate incursions into the neo-Baroque or combinations of the two.

A graphic linear style of drawing first manifested itself at the 1925 Exhibition in the carpets of Georges Chevalier and Léon Voguet.[72] Within the space of a few years, the style had

191 Maurice Dufrène (attr.), carpet with a sprig motif, c. 1935, wool pile, 387 x 309 cm (152 ⅜ x 121 ⅝ in.).

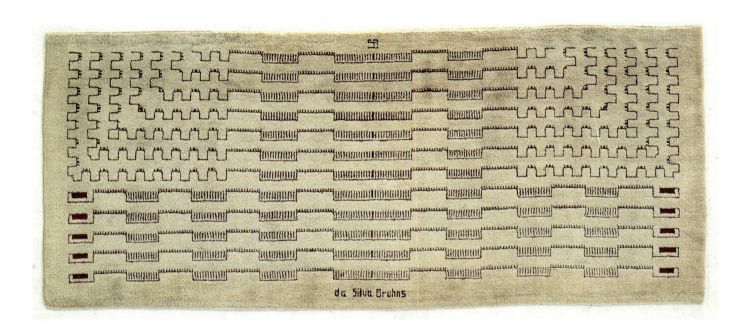

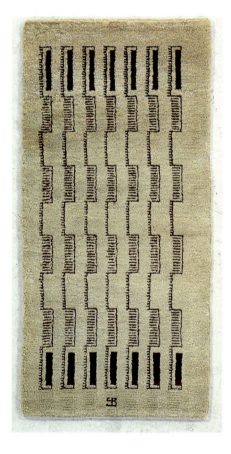

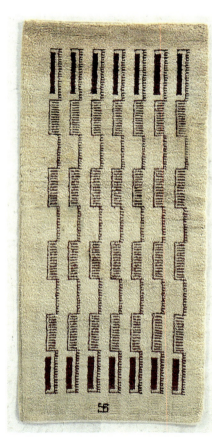

192–4 Ivan Da Silva Bruhns, set of three carpets with linear designs, *c.* 1935, wool pile, monogrammed, (smaller two) 185 x 84 cm (72 ⅞ x 33 ⅛ in.), (larger one) 320 x 135 cm (126 x 53 ⅛ in.). Made in the Manufacture de Savigny, Savigny-sur-Orge.

evolved towards a minimalist grouping of motifs often reduced to their simplest form – a few undulating lines, repeating concentric circles, crosshatching or sprig-like motifs – picked out in sombre colour schemes on large expanses of bare field; Maurice Dufrène's carpets of the thirties are typical examples (ill. 191). Alfred Porteneuve (1896–1949), Ruhlmann's nephew, who inherited the studio after the designer's death in 1933, Paul Follot, Pierre-Paul Montagnac, Paule Leleu (1906–87) and Da Silva Bruhns were among the many designers who employed such decorative devices during the thirties. The Brazilian designer used either a few repeating straight or undulating lines or one or two Aztec motifs, sparingly arranged on plain grounds in neutral or pastel shades (ills 192–194). Max Vibert's rug designs for the Studium Louvre were mostly abstract compositions, occasionally overlaid with areas of crosshatching, honeycomb patterning or naively drawn figures which she called 'Haï-Kaï' (ill. 195).

At the other end of the design spectrum, the reaction against the austerity of Modernism led predictably to a resurgence in the vocabulary of classical antiquity and the Baroque. This was subtly interpreted by Arbus and Süe, who borrowed the tried and true repertoire of antique motifs, from the lyre, the scallop shell and the Greek key pattern to Cupid's bow and arrows (ill. 196). An imposing piece decorated with palm fronds and scallop shells, created by Süe for the stand of the Mobilier National at the 1937 International Exhibition, was woven in the Savonnerie workshop (ill. 197). André Groult's ornate treatment of the theme of sea monsters in *The Sea*, a carpet commissioned by the Mobilier National for the Ministère de la Marine,

195 Max Vibert, carpet designed for the Studium Louvre, *c*. 1930. The carpet was shown in the office presented by the Studium Louvre at the Colonial Exhibition held in Paris in 1931.

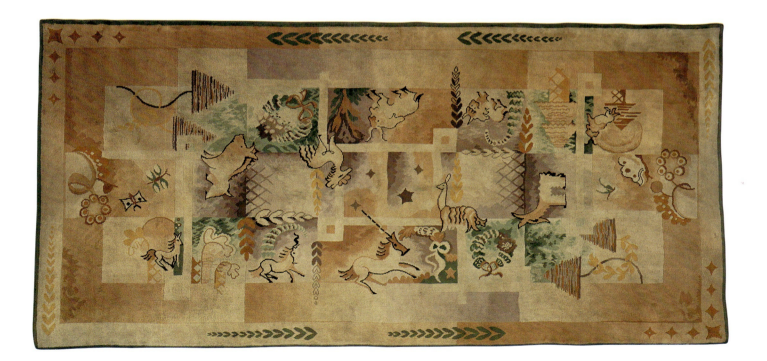

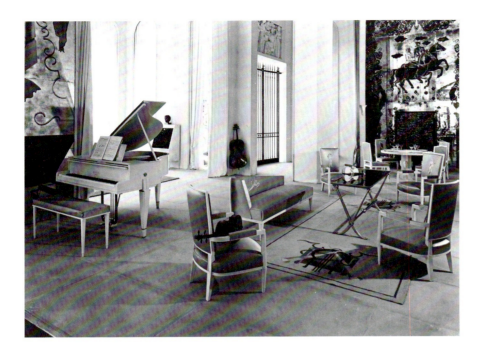

196 Music room in the 'Demeure en Ile-de-France'
 designed by André Arbus (1903–69) for the
 pavilion of the Société des Artistes-Décorateurs
 at the International Exhibition held in Paris, 1937.
 Carpet decorated with lyre motifs by André
 Arbus, made by Hamot of Aubusson. Engraved
 mirrors by Paule and Max Ingrand. Arbus was
 among the younger generation of interior
 decorators who sought to revive classicism
 in the 1930s.

197 Louis Süe, carpet design made in the Savonnerie
 workshops, displayed on the stand of the
 Mobilier National at the 1937 International
 Exhibition.

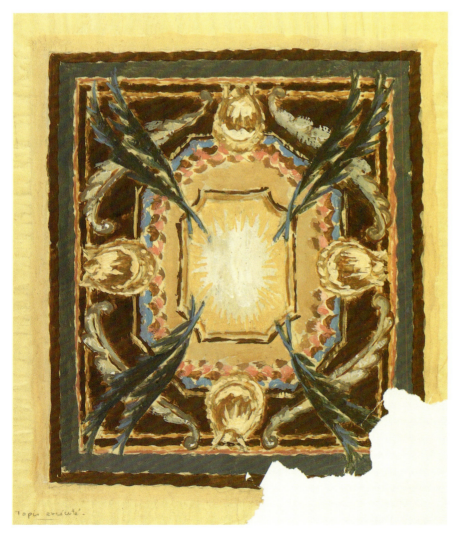

(opposite)

198 Henri Gonse, *Spanish Carpet*, woven by the
 Manufacture de Tapis, Cogolin, *c.* 1935–40,
 tufted wool, *moquette* technique, 665 x 325 cm
 (245½ x 132 in.). Gonse designed carpets
 based on the layout of French classical gardens
 for the manufacturer during the 1930s.

199 André Groult, *La Mer (The Sea)* or *L'Eau (Water)*,
 1942. This pile carpet was designed for the
 Mobilier National, and made by the Manufacture
 Nationale de la Savonnerie for the Ministère
 de la Marine.

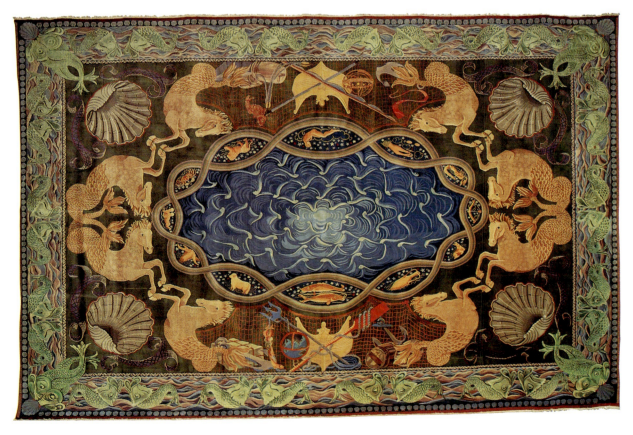

200 Jean Hugo, carpet embroidered by Frosca
 Munster, Maria de Gramont, François Hugo,
 Jean Bourgoin and Boris Kochno, 1934,
 245 x 198 cm (96 ½ x 78 in.).

201 Dominique, carpet design with neo-Directoire
 motifs, c. 1935, gouache.

202 André Arbus, carpet with architectural motifs,
 made for the office of the director of a French
 steelworks, Paris, 1940, hand-knotted, wool
 pile, 500 x 350 cm (196 ⅞ x 137 ¾ in.).

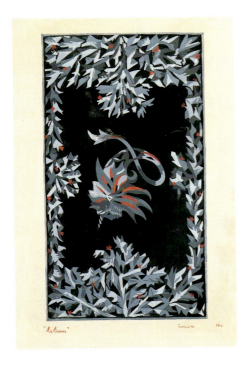

203 Lucien Coutaud, *Unicorn*, flatweave carpet
woven by the Atelier Pinton, Aubusson, 1942,
250 x 140 cm (98 ³/₈ x 55 ¹/₈ in.).

204 Paule Leleu, carpet, *c.* 1936, hand-knotted,
wool pile, 450 x 270 cm (177 ¹/₈ x 106 ¹/₄ in.),
signed. Leleu designed the fabrics and carpets
for her family's interior decoration firm from
1936 onwards.

recalls the florid grandiloquence of its 17th-century forbears (ill. 199).[73] Da Silva Bruhns and
Ernest Boiceau also occasionally used this decorative style. Paul Follot and René Prou revived
the theme of the signs of the zodiac, while centaurs and mythical Greek figures bound over
an embroidered carpet created by the painter Jean Hugo (1894–1984) (ill. 200). Dominique
used the vocabulary of the Directoire period (ill. 201) and Emilio Terry (1890–1969) that of the
Savonnerie and Aubusson carpet.

Decorative artists such as Arbus and Süe also borrowed the detailing of Baroque
architecture, such as ova, niches, pronounced mouldings and caisson arrangements, albeit
in a simplified form (ill. 202). Arbus created a handsome rug with *trompe-l'oeil* architectural
motifs for the presidential apartments in the Château de Rambouillet, while Henri Gonse
created a line of carpets for the Manufacture de Tapis, Cogolin, based on the layout of formal
gardens (ill. 198). Lucien Coutaud (1904–77) (ill. 203), Paule Leleu (1906–87) (ill. 204) and Paule
Marrot (1902–87) perpetuated the floral tradition by making use of vegetal motifs, and Emile
Gaudissart's creation for the first-class lounge on the liner *Normandie* features an elaborate
central spray of floral cornucopias, surrounded by large expanses of plain field (ills 205, 206).[74]

Some of the most beautiful carpets of the period are those designed and made in the
workshop of Ernest Boiceau (1881–1950), using the Cornély stitch: their fine quality meant
that they could also serve as wall-hangings. A versatile Swiss designer, Boiceau created rugs
that ranged from geographic maps to plans of buildings to abstract designs, in addition to a
large number of medallion, animal and floral designs (ill. 207). A carpet in the Yves Saint
Laurent collection is a typical example, with a central medallion containing a pattern of flying
parrots in repeat, set off by pairs of parrots placed in each corner. The lifelike depiction of the
bird motifs is quite an achievement, given the limitations of the technique.

Even so, overall production diminished considerably compared with the previous
decade. The important state and private commissions which had formerly supplied the

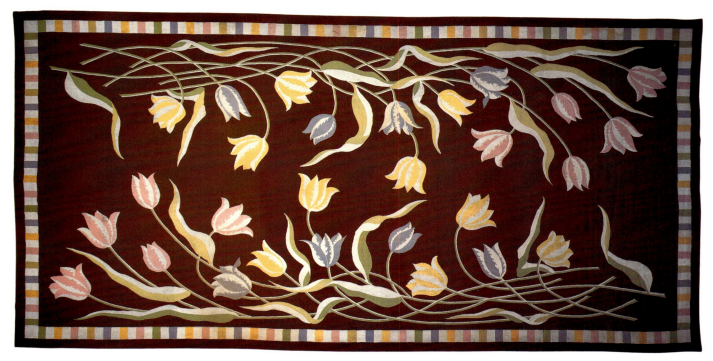

artistes-décorateurs with a reliable source of income were few and far between during the thirties. Launched in 1935, the liner Normandie represented one of the more notable exceptions. Potentially flammable elements such as tapestries were nevertheless reduced to a minimum on the liner – precautions which did not prevent it from being destroyed by fire a few years later. The lack of an official government policy, carpet manufacturers complained, meant that many potential commissions, such as the series of rugs woven by Armenian immigrants in a Marseilles workshop, had slipped through their fingers.[75] The economic crisis put many designers out of work and had disastrous consequences for the handweaving industry centred in Aubusson and for the small weaving studios which shared Paul Poiret's fate in declaring bankruptcy.

The International Exhibition of Arts and Techniques of Modern Life, held in Paris in 1937, symbolized the malaise gripping the luxury craft industries. Weavers and textile manufacturers, including the Manufacture des Gobelins, displayed their wares in a single pavilion and a few carpets were shown on the regional and foreign stands. The Société des Artistes-Décorateurs set up its own pavilion which housed contributions by its members. But as the exhibition's title suggests, the event focused on technology and not on the luxury industries, and as a result the artistes-decorateurs occupied modest stands rather than the luxurious individual pavilions which had served as a showcase for their work twelve years previously.

The alarm bell was sounded by the Exhibition's textile committee, who were all too aware of the dramatic fall-off in production which had resulted from the diminishing role of textiles in the home and the fashion for plain fabrics and carpeting which required little or no artistic intervention. Committee members, including designers Jean Beaumont, Robert Bonfils, Marianne Clouzot, René Gabriel, Hélène Henry and Gustave Jaulmes, as well as the Aubusson tapestry and carpet workshops of Braquenié, Hamot and Pinton Frères and even the big industrialists, from the Manufacture Française de Tapis et de Couvertures to Lorthiois-Leurent, were for once unanimous in warning that 'the fate of French taste is in danger'.[76] The statement was prophetic, at least insofar as the designer carpet was concerned, since production never achieved its former levels.

MODERNISM IN BELGIUM

Just as Dada had grown out of a reaction against the devastation caused by the war, a countertrend to the excesses of Art Deco began to grow in Belgium, expressed in the leftist ideology of Romain Rolland, a fierce opponent of nationalist and capitalist ideology. His views were supported by L'Art Libre, a progressive magazine which was also sympathetic to the views of the Dutch De Stijl group. Although L'Art Libre had already foundered by 1920, its tenets were endorsed by a new magazine, 7 Arts. Founded in 1922 by a group of progressives including

205 First-class lounge of the liner Normandie, designed by Roger-Henri Expert and Pierre Patout, 1935. The carpet is by Emile Gaudissart.

206 Emile Gaudissart, Cornucopia, carpet design for the liner Normandie, 1935, made by the Manufacture de Tapis, Cogolin.

207 Ernest Boiceau, Tulips, 1928, embroidered in wool in the Cornély stitch, 800 x 400 cm (315 x 157 ½ in.), monogrammed. Made for an apartment in New York designed by American decorators Diane Tate and Maryan Hall.

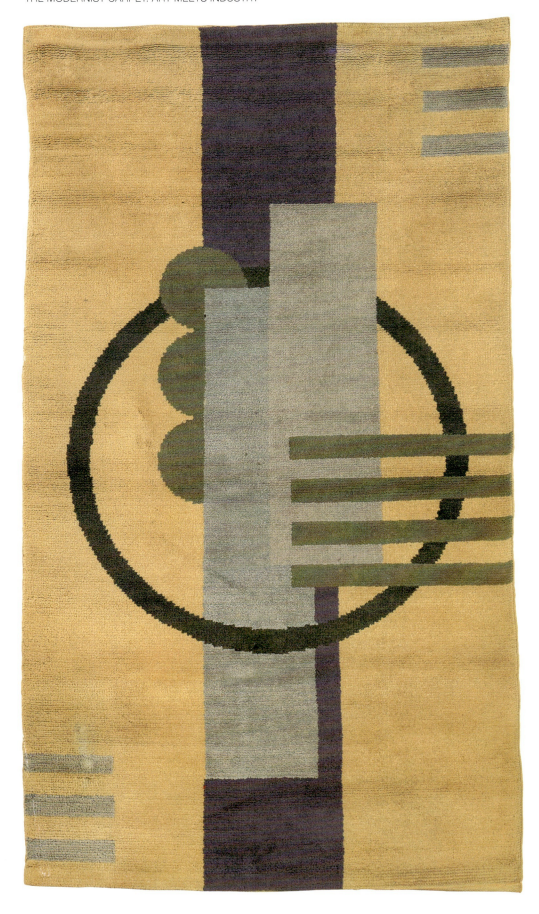

208 Karel Maes, carpet in a Modernist
 design, *c.* 1930, hand-knotted,
 wool pile, 200 x 111 cm
 (78 ¾ x 43 ¾ in.).

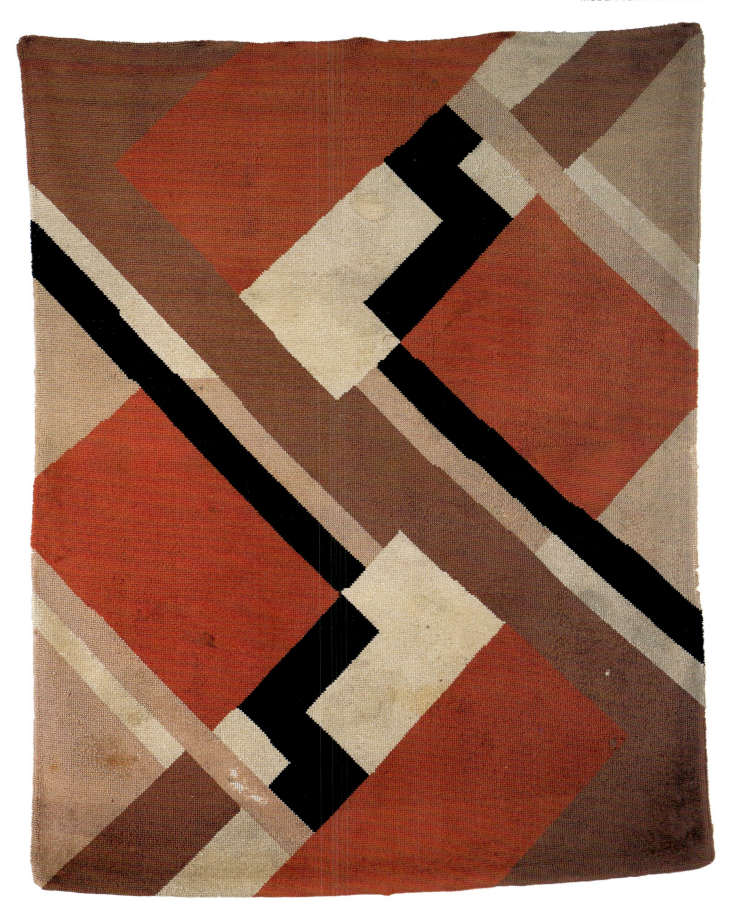

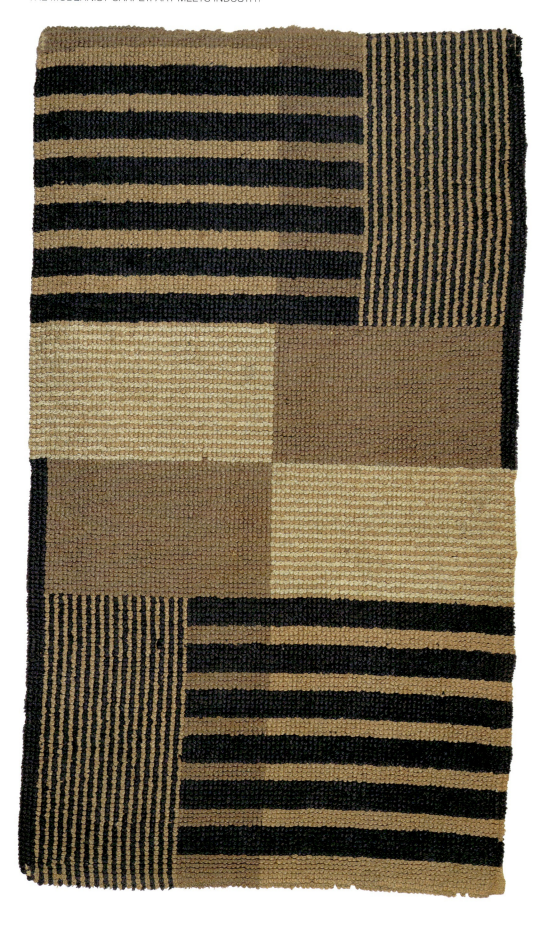

213 L. H. de Koninck, rug for a bedroom, *c.* 1923, hand-hooked, wool, 143 x 80 cm (56 ¼ x 31 ½ in.).

BRITAIN ENDORSES PROGRESSIVE DESIGN

Following the Omega Workshops' ill-fated attempt to revitalize the decorative arts, the applied arts in Britain remained singularly lacklustre until the late twenties. When the Arts and Crafts Movement finally lost its grip, it was replaced by Modernism, also known as the Modernistic style. A puritan streak caused the British to welcome Cubist and Constructivist concepts, which became the basis of a British design revival during the thirties. Avant-garde theory gradually infiltrated the British sensibility, providing the arts with fresh impetus. The Russian Constructivists Antoine Pevsner and Naum Gabo emigrated to Britain in 1922, which led artists like Ben Nicholson (1894–1982) to abandon figurative painting in favour of abstraction (ill. 214). Walter Gropius and Marcel Breuer briefly fled to Britain from Nazi Germany, as did Bauhaus weaver Margaret Leischner, who was to settle there permanently. A leading member of the French-based group Abstraction-Création and director of the 7&5 Society, Nicholson organized an exhibition of abstract painting in London in 1935, and this event, together with a show of Surrealist paintings held at the Burlington Galleries the following year, and an increasing awareness of Scandinavian design, became a deciding factor in the swing towards progressive design.

214 Ben Nicholson, *Project*, pile carpet, *c*. 1939–44, made by the Lucie Weill Gallery, Paris. Nicholson was one of the first British artists to endorse abstract art.

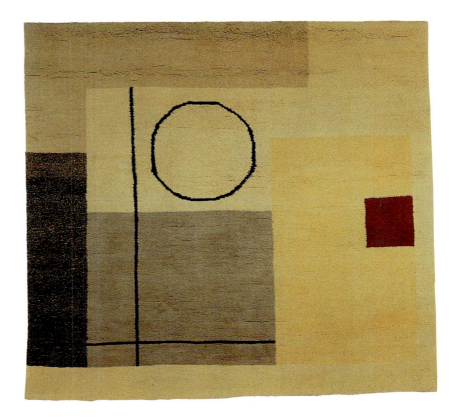

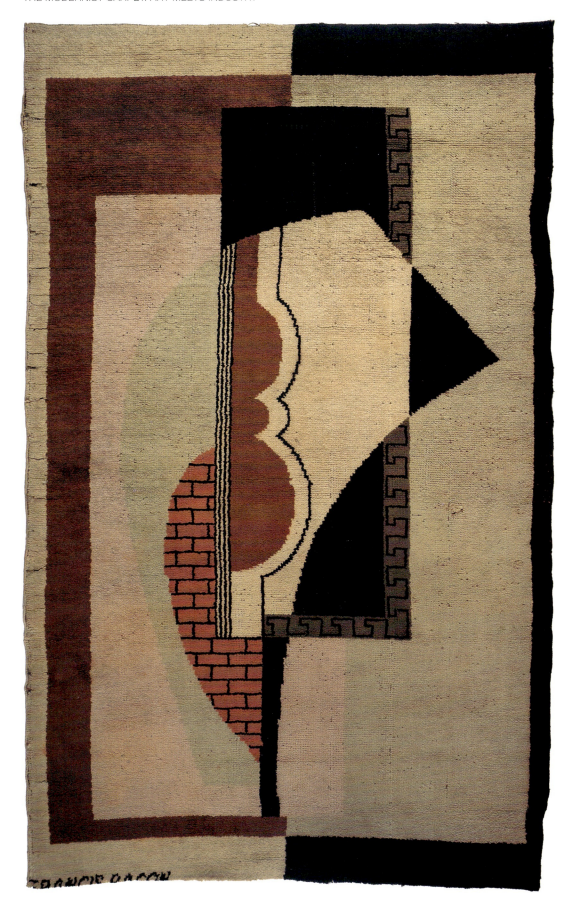

215 Francis Bacon, carpet
executed by the Wilton
Royal Carpet Factory,
c. 1929, hand-knotted,
wool pile, 200 x 115 cm
(78 ¾ x 45 ¼ in.).

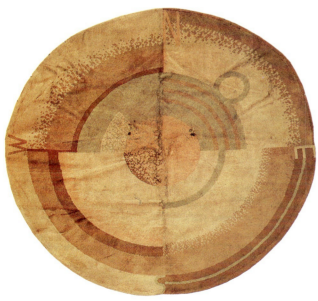

In an effort to encourage industrial design, the Design and Industries Association, an official body modelled on the Werkbund, had been founded as early as 1915. The goals of the Society of Industrial Design, founded in 1930, were similar. The first magazines devoted to industrial design appeared, *Design in Industry* and *Design for Today*, whose inaugural issue in May 1933 discussed the teaching methods practised in German schools. The profession of textile designer was given official recognition, due largely to the efforts of influential designers such as Marion Dorn, Ethel Mairet and Margaret Leischner.

In the interim, interior decoration was an up-and-coming profession. The French example, coupled with a recession which had caused wide-scale redundancies, meant an upsurge in the number of freelance interior decorators, who worked in close collaboration with their clients. Among the first was the painter Francis Bacon (1909–92), who had spent time in Berlin and Paris in 1926 and 1927 before returning to Britain to begin a career in interior design. The August 1930 issue of *The Studio* hailed the artist, whose decorative schemes followed Cubist principles, as 'the new look in British Decoration',[82] and his carpets, woven by the Wilton Royal Carpet Factory, echo these Cubist sensibilities (ills 215, 216). The influence of Cubism is also apparent in rugs designed by Edward McKnight Kauffer (1890–1954) and Ronald Grierson (1901–92); on the other hand, those by architect and designer Serge Chermayeff (1900–96) are more obviously influenced by Delaunay's theories on simultaneous contrasts (ill. 217).

A surprising number of women succeeded in making their mark on interior decoration during the thirties. Aside from Vanessa Bell, well-known decorators included Syrie Maugham, Betty Joel, Marian Pepler and Marion Dorn. Betty Joel (1896–1985) sold her own designs in the London show-rooms she ran with her husband David Joel. Designed to coordinate with her interiors, her rugs are characterized by a few bold abstract motifs, some bevelled in relief (ill. 218). Trained as an architect, Marian Pepler (1904–97) pursued further training as a textile designer and worked as a colour and interior decoration consultant for the firm of Gordon Russell as well as designing for industry (ill. 220).

Widely considered one of the most imaginative textile designers of her generation, Marion Dorn (1899–1964) was the first to truly challenge contemporary French production. Dorn was American, as was her future husband, Edward McKnight Kauffer. Their first joint exhibition of carpets, woven by the Wilton Royal Carpet Factory, was held at the Arthur Tooth Gallery in 1929.[83] In 1934, she founded her own store, Marion Dorn Ltd, in London. Her repertoire was to a

216 Roy de Maistre, *Interior*, 1930, oil on canvas, 61.2 x 50.8 cm (24 x 20 in.), Manchester Art Gallery. This painting shows Francis Bacon's studio with a rug *in situ*.

217 Serge Chermayeff, *Compass*, 1932, hand-knotted, wool pile, diameter 283 cm (111 ⅜ in.). A circular carpet designed for the office of Lord Reith at the BBC, it was probably made by the Wilton Royal Carpet Factory.

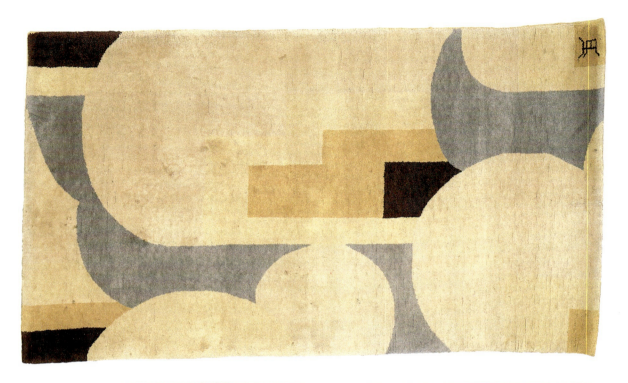

218 (opposite) Betty Joel, wool pile rug, woven in T'ien-Tsin, China, *c.* 1930, 121 x 206.5 cm (47 ⅝ x 81 ¼ in.), monogrammed. The same design was woven in several different formats.

219 Marion Dorn, pile carpet with a geometric design, hand-knotted by the Wilton Royal Carpet Factory, 1930s, 135 x 195 cm (53 x 77 in.), monogrammed.

220 (below) Marian Pepler, *Boomerang*, carpet made by the Wilton Royal Carpet Factory, 1929–30, hand-knotted, wool pile, 203 x 325 cm (80 x 128 in.), signed. The linear pattern echoes contemporary French design.

great extent abstract, consisting of twisted coils, spirals, zig-zags and geometric devices (ills 219, 221), some of which recall the work of Da Silva Bruhns. Yet she never abandoned figurative elements and many of her designs feature stylized animals, vegetal motifs and shells. The colour schemes tend to be sombre: bottle green, Etruscan red, grey and particularly beige and brown. The powerloom carpeting woven from her design for the Savoy Grill Room in 1933 was a repeating pattern of roundels containing birds, fish and leaves. She also created a range of textured and monochrome weavings, including the carpet which matched the famous all-white drawing room of Syrie Maugham's house in Chelsea (1933) (ill. 222).

Known primarily for his work as an illustrator, Edward McKnight Kauffer expounded his theories on carpet design in an issue of *The Studio* which was published to coincide with the exhibition at the Arthur Tooth Gallery. His earliest carpets recall the severe rectilinear patterns of the Bauhaus weavers or the mottled and geometric creations of Da Silva Bruhns (ill. 223). A pile carpet in the Musée des Arts Décoratifs, Montreal, represents an attempt to create a woven equivalent of the reliefs of Jean Arp's biomorphic sculptures, and reveals the influence of Surrealism.[84]

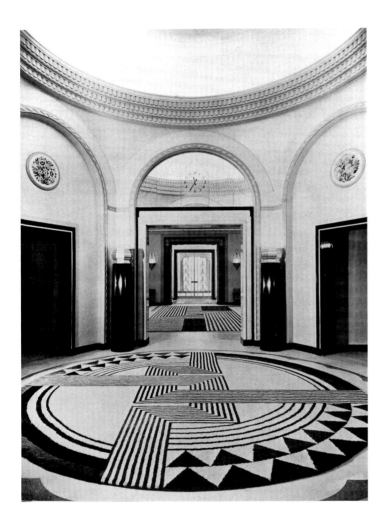

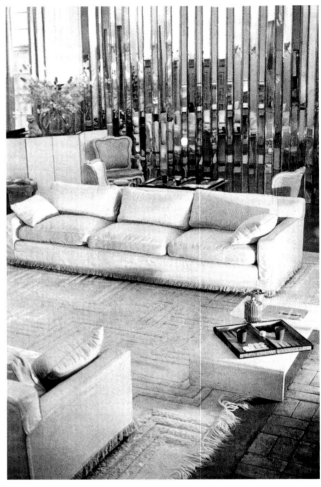

Progressive design was now officially endorsed by manufacturers and officialdom alike. London Transport acquired *moquette* patterns for its trains designed by Enid Marx and Marion Dorn, among others. The Wilton Royal Carpet Factory launched the Wessex line (ill. 224), and Morton Sundour Fabrics set up a new department, Edinburgh Weavers, specializing in modern textile design, and began to sell its 'Constructivist' range of textiles and carpets in 1937. Designs were acquired from Marian Pepler, Hans Aufseeser, Terence Prentice, Jean Varda, John Tandy (ill. 225) and Ashley Havinden (ill. 226). The stark range of motifs, limited to a few lines or bold brushstrokes or reminiscent of biomorphism, encapsulates British Modernism.

In 1936, Nikolaus Pevsner reported that while a few carpet manufacturers still specialized in copies of oriental patterns, the bulk of the trade was now Modernistic. In fact, the critic

221 Lobby of Claridge's Hotel, London, with carpets by Marion Dorn, *c*. 1935. The carpet has since been reissued in the tufted technique by V'Soske Joyce, Ireland, from Dorn's original pattern.

222 Syrie Maugham's all-white drawing room in her Chelsea home, furnished with a carpet in the half-pile technique by Marion Dorn, 1933.

223 (opposite) Edward McKnight Kauffer, carpet woven by Wilton Royal Carpet Factory, *c*. 1935, hand-knotted, wool pile, 127 x 179 cm (50 x 70 ½ in.), monogrammed.

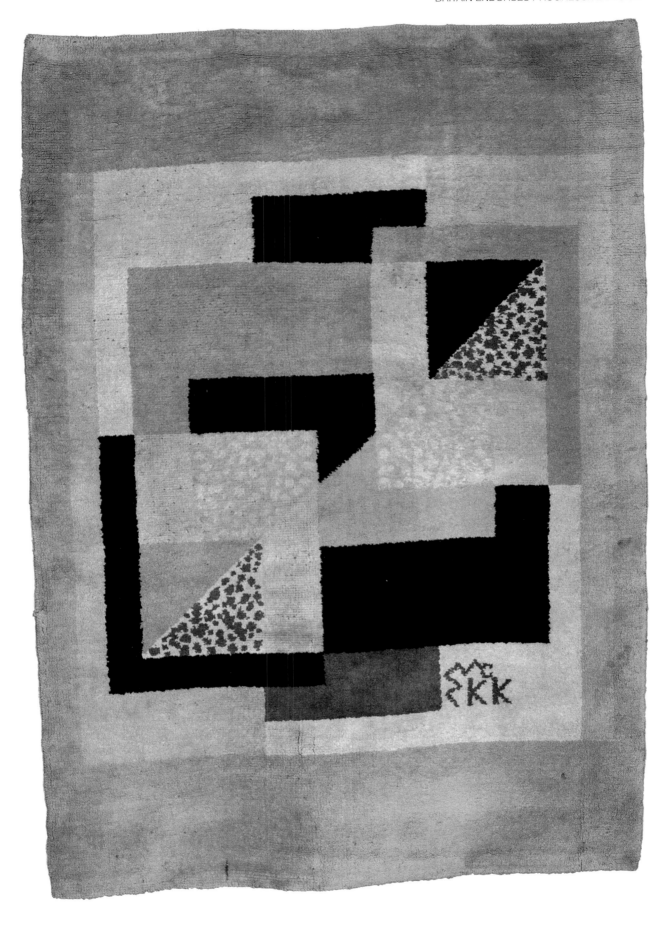

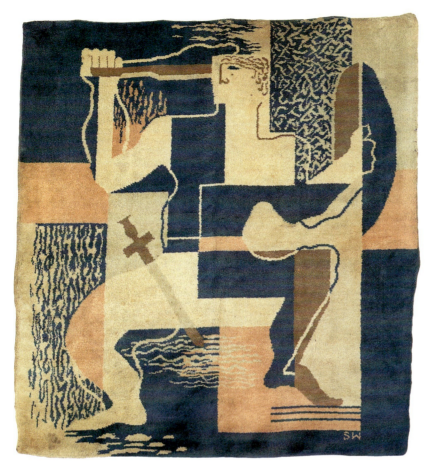

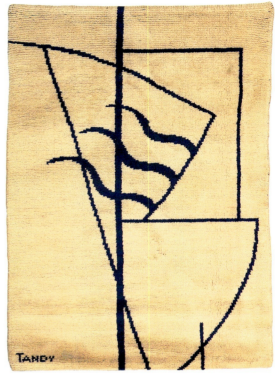

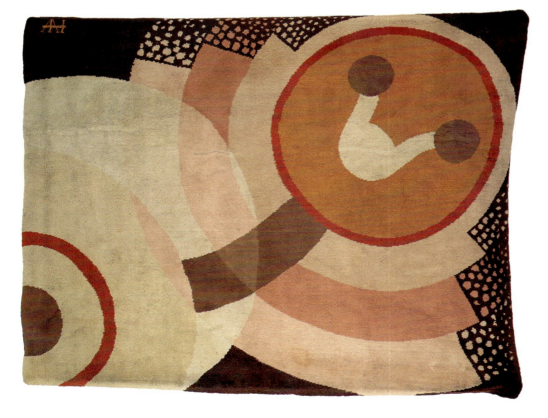

224 (above left) Sheila Walsh, *Warrior*, c. 1930, hand-knotted wool pile, 211 x 189 cm (83 ⅛ x 74 ⅜ in.), monogrammed. Probably made for the Wilton Royal Carpet Factory's Wessex line.

225 (above) John Tandy, carpet manufactured by the Wilton Royal Carpet Factory, c. 1937–38, hand-knotted, wool pile, 180 x 122 cm (70 ⅞ x 48 in.), signed.

226 (left) Ashley Havinden, carpet in a 'simultaneous contrast' design, c. 1935, hand-knotted, wool pile, 255 x 200 cm (100 ⅜ x 78 ¾ in.), monogrammed.

227 Rex Whistler, *Neptune, c.* 1932, oil on canvas,
73.5 x 49.5 cm (29 x 19 ½ in.). A design for
an Axminster carpet made for the dining room
of Edward James's home in Wimpole Street,
London. The image was taken from a
Baroque tapestry.

deplored this 'abyss of vulgarity in design...derived from misunderstood Continental Cubism', which he went so far as to equate with an 'indictment of contemporary civilization'.[85] In a predictable backlash, Victorian taste for the ornate was about to make a comeback. Would Pevsner have found the carpet designed by the painter Rex Whistler for the London home of Edward James, a splendid exercise in the Baroque (ill. 227), more congenial to his taste?

DE STIJL AND THE TRIUMPH OF NEO-PLASTICISM

Due largely to the growing influence of rationalism in Dutch architecture, advocated by such groups as *De 8* and *Opbouw* (which merged in 1932), the school of Nieuwe Bouwen (New Architecture) had by the mid-twenties largely ousted the Amsterdam school from the limelight. Functionalist theory was aided and abetted by the De Stijl movement, which took its cue from the European avant-garde. De Stijl was founded in Leyden in 1917 by painters Theo Van Doesburg, Piet Mondrian, Vilmos Huszár (1884–1965), Bart Van der Leck (1876–1958), the Belgian sculptor Georges Vantongerloo (1886–1965) and the architect J. J. P. Oud. Their doctrine, Neo-plasticism, called for an art that was logical rather than emotive, expressed in terms of rigorous geometric abstraction which tolerated no deviation from the horizontal and vertical line. The palette was restricted to primary colours, although three 'non-colours' – white, black and grey – were also permitted. Geared primarily towards painting at the outset, Neo-plasticist doctrine was next applied to interior design and architecture. If the public would have their interiors executed according to the principles of Neo-plasticism, Mondrian claimed, it would obviate the need for painting.[86]

Van Doesburg's interest in textiles and the series of articles he wrote on the subject in *Interieur* in the early thirties have already been noted. Like Klee, the artist perceived an affinity between weaving and music. Echoing Loos's refrain, Van Doesburg equated ornamentation with primitivism, arguing for a rationalist approach to textile design. He claimed that modern teaching methods should emulate those of the Bauhaus and cited African textiles as a perfect example of homogeneity between the raw materials, the design process and the weaving technique. Van Doesburg's stance in favour of functional textiles did not, however, prevent him from defending handwoven pieces, which he claimed would serve as a synthesis of the textile arts, in the manner of a painting or sculpture. He singled out the carpets of Jean Arp, Sophie Taeuber-Arp and Sonia Delaunay as models of their kind.[87]

Although a carpet has recently been produced by the Tapis de Cogolin from a painting by Mondrian, neither he nor Van Doesburg actually designed carpets, but several other De Stijl artists did so, including Huszár, Van der Leck and Vantongerloo. Huszár served as colour advisor for the decoration of the Bruynzeel house, designed by Piet Zwart in 1921, and created a carpet decorated with juxtaposed straight lines for the living room.[88] Two more

228 Vilmos Huszár, a set of interior designs for an exhibition by De Stijl artists in Berlin in 1923, reproduced in *L'architecture vivante*, Autumn 1924. The furniture was by Gerrit Rietveld.

229 Vilmos Huszár, wool pile carpet made for the bedroom of the Bruynzeel House, probably by Het Paapje workshop, 1921, 203 x 107 cm (79 $^7/_8$ x 41 $^1/_8$ in.). The work of the Neo-plasticists is characterized by blocks of colour, generally in primary shades.

strikingly unadorned pieces presently in the Gemeentemuseum, The Hague, were created by Huszár and P. J. C. Klaarhamer for the bedroom. With a plain field and an equally plain wide border, both are in black and clear blue, but the colours are reversed (ill. 229).[89]

As early as 1912, Bart Van der Leck elected to live in a white-walled interior highlighted with cushions, upholstery and rugs in primary colours. Proximities in their work drew him to Mondrian, whom he met in 1916. Shortly after joining De Stijl, Van der Leck painted his famous *Mathematical Images* (Museum of Modern Art, New York). This was a series of abstract paintings in which he attempted to activate space through an arrangement of small geometric figures – rectangles, squares, diamonds – of similar size and colour intensity, intended to serve as a dynamic counterpoint to each other. Both Van der Leck and Huszár had begun as stained glass craftsmen, and this background was crucial in their development as artists; it is probably no coincidence that their paintings call to mind leaded windows. Opposed to the theoretical stand taken by De Stijl, Van der Leck left the group by 1920, although he remained faithful to their aesthetic values long after the break.[90]

In 1929, Van der Leck was hired by Metz & Co., a department store based in Amsterdam with a branch in The Hague. In launching an interior-design department and appointing interior architects Paul Bromberg and later Willem Penaat to head it, its director, Joseph de Leeuw, was following the example of Liberty's of London. De Leeuw had little respect for the work of his compatriots and the earliest designs were commissioned from foreigners, including Jean Burkhalter, Djo-Bourgeois and the Constructivist Pavel Mansurov.[91]

When de Leeuw met Van der Leck and the architect Gerrit Rietveld, designer of the famous De Stijl chair, Metz reversed its policy. In his capacity as colour advisor to the interior design department, Van der Leck created a range of carpets for Metz. At the outset, some were woven in Aubusson but the majority were woven by the Société Africaine de Filature et de Tissage in Rabat.[92] The earliest are close in spirit to his *Mathematical Images* and feature small confetti-like shapes in primary colours, sparsely arranged in symmetrical compositions on a dark or light ground (ill. 231). A study dated 1935 in the Textile Museum, Tilburg, shows the method Van der Leck used to calculate the proportions. These might feasibly have been intended as carpet designs from the beginning, but Van der Leck may also have submitted earlier paintings to Metz for execution. Three of these rugs were shown together with furniture by Rietveld at the U.A.M. exhibition in Paris in 1930

230 Georges Vantongerloo, reversible mat in the *moquette* technique, produced by Metz & Co., Amsterdam, 1937.

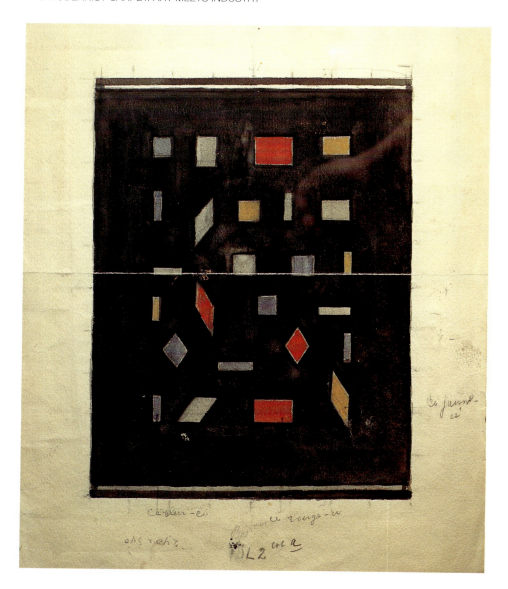

231 Bart Van der Leck, carpet design for the
Metz department store, 1918, gouache
and pencil on paper, 37.9 x 28 cm
(14 7/8 x 11 in.).

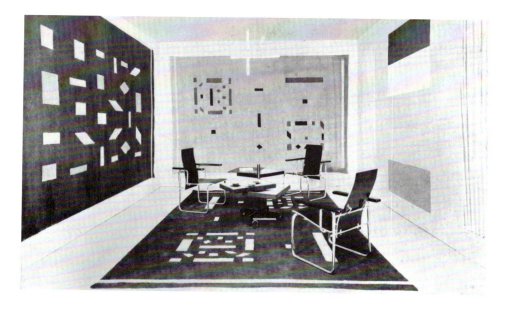

232 The Metz & Co. stand at the U.A.M.
exhibition, Paris, 1930. The tubular metal
furniture is by Gerrit Rietveld, with carpets
by Bart Van der Leck. As well as textiles,
Van der Leck designed many other
products for the Metz store, including
ceramics, tiles and even carrier bags,
all using the same characteristic
geometric motifs.

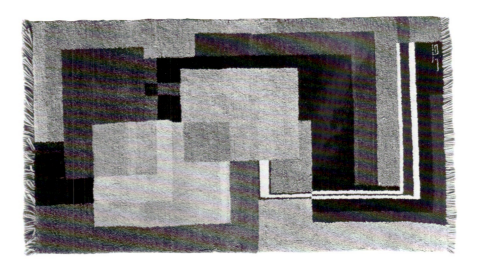

233 Jaap Gidding, Modernist carpet, *c.* 1930, hand-
knotted, monogrammed. Woven by the Studio
de Saedeleer.

234 Jan Gompertz, carpet executed by Kinheim
of Beverwijk, *c.* 1930, wool pile, 195 x 240 cm
(76 ¾ x 94 ½ in.).

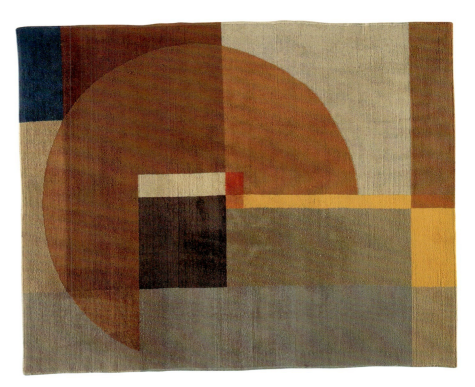

(ill. 232). In 1937, the firm issued a range of inexpensive mats by the Veneta company in Hilversum from designs by Georges Vantongerloo (ill. 230). Warp-pile *moquette* woven on a Jacquard treadle loom, they are unusual in being reversible.

Jaap Gidding was one of the Dutch designers who came to endorse the new aesthetic. Two of Gidding's carpets made by the Studio de Saedeleer show strict obedience to the precepts of Neo-plasticism (ill. 233).[93] Four more remain in situ in the Van Buuren Museum in Brussels. Interior designers Frits Spanjaard (1889–1978), a member of the group known as the Hague Rationalists, and Jan Gompertz (1887–1963), associated with the Rotterdam branch, also created Modernist carpets worthy of note; examples are conserved in the Gemeentemuseum, The Hague (ill. 234).

Independent craft workshops included those of Hans Polak (1884–1969) and Kitty Van der Mijll-Dekker (1908–2004). Polak's Het Paapje workshop in Voorshoten, founded in 1920, was modelled on the Studio de Saedeleer. A student of Gunta Stölzl at the Bauhaus, Van der Mijll-Dekker established a craft studio in Unspeet with fellow students Greten Kähler and Hermann Fischer in 1932. A surviving carpet in the Stedelijk Museum, Amsterdam, demonstrates her technical virtuosity. In a composite technique of looped and cut pile combined with the weft-float technique, it was woven in a single shade of ivory wool in varying thicknesses (ill. 235).

SCANDINAVIAN MODERN

The Finns made a worthy contribution to the textile arts between the wars, but it was the Swedes who proved themselves to be most versatile in designing furnishings to suit modern taste. Dubbed 'Swedish Modern', Swedish design successfully extended to glass, ceramics, furniture and textiles and eventually had international ramifications. A group of reformers became aware of the need to foster collaboration between artists and industry, along the lines of the Werkbund. Among this group was Gregor Paulsson, who attempted to reorganize the Swedish Craft Society. In 1917, the society held an exhibition on home decoration at the Liljevalchs Konsthall in Stockholm, a show which broke with the traditional theme of the ideal home of the elite, instead taking the form of small apartments equipped with good-quality but inexpensive furnishings, accessible to modest incomes.

The master weavers of Scandinavia generally ran their own studios and tended to be well versed in the structural aspects of weaving. Among them were Signe Asplund, Thyra Grafström (1864–1925), Elsa Gullberg (1886–1984), whose craft studios were in Stockholm, Agda Österberg (1891–1987) (ill. 236), and Märta Måås-Fjetterström (1873–1941), who set up a workshop in Båstad, near Lund. In her reliance on peasant art and in shunning involvement with textile manufacturers, Måås-Fjetterström belonged to the old school of master weavers. Yet Sweden's most celebrated textile artist proved to be an important innovator, inventing new techniques,[94] finding new applications for old ones and breaking with graphical representation to focus on the aesthetics of fibres and textures. A carpet in the Röhsska Konstslöjdmuseet in Gothenburg shows that as early as 1923, Måås-Fjetterström was seeking to create surface interest from textural effects rather than pattern. Woven in the *glesrya* technique, the field was made of widely spaced rows of long linen pile, the outer edges finished with short extra rows to create a border (ill. 237).

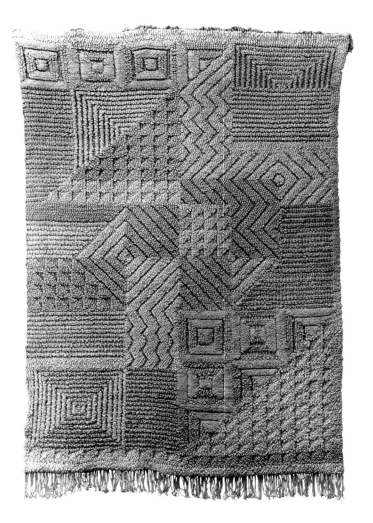

235 Kitty Van der Mijll-Dekker, wool carpet in a mixed half-pile, looped and weft-float technique, 1936.

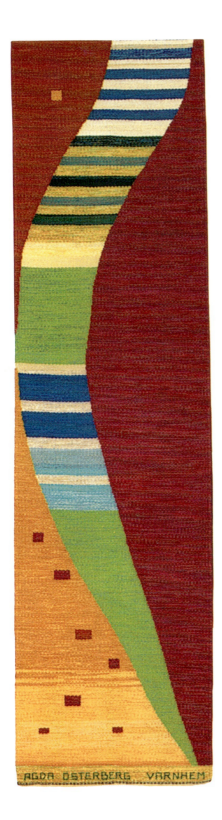

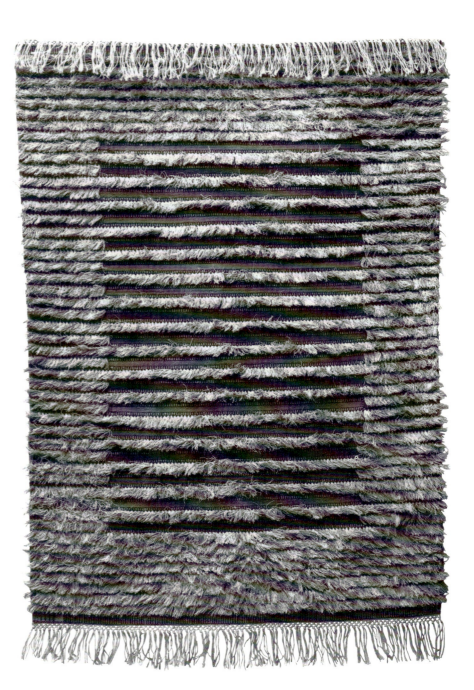

236 Agda Österberg, flatweave runner, 1930s,
 950 x 74 cm (374 x 29 in.), made at her
 workshop in Varnhem.

237 Märta Måås-Fjetterström, *Silverryan (The Silver Rug)*, 1923, 250 x 153 cm (98 ⅜ x 60 ¼ in.),
 monogrammed. A carpet in the so-called *glesrya* technique, characterized by widely spaced
 rows of linen knots. The weaver was one of the first to focus on the aesthetics of texture.

Among the traditional techniques which Måås-Fjetterström infused with a new lease of life were rag rugs and half-pile rugs. For a rag rug now in the Textile Museum in Sandviken, near Hogbö, the master weaver put some surplus blue overalls to good use, tearing them into strips which served as the pile, regularly interspersed with knots in linen and the more traditional wool (ill. 238). After seeing her weavings displayed at the 1925 Paris exhibition, British manufacturer James Morton enthused: 'It is worth getting a specimen of everything fresh she does... she is a creative poet working in new materials.'[95] A pile rug woven in a mixed technique, with knots tied in linen and fragments of fabric which he purchased during a visit to the Båstad workshop has since been donated to the Victoria and Albert Museum. In half-pile or *halvflossa* rugs, Måås-Fjetter-

ström would use a single shade of yarn instead of several, allowing the design to stand out in relief through a play on surface rather than colour. One example recently on the market, identical to an example in the Nationalmuseum, Stockholm, shows a niche reminiscent of a Turkish prayer rug (ill. 239). Woven entirely in ivory yarn, the rug resembles the work of Evelyn Wyld.

Functionalism made an effective breakthrough at the exhibition held in Stockholm in 1930. Traditional crafts were displayed side by side with machine-made goods designed by artists. The powerloom carpeting made by the Kasthalls Mattfabrik in Kinna from designs by Greta Gahn (1894–1996) and Märta Gahn (1891–1973) ushered in a new era, manufacturers having until then confined their production to copies of oriental rugs. Also on display was the work of Karna Asker (1897–1989), a textile designer who invented a new process for making pile carpets called the *Ava-flossa* technique, woven partly by hand and partly by machine using a method similar to velvet.[96] Her designs were also selected for inclusion at the exhibition of modern rugs held at the Metropolitan Museum of Art, New York in 1929.[97]

The 1930 exhibition also marked a stylistic turning point. The stark geometric compositions of Karna Asker and Inga Wedel (1900–84) were now inspired more by foreign influences than folk heritage.[98] Stylistically speaking, the most unusual pieces were the three handhooked rugs designed and executed by Ingegerd Torhamn (1898–1994), which represented a complete break with tradition. Now in the Nationalmuseum, Stockholm, two were inspired by the Constructivist movement, while the third was taken from a painting by Georges Braque on the theme of a man with a guitar (ills 240, 241).

The same generation of textile artists also included art weaver Barbro Nilsson (1899–1983), textile designers Astrid Sampe (1909–2002), Marianne Strengell and Viola

238 Märta Måås-Fjetterström, detail of a rag rug, 1934, 200 x 100 cm (78 ¾ x 39 ⅜ in.), monogrammed. This mat was knotted in linen yarn and strips torn from surplus overalls, in Måås-Fjetterström's workshop in Båstad.

239 Märta Måås-Fjetterström, wool rug in the voided or half-pile technique, *c*. 1934, 406 x 310 cm (160 x 122 in.).

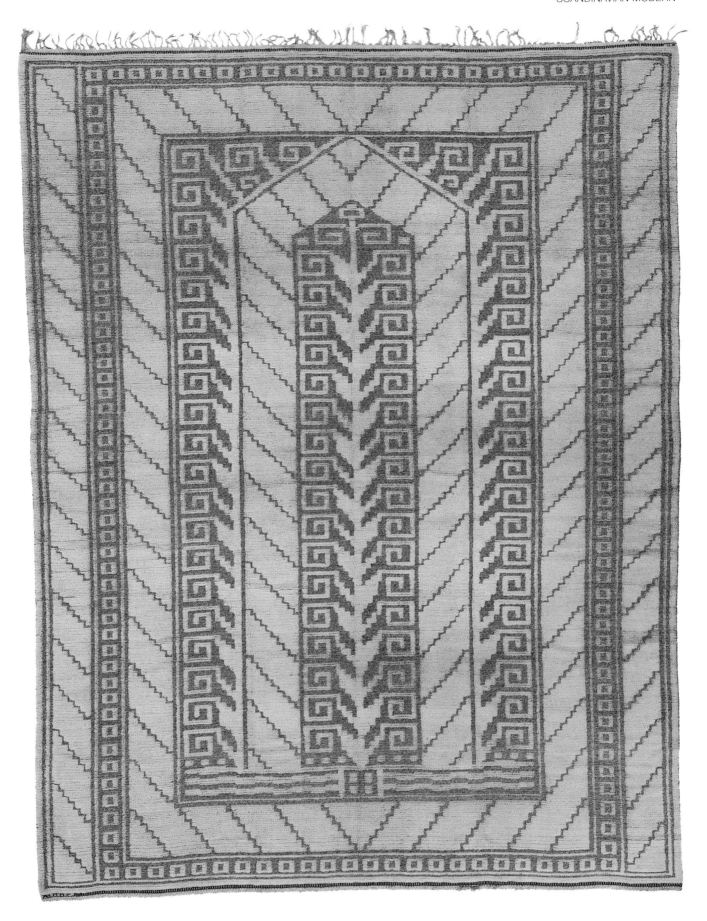

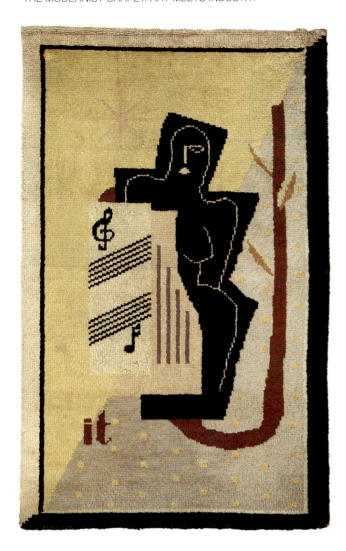

Gråsten (1910–94) and the industrial designer Sigvard Bernadotte (1907–2002). Nilsson was chief designer and director of Märta Måås-Fjetterström A.B., the limited company formed after the death of the textile artist in 1941 (ill. 242). Bernadotte designed a line of carpets for the Nordiska Kompaniet, whose textile department was headed by Sampe from 1937 until its closure in 1971 (ill. 243). Primarily interested in the effects of texture, Strengell created her designs from a mix of natural and synthetic fibres, a line of research which she pursued once she had taken up an appointment at the Cranbrook Academy in Detroit. Gråsten, who had made her debut at the 1930 exhibition, was among the first weavers to use the extremely long pile characteristic of the modern *glesrya* rug.[99] She wove the pile rug for the Gothenburg Town Hall from a design by Gunnar Asplund, Sweden's most celebrated Modernist architect. Decorated with building tools and initials, it celebrated the individuals involved in the building's construction and remains *in situ*.

Unlike that of its neighbours, Denmark's folk-weaving tradition had been virtually wiped out in the wake of industrialization by the end of the 19th century. The craft enjoyed a revival from 1928, with the founding of the Danish Handicraft Guild, which established schools in

240 Ingegerd Torhamn, hand-hooked *flossa* rug, 1930, wool, 190 x 115 cm (74 ¾ x 45 ¼ in.). The Cubist design was inspired by a Braque painting.

241 Sven Markelius, living room exhibited at the Exhibition of Decorative Arts and Industrial Design, Stockholm, 1930, with a carpet by Ingegerd Torhamn.

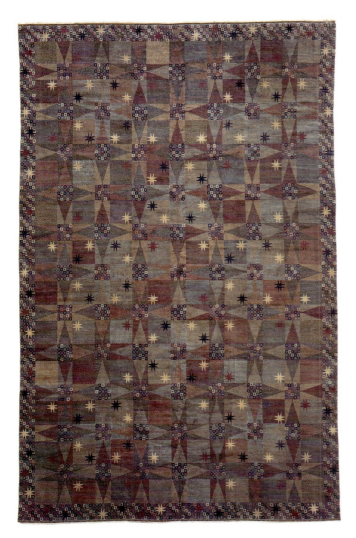

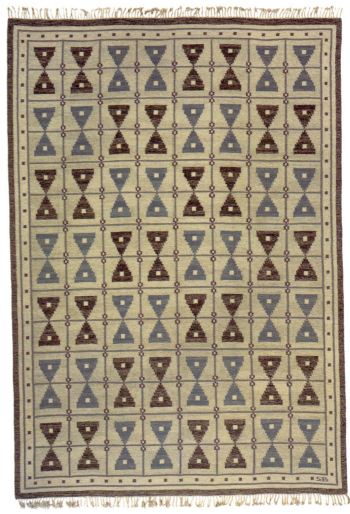

242 Barbro Nilsson, carpet, c. 1940, wool pile on
 linen warp, 559 x 343 cm (220 ⅛ x 135 in.).
 Nilsson became director of Märta Måås-
 Fjetterström A.B. after the death of its founder.

243 Sigvard Bernadotte, *Hourglass*, flatweave
 carpet, c. 1940, 371 x 249 cm (146 x 98 in.),
 monogrammed. Bernadotte also designed
 carpets in the voided pile technique.

areas where a cottage industry was likely to take root. Among the pioneers was Gerda Henning (1891–1951), who set up a weaving workshop in Copenhagen and revived the tradition of handwoven rugs. Similar studios were founded by Henny Baumann and Lis Ahlmann (1894–1979), who trained under Henning.

Henning introduced the fashion for rugs in natural fibres. A circular rug in a mosaic pattern in shades of brown, white and black designed and woven by her is in the Kunstindustrimuseet in Copenhagen. Arne Jacobsen (1902–71), Denmark's foremost Modernist architect, also opted for natural fibres in a carpet he designed in 1935, with a striking pattern consisting of a stylized bird's-eye view of the seashore. The husband-and-wife team of Mogens Koch (1898–1992) and Ea Koch also favoured striking geometric patterns woven in natural yarns from Faeroe Islands sheep.[100] The handsome half-pile carpets of Paula Trock (1889–1979) and the abstract designs of Juliana Sveinsdottir (1889–1966), an Icelandic designer who made a career in Denmark, are also worthy of note. The revival encouraged Danish textile manufacturers to start collaborating with freelance weavers and designers during the thirties.

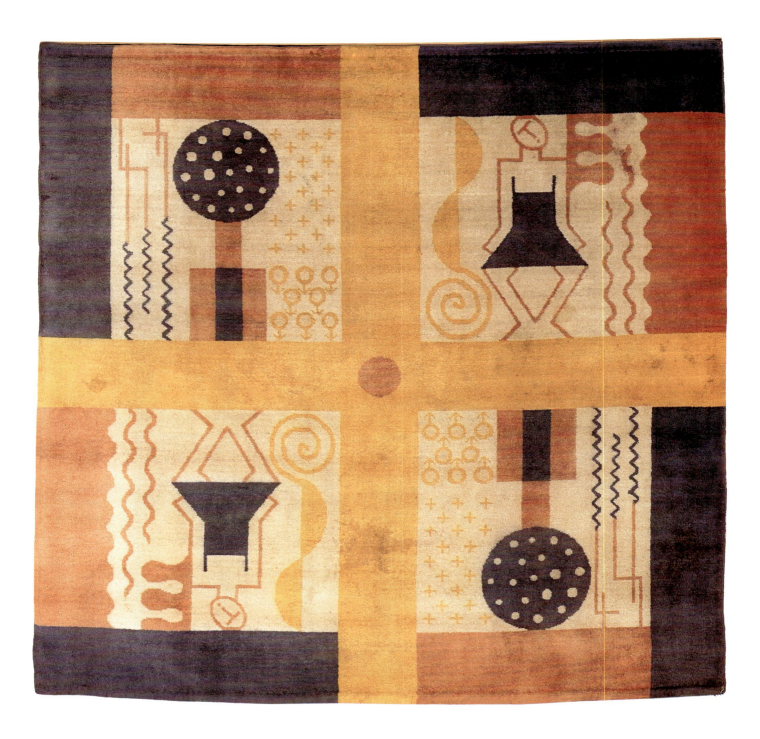

244 Ilonka Karasz, carpet for a child's nursery, 1928, wool pile, 273.1 x 271.8 cm
(107 ½ x 107 in.). Made by Ginzkey of Maffersdorf, and designed for an exhibition
at the American Designers' Gallery, New York.

AMERICAN STREAMLINED

The European example made American designers acutely aware of the need to create their own national style. They quickly responded to the challenge and an early exhibition of their work was held at the American Designers' Gallery, New York, in the autumn of 1928. United under the same banner were Americans Donald Deskey, Henry Varnum Poor, Ruth Reeves and William Zorach, and recent arrivals from Europe, including Paul Frankl, Pola and Wolfgang Hoffmann (1900–69) and Ilonka Karasz. Karasz is credited with designing the first Modernist nurseries, one for each sex, which were exhibited at this event. The Metropolitan Museum now owns the carpet from the little girl's room, decorated with stylized figures which distantly recall Karasz's Eastern European origins (ill. 244). A year later, the AUDAC (American Union of Decorative Artists and Craftsmen) was founded. The philosophy of this short-lived organization, which sought to foster fruitful collaboration between artists and industry, would live on after its demise.

In 1929, an exhibition of contemporary glass and rugs was held at the Metropolitan Museum. Organized with the aid of the Paris-based American photographer Thérèse Bonney (1894–1978), it consisted of a selection of carpets in Art Deco and Modernist designs made by both European and American designers. The show was unusual in exhibiting powerloom carpeting, mainly of German manufacture, alongside handwoven rugs. Pieces by Da Silva Bruhns, Evelyn Wyld, Marion Dorn and Serge Chermayeff were displayed together with contributions from Märta Måås-Fjetterström, Karna Asker and Elsa Gullberg.[101] In his preface to the catalogue, Charles H. Richard called attention to the very different production methods used in France and Germany, the two most active carpetmaking centres, and expressed the hope that American manufacturers would be able to suggest worthwhile solutions to their dilemma.[102]

The well-established Bigelow Hartford Carpet Company and Macy's department store were among the firms that rose to the challenge. American designers were influenced by the Bauhaus and modern Scandinavian design, although the social ideology of the Bauhaus was notably absent. Bigelow Hartford produced carpeting by Eliel Saarinen and Ruth Reeves, while Macy's sold carpets designed by Teresa Kilham (made by the Kilmarnock Corporation) and Lydia Rahlson (made by the Hill Gerhard Co.). Within a few months, however, the stock market had crashed. Faced with a declining market, American manufacturers attempted to

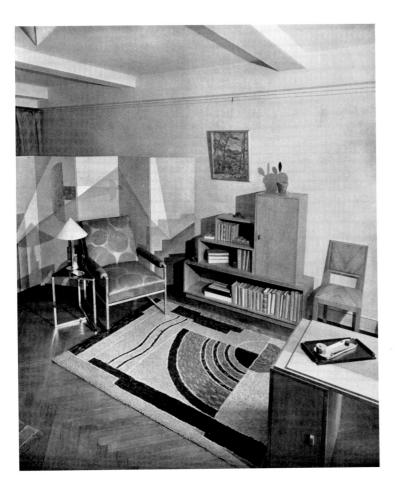

245 Harriet E. Brewer, room design, c. 1930. The metal furniture and lamp are by Russian-born designer Alexander Kachinsky; the carpet reflects the influence of the Synchromist movement.

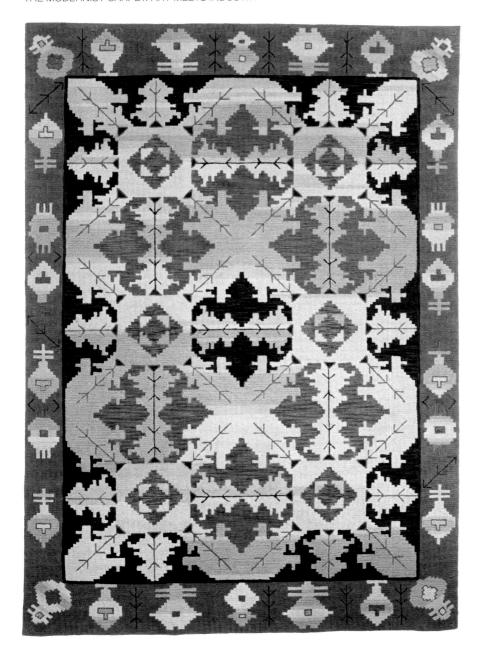

246 Stanislav V'Soske, *Marco Polo* carpet, 1939.
During the 1930s V'Soske perfected the tufted
carpet, a technique similar to the one used for
making candlewick bedspreads. This design
distantly recalls a Turkoman carpet.

247 Man's den furnished with a carpet in a zig-zag
pattern designed by Joseph Urban, for the 1929
exhibition 'The Architect and the Industrial Arts'
at the Metropolitan Museum, New York.

stimulate sales by hiring freelance industrial designers, in order to improve the quality of their products.

This fascination with machines and speed translated into a design idiom which the Americans could justifiably call their own. Streamlining, expressed as rounded edges meant to symbolize speed, was applied to every conceivable type of object, from radios and refrigerators to trains. But streamlining adapts itself awkwardly to flat surfaces and is not normally a feature of contemporary textile design. Among the modern concepts which did adapt themselves well to the medium were the abstract designs favoured by Gilbert Rohde (1894–1944), Donald Deskey, Hans Hofmann, Emily Reiss, Ralph M. Pearson and sculptor John Storrs, and the colour harmonies introduced by artists of the Synchromist movement (ill. 245), whose leading light, Morgan Russell, had like Delaunay discovered Chevreul's theories on

248 John Ferren, carpet in an abstract design, 1942,
tufted technique, wool, 274.3 x 200.7 cm
(108 x 79 in.). Woven by the V'Soske workshops,
Grand Rapids, Michigan. In 1942, V'Soske
asked ten modern artists to design rugs, which
were displayed in an exhibition at the Museum
of Modern Art, New York.

249 Arshile Gorky, *Bull in the Sun*, 1942, wool, tufted
technique, 216 x 296 cm (85 x 116 ½ in.), made
in the V'Soske workshops, Grand Rapids.

colour during a stay in Paris. American rugs were often decorated with segmented circles and
zig-zags, intended to symbolize lightning bolts and represent the machine age (ill. 247).

The new focus on structure appealed to American designers. The public had seen tex-
tured carpets designed by Scandinavian weavers at the 1929 exhibition. Donald Deskey and
particularly Stanislav V'Soske were among the foremost designers of textured carpets. Using
the tufting gun, V'Soske succeeded in achieving some remarkable textural effects (ill. 20).
Changing the calibre of the needles made it possible to insert yarn of varying thicknesses, and
the pile was then sheared to created differences in level, left in loops, carved or incised.
V'Soske used only natural fibres but freely combined wool and silk (ill. 246). His work was
exhibited at many events, including San Francisco's Golden Gate Exhibition in 1939. In 1942,

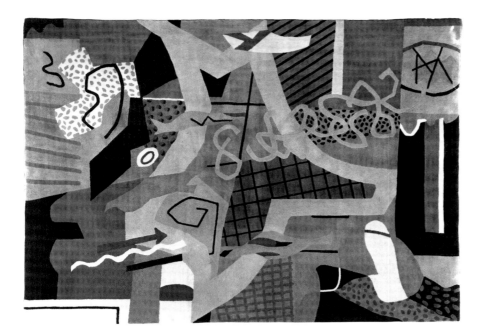

250 Stuart Davis, *Flying Carpet*, carpet made by
 the V'Soske workshops, 1942, wool, tufted
 technique, 216 x 366 cm (85 x 144 ⅛ in.).

V'Soske launched a range of designs by ten contemporary artists, including John Ferren (ill. 248), Arshile Gorky (ill. 249), Marguerite Zorach and Stuart Davis (ill. 250),[103] which were exhibited that year at New York's Museum of Modern Art.

During the thirties, textile design as a profession gained increasing acceptance when a second influx of immigrants fleeing the political upheavals in Europe arrived in America. Two Bauhaus weavers were hired to head the textile departments of important American schools: Anni Albers was appointed head of the textile department at the Black Mountain College, North Carolina, in 1933, while Marli Ehrmann (1904–82) did the same job for the New Bauhaus, at the Chicago Institute of Design, which opened its doors in 1937. Unsurprisingly, these weavers introduced German educational methods into the curriculum.

The first American to achieve renown as a textile designer was Ruth Reeves (1892–1966), mentioned earlier in connection with Radio City Music Hall. A student of Fernand Léger, Reeves designed many textiles for the firm of W. and J. Sloane, which honoured her with a personal exhibition of her designs in 1930.

When Finnish designer Marianne Strengell took over the weaving department of the Cranbrook Foundation after Loja Saarinen's retirement in 1942, the school began to gear its teaching towards design for industry. Strengell, who also worked as a freelance industrial designer, introduced experimental techniques, fibres and dyes, merchandising and courses on powerloom weaving into the curriculum. In 1945 a powerloom was actually installed, an innovation which excited the interest of other weaving faculties in Chicago and North Carolina. The first graduate student to be appointed to the Cranbrook faculty was Robert D. Sailors in 1944, as assistant instructor to Strengell for the powerloom weaving courses. The names of Ed Rossbach and Jack Lenor Larsen should also be singled out among the talented textile designers to graduate from the school, dubbed the American Bauhaus.

NOTES

1 Joan Campbell, *The German Werkbund. Politics of Reform in the Applied Arts*, Princeton University Press, Princeton, N.J., 1978, pp. 56, 205.

2 They included the Vereinigte Smyrna-Teppich-Fabriken in Berlin-Cottbus, and Gebrüder Schoeller in Düren. For a complete list, see *Offizieller Katalog der Deutsche Werkbund Austellung Köln 1914*, Cologne, 1914; fascimile reprint by Wienand, n.d.

3 Herbert Bayer, Walter Gropius, Ise Gropius, *Bauhaus 1919–1928*, Museum of Modern Art, New York (exhibition catalogue), 1938, p. 2.

4 Magdalena Droste, *Gunta Stölzl. Weberei am Bauhaus und aus eigener Werkstatt*, Bauhaus Archives, Berlin (exhibition catalogue), 1987, p. 12.

5 Christian Geelhaar, *Paul Klee and the Bauhaus*, Adams & Dart, Bath, 1973, p. 35.

6 Theo Van Doesburg, 'Oude en Nieuwe Textiel-Kunst/L'Art Textile Jadis et Aujourd'hui', *Interieur* (Amsterdam), 1930, p. 1696; 1931, pp. 18–20 and 66–69.

7 Anni Albers earned her Bauhaus diploma by designing a sound-absorbing textile for the school hall in the Bundesgewerkschaft School, Bernau.

8 In *Lust zu Weben*, a manuscript conserved by the Bauhaus archives, quoted in Droste 1987, p. 10.

9 Presently on loan to the Bauhaus archives in Berlin, and illustrated in Droste 1987, pp. 68–69, and in Sigrid Wortmann Weltge, *Bauhaus Textiles. Women Artists and the Weaving Workshop*, Thames & Hudson, London, 1993, col. pl. 4.

10 Illustrated in Bayer, Gropius and Gropius 1938, p. 145, the carpet is described as 'Smyrna wool', a contradiction in terms. This particular rug is flatweave, and not pile as implied by the term 'Smyrna'.

11 Droste 1987, pp. 14, 97.

12 Letter to Bernd Grönwald, published in *Form und Zweck*, no. 5, 1981, quoted in Droste 1987, p. 20.

13 Droste 1987, p. 21.

14 An exhibition devoted to the work of Anni Albers was organized by the Musée des Arts Décoratifs, Paris, in 1999.

15 See for example the German rugs illustrated in Cornelia Bateman Faraday, *European and American Carpets and Rugs*, Dean Hicks & Co, Grand Rapids, 1929, pp. 467–69 (reissued by Antique Collectors Club, Woodbridge, 1990).

16 The originals have not survived, but two samples in ivory and brown bouclé yarns have been rewoven by Müller-Hellwig for the Bauhaus Archives, Berlin.

17 *Suisse. Exposition Internationale des Arts Décoratifs et Industriels Modernes Paris 1925. Catalogue*, n.d., 2nd ed., p. 85, no. 156. The carpet is a flatweave and not an embroidery as described in the catalogue.

18 The intended use of working drawings for textiles in the Arp Foundation, Bonn, remains ambiguous.

19 Le Corbusier, 'Des yeux qui ne voient pas...les paquebots', *L'Esprit Nouveau*, no. 8, n.d. (1921), n.p.

20 Illustrated in *L'Architecture d'Aujourd'hui*, July 1937, p. 72.

21 *Charlotte Perriand. Un Art de Vivre*, Musée des Arts Décoratifs, Paris (exhibition catalogue), 1985, p. 25.

22 Le Corbusier, *L'Art Décoratif d'Aujourd'hui*, Paris, 1925 (reprinted 1980), p. 90.

23 In *Bulletin de la Vie Artistique*, 15 July 1925, quoted in Yvonne Brunhammer and Suzanne Tise, *The Decorative Arts in France 1900–1942*, Rizzoli, New York, 1990, pp. 111–12.

24 Pierre Francastel and Guy Habasque, *Robert Delaunay, du Cubisme à l'Art Abstrait*, S.E.V.P.E.N., Paris, 1957, p. 29.

25 Robert Delaunay, quoted in Francastel and Habasque 1957, p. 42.

26 Quoted in the catalogue of the exhibition *Les Années UAM* organized by Chantal Bizot, Yvonne Brunhammer and Suzanne Tise at the Musée des Arts Décoratifs, Paris, 1987, n.p.

27 The interior decorator Nicolas Muratore used this model on his stand at the Salon des Artistes-Décorateurs in 1927. The design was reissued by the Galerie Jacques Damase in 1967.

28 Van Doesburg 1931, p. 1873.

29 Jean Arp's carpet designed with a pattern of concentric ovals divided by randomly drawn lines which provoke a reversal of the chromatic values is illustrated in Van Doesburg 1931, p. 1832.

30 Originally published in Maurice Matet, *Tapis*, Paris, n.d., pl. 12 A, B, the original projects are presently in the holdings of the Victoria and Albert Museum. *Bobadilla* has been reissued by Ecart International under the name *Collage*.

31 Peter Adam, *Eileen Gray, Architect, Designer*, Thames & Hudson, London, 1987, p. 63.

32 Quoted in Adam 1987, p. 135.

33 See Cécile Briolle, Agnès Fuzibet, Gérard Monnier, Robert Mallet-Stevens, *La Villa Noailles. Paris*, Editions Parentheses, Marseilles, 1990.

34 Adam 1987, p. 244.

35 Hedwig Jungnickel's work was incorrectly attributed to Walter Gropius by Sonia Delaunay in *Tapis et Tissus*, Editions Charles Moreau, Paris, n.d. (1929), pl. 42–2.

36 Delaunay n.d. (1929).

37 Bonney 1929, pp. 197–98.

38 See Marc Vellay, Kenneth Frampton, *Pierre Chareau*, Thames & Hudson, London, 1986, p. 221.

39 Inv. 38.606B. Incorrectly attributed to Mallet-Stevens in the catalogue of the exhibition 'Le Vingtième Siècle au Tapis' held in Aubusson in 1991, p. 52. The attribution to Burkhalter is upheld by the Musée des Arts Décoratifs, and by *Art et Décoration*, June 1929, p. 180.

40 Bonney 1929, p. 186.

41 Louis Cheronnet, *Jacques Adnet*, Art et Industrie, Paris, 1948, n.p.

42 A. H. Martinie, 'Les Tissus et Papiers Peints d'Eric Bagge', *Art et Décoration*, 1929, p. 141.

43 Paul-Sentenac, 'Les Meubles et les Tapis de Renée Kinsbourg', *Renaissance*, March 1929, p. 150.

44 Bonney 1929, p. 191.

45 See the Wyld archives (attributed to Gray) in the Royal Institute of British Architects, London.

46 Many of these designs, presently in the archives of the Royal Institute of British Architects, are straight copies of Eileen Gray's work.

47 This particular model by Wyld was also chosen by the architects H. and S. Barberis for their stand at the 1925 International Exhibition. See Maurice Dufrène, *Ensembles Mobiliers*, Editions Charles Moreau, Paris, n.d., vol. I, pl. 21.

48 Illustrated in Guy Bujon, Jean-Jacques Dutko, *E. Printz*, Editions du Regard, Paris, 1986, pp. 135, 144, 194 and 196. The attribution to Wyld is based on photographs of the rugs in her archives conserved in the RIBA, London.

49 See *L'Architecture Vivante*, winter 1929, pls. 32, 34, 37, 49, 50 and 54.

50 The original does not appear to have survived. To judge by a contemporary photograph, illustrated in Adam 1987, p. 209, the white motifs would appear to have been executed in tufted pile to stand out against a flatweave ground.

51 'E1027' represented the combined initials of Gray and Badovici: 'E' for Eileen; '10' and '2' for the tenth and second letters of the alphabet representing Badovici's initials; and '7' for Eileen's surname.

52 Information kindly supplied by Peter Adam.

53 Cuttoli claimed that Jean Lurçat began working for her in 1921; the artist, on the other hand, stated that he began to design tapestries for Cuttoli in 1923. See Jean Lurçat, *Tapisserie française*, Bordas, Paris, 1947, p. 39.

54 Illustrated in Matet, op. cit., pl. 23 A. Maurice Matet's publication is undated, but Picasso's carpet may be dated approximately to this time by other pieces reproduced in the album. Picasso designed his first tapestry cartoon, *The Minotaur*, for Cuttoli in January 1928. It was executed by the Manufacture des Gobelins in 1935.

55 Bonney 1929, p. 197.

56 Mildred Constantine, Albert Châtelet, *An Exhibition of Contemporary French Tapestries*, Slatkin Galleries, New York, 1965, p. 6. Fine tapestries were included in the catalogue, but most of the pieces described as tapestries are in fact pile rugs.

57 Bonney 1929, p. 197.

58 Hans Wichmann, *Von Morris bis Memphis. Textilien von der Neuen Sammlung Ende 19 bis Ende 20 Jahrhundert*, Birkhäuser, Basel, 1990, p. 200.

59 Martin Eidelberg, 'Biomorphic Modern', in *What Modern Was*, Musée des Arts Décoratifs, Montreal (exhibition catalogue), 1991, pp. 88–95.

60 Since donated to the Musée des Arts Décoratifs, Paris.

61 Paul Fierens, 'L'Exposition des Arts Décoratifs à Stockholm', *Art et Décoration*, September 1930, p. 86.

62 Unfortunately none of the early pieces have yet come to light. If one is to judge by contemporary photographs, it would seem that Gray was transposing collages into textile form by varying the lengths of the pile by the early twenties. In a carpet published in *Wendingen*, 1924, p. 10, the pile of the dark cut-out shapes appears longer than the lighter ground.

63 Félix Marcilhac, *Jean Dunand, His Life and Works*, Thames & Hudson, London, 1991, p. 90.

64 The same design was also woven in coloured yarns. See the example sold by Sotheby's, Monaco, 25 May 1980, lot 85.

65 *The Studio* and *Good Furniture Magazine* were among the magazines who wrote to her requesting documentation for future publication. Royal Institute of British Architects, London, Wyld archives (attributed to Eileen Gray).

66 Compare Gray's rug, reproduced in Delaunay, *Tapis et Tissus*, pl. 22A, with the work by Vordemberge-Gildewart illustrated in Hans Jaffé, *De Stijl 1917–1931. The Dutch Contribution to Modern Art,* Harvard University Press, Cambridge, Mass., 1986, fig. 45.

67 The design was published by Matet, op. cit., pl. 36. Matet's album was undated but included models by other designers published elsewhere by this date.

68 The date at which she began doing so is in dispute. An advertisement in *Art et Industrie* in 1936 claims that the workshop began using rayon in 1915. In her master's thesis, *Hélène Henry, ses Tissus*, Université de Paris X, Nanterre, 1986, Catherine Jarrosson-Berthoud states on p. 19 that Henry had little or no previous weaving experience prior to opening her workshop in February 1923. The weaver herself, on the other hand, informed the journalist Renée Moutard-Uldry, in 'Hélène Henry', *Mobilier et Décoration*, vol. 34, 1954–57, p. 316, that she set up her atelier in 1920.

69 Quoted in Susan Day, *Louis Süe. Architectures*, Institut Français d'Architecture, Paris; and Pierre Mardaga, Brussels, 1986, p. 69.

70 Waldemar-George, *André Arbus*, Art et Industrie, Paris, 1948, n.p.

71 F(abien) S(ollar), 'Notre Enquête. Evolution ou Mort de l'Ornement?', *Art et Décoration*, 'Les Echos d'Art', vol. LXII, July 1933, pp. i–iv.

72 See for example the carpets laid in the office and bedroom designed by Ruhlmann illustrated in Maurice Dufrène, *Ensembles Mobiliers*, Ch. Moreau, Paris, n.d., vol. I, pl. 3–4.

73 Félix Marcilhac, *André Groult, Décorateur-Ensemblier du XXe siècle*, Editions de l'Amateur, Paris, 1997, p. 244–45.

74 Woven by the Tapis de Cogolin, which conserves a preparatory drawing, the final version was executed slightly differently. See Louis-René Vian, *Arts Décoratifs à Bord des Paquebots Français*, Eds. Fonmare, Paris, 1992, pp. 192, 196, 275.

75 Jean Babonneix, *La Crise d'une Vieille Industrie. Le Tapis et la Tapisserie d'Aubusson*, Paris, 1935, p. 153.

76 Edmond Labbé, *Exposition Internationale des Arts et Techniques dans la Vie Moderne (1937). Rapport Général*, Paris, 1939, vol. 6, p. 145.

77 Jean Teugels, 'Le Studio de Saedeleer', *Sélection. Chronique de la Vie Artistique et Littéraire*, vol. 5, no. 4, January 1926, p. 279. I would like to express my thanks to Marijke Detremmerie, curator at the Museum voor Sierkunst in Ghent, for bringing this article to my attention.

78 Sibylle Valcke, 'Le Studio de Saedeleer', in Pierre Loze, Dominique Vautier, *Art Déco Belgique 1920–1940*, exhibition organized by Pierre Loze and Dominique Vautier at the Musée d'Ixelles, Brussels, 1988, p. 214.

79 Jean Teugels, 'Le Studio de Saedeleer', *Sélection. Chronique de la Vie Artistique et Littéraire*, vol. 5, no. 4, January 1926, p. 284.

80 Information kindly supplied by Anne Van Loo, former curator of the Musée d'Architecture in Brussels. Baugniet's stand at the 1930 La Louvière exhibition is reproduced in *Akarova. Spectacle et Avant-Garde 1920–1950*, Archives d'architecture moderne, Brussels, 1988, p. 211.

81 When de Koninck was dissatisfied with the original manufacturer's version of the carpet he designed for the Gobert Villa, he had the rug executed by the Studio de Saedeleer. For further details, see *Louis Herman de Koninck. Architecte des Années Modernes*, Archives d'Architecture Moderne, Brussels, 1989, pp. 228–31.

82 *Thirties: British Art and Design Before the War*, catalogue of the exhibition at the Hayward Gallery, London, 25 October 1979–13 January 1980, p. 73.

83 Dorn was offered a directorship of the factory in 1933. She declined, but would appear to have acted as consultant. Information kindly supplied by Gill Coveney, curator of the Wilton Royal Museum.

84 At one point, McKnight Kauffer shared a studio with Man Ray. See Martin Eidelberg, ed., *Design 1935–1965. What Modern Was*, catalogue of the exhibition organized by David A. Hanks Associates Inc. for the Musée des Arts Décoratifs, Montreal, 1991, p. 379.

85 Nikolaus Pevsner, 'The Designer in Industry, I. Carpets', *Architectural Review*, April 1936, p. 187.

86 In *De Stijl*, vol. III, pp. 58–59, quoted in Hans Jaffé, *De Stijl 1917–1931. The Dutch Contribution to Modern Art*, Harvard University Press, Cambridge, Mass., 1986, pp. 162–63.

87 Theo Van Doesburg, 'Oude en Nieuwe Textiel-Kunst/L'Art Textile Jadis et Aujourd'hui', *Interieur*, vol. 48, 1930, pp. 1651–57, 1695–97, 1784–87, 1825–33, 1867–74 and vol. 49, 1932, pp. 12–21 and 65–70.

88 Illustrated in Sjarel Ex, Els Hoek, *Vilmos Huszár. Schilder en Ontwerper 1884–1960. De Grote Onbekende van De Stijl*, Reflex, Utrecht, 1985, fig. 92, p. 65.

89 According to information kindly supplied by the curator, Dr Marjan Boot, these may have been woven in Hans Polak's Het Paapje workshop.

90 R. W. D. Oxenaar, E. L. de Wilde, *Bart Van der Leck 1876–1958*, Rijksmuseum Kröller-Muller, Otterlo, 1976, n.p. (exhibition catalogue).

91 The author would like to acknowledge her debt to Petra Dupuits-Timmer, who was kind enough to pass on information on Metz & Co. taken from her doctoral thesis on the firm (Vrije Universiteit, Amsterdam).

92 The date at which this began is uncertain. I would like to express my thanks to Mrs Gina de Leeuw and Matteo de Monti for allowing me access to their archives and for their invaluable assistance with the carpets designed for Metz & Co.

93 Illustrated in Sonia Delaunay 1929, pl. 16.

94 A flatweave tapestry with a supplementary pattern weft, the MMF technique was not used for making floor coverings.

95 Quoted in Jocelyn Morton, *Three Generations in a Family Textile Firm*, Weidenfeld & Nicolson, London, 1971, p. 288.

96 Nils G. Wollin, *Svenska Textilier 1930. Swedish Textiles 1930. Textiles Suédois 1930*, Utställningsförlaget, Stockholm, 1930, p. 24.

97 American Federation of Arts, *Catalogue. International Exhibition. Contemporary Glass and Rugs*, Southworth Press, Portland, Maine, 1929, n.p.

98 Illustrated in Wollin 1930, figs 105, 106.

99 Information kindly supplied by Dr Barbro Hovstadius, curator at the Nationalmuseum, Stockholm.

100 Hans Lassen, 'A Novel Branch in Art: the Modern Danish Knotted Rug', *Haandarbejdets Fremme*, no. 2, 1962–63, pp. 35–38.

101 Curiously, however, no Bauhaus weavings were selected for inclusion.

102 American Federation of Arts, *Catalogue. International Exhibition. Contemporary Glass and Rugs*, Southworth Press, Portland, Maine, 1929, n.p.

103 Of these ten designs, only Stuart Davis's *Flying Carpet* is still made. Interview with Ellen Herzmak, V'Soske Inc., 14 November 1990.

BIOGRAPHIES OF ARTISTS, MANUFACTURERS AND RETAILERS

Names marked with an asterisk (*) have separate entries in this section.

ADNET, JACQUES Châtillon-Coligny (Loiret) 1900–Paris 1984
French designer, trained at the Ecole Nationale Supérieure des Arts Décoratifs, Paris. From 1922 to 1928, Jacques and his twin Jean worked for the Atelier La Maîtrise* at the Galeries Lafayette, Paris, directed by Maurice Dufrène*. In 1928 Jacques was appointed director of the Compagnie des Arts Français*, while his brother remained at the department store as artistic director. Important interiors by Jacques Adnet include Frank J. Gould's town house, the Saint Gobain pavilion at the 1937 International Exhibition in Paris (with René Coulon, architect), the president's office in the Château de Rambouillet (1947) and the liner *Ferdinand de Lesseps* (1952). From 1959, he ran the Ecole des Arts Décoratifs, Paris. Once independent, Adnet abandoned Art Deco for a streamlined Modernist style. Early carpets by the Adnet brothers are signed jointly JJA. From 1928, Jacques Adnet signed himself JA. **Sources:** Henri Clouzot, 'Jacques Adnet, Décorateur', *Mobilier et Décoration*, August 1932, p. 355; Louis Cheronnet, *Jacques Adnet*, Art et Industrie, Paris, n.d. (c. 1950).

À LA PLACE CLICHY see GRANDS MAGASINS À LA PLACE CLICHY

ALBERS, ANNELIESE (ANNI, née FLEISCHMANN)
Berlin-Charlottenberg 1899–Orange (Conn.) 1994
German weaver, textile designer and printmaker, naturalized American. Studied at the Kunstgewerbeschule, Hamburg, then enrolled at the Bauhaus (1922). She was taught theory by Itten* and Klee* and experimental weaving techniques by Gunta Stölzl*. In 1933 she emigrated to the United States with her husband and fellow student, the sculptor Josef Albers. From 1933 to 1949, she taught weaving at Black Mountain College, North Carolina. She wrote several books and was the first weaver to be honoured with a solo exhibition at the Museum of Modern Art, New York, in 1949. She began printmaking in 1963. **Sources:** Nicolas Fox Weber, M. J. Jacob, R. S. Field, *The Woven and Graphic Art of Anni Albers*, Smithsonian Institution, Washington, D.C., 1985 (exhibition catalogue).

ALFOMBRAS Y TAPICES AYMAT, S.A.
Spanish tapestry and carpet-weaving workshop founded in 1920 in Sant Cugat del Vallès by Tomàs Aymat Martínez (1892–1944), who was also chief designer. The workshop's tapestries and carpets were displayed at the Paris salons and at the 1925 International Exhibition. Many were woven from works by the great masters of 20th-century painting. Production was interrupted during the Spanish Civil War (1936–39), and from 1947 until 1954, when it was revived by Miguel Samaranch, who managed the workshop until its closure in 1980. **Sources:** Josep Llorens Artigas, *Tomàs Aymat*, Barcelona, 1926; information supplied by Mercé Viñas de Samaranch.

ALIX, CHARLOTTE see SOGNOT ET ALIX

ARBUS, ANDRÉ Toulouse 1903–Paris 1969
French designer, sculptor and architect. Trained at the Ecole des Beaux-Arts, Toulouse, and in his family's cabinetmaking workshop. In 1930, he moved to Paris and founded the Galerie L'Epoque. His elegant interiors designed for a wealthy elite were shown at the Paris salons. A prototype for a single-family house shown at the 1937 International Exhibition launched his career as an architect. Arbus designed liner interiors for the *Provence* (1951), the *Bretagne* (1952), the *Lebourdonnais* (1952) and the *Viet-Nam* (1952) and several luxury suites for the Mobilier National, including the presidential apartments in the Château de Rambouillet. He taught decorative arts at the Ecole des Arts Décoratifs and sculpture at the Ecole des Beaux-Arts, Paris. Arbus's rugs are designed to harmonize with his interiors in the French classical tradition. Braquenié*, Hamot* and the Tapis de Cogolin* commissioned designs from him. **Sources:** Waldemar-George, *André Arbus*, Art et Industrie, Paris, 1948; Yvonne

Brunhammer and Marie-Laure Perrin, *André Arbus. Architecte-Décorateur des Années Quarante*, Editions Norma, Paris, 1996.

ARP, JEAN (HANS) Strasbourg 1887–Basel 1966
Painter, sculptor and designer of German birth, naturalized French (1926). Studied at the Academy of Fine Arts, Weimar, and the Académie Julian, Paris. Arp forged links with many avant-garde movements, including Der Blaue Reiter, Dada, the Surrealists and Abstraction-Création. He designed silverware for Christofle and textiles and tapestries with his wife, Sophie Taeuber-Arp*, and the Aubette Dance hall and cinema (1926), Strasbourg, in collaboration with Taeuber-Arp and Theo Van Doesburg. From around 1927 to 1940, the couple lived in Meudon, today the headquarters of the Arp Foundation. At least seven carpets were woven from works by Arp, five by the Maison Myrbor* from the late twenties onwards. Some echo the biomorphic forms of his sculptures. **Sources:** Jane Hancock, Stefanie Poley, *Arp 1866–1966*, Musée d'Art Moderne de la Ville de Paris, Paris, 1986 (exhibition catalogue); *Tapis de Maîtres*, Galerie Weill-Seligman, Paris, n.d.

ATELIER DE LA DAUPHINE see FAYET, GUSTAVE

AUBUSSON (Creuse)
Town in central France famed since the Middle Ages for the manufacture of fine tapestry. The weaving of carpets dates only from 1742, when Louis XV's minister of finance, Jean-Henri-Louis Orry de Fulvy, perceived the potential demand for 'tapis de Turquie' which neither the royal Savonnerie* workshops nor foreign imports (mainly from Anatolia) could satisfy. The venture was subsidized by the crown until 1746, when Paris entrepreneurs Pierre Mage and Jacques Dessarteaux took over the workshops. The first pile carpets were inspired by Turkish models, but through the work of *peintre-cartonniers* Pierre-Josse Perrot and Louis-Joseph Le Lorrain, the style soon became uniquely French. By the end of the century, production had diversified to include needlepoint, *moquette* and tapestry-weave or 'Aubusson' rugs and the number of workshops had increased beyond a cottage industry. The prosperity enjoyed by Aubusson and its neighbour Felletin during the first half of the 19th century can be largely attributed to carpet manufacture, but productivity declined under the double blow inflicted by the 1848 revolution coupled with competition from the British. Attempts were made to improve the aesthetic standards of handwoven carpets, to a great extent limited to revival styles, by founding schools of decorative art intended to train the *cartonniers*. In 1867 Sallandrouze Frères* imported powerlooms and a colony of British workers from Kidderminster to operate them. In the 20th century, designers including Antoine Jorrand, Maurice Dufrène* and Paul Follot* gave the handwoven carpet industry new impetus. Until recession struck in the thirties, large quantities were made by firms such as Braquenié*, Pinton*, Lauer* and Hamot*. Two new factories were also founded in nearby Bourganeuf by Marcel Coupé* and Fernand Windels*. **Sources:** Francis Leconte, *Une Industrie de Luxe. L'Industrie du Tapis à la Main à Aubusson*, doctoral thesis, Dijon, 1910; Madeleine Jarry, *The Carpets of Aubusson*, F. Lewis, Leigh-on-Sea, 1969.

AUX FABRIQUES D'AUBUSSON see CROC & JORRAND

AYMAT, TOMÀS see ALFOMBRAS Y TAPICES AYMAT, S.A.

BACKHAUSEN UND SÖHNE, Vienna and Hoheneich
Austrian textile manufacturer, founded in 1849 in Gumpendorf by Karl and Johann Backhausen, sons of a German weaver. A new plant was built in Hoheneich in 1870, when carpet production began. Several grades of hand-knotted 'Smyrna' carpets were woven by hand; Wilton and Brussels powerlooms were installed towards the end of the 19th century. Early production was limited to revival styles, but contact with artists from the Secession inspired the firm to orient its output towards modern design

and produce its own lines of carpets and fabrics designed by in-house and freelance designers, particularly those from the Wiener Werkstätte*. Suspended during the Second World War, production recommenced in 1955 and still continues today. **Source:** Backhausen archives, Vienna.

BACON, FRANCIS Dublin 1909–Madrid 1992

British painter, largely self-taught. After a stint in Berlin and Paris, where he discovered the avant-garde, he returned to London in 1929 and set up a studio at 17 Queensberry Mews, earning his living as an interior decorator. A joint exhibition in 1930 with painter Roy de Maistre displayed his paintings and rugs to the public. Bacon is known to have designed at least seven carpets, all Cubist patterns, woven by the Wilton Royal Carpet Factory*, before he gave up design to paint full-time. **Sources:** *The Studio*, August 1930; *Thirties: British Art and Design before the War*, Hayward Gallery, London, 1979 (exhibition catalogue); David Sylvester et al., *Francis Bacon*, Centre Georges Pompidou, Paris, 1996 (exhibition catalogue).

BAGGE, ERIC Antony (Seine) 1890–Paris 1978

French architect and decorator of Swedish origin. From 1919 Bagge showed his interiors at the Salon d'Automne and the Société des Artistes-Décorateurs and worked for interior decoration studios, including La Maîtrise*. Together with René Prou* he designed the boudoir and bathroom in the 'Ambassade Française' pavilion at the 1925 International Exhibition. In 1929, he was appointed artistic director of the Palais de Marbre, the furniture store of Mercier Frères. His work as an architect includes apartment buildings, townhouses, the church of Saint-Jacques in Montrouge and several stands at the 1937 International Exhibition. Textile manufacturers who commissioned designs from him included Rodier, the MFTC* and Lucien Bouix*, with whom he signed an exclusive contract in 1928. His early carpet designs, such as the one for the stateroom on the *Ile-de-France* (1927) are characteristically Art Deco. His mature style, seen in the metered fabrics, carpeting and handwoven carpets he designed for Bouix*, consisted of symmetrical abstract patterns, with occasional use of stippled and rainbow motifs. **Sources:** G. Rémon, 'Les Tissus d'Eric Bagge édités par Lucien Bouix', *Mobilier et Décoration*, May 1929; A. H. Martinie, 'Les Tissus et Papiers Peints d'Eric Bagge', *Art et Décoration*, November 1929; G. Rémon, 'Nouvelles Conceptions du Tapis Moderne', *Mobilier et Décoration*, November 1930.

BAUCHER, RENÉ Bavilliers (Belfort) 1902–Brussels 1983

French painter and designer, a student of the sculptor Edouard Navellier. During the twenties Baucher showed his pictures at the annual Paris salons and worked for the Atelier Pomone*; there, he met his future wife, Belgian artist Sylvie Féron (1898–1984), with whom he founded a design studio, first in Paris (1928), then in Brussels (1933). The couple designed functional interiors for shops, schools, hospitals, offices and banks in Belgium and the Congo, and their furnishings were sold with the work of other avant-garde designers in their store, Baucher et Féron, until 1980. **Sources:** *Dictionnaire Biographique des Artistes en Belgique depuis 1930*, Arto, Brussels, 1987; *Mobilier et Décoration*, June 1931.

BAUGNIET, MARCEL-LOUIS Liège 1896–Brussels 1995

Belgian painter, designer and art critic. A student of Symbolist painter Jean Delville at the Academy of Fine Arts, Brussels, Baugniet turned to abstraction after discovering the work of the Constructivist and De Stijl movements. With Pierre-Louis Flouquet and Karel Maes* he co-founded the avant-garde magazine *7 Arts* (1923) and later the group *L'Assaut*. In 1930 he opened an interior decoration store, Baugniet et Cie, in Brussels and began to design functional furniture in tubular metal, lighting and stained-glass windows. His Standax modular furniture was exhibited at the 1937 International Exhibition in Paris. He also designed sets and costumes for his wife, the ballet dancer Akarova, in addition to Modernist carpets with starkly simple patterns or textured effects. **Sources:** *Marcel-Louis Baugniet. 50 Jahre Konstructivismus*, Belgisches Haus, Cologne, 1976 (exhibition catalogue); Anne Van Loo, ed., *Akarova. Spectacle et Avant-Garde 1920–1950*, Archives d'Architecture Moderne, Brussels, 1988.

BEAUMONT, JEAN (GEORGES or JEAN-GEORGES) Elbeuf (Seine-Inférieure) 1895–Paris 1978

French artist and textile designer. Between 1919 and 1939, Beaumont worked for the Atelier La Maîtrise* and showed his work at the annual Paris salons and the Musée Galliera. He designed porcelain for the Manufacture de Sèvres, as well as enamels, lacquer, posters and screens, but he specialized in textiles. In addition to creating tapestries for the Manufacture de Beauvais and Aubusson* firms, Beaumont designed fabrics for Tassinari et Chatel and Cornille et Cie and carpets for Braquenié*, Hamot*, Bouix* and Aux Fabriques d'Aubusson*. His repertoire consisted mainly of lush floral designs. **Sources:** Susan Day, *Allgemeines Künstlerlexikon*, vol. VII, Saur, Leipzig, 1993; F(abien) S(ollar), 'Tapis', *Echos d'Art*, January 1931.

BELL, VANESSA London 1879–Firle, Sussex 1961

British painter and decorator trained at the Royal Academy school. Elder sister of Virginia Woolf and wife of Clive Bell, she was an intimate of the Bloomsbury Group. From 1913, Bell designed numerous avant-garde decorative schemes, textiles, pottery and accessories for the Omega Workshops*, of which she was a co-director along with Roger Fry and Duncan Grant*. After the firm was liquidated in 1919, Bell and Grant collaborated on decorative schemes that included the murals for Berwick Church in Sussex and interiors for the liner *Queen Mary*. Her carpets were woven by the Wilton Royal Carpet Factory*. Bell designed textiles for several British manufacturers, including Allan Walton*, as well as costumes and theatre sets. **Source:** Frances Spalding, *Vanessa Bell*, Weidenfeld & Nicolson, London, 1983.

BÉNÉDICTUS, ÉDOUARD Paris 1878–Paris 1930

Born in Paris to Dutch parents, Bénédictus was a descendant of the philosopher Spinoza. Trained as a painter, he was also a musician, composer, poet, chemist and the inventor of 'Triplex' glass. He worked as an illustrator for the magazine *Art et Décoration* (1903–10) and published several pattern books, including *Variations* (1923), *Nouvelles Variations* (1926) and *Relais* (1930). The Tapis de Cogolin*, the Grands Magasins à la Place Clichy*, the MFTC*, the Ateliers BAG, La Maîtrise*, D.I.M.*, Brunet-Meunié*, Aux Fabriques d'Aubusson* and Templeton's* were among the many manufacturers and retailers who wove carpets from his designs. Bénédictus's designs evolved from a floral style to the abstract language that he adopted shortly before his death. **Sources:** Gaston Varenne, 'Tapis et Tissus de Bénédictus', *Art et Décoration*, April 1924; Marie-Noëlle de Gary, *Rythme et Couleur de l'Art Déco. Edouard Bénédictus*, Musée des Arts Décoratifs, Paris, 1986 (exhibition catalogue).

BERGER, OTTI Zmajavac-Baranta, Croatia 1898–Auschwitz, Poland 1944

Croatian weaver and textile designer. Trained at the Academy of Art in Zagreb (1921–26) and at the Bauhaus (1927–30) under László Moholy-Nagy, Paul Klee*, Vasily Kandinsky and Gunta Stölzl*. Under Lilly Reich, she briefly headed the Bauhaus weaving workshop. From 1932 she ran her own laboratory in Berlin, working as an industrial designer and consultant. After emigrating to England in 1937, Berger worked as a freelance but returned to her homeland via Prague in 1939 and was deported to Auschwitz, where she died. **Source:** Sigrid Wortmann Weltge, *Bauhaus Textiles. Women Artists and the Weaving Workshop*, Thames & Hudson, London, 1993.

BERGNER, LÉNA (HELENE) Coburg 1906–Baden Soden 1981

German weaver and textile designer. She trained at the Bauhaus, studied dyes at the Dye School in Sorau, and went on to head the Bauhaus dye workshop (1929). After emigrating to Russia with her husband, the architect Hannes Meyer, she directed the East Prussian Handweaving Studio in Königsberg (now Kaliningrad). The couple then

settled in Switzerland, where she wove rugs from her own designs (1936–39). Exiled in Mexico during the war, Bergner worked as a textile and graphic designer before returning to Switzerland permanently in 1949. **Source:** Sigrid Wortmann Weltge, *Bauhaus Textiles: Women Artists and the Weaving Workshop*, Thames & Hudson, London, 1993.

BERNADOTTE, SIGVARD Stockholm 1907–Stockholm 2002
Swedish architect, set designer and industrial designer. Son of King Gustavus VI Adolphus and Princess Margaret, Bernadotte studied at the University of Uppsala and the Stockholm School of Art. From 1930, he designed silverware for the firm Georg Jensen of Copenhagen, of which he later became director. He founded a design studio with Acton Björn in Copenhagen (1949–64), then worked independently, designing film sets, bookbindings, porcelain, glass, furniture, camping plastics and heavy machinery. President of the International Council of Societies of Industrial Design (1961–63), Bernadotte was influential in establishing the profession of industrial design in Europe. A range of his fabrics and handwoven carpets was issued by the Stockholm firm of Nils Nessim. The colour schemes, in shades of red, silver-grey and moss green, were inspired by the Swedish landscape. **Source:** Ann Lee Morgan, Colin Naylor, eds., *Contemporary Designers*, Macmillan, London, 1984.

BIGELOW CARPET CO., Lowell (Mass.)
American carpet manufacturer. In 1837, Alexander Wright of the Lowell Manufacturing Co. asked Erastus Brigham Bigelow (1814–79), inventor of the first powerloom for making coach lace, to adapt the mechanism for carpet looms. Bigelow succeeded first in adapting two-ply ingrain and later Brussels and Wilton carpeting to powerlooms, patented in 1846. In 1848, Bigelow and his brother Horatio N. Bigelow acquired exclusive rights to manufacture Brussels strip carpeting in America, and in 1850 set up mills in Lowell (Mass.) and Derby (Conn.). In 1899 Bigelow merged with Lowell Manufacturing Co. and in 1929 with the John Sanford Company. Today the firm is part of the Karastan-Bigelow group. The firm wove designs by Ruth Reeves* and Henrietta Reiss. **Source:** John S. Ewing, Nancy P. Norton, *Broadlooms and Businessmen. A History of the Bigelow-Sanford Carpet Company*, Harvard University Press, Cambridge, Mass., 1955.

BOBERMAN, VLADIMIR (VOLDEMAR)
Erivan, Caucasus 1897–Ibiza, Spain 1977
Painter and decorator of Armenian origin, naturalized French. From 1919, Boberman showed his pictures at the Salon des Indépendants and interiors designed with Jacques Mottheau at the Salon d'Automne. Specializing in textile design, Boberman created tapestry cartoons for the Manufacture Nationale des Gobelins, designed the carpet of the Scala Theatre in Milan and produced well over forty carpet designs for D.I.M.*, which published an album of his working drawings in around 1929. The MFTC*, Tapis de Cogolin* and Braquenié* also commissioned work from him. A follower of abstraction, he also drew inspiration from African folklore and favourite pastimes like hunting, travel, sports, music, card games and even smoking accessories. In the post-war period, he occasionally produced figurative designs, the precise draughtmanship contrasting sharply with his pre-war style. **Sources:** Nath Imbert, *Dictionnaire National des Contemporains*, Editions Lajeunesse, Paris, 1936; Maurice Raynal (pref.), *Idées Décoratives Nouvelles. V. Boberman. Tapis édités par D.I.M.*, Paris, n.d.; G. Rémon, 'Tapis de Boberman édités par D.I.M.', *Mobilier et Décoration*, July 1929; 'Le Tapis', *Ce-Temps-Ci. Cahiers d'Art Contemporain*, October 1929.

BOICEAU, ERNEST Lausanne 1881–Essonne 1950
Swiss designer based in Paris. Trained in Munich and at the Ecole des Beaux-Arts, Paris, Boiceau founded an embroidery and tapestry workshop in 1910 which supplied the great couture houses and the theatre. In 1925, he opened his own Paris couture

house, followed by a design studio on the avenue Matignon (1933). His finely crafted luxury furniture and accessories were sold in France, Switzerland, Belgium and America. Easily identifiable, his carpets show great technical and aesthetic originality. Often signed, his designs range from medallion and animal rugs to symmetrical kaleidoscopic and abstract compositions and plans of buildings. Some have a Chinese influence, some are neoclassical, and others are inspired by Aubusson models. Boiceau liked to experiment with new weaving techniques and successfully adapted the Cornély stitch, a semi-mechanized embroidery technique, to carpet manufacture. **Sources:** *Ernest Boiceau, André Arbus, Masters of French Style*, Barry Friedman Gallery, New York, 1989 (exhibition catalogue); Patrick Mauriès, 'Style. Un Néo-classicisme Distingué', *Maison et Jardin*, no. 412, 1995.

LUCIEN BOUIX, Paris and Lyons
French manufacturer of furnishing fabrics, tapestry and carpets. Founded as Junquet et Bouix in 1854, the firm displayed its products at many international exhibitions. For many years Bouix himself was honorary president of the Chambre Syndicale de Tissus d'Ameublement, but the firm was forced into liquidation sometime after the Second World War, unable to compete with competition from the third world. Eric Bagge*, Jean Beaumont*, Yvonne Fourgeaud* and Auguste Thomas all designed carpets and carpeting for the firm. **Sources:** Archives Nationales F12/8529; *Exposition Universelle et Internationale de Gand* (1913); *Art et Industrie*, October 1929.

BOUTIQUE PIERRE CHAREAU see **CHAREAU, PIERRE**

BRACQUEMOND, PIERRE Paris 1870–1926
French painter and interior decorator, who studied under his parents, painters Félix and Marie Bracquemond, at the Ecole des Beaux-Arts. A set of furniture commissioned by the Mobilier National and designed by his father was upholstered in tapestries designed by both father and son. Pierre Bracquemond designed over seventy different carpets in floral and arabesque designs, on marbled or striped grounds. A solo exhibition of his work was held at the Galerie Manuel, Paris, in 1921. **Sources:** Louis Vauxcelles, 'Tapis de Pierre Bracquemond', *L'Amour de l'Art*, June 1920; *La Manufacture des Gobelins dans la Première Moitié du XXe siècle*, Galerie Nationale de la Tapisserie, Beauvais, 1999 (exhibition catalogue).

BRANGWYN, SIR FRANK Bruges 1867–Ditchling (Sussex) 1956
English painter and decorator, born in Bruges. Brangwyn trained at the South Kensington Art School, then worked as a draughtsman in William Morris's Merton Abbey workshops (1882–84). In addition to designing murals, stained-glass windows, posters, furniture and carpets, Brangwyn pursued a successful career as an artist. In 1895 Siegfried Bing commissioned him to decorate the façade of his store Art Nouveau in Paris. President of the Royal Society of British Artists (1913–18), Brangwyn was elected to the Royal Academy in 1919 and knighted in 1941. **Sources:** Herbert Furst, *The Decorative Art of Frank Brangwyn*, Bodley Head, London, 1924; William de Belleroche, *Brangwyn's Pilgrimage. The Life-Story of an Artist*, Chapman & Hall, London, 1948; Dominique Maréchal, *Collectif Frank Brangwyn*, Stedelijke Musea, Bruges, 1987 (exhibition catalogue).

BRAQUENIÉ ET CIE, Paris and Aubusson
French manufacturer and retailer of fine tapestry, furnishing fabrics and carpets. The firm was founded in pre-Revolutionary times by Pierre-Jean Démy, a Parisian cloth merchant. In 1842, his son Pierre-Antoine Démy formed a partnership with the Belgian Alexandre Braquenié (1812–79) and later his brother Henri-Charles Braquenié. On the latter's marriage to a descendant of the founder, the firm was renamed Braquenié Frères and in 1876 Braquenié et Cie. Alexandre Braquenié began weaving fine tapestry and carpets in a workshop in Aubusson in 1843; this was followed by

purpose-built factories in Aubusson (1860) and at Ingelmunster (1857) and Mechlin (1869) in Belgium. Metered fabrics and strip carpeting were made in Tourcoing, in partnership with Choqueel. The firm employed up to twenty in-house designers at a time. Their carpets graced the palaces of the Emperor Napoleon III and the dining room of the Ottoman Sultan in the Palace of Dolmabahçe, Istanbul, and the homes of the Marquess of Païva and Victor Hugo. After a decline in production during the First World War, the company enjoyed renewed prosperity during the twenties. Rugs were woven from designs by Ruhlmann*, Albert-Armand Rateau, Jane Lévy*, Süe* and Mare*, Follot*, Lurçat*, Beaumont* and Boberman*. A range designed by Da Silva Bruhns* was issued during the forties and fifties. Braquenié et Cie was recently taken over by the Pierre Frey company. **Sources:** Archives Nationales F12/5097; F12/8538; *Braquenié 1823–1993 présente Rêve de Décors, Décors de Rêve*, Bagatelle, Paris (exhibition catalogue), 1993–94.

BRUMMER, EVA Tampere 1901–Espoo, Finland 2007
Finnish weaver and textile designer trained at the School of Industrial Arts, Helsinki. She founded her own weaving studio in 1929, with the intent of reviving the *ryijy*. Her rugs, made in the voided-pile technique, evolved from colourful to more restrained colour schemes. Her work was awarded several prizes at the Milan Triennale. Throughout her life she was a member of the Friends of Finnish Handicraft.

BRUNET-MEUNIÉ ET CIE, Paris
French manufacturer of furnishing fabrics and carpets. Founded in 1815, the company was reincorporated as Brunet-Meunié in 1925, as the Ets. P. Meunié in the thirties and later as Neveu Brunet et Cie. The firm specialized in manufacturing *fibranne* fabrics, but also produced rugs from designs by Pierre-Paul Montagnac and Paul Fréchet. Lines of pile carpets and powerloom carpeting were commissioned from designers Bénédictus* and J. Fressinet.

BURKHALTER, JEAN Auxerre (Yonne) 1895–Blacy (Yonne) 1984
French architect and designer trained at the Ecole des Arts Décoratifs, Paris. Burkhalter worked briefly for Jules Coudyser*, who taught him weaving techniques, and then for the Atelier Primavera*. He showed fabrics, carpets and silverware at the Salons des Artistes-Décorateurs from 1919 onwards and a studio/dining room produced by the firm, as well as a fountain designed with the Martel brothers at the 1925 International Exhibition. A founder member of the U.A.M., Burkhalter took an active part in the group's activities. Appointed professor at the School of Industrial Arts in Grenoble, he directed the Municipal Art School in Auxerre from 1935, followed by the Art School in Saint-Etienne and the Decorative Arts School in Limoges. Burkhalter's penchant for abstract art is reflected in the rugs he designed for the Boutique Pierre Chareau*. Some recall a lunar landscape while others are irregular in shape with marbled and speckled effects. Yet others resemble the strokes of a paintbrush. **Sources:** Léon Moussinac, 'Jean Burkhalter', *Art et Décoration*, March 1930; Arlette Barré-Despond, *U.A.M. Union des Artistes Modernes*, Editions du Regard, Paris, 1986.

CALDER, ALEXANDER Philadelphia 1898–New York 1976
American painter and sculptor. Trained as an engineer at the Stevens Institute of Technology in Hoboken, then at the Art Students' League in New York. From 1925 he divided his time between the United States and Paris, where he forged links with the Surrealists. Famous for his mobiles, Calder also painted murals and designed jewelry, tapestry cartoons and carpets. Three carpet designs were produced by the Galerie Cuttoli-Weill from earlier works by Calder from the fifties. In later life, he designed carpets which were hand-hooked by his wife, Louisa Calder. **Sources:** *Tapis de Maîtres*, Galerie Weill-Seligman, Paris, n.d.; Mildred Constantine, Albert Châtelet, *An Exhibition of Contemporary French Tapestries*, Charles E. Slatkin Galleries, New York, 1965.

CHAREAU, PIERRE Bordeaux 1883–New York 1950
French architect and decorator. Chareau entered Waring & Gillow's* Paris branch as an apprentice, then in 1924 opened an interior decorating store, La Boutique. He exhibited an office-cum-library in the 'Ambassade Française' pavilion at the 1925 International Exhibition. A founder member of the U.A.M., Chareau was closely involved with the avant-garde, and together with the Dutch architect Bernard Bijvoët, designed the Maison de Verre in Paris (1927–32). The rugs sold in his Paris store were designed by Lurçat*, Burkhalter* and Philippe Hosiasson* and woven by Coupé*. Chareau sometimes used pieces by Gray* and D.I.M.* in his own interiors. He may also have designed the rainbow-patterned carpets which accompany his early projects himself. In 1940 he emigrated to the United States. **Sources:** Marc Vellay, Kenneth Frampton, *Pierre Chareau*, Thames & Hudson, London, 1986; Brian Brace Taylor, *Pierre Chareau, Designer and Architect*, Taschen, Cologne, 1992.

CHERMAYEFF, SERGE (IVAN) Grosny, Azerbaijan 1900–Wellfleet (Mass.) 1996
Architect, painter and designer, naturalized British, then American. Schooled in Moscow, then at Harrow in England. Designer for the London firms of E. Williams Ltd and Waring & Gillow*, Chermayeff created furnishings, textiles and accessories, and continued to do so after coming to prominence as an architect, in partnership with Eric Mendelsohn. Their best-known work is the De La Warr Pavilion in Bexhill. In 1940 Chermayeff emigrated to the United States, where he taught at several universities, including the Chicago Institute of Design, Harvard and Yale. **Sources:** Muriel Emanuel, ed., *Contemporary Architects*, Macmillan, London, 1980; Mel Byars, *Design Encyclopedia*, Laurence King, London, 1994.

CLESS-BROTHIER, CAMILLE-PAULINE born Paris
French textile designer of Swiss origin, active during the twenties. She took part in the Salons of the Société Nationale, and showed carpets at the Salon des Artistes Français and the Salon des Indépendants, Paris. The Grands Magasins à la Place Clichy* produced a carpet from one of her Modernist designs in 1927.

COLENBRANDER, THEODOOR C. A. Doesburg 1841–Arnhem 1930
Trained as an architect, Colenbrander worked with L. H. Eberson and built several country houses in Arnhem but later abandoned his vocation for the applied arts. After a three-year stint in Paris (1867–70), he returned to Holland, where he served as artistic director of the Rozenburg art pottery in The Hague and became a partner in the RAM pottery, Arnhem. Colenbrander also worked as a freelance designer of batiks and carpets for several manufacturers. He became artistic director of the Amersfoortsche Tapijtfabriek in 1895, and was retained as a consultant after the company merged with the Deventer Tapijtfabriek* in 1901. Pioneer of the 'batik style' which dominated Dutch carpet design into the twenties, Colenbrander was much emulated by his peers. **Sources:** *T. A. C. Colenbrander 1841–1930*, exhibition at the Municipal Museum, Arnhem, 1987; Richard Mills, *Jong Holland*, no. 2, 1994; M. W. F. Simon Thomas, *Dictionary of Art*, Macmillan, London, 1996.

COMPAGNIE DES ARTS FRANÇAIS, Paris
French design studio founded in Paris in 1919 by Süe* and Mare*. They built and furnished several villas and decorated many private apartments, ocean liners, shops, offices and restaurants, often in close collaboration with well-known contemporary artists, and they exhibited two pavilions at the 1925 International Exhibition. A 1927 inventory lists twenty-eight carpets, including three Jacquard throw rugs and seven powerloom carpeting designs. Their pile carpets were woven by Lauer*. In 1928, the Compagnie was bought out by the Galeries Lafayette, and Jacques Adnet* was appointed artistic director. He introduced a progressive style, the complete antithesis of his predecessors. As well as his own designs, Adnet sold carpets by Jourdain*, Pouchol, Marianne Clouzot, Kinoshita, Marguerite Dubuisson*, Dufrène* and

Guiguichon*. **Sources:** Ernest Tisserand, 'Les Tapis de la Compagnie des Arts Français', *Mobilier et Décoration*, vol. 9, 1929; Susan Day, *Louis Süe Architectures*, Institut Français d'Architecture, Paris, and Pierre Mardaga, Liège, 1986; Florence Camard, *Süe et Mare et la Compagnie des Arts Français*, Editions de l'Amateur, Paris, 1993.

COUDYSER, JULES Lille 1867–Paris 1931

French interior designer, who specialized in manufacturing and retailing embroideries, lace, furnishing fabrics, wall-hangings, and carpets from his Paris store. Vice-president of the textiles committee at the 1925 International Exhibition, Coudyser's rugs were used in the office of the exhibition's director, the 'Maison du Tisserand' and were shown on the stands of Saddier et Fils, Guélis Frères, Ausseur, Eric Bagge*, Guérin Frères, Georges Champion and Galerie Mathieu, as well as Coudyser's own. He became a professor at the Conservatoire des Arts et Métiers, and his carpet designs were woven by manufacturers including Tabard*, the Point Sarrazin* and the Manufacture de Béarn*, which he co-founded, as well as in Oran. **Sources:** Archives Nationales F12/8559; Yvanhoé Rambosson, 'Mort de Jules Coudyser', *Comoédia*, 21 January 1931; Interview with Jean Coudyser.

Ets. Marcel COUPÉ, Paris and Bourganeuf (Creuse)

French manufacturer of tapestries, pile carpets and *moquette*. Founded in 1905, the factory was located in Bourganeuf, with offices in Paris. Coupé wove carpets for numerous retailers and decorators, including the Boutique Pierre Chareau*, the Atelier La Maîtrise*, Fernand Nathan, Paul Follot*, René Herbst*, Clément Mère, Raoul Lux, René Crevel*, Saddier Frères, Georges de Bardyère, Jacques Klein*, Maurice Dufrène* and Jacques Vergé*. Henri Pinguenet designed the textiles shown on their stand at the 1925 International Exhibition, and Coupé himself was a member of the textiles committee at the 1937 Exhibition. The company foundered after the Second World War, for the same reasons as Bouix*. **Source:** Amedée Carriat, *Dictionnaire Bio-Bibliographique des Auteurs du Pays Creusois et des Ecrits les Concernant des Origines à Nos Jours*, Société des Sciences Naturelles et Archéologiques de la Creuse, Guéret, 1971.

CRANBROOK FOUNDATION, Detroit see SAARINEN, LOJA

CREVEL, RENÉ Rouen 1892–Villeneuve-Loubet (Alpes-Maritimes) 1971

French painter and decorative artist active between the wars (not to be confused with the Surrealist poet of the same name, 1900–35). A portrait and landscape painter, Crevel made his debut at the Salon d'Automne in 1920. A member of the Société des Artistes-Décorateurs, he collaborated with Follot* on the society's stand at the 1925 International Exhibition. He also designed ceramics and Limoges porcelain, jewelry, wallpaper, decorative panels and carpets which were made by the MFTC*, Grands Magasins à la Place Clichy*, Hamot*, Point Sarrazin* and Coupé*. By 1928, Crevel had moved from floral and animal patterns to abstraction.

CROC & JORRAND, Paris and Aubusson

French tapestry and carpet manufacturer founded in 1825 by Pierre Croc. In 1868, the factory geared its production towards powerloom carpeting, without entirely abandoning handweaving. Adolphe Jorrand became a partner after marrying the founder's granddaughter in 1861. Their sons included Antoine Jorrand, who by 1900 was the chief designer. The firm remained in family hands until it was sold to the Kaplan Bank in 1923. Under the name 'Aux Fabriques d'Aubusson', the firm wove carpets by Bénédictus*, Jean Beaumont* and Dominique* before it was liquidated in 1935. **Sources:** Archives Nationales F12/5117; Interviews with Elisabeth Erlevint, Gilles Jorrand.

CUTTOLI, MARIE see MAISON MYRBOR

DA SILVA BRUHNS, IVAN Paris 1881–Antibes 1980

Brazilian painter and designer, born in France. The best-known and most prolific Art Deco carpet designer abandoned a career in medicine for the arts. From 1919, when he held his first carpet exhibition, he specialized in this particular field and to a lesser extent, in the design and manufacture of fabrics. His first rugs were woven on a piece-work basis by a weaver in a village in the Aisne region; in 1925, he founded a workshop, the Manufacture de Savigny, in the Paris suburb of Savigny-sur-Orge (Essonne), with showrooms in Paris. In addition to ocean liners – *Ile-de-France* (1927), *Atlantique* (1931), *Normandie* (1935) – Da Silva made carpets for French embassies in Berlin, Warsaw and Washington, for the French Senate, and for the United Nations Headquarters in Geneva. Designers who used his carpets included Emile-Jacques Ruhlmann*, Paul Follot* and Pierre-Paul Montagnac and particularly Jules Leleu*. Da Silva also supplied designs for the Manufacture de la Savonnerie*, Braquenié*, Pinton* and Dominique*. Made with the Savonnerie knot, the rugs from the Savigny workshop (1925–40) were available in three grades. Da Silva's monogram and signature in Gothic letters are normally woven into the pile. Stylistically, his production can be roughly divided into six overlapping periods: floral and geometric patterns, c. 1919–20; dense symmetrical geometric compositions, c. 1920–35; Cubist patterns, c. 1928–35; designs based on circular motifs, 1929–31; sparse geometric decoration, linear and asymmetrical compositions, c. 1929–40; geometric carpets with stylized animal motifs, c. 1935–60. **Sources:** 'Atelier Ivan Da Silva Bruhns', Hôtel Drouot, Paris, 13 February 1984 (auction catalogue); Marianne Lamonaca Loggia, *The Carpet Designs of Da Silva Bruhns*, Cooper Hewitt, New York, 1985 (dissertation); *Ivan Da Silva Bruhns. Ensemble de Projets de Tapis. Gouaches et Aquarelles,* Hôtel Drouot, Paris, 17 June 1998 (auction catalogue); Susan Day, 'Art Deco Masterworks. The Carpets of Ivan Da Silva Bruhns', *Hali*, no. 105, July–August 1999, pp. 78–81.

DAUPHINE, Atelier de la see FAYET, GUSTAVE

DELAUNAY, SONIA (née TERK) Gradizsk, Ukraine 1885–Paris 1979

Naturalized French artist, decorator and textile designer. Studied drawing in Karlsruhe, then at the Académie La Palette, Paris. After marrying the painter Robert Delaunay in 1910, she began to design bookbindings, lamps, fabrics and clothing, influenced by Cubism and by her husband's theories on 'simultaneous contrasts'. Exiled in Portugal and Spain during the war, Sonia Delaunay opened a Paris boutique in partnership with the furrier Jacques Heim in 1924, which sold clothing, accessories, screens, fabrics and carpets from her own designs. The carpets were hand knotted in Spain. She also designed costumes for the ballet, theatre and films, including Marcel L'Herbier's *Le Vertige* (1926). In 1929 she joined the U.A.M. and published the album *Tapis et Tissus*. In 1937, she and Robert Delaunay collaborated on the Pavillon de l'Air at the Paris exhibition. She retired to an artists' colony in Grasse in 1941 after the death of her husband. In 1965, at the instigation of Jacques Damase, the Galerie La Demeure in Paris issued a new collection of her work and an exhibition of her carpets and graphics was held at the gallery in 1970. Since this date, her carpets have been handtufted. The Studio de Saedeleer*, the Manufacture de Lodève* and the Galerie Artcurial also produced carpets from her designs. **Sources:** Jacques Damase, *Sonia Delaunay: Fashion and Fabrics*, Thames & Hudson, London, 1991; Emile Giglioli, 'Les Tapis de Sonia Delaunay', *XXe Siècle*, June 1970.

DESKEY, DONALD Blue Earth, Minnesota 1894–Vero Beach, Florida 1989

American architect and industrial designer. Studied architecture at Berkeley University and painting in New York, Chicago and Paris. After visits to the 1925 International Exhibition and the Bauhaus, he returned to New York and founded a design studio with Philip Vollmer, Deskey-Vollmer Inc., in 1927. Helena Rubinstein and John D. Rockefeller were among his clients but his best-known work is the interior of Radio

City Music Hall in New York. Founder and professor of the School of Industrial Design, New York, co-founder of AUDAC and of SID (the Society of Industrial Designers). Deskey made furniture from fine woods, but also experimented with modern materials such as chrome, Bakelite, aluminium and Formica. His carpet designs, machine-hooked by the New England Guild, reveal the same duality: some are figurative, while others are abstract or Cubist. **Source:** David A. Hanks, Jennifer Toher, *Donald Deskey, Decorative Designs and Interiors,* E. P. Dutton, New York, 1987.

DEUTSCHE WERKSTÄTTEN FÜR HANDWERKSKUNST, Dresden

Founded in 1898 by the cabinetmaker Karl Schmidt, the workshops produced quality mass-produced furniture and accessories from models by Arts and Crafts and Jugendstil designers. Branches were established in Berlin, Hamburg and Hanover. The workshops produced a line of fabrics, pile carpets and carpeting named the 'Dresdner Künstlerstoffe'. In 1907 the firm merged with the Vereinigte Werkstätten für Kunst und Handwerk* and the Werkstätten für Wohnungseinrichtung, both in Munich, under the name Deutsche Werkstätten, and production was centralized in Dresden. A vast enterprise which by 1910 employed over six hundred workers, the Dresden workshops were destroyed during the Second World War. Textile production recommenced in 1950 in Munich, under the name DeWeTex, now the WK-Verband. **Source:** Hans Wichmann, ed., *Deutsche Werkstätten und WK-Verband 1898–1900*, Prestel, Munich, 1992.

D.I.M. (DÉCORATION INTÉRIEURE MODERNE), Paris

French interior design studio founded in Paris in 1914 by cabinetmaker René Joubert (1878–1931) and set designer Georges Mouveau (1878–1959). In 1924 Joubert formed a new partnership with Philippe Petit (1900–45), a former student at the Ecole Bernard Palissy. After the death of Joubert in 1931, Petit left the firm. The company's output included furnishings, lighting and textiles designed by the studio, which also commissioned work from freelance designers. D.I.M. designed the dining room in the stand of the Société des Artistes-Décorateurs at the 1925 Paris Exhibition, as well as liner and aeroplane interiors. Carpet designers affiliated with D.I.M. included A. Moser, A. Ekman, Yvonne Parigot, Bénédictus*, Francis Jourdain*, Follot* and particularly Boberman*. **Sources:** G. Rémon, 'Les Tapis de Joubert et Petit édités par D.I.M.', *Mobilier et Décoration*, November 1927; 'Le Tapis', *Ce Temps-Ci. Cahiers d'Art Contemporain*, October 1929.

DJO-BOURGEOIS (GEORGES BOURGEOIS)

Bezons (Seine-et-Oise) 1898–Paris 1937

French architect, designer and painter who trained under Robert Mallet-Stevens* at the Ecole Spéciale d'Architecture, Paris. His only built work is a Modernist villa in Saint-Clair (Var). He regularly showed his interiors at the salons organised by the Société des Artistes-Décorateurs. Djo-Bourgeois first worked for the Studium Louvre*, and designed a smoking room and an office shown in the workshop's pavilion at the 1925 International Exhibition. He left to found his own Paris design studio, in partnership with his wife Elise (d. 1986), Paul Brandt and Louis Tétard. His wife designed the fabrics and carpets to accompany his projects, including a bedroom in the villa designed by Mallet-Stevens for the Vicomte de Noailles at Hyères. Invariably abstract, made up of squares and rectangles in the style of De Stijl, her designs may have been executed in the workshop of Hélène Henry*. **Source:** Susan Day, *Allgemeines Künstlerlexikon*, vol. 25, 2000.

DOMINIQUE, Paris

French interior decoration studio founded in Paris in 1922 by André Domin (1883–1962), his wife and the art critic Marcel Genevrière (1885–1967). The studio designed interiors for liners of the Compagnie Générale Transatlantique, the Salon des Paysages at the Elysée Palace and the home of Jean Puiforcat in Biarritz.

The carpets were designed in-house and made by the Maison Hamot* and the Tapis de Cogolin*; they were also acquired from independent designers, including Da Silva Bruhns*. The patterns were mostly abstract, including those created for the reception room of the 'Ambassade Française' at the 1925 International Exhibition and the stateroom 'Rouen' on the liner *Normandie*. Others were textured or classical in inspiration. The firm closed in 1970. **Sources:** *Who's Who in France*, 1953–54; *Echos des Industries d'Art*, January 1928; *Art et Industrie*, October 1929.

DORN, MARION San Francisco 1899–Tangiers 1964

American textile designer, resident in England between the wars. She studied at Stanford University, California, then worked in Paris and New York before settling in London with future husband Edward McKnight Kauffer* in 1925. A joint exhibition of their carpets woven by the Wilton Royal Carpet Factory* was held at the Arthur Tooth Gallery in 1929. In 1934 she founded Marion Dorn Ltd, a design studio in London. Clients included Claridges, the Savoy, Berkeley and Strand Palace Hotels, the Cunard line (liners *Orion*, 1934; *Queen Mary*, 1934; *Orcades*, 1937) and Syrie Maugham. Dorn is known to have designed over a hundred carpets, some of which were made by designer and weaver Jean Orage* in her Chelsea workshop. She designed on commission for Edinburgh Weavers* and Wilton Royal Carpet Factory, for whom she also acted as a consultant. Powerloom carpeting was made from her designs by H. M. Southwell and Woodward Grosvenor*. On the outbreak of the Second World War, she returned to America and from 1951 to 1962 ran the design department of the firm Edward Fields, together with Louis Fischer. A carpet by Dorn graced the Ambassadors' Room in the White House (1962). She died in Tangiers soon after setting up a studio there. Her work consisted mostly of abstract Modernist designs featuring a few large motifs and textured rugs. **Source:** Valerie Mendes, 'Marion Dorn, Textile Designer', *Decorative Arts Society 1890–1940 Bulletin 2*, 1978.

DRESDNER WERKSTÄTTEN see DEUTSCHE WERKSTÄTTEN

DUBUISSON, MARGUERITE Lille 1883–Lille 1967

French painter, decorator and ceramicist, a student of Fernand Sabatté at the Ecole des Beaux-Arts, Paris. Active in Paris between the wars, Dubuisson worked for the Atelier La Maîtrise* and designed several carpets in floral patterns similar to those of Dufrène*. After launching her own Paris studio, she adopted a Modernist language. Her carpets were retailed by the Compagnie des Arts Français*.

DUFRÈNE, MAURICE-ELYSÉE Paris 1867–Nogent-sur-Marne 1955

French decorator, who studied at the Ecole des Arts Décoratifs, Paris. In 1899, Dufrène was appointed director of the newly created Maison Moderne, a decorating firm that played a key role in the development of Art Nouveau. A founder member and one-time president of the Société des Artistes-Décorateurs, Dufrène directed the Atelier La Maîtrise* at the Galeries Lafayette (1921–46) and taught at several schools of decoration, including the Ecole Boulle (1912–23). A prolific designer, Dufrène created furniture, glass, lighting, silverware, clocks, pottery and textiles. In addition to the interiors of the La Maîtrise stand and a small salon in the pavilion of the Société des Artistes-Décorateurs at the 1925 Paris Exhibition, Dufrène received many official commissions for embassies and the French Prime Minister's offices in the Elysée Palace. From the thirties, he abandoned the richly ornamented floral and superimposed medallion designs which characterize his early work for sparsely decorated carpets or textured patterns. **Source:** *Meubles 1920–1937*, Musée d'Art Moderne de la Ville de Paris, Paris, 1986 (exhibition catalogue).

EDINBURGH WEAVERS

The experimental design unit of manufacturer Morton Sundour Fabrics Ltd*, set up by James Morton in 1928. The unit was formed with the intention of creating

modern fabrics and carpets in the spirit of the Bauhaus, using natural and synthetic fibres. With this end in view, Morton acquired the St Edmundsbury craft workshop at Letchworth, then directed by Edmund Hunter. In 1932 the unit was transferred to Morton Sundour's headquarters in Carlisle and from this time on it was headed by James's son Alastair Morton (1910–63), who had been trained in the studio of weaver Ethel Mairet. In 1937 Morton launched the 'Constructivist' range, designed by Ashley Havinden*, Marion Dorn*, Marian Pepler*, Paul Nash*, Ben Nicholson*, Jean Varda and John Tandy, among others. **Source:** *Alastair Morton and Edinburgh Weavers*, Scottish National Gallery of Modern Art, Edinburgh, 1978 (exhibition catalogue).

ERNST, MAX Brühl 1891–Paris 1976

German artist, who studied philosophy, psychiatry and art history in Bonn before turning to painting. Ernst progressively discovered Cubism, Expressionism and Dada, and after settling in Paris in 1922, became a primary force in the Surrealist movement. Four carpets were produced by the Maison Myrbor from works by Ernst. One entitled *Lignes* recalls his 'frottages' or wood rubbings of the twenties, while the other three are based on astrological themes, reflecting the cosmic symbolism central to his work in the fifties. **Source:** *Tapis de Maîtres*, Galerie Weill-Seligman, Paris, n.d.

EYRE DE LANUX Johnstown (Pennsylvania) 1894–1996

American artist and designer trained at the Art Students' League, New York. Born Elizabeth Eyre, she adopted the pseudonym on settling in Paris with her husband, French diplomat Pierre de Lanux. The couple frequented such luminaries as Jean Cocteau, Picasso*, Matisse, James Joyce, Gertrude Stein and Man Ray, and Eyre wrote a column for *Town and Country*. After meeting Evelyn Wyld* through Eileen Gray* in 1927, Eyre left her husband to form a partnership with Wyld. Wyld and Eyre first showed their interiors at the Salon des Artistes-Décorateurs in 1928. The furniture, in wood, lacquer or plate glass, inspired by Gray's, was mostly designed by Eyre and the carpets by Wyld, although Eyre also created some carpets in abstract patterns, which are signed EL. She eventually returned to the United States, where she continued to paint and write short stories for magazines. **Source:** Mel Byars, *Design Encyclopedia*, Laurence King, London, 1994.

FAYET, GUSTAVE Béziers 1865–Paris 1925

French painter and decorator. Fayet spent the better part of his life as curator of the Béziers Museum. Encouraged by his friend and mentor Odilon Redon, whom he met in 1905, Fayet took up painting watercolours late in life. In around 1920 he formed a partnership with M. and Mme Dumas, who ran a carpet-weaving workshop on Paris's Left Bank. The Atelier de la Dauphine owned exclusive rights to produce his designs. A retrospective exhibition devoted to Fayet and Redon was held after Fayet's death in 1925. **Sources:** Tristan Klingsor, 'Les Tapis de Gustave Fayet', *L'Art et les Artistes*, November 1923; Arsène Alexandre, 'Les Tapis Vivants de Gustave Fayet', *Renaissance de l'Art Français*, 1923; René-Louis Doyon, *D'Autres Couleurs ou les Tapis de Gustave Fayet*, Paris, 1924; André Suarez, *Gustave Fayet et ses Tapis*, Paris, n.d.; André Fréchet, 'L'Atelier de la Dauphine. Les Tapis de Gustave Fayet', *Mobilier et Décoration*, March 1926.

FETTÉ-LI COMPANY, Beijing

Chinese carpet manufacturer, founded in around 1920 by Helene Fetté, an American businesswoman, and Li Meng Shu, a weaver. At its peak, up to two thousand workers were employed weaving pile carpets for the firm. In-house designers, directed by Fetté, used motifs taken from ancient silks, such as the lotus and the dragon, as well as elements from outside of Chinese carpet design, including fans, trees or animals. The factory closed in 1948 when the Communists came to power. **Source:** Margaret Setton, 'Chinese Rugs. The Fetté-Li Company', *Oriental Rug Review*, January–February 1991.

FEURE, GEORGES DE (pseudonym of Georges van Sluijters) Paris 1868–Paris 1943

French Symbolist painter, decorator and lithographer. Son of a Dutch architect, he worked as a craftsman in Holland before returning to France in 1891. Artistic director of Siegfried Bing's pioneering Art Nouveau store, de Feure designed furniture, porcelain, jewelry, stained-glass windows, wallpaper, textiles and accessories. In the twenties, de Feure abandoned the floral patterns which typified his early style for a figurative, abstract or geometric repertoire. A typical example is the carpet designed for Madeleine Vionnet's Paris couture house (1922). He also designed a range of carpets for the MFTC*. **Source:** Ian Millman, *Georges de Feure, 1868–1943*, Van Gogh Museum, Amsterdam, 1993.

FOLLOT, PAUL Paris 1877–Sainte-Maxime 1941

French designer, son of the wallpaper manufacturer Félix Follot. A student of Eugène Grasset at the Ecole des Arts Décoratifs, Paris, Paul Follot joined Julius Meier-Graefe's Maison Moderne as a decorator in 1901. A founder member of the Société des Artistes-Décorateurs, he successfully achieved the transition from Art Nouveau to Art Deco. Working from a studio in his Paris town house, which he designed with the architect Pierre Selmersheim (1913), Follot created ornate luxury furniture and accessories in the 18th-century tradition. From 1923 he managed Pomone*, the decorating department of the Au Bon Marché department store, and from 1928 the Paris branch of Waring & Gillow*. Follot designed well over thirty carpets, woven by several manufacturers, including the Ets. Marcel Coupé*, the MFTC*, the Tapis de Cogolin* and Lorthiois-Leurent et Cie. In addition to floral and neoclassical carpets, he also created a series of geometric and linear patterns, which were used in the staterooms he designed for the liner *Normandie*. **Sources:** Léon Riotor, *Paul Follot*, Paris, 1923; Jessica Rutherford, 'Paul Follot', *The Connoisseur*, June 1980, pp. 86-91.

FOURGEAUD, YVONNE Niort (Deux-Sèvres) 1889–Paris 1987

French painter and designer active during the twenties. Fourgeaud designed carpets in floral and abstract patterns for several manufacturers and retailers, including Mariage and Delarue in Roubaix and the Grands Magasins à la Place Clichy*.

FRY, ROGER see OMEGA WORKSHOPS

GABRIEL, RENÉ Maisons-Alfort 1890–Paris 1950

French designer, lithographer and set designer trained at the Ecole des Arts Décoratifs, Paris. From 1920, Gabriel manufactured and retailed his own wallpaper designs in his Paris shop, 'Au Sansonnet'. While he did not disdain the design of luxury furnishings, Gabriel was a disciple of Francis Jourdain* in actively seeking to promote mass production of his work. In 1934 he founded the Ateliers d'Art in Neuilly-sur-Seine, which manufactured modular furniture known as 'Eléménts RG'. He also designed theatre sets for plays including Louis Jouvet's *Léopold le Bien-Aimé*. President of the Société des Artistes-Décorateurs, Gabriel also taught the decorative arts and was a member of the board of administration of the Union Centrale des Arts Décoratifs, Paris. An exhibition of his Modernist carpets was held in Antwerp in 1933. **Source:** Renée Moutard-Uldry, 'Dictionnaire des Artistes-Décorateurs', *Mobilier et Décoration*, vol. 34, 1954, no. 2.

GAUDISSART or GAUDISSARD, EMILE Algiers 1872–Paris 1957

French painter, sculptor, decorator and textile designer. Trained as a sculptor at the Ecole des Beaux-Arts, Paris, Gaudissart was commissioned by the French state to create a great many statues and commemorative monuments both in France and his native Algeria. His work was shown regularly at the Salon des Artistes Français, the Salon des Artistes-Décorateurs and the Salon d'Automne. He designed tapestry cartoons for the state-run Beauvais and Gobelins workshops and for Aubusson manufacturers. Ruhlmann* and René Gabriel* used his carpets on their stands at the

1925 International Exhibition, and Braquenié*, Schenk, the Tapis de Cogolin* and the Grands Magasins à la Place Clichy* were among the companies that commissioned his designs. **Sources:** Ernest Tisserand, 'Un décorateur poète: Emile Gaudissard', *L'Art et les Artistes*, vol. 14, 1926–27; *Amour de l'Art*, 1933.

GIDDING, JAAP Rotterdam 1887–Hillegersberg 1955
Dutch decorator and textile designer. Gidding trained as a decorator under his father, owner of an interior decoration firm in Rotterdam. He worked as a mosaicist in The Hague and furthered his education at the city's Academy of Fine Arts. He lived briefly in Munich and Paris, then returned to Amsterdam to run the family business with his brother. In 1929 he set up his own studio, and designed decorative panels, ceramics, mosaics, stained glass, fabrics, wallpaper and carpets, as well as the interiors of twelve cinemas, including the Tuschinski Theatre, Amsterdam. Gidding's textiles were displayed in the Dutch pavilion at the 1925 International Exhibition, and the Studio de Saedeleer* and the KVT* acquired rug designs from him. He switched from the batik style to an abstract Modernist vocabulary in the late twenties. **Sources:** *Wendingen*, no. 6, 1918; Titus M. Eliëns, Marjan Groot, Frans Leidelmeijer, eds., *Avant-Garde Design. Dutch Decorative Arts 1880–1940*, Philip Wilson, London, 1997.

GINZKEY, Vratislavice (formerly Maffersdorf), Czech Republic
Blanket and carpet manufacturer, founded by Ignatius Ginzkey in 1843. By the turn of the century, one hundred handlooms and two hundred and fifty powerlooms were in operation and branches had been established worldwide. The firm was one of the first to bestow social benefits on its staff, which numbered 1,500 in 1900. The firm wove hand-knotted carpets and powerloom carpeting, including ingrain, Brussels, Wilton, chenille and pre-printed tapestry warp carpets. Machine tufting was introduced in 1960. Present at many international exhibitions in Europe and the United States, Ginzkey produced revival styles by in-house designers and initiated a policy of commissioning designs from artists including Josef Hoffmann*, C. F. A. Voysey* and particularly Hans Christiansen. More recently, it has produced work by Marguerite Zorach. The firm's name is sometimes embroidered on the underside of its rugs. It presently operates under the name of Bytex Co. **Sources:** Ferdinand Leborgne, *Exposition Universelle de 1900. Rapports du Jury International. Classe 70 Tapis, Tapisseries et Autres Tissus d'Ameublement*, Imprimerie Nationale, Paris, 1901.

GRANDS MAGASINS À LA PLACE CLICHY, Paris
Department store founded in 1882. Formerly a haberdasher's, the shop came to specialize in furnishings and oriental carpets. In 1927, the firm commissioned a range of twelve carpets from freelance designers, including Jacques Vergé*, Francis Jourdain*, Edouard Bénédictus*, Suzanne Kaerling and Yvonne Fourgeaud*. Taken over by the Bazar de l'Hôtel de Ville (BHV), the store has since been sold.

GRANT, DUNCAN Rothiemurchus, Scotland, 1885–Charleston, Firle (Sussex) 1978
British painter and decorator trained at the Westminster School of Art in London and at La Palette academy, Paris. A member of the Bloomsbury Group and co-director of the Omega Workshops*, Grant created interiors, pottery, screens, fans, toys, fabrics and carpets in abstract designs. After the workshop was dissolved in 1919, the painter continued to design interiors with Vanessa Bell* during the twenties and thirties, including decorative panels for the liner *Queen Mary* and textiles for the firm of Allan Walton* (1931–38). He also designed theatre and ballet sets and costumes and painted numerous murals, including those at Newnham College, Cambridge. **Source:** Raymond Mortimer, *Duncan Grant*, Penguin, London, 1944.

GRÅSTEN, VIOLA Keuru-Tavastehus 1910–Stockholm 1994
Finnish textile designer, trained at the School of Industrial Arts in Helsinki. Gråsten's work exhibited at the 1937 Paris exhibition earned her the first in a series of gold medals.

Gråsten's geometric and figurative patterns reveal the influence of Finnish folk heritage. An innovative colourist, she used colour combinations that were formerly considered impossible, such as blue with green and orange with red. In 1945 she settled in Sweden, where she worked for the Nordiska Kompaniet*, then as artistic director of Mölnlycke Fabrics, Gothenburg (1956–73). During the 1970s she worked as a freelance designer. **Source:** Mel Byars, *Design Encyclopedia*, Laurence King, London, 1994.

GRAY, EILEEN Enniscorthy, Ireland 1878–Paris 1976
Irish architect and designer trained at the Slade School of Art in London. In 1906 she settled permanently in Paris, where she was joined by a childhood friend, Evelyn Wyld*. Following a trip to Morocco, the two set up a business in Paris in 1910, designing and manufacturing carpets. Gray also designed custom-made furniture, particularly in lacquer; both her furniture and carpets were sold at the Galerie Jean Désert, which she managed from 1922 to 1929. After her partnership with Wyld ceased in 1927, some of her rugs were woven by weavers in Vezelay, where her friend Jean Badovici owned a house. By this time, Gray had met Le Corbusier and members of the De Stijl movement, and this determined the course of her future career. In 1929 she built the E1027 villa, a landmark of Modernist domestic architecture, and joined the U.A.M. After becoming an architect, she continued to create rugs, but only as an accompaniment to her interiors. Her rug designs resemble her abstract paintings. Gray was one of the first designers in France to use undyed yarns, translate the art of collage into carpet form and experiment with unusual materials, including perforated felt or metallic curtain fabric for floor coverings. Interest in her work revived during the seventies, and since then her designs have been issued by the Tapis de Cogolin*, Morton's* of Donegal and Ecart International, some of them for the first time. **Sources:** Jean Badovici, 'Eileen Gray', *L'Architecture Vivante*, winter 1929; Isabelle Anscombe, 'Expatriates in Paris: Eileen Gray, Evelyn Wyld and Eyre de Lanux', *Apollo*, February 1982; Peter Adam, *Eileen Gray, Architect, Designer*, Thames & Hudson, London, 1987; Philippe Garner, *Eileen Gray: Design and Architecture 1878–1976*, Taschen, Cologne, 1993.

GRIERSON, RONALD London 1901–London 1992
British textile and wallpaper designer. Attended the Hammersmith School of Art and Grosvenor School of Modern Art. Grierson designed posters, wallpaper, textiles and carpets in the Modernist idiom. He and his wife also produced embroideries. Grierson's flatweaves were mostly woven by Jean Orage* and the pile rugs by a craft studio in India. He worked freelance for several wallpaper and textile manufacturers, including the Wilton Royal Carpet Factory* and S. J. Stockwell. A solo exhibition of his work was held at the Redfern Gallery, London, his retailer, in 1936. Author of *Woven Rugs* (1952), Grierson taught at the Camberwell School of Art and at the Hampstead Garden Suburb Institute in London. **Source:** Mel Byars, *Design Encyclopedia*, Laurence King, London, 1994.

GROULT, ANDRÉ Paris 1884–Paris 1967
French designer. Like his brother-in-law Paul Poiret*, Groult was an early exponent of Art Deco. In 1912 Groult established a workshop which produced furniture, wallpaper and printed cretonnes to his own and other artists' designs in his wife Nicole Poiret's Paris haute-couture house. Groult designed several pavilions for the 1925 International Exhibition in Paris, including the *chambre de Madame* in the 'Ambassade Française'. He also created interiors for luxury liners, including the *Normandie*. He created a series of *Coloriste* carpets in the period leading up to the First World War and a rug with rainbow whorls made by the Tapis de Cogolin* for the 1937 International Exhibition, but appears to have designed few in the interim. In 1944, he produced a series of designs representing the elements for the Mobilier National, one of which was woven for the Naval Ministry by the Savonnerie* (1948). **Source:** Félix Marcilhac, *André Groult, Décorateur-Ensemblier du XXe siècle*, Editions de l'Amateur, Paris, 1997.

GUIGUICHON, SUZANNE Paris 1901–1985
French designer. A student of Maurice Dufrène*, Guiguichon worked for the Atelier La
Maîtrise* from 1921 to 1929. Her production, shown regularly at the annual salons,
included furniture, lighting and accessories and a bedroom designed with Gabriel
Englinger (1898–1983) for the La Maîtrise* pavilion at the 1925 Paris exhibition. At the
time her rugs resembled the floral patterns of Dufrène. After she had established her
own business in 1930, her designs became less ostentatious, and were marked by
discreet good taste adapted to Modernist canons. Important commissions included
the presidential bedroom in the Château de Rambouillet (1947). She taught in several
schools, including the Ecole des Arts Décoratifs, Paris. **Source:** Renée Moutard-Uldry,
'Dictionnaire des Artistes-Décorateurs', *Mobilier et Décoration*, vol. 34, 1954, no. 4.

GULLBERG, ELSA Malmö 1886–Vaxholm, near Stockholm 1984
Swedish textile artist trained at the School of Industrial Art in Stockholm. In 1927
Gullberg founded her own company in Stockholm, Elsa Gullberg Textilier och
Inredning, which sold inexpensive ranges of handwoven and mechanically made
textiles. Gullberg is credited with designing some 3,000 carpets, mostly her own
designs in floral and geometric patterns. Her firm also wove a carpet designed by
Märta Afzelius for the liner *Kungsholm* (1928), and rugs by Alfe Munthe and Viola
Gråsten*. **Source:** Barbro Hovstadius, *Elsa Gullberg, Textil Pionjär*, Nationalmuseum,
Stockholm, 1989 (exhibition catalogue).

PHILIPP HAAS UND SÖHNE, Ebergassing and Vienna
Austrian manufacturer of furnishing fabrics and carpets, founded in Gumpendorf,
near Vienna, by Philipp Haas in 1810. By the mid-19th century, branches had been
established worldwide, in Hungary, Bohemia, Italy and Bradford, England. The quality of
the products shown by the firm at international exhibitions earned high praise, but with
the fall of the Austro-Hungarian empire, the firm lost most of its subsidiaries outside
Austria. Artists who designed for the firm included Otto Eckmann, Dagobert Peche*
and Eduard Josef Wimmer-Wisgrill. The Ebergassing factory was converted into an
aircraft hangar during the Second World War, during which the Vienna headquarters
of the 'Haas-Haus' were bombed and its design archive destroyed.

HABLIK, WENZEL see HANDWEBEREI HABLIK-LINDEMANN

HAESAERTS, PAUL Boom 1901–Brussels 1974
Belgian artist, film-maker and art historian. During the twenties, Haesaerts frequented
the Etikhove group and in 1925 took on the role of artistic director of the Studio de
Saedeleer*. A believer in flat, symmetrical, tightly packed compositions, Haesaerts's
rug designs are characterized by the use of stick-like animal and human figures and
the schematic rendering of buildings in a small number of sharply contrasted shades.
He also favoured abstract Modernist designs. From the thirties onwards, Haesaerts
taught at the La Cambre school of design in Brussels and wrote biographies of Belgian
painters. **Source:** Richard Kerremans, 'Paul Haesaerts', in *Art Déco Belgique*, Palais
des Beaux-Arts, Brussels, 1989 (exhibition catalogue).

Maison HAMOT, Paris and Aubusson
Formerly cloth merchants, the firm was acquired by Duplan and Hamot in 1770.
Towards the end of the 19th century, Georges and René Hamot took over the
Aubusson workshop and began to manufacture fine tapestry, needlepoint and
handwoven carpets. Powerloom carpeting was contracted out to a manufacturer
in the north. The firm won a Gold Medal at the 1889 Universal Exhibition. Hamot made
rugs by Boberman*, Jaulmes*, Dominique*, Follot* and Crevel*, as well as a design by
Jacques Despierre for the Château de Rambouillet (1955), and designs were also
commissioned from Pierre Bracquemond*, Jean Beaumont*, Paule Marrot and
particularly André Arbus*. The Maison Hamot sold the Manufacture Saint-Jean in 1987
but continued until recently to trade in textiles from its Paris office, the weaving of pile

carpets being subcontracted to the Tai Ping Co. in Hong Kong. **Source:** Interview with
René Hamot.

HANDWEBEREI HABLIK-LINDEMANN, Itzehoe, Hamburg, Germany
German weaving studio founded in 1917 by the painter Wenzel Hablik (1881–1934)
and his wife, the designer and weaver Elisabeth Lindemann (1879–1960), who had
trained under Jugendstil designer Gertrud Kleinhempel. The workshop produced
furnishing fabrics, cushions, tablecloths, tapestries and carpets. The couple drew
inspiration from folk traditions, but also from modern art and contemporary events.
Lindemann preferred natural fibres and dyes, the result of her contacts with the
Handarbetets Vanner in Sweden. After the death of Lindemann, the workshop
was run by their daughter until 1964. **Sources:** Heinz Spielmann, Susanne Timm,
Wenzel Hablik, catalogue of works in the Schleswig-Holsteinischen Landesmuseum,
Neumünster, 1990; 'Handgewebte Stoffe von Hablik-Lindemann, Itzehoe', *Die Kunst*,
1932–33, pp. 216–18.

HAVINDEN, ASHLEY Maidstone, Kent 1903–Hertingfordbury, Hertfordshire 1973
English painter and designer, trained at the Central School of Arts and Crafts, London.
Artistic director and later president of William S. Crawford Associates, Havinden
created many advertising campaigns. He began designing carpets in 1932, at the
instigation of decorator Duncan Miller, who sold them in his store and mounted a
one-man show of Havinden's work in 1937. Havinden also designed carpets for the
Edinburgh Weavers*, Wilton Royal Carpet Factory* and Simpson's department store.
The carpets, signed simply 'Ashley', are characterized by a few large-scale abstract
motifs scattered on the field, some reminiscent of Jean Arp's* biomorphic sculptures.
Sources: Richard Calvocoressi, 'Ashley's Textiles', *Decorative Arts Society 1890–1940,
Bulletin 3*, 1979; Jean Clair, *Les Années Vingt, Age d'Or des Métropoles*, Musée des
Beaux-Arts, Montreal, 1991 (exhibition catalogue).

HENRY, HÉLÈNE Champagne (Haute-Saone) 1891–1965
French master weaver and designer. Henry wove furnishing fabrics, table linen, velvets,
brocades and carpets in her Paris studio. Henry's textiles furnished government
offices, embassies, liners, cinemas, private homes and the reception hall of the United
Nations in Geneva, and she collaborated with other members of the U.A.M., including
Chareau*, Herbst*, Sognot* and Mallet-Stevens*. Henry sought to create subtle effects
by mixing materials such as wool, silk, cotton and synthetic fibres in neutral shades;
her equally low-key carpets in subdued rationalist designs were mostly either
monochrome or limited to two shades. Henry refused to work with industrialists who
nonetheless plagiarized her designs. She was awarded the Légion d'Honneur in 1937.
After her death, the workshop was run by her son under the name Tissages Van
Melle. **Sources:** Catherine Jarrosson-Berthoud, *Hélène Henry, ses Tissus*, master's
thesis at the Université de Paris X Nanterre, 1986; Renée Moutard-Uldry, 'Hélène
Henry', *Mobilier et Décoration*, vol. 34, 1954–57.

HERBST, RENÉ Paris 1891–Paris 1982
French architect and designer, trained in Paris, London and Frankfurt. Initially an
exponent of Art Deco, Herbst designed several stands in the 'rue des Boutiques'
at the 1925 Paris exhibition. He soon became a leading figure in industrial design,
a founder member and president of the U.A.M. and its offshoot Formes Utiles.
Although he counted the Aga Khan and the Maharaja of Indore among his clients,
Herbst sought to democratize modern design by manufacturing mass-produced
tubular metal furniture to his own designs. His work includes cinemas, restaurants,
shops, offices, liner interiors, streamlined liner cabins (in collaboration with the OTUA)
and exhibition stands, including the Advertising pavilion at the 1937 Paris exhibition.
His carpets, in abstract designs, were woven by the Ets. Marcel Coupé*.
Source: Solange Goguel, *René Herbst*, Editions du Regard, Paris, 1990.

HOFFMANN, JOSEF Pirnitz (Moravia) 1870–Vienna 1956
Austrian architect and designer, trained at the Decorative Arts School in Brno
(now Czech Republic) and the Akademie der Bildenden Künste, Vienna, under Otto
Wagner. Hoffmann played a key role in the creation of the *Secessionstil*; his major
buildings include the Purkersdorf Sanatorium in Vienna and the Palais Stoclet in
Brussels. In 1903 he and painter Koloman Moser founded the Wiener Werkstätte*
interior decoration firm, and from 1912, Hoffmann headed the Austrian branch
of the Werkbund. Hoffmann's early carpet designs, executed by Backhausen*, are
symmetrical lattice patterns in a limited range of sober colours; from 1910 they
become more intricate, mixed with curvilinear elements in bright shades; from 1913,
he tended towards loosely organized floral compositions and later medallion designs.
Backhausen continues to produce Hoffmann's strip carpeting as does Vorwerk.
Ginzkey* also wove carpets from his designs. **Source:** Eduard Sekler, *Josef Hoffmann:
the Architectural Work*, Princeton University Press, Princeton, 1985.

HOSIASSON, PHILIPPE Odessa (Georgia) 1898–Paris 1978
Painter and designer of Russian origin, naturalized French. Hosiasson came to Paris
in 1924 to design sets for the Ballets Russes. He worked for Le Printemps department
store and painted the murals of the Pavillon de la Martinique at the 1937 Paris
exhibition. A founder of the Salon des Surindépendants, Hosiasson abandoned
figurative painting for abstraction, but returned to classical canons in around 1947.
He designed rugs in abstract designs for Chareau* during the twenties and Aubusson
rugs during the forties. **Source:** *Amour de l'Art*, 1934.

ITTEN, JOHANNES Süderen-Linden 1888–Zurich 1967
Swiss painter, designer and theoretician trained at the School of Fine Arts, Geneva and
at Adolf Hölzl's academy in Stuttgart. He showed avant-garde pictures at the Sturm-
Galerie, Berlin in 1916. Itten taught theory at the Bauhaus in Weimar (1919–23), then
left to set up the short-lived Ontos weaving workshop at Herrliberg, near Zurich,
assisted by former students Gunta Stölzl* and Mila Hoffmannlederer (1923–26). From
1926 to 1934 he ran his own school in Berlin-Wilmersdorf, then directed the Höhere
Fachschule für Textile Flächenkunst in Krefeld (1932–38). On his return to Switzerland,
he joined the Swiss Werkbund and directed the Decorative Arts School and Museum,
Zurich (1938–54) and the Textilfachschule, Zurich (1943–60). Involved in the
foundation of Zurich's Rietberg museum (1952–55), Itten also published his theories
on colour and teaching methods at the Bauhaus, which are still basic reference works.
Itten's carpet designs are in the Itten-Archiv in Zurich and a small rug that he both
designed and wove is in the Bellerive Museum, Zurich. **Source:** Sigrid Wortmann
Weltge, *Bauhaus Textiles. Women Artists and the Weaving Workshop*,
Thames & Hudson, London, 1993.

JALLOT, LÉON Nantes 1874–Paris 1967
French cabinetmaker and designer. Jallot managed the furniture workshop at Siegfried
Bing's Art Nouveau shop (1898–1901), then set up his own Paris design studio in
1903. A founder member of the Société des Artistes-Décorateurs, Jallot designed
furniture, textiles and lighting and contributed to two pavilions, 'Une Ambassade
Française' and 'L'Hôtel du Collectionneur', at the 1925 Paris exhibition. His son
Maurice-Raymond (born 1900), a student of the Ecole Boulle, joined the firm as
partner in 1921. Jallot's carpet designs were initially floral and later abstract. He also
used rugs by other designers in his interiors, namely Jules Coudyser* and René
Paquet, supplier of the fur rug shown on his stand at the 1925 exhibition. **Source:**
Renée Moutard-Uldry, 'Dictionnaire des Artistes-Décorateurs', *Mobilier et Décoration*,
vol. 34, 1954, no. 7.

JAULMES, GUSTAVE-LOUIS Lausanne 1873–Paris 1959
Swiss painter and decorator, naturalized French. Trained as an architect at the Ecole

des Beaux-Arts, Paris, and showed his pictures at the annual salons from 1902.
A collaborator of Süe* and Mare*, Jaulmes was among the first *Coloriste* designers.
Jaulmes created posters, pottery and book illustrations but specialized in fine tapestry,
many commissioned by the Manufacture Nationale des Gobelins, and murals including
the Villa Kerylos at Beaulieu, the Salle des Fêtes in the Grand Palais at the 1925
International Exhibition and the foyer of the Théâtre du Palais de Chaillot at the 1937
exhibition. Jaulmes also decorated many hotels, casinos, town halls and private
homes. His carpets never diverged from a classical vocabulary. The Maison Hamot*
commissioned designs from him. **Source:** Christiane Guttinger, *Gustave Jaulmes,
Peintre-Décorateur*, thesis, Ecole du Louvre, Paris, 1982.

JOEL, BETTY Hong Kong 1896–Andover, Hampshire 1985
British designer. In 1921, Betty Joel and her husband David Joel founded a furniture
manufacturing company, Betty Joel Ltd, in London. The Savoy and St James hotels,
the Royal Society of Medicine and Revillon Frères numbered among their clients. Betty
Joel also designed fabrics and carpets in a Modernist vein, featuring a few large-scale
geometric or abstract motifs or lines on a field without borders. Woven in Tientsin,
China, the carpets bear her monogram, which resembles Chinese characters. She
retired in 1937. **Source:** Mel Byars, *Design Encyclopedia*, Laurence King, London, 1994.

JOUBERT, RENÉ see D.I.M.

JOURDAIN, FRANCIS Paris 1876–Paris 1958
French interior designer, painter and art historian, son of Frantz Jourdain. Studied
under Eugène Carrière at the Ecole des Beaux-Arts in Paris. A militant socialist,
founder of the Société de l'Art Pour Tous, Jourdain was a founder member of the
U.A.M. and its subsidiary Formes Utiles. In 1912 he founded 'Les Ateliers Modernes',
a workshop in Esbly, with a view to producing quality budget modular furniture from
his own designs. In 1919, he opened a boutique, Chez Francis Jourdain, which sold
his furniture, pottery, lighting, fabrics and carpets. He showed a room for physical
exercise in the Société des Artistes-Décorateurs pavilion at the 1925 Paris exhibition.
While some of his carpets are decorated with a scattering of stylized flowers, most are
simple geometric designs, many made up of boxed squares and rectangles, some
recalling leaded glass. Laplante, the Maison Myrbor* and the Grands Magasins à la
Place Clichy* commissioned designs from him. **Source:** Suzanne Tise, 'Francis
Jourdain', in Arlette Barré-Despond, *Jourdain*, Rizzoli, New York, 1991.

KARASZ, ILONKA Budapest 1896–Warwick (N.Y.) 1981
Decorator of Hungarian origin, who emigrated to the United States in 1913. Based in
New York, Karasz created furniture, textiles, wallpaper, pottery, silverware, lighting and
book illustrations, often in collaboration with her sister Mariska (1898–1960), a writer
and fashion designer who made fabrics and needlepoint tapestries. Ilonka Karasz
exhibited with the American Designers' Gallery from 1929, and AUDAC (the American
Union of Decorative Artists and Craftsmen) devoted an exhibition to her work in 1931.
Surviving carpet designs reveal her love of bright colours and stylized Modernist
patterns. **Sources:** *American Art Annual. Directory of Craftsmen and Designers*,
Washington, D.C., 1930; Mel Byars, *Design Encyclopedia*, Laurence King, London,
1994.

KAUFFER, EDWARD McKNIGHT Great Falls (Montana) 1890–New York 1954
American painter, decorator and graphic designer. Studied at the Mark Hopkins
Institute in San Francisco and at the Art Institute of Chicago. After a brief spell in Paris,
Kauffer lived in England from 1914 to 1940. A member of the Omega Workshops*,
he frequented the Vorticists and Group X and designed posters for the London
Underground, Shell and British Petroleum. An exhibition of his work was held at the
Museum of Modern Art, New York, in 1937. At the end of the twenties, Kauffer began
to design carpets, inspired by his companion and associate Marion Dorn*. Mostly

abstract compositions, some show the influence of Da Silva Bruhns*. By the thirties, he evolved to biomorphic forms of Surrealist inspiration. In 1940 the couple returned permanently to the United States. **Source:** Mark Haworth Booth, *E. McKnight Kauffer, A Designer and his Public*, Gordon Fraser Gallery, London, 1979.

KERKOVIUS, IDA Riga, Latvia 1879–Stuttgart 1970
Latvian painter and weaver. She studied painting in Riga, in Stuttgart under Adolf Hölzl and in Berlin under Adolf Mayer, then worked as an assistant to Hölzl at the Stuttgart Academy. Encouraged by her student Johannes Itten*, Kerkovius enrolled at the Bauhaus where she specialized in weaving (1920–23). She returned to Stuttgart during the thirties, when her work was denounced as degenerate and banned by the Nazis. She successfully re-established her career after the war in the same city, where she continued to exploit the textile medium as an art form, became a professor and joined the Deutscher Künstlerbund. **Source:** Sigrid Wortmann Weltge, *Bauhaus Textiles. Women Artists and the Weaving Workshop*, Thames & Hudson, London, 1993.

KINHEIM, Beverwijk (Holland)
Dutch carpet workshop, founded by Cornelia Polvliet-van-Hoogstraten (1882–1966) and her husband in 1909. The workshop originally wove designs in an oriental vein, but from 1912 until its closure in 1973, production was geared towards designs by contemporary artists including Nieuwenhuis*, Lion Cachet*, Frits Spanjaard, Jan Gompertz, Jaap Gidding*, Tom Poggenbeck, Willem Penaat and Jacob Van den Bosch. Carpets are woven in the Turkish knot and the workshop's monogram, a swastika, is normally embroidered on the underside. **Source:** *Geknoopt bij Kinheim*, Huize Scheybeeck, Beverwijk, 1974 (exhibition catalogue).

KINSBOURG, RENÉE Rouen 1888–[?]
French decorator, active between the wars. Kinsbourg ran a Paris interior decoration firm, 'Aux Arts de France', and first participated in the Paris salons in 1924. Preferring curving forms to geometric designs, she produced carpets inspired by the theatre, the circus or everyday objects such as fans, scarves, paintbrushes and ropes, as well as completely abstract designs such as the piece exhibited in New York in 1929. Subtle shades of grey, blue, ochre and brick red tended to dominate. **Source:** Paul Sentenac, 'Les Meubles et les Tapis de Renée Kinsbourg', *Renaissance de l'Art Français*, March 1929.

KLEE, PAUL Munchenbuchsee 1879–Muralto-Locarno 1940
Swiss poet, musician, theorist and painter, trained at the Academy in Munich. A member of the Expressionist group Der Blaue Reiter from 1912, Klee sought to achieve a greater rapprochement between painting and other media, such as glass, wood and textiles. Invited to teach theory at the Bauhaus in 1920, Klee's courses on colour were based in part on Robert Delaunay's theories. Under pressure from the Nazis, Klee left the Bauhaus in 1931 to take up a post at the Düsseldorf Academy, but returned to Switzerland permanently two years later. The Maison Myrbor* wove three pile carpets from works by Klee. **Sources:** Mildred Constantine, Albert Châtelet, *An Exhibition of Contemporary French Tapestries*, Charles E. Slatkin Galleries, New York, 1965; *Tapis de Maîtres*, Galerie Weill-Seligman, Paris, n.d.

KLEIN, JACQUES (or JACQUE) Malaunay (Seine-et-Marne) 1899–1963
French decorator. He designed wallpaper, fabrics, lighting and carpets for La Maîtrise*, which were first shown at the Salon d'Automne in 1920. His furniture was made by Delepoulle and Gouffé until 1942, when he established his own business in Paris. His carpets of the twenties reveal an innate gift for colour. He also produced designs for Braquenié*. **Source:** Pierre Kjellberg, Guillemette Delaporte, *Le Mobilier du XXe Siècle. Dictionnaire des Créateurs*, Editions de l'Amateur, Paris, 1994.

KOCH-OTTE, BENITA see OTTE, Benita

KONINKLIKJE VERENIGDE TAPIJTFABRIEKEN (KVT),
Moordrecht, near Rotterdam
Dutch carpet manufacturer. The KVT (United Royal Carpet Factories) resulted from a 1919 merger of three firms: the Deventer Tapijtfabriek of Rotterdam, founded by G. Birnie in 1797; the Koninklijke Tapijtfabriek Werklust, founded by W. Stevens in 1854, and the 's-Gravenhaagsche Smyrnatapijtfabriek, a small craft workshop founded in The Hague in 1901. King Willem III was a shareholder. Following the merger, only the Rotterdam factory, which had previously absorbed the Amersfoortsche Tapijfabriek (1901) and retained Theodoor C. A. Colenbrander* as artistic director, continued to weave rugs by hand. The firm made handwoven imitations of Turkish, Persian and other oriental carpets, but also commissioned modern pieces from Dutch and foreign designers, including Jaap Gidding*, R. N. Van Dael, Jan Gompertz, Nieuwenhuis* and Martta Taipale. The company closed in 1979. **Sources:** Ferdinand Leborgne, *Exposition Universelle de 1900. Rapports du Jury International. Classe 70. Tapis, Tapisseries et Autres Tissus d'Ameublement*, Imprimerie Nationale, Paris, 1901; Mienke Simon Thomas, 'KVT', in *Industry and Design in the Netherlands*, Stedelijk Museum, Amsterdam, 1986 (exhibition catalogue).

ŁAD ARTISTS' COOPERATIVE, Warsaw
Founded in 1926 by a group of professors at the School of Fine Arts in Warsaw, Ład produced ceramics and metalwork and specialized in the manufacture and sale of flatweave carpets and fabrics made from linen, wool and silk. Flatweaves by Wanda Sakowska-Wanke, Helena Bukowska, Eleonora Plutynska, Julie Grodecka, Adalbert Jastrzebowski, Wojciech Jastrzebowski, Karolina Mikotajczykowna and Halina Karpinska were among those woven in the workshop. Most consist of geometric repeating or medallion patterns reminiscent of the country's folk heritage, which had long been subject to oriental influence. **Source:** Edward Woroniecki, 'Les Kilims et les Tissus de Lin Modernes en Pologne', *Art et Décoration*, February 1930.

LANUX, EYRE DE see EYRE DE LANUX

Ets. LAUER, Paris, Lyons, Aubusson and Cogolin (Var)
French textile manufacturer. Founded by Jean-Philippe Lauer in 1860, the firm wove furnishing fabrics in its Puteaux factory, and later in Lyons, under the name La Lyonnaise d'Ameublement. In 1902, a tapestry and carpet workshop was founded in Aubusson, directed by Lauer's son Maurice. In about 1928, the department was transferred to Cogolin, under the management of Jean Lauer, grandson of the founder. The firm wove carpets for decorators including Alavoine, Dominique*, Gaudissart*, Süe* and Mare*, Dufrène*, Groult*, Leleu*, Printz*, Jansen, Prou*, Jean Pascaud and Jean Picart-le-Doux. As well as revival styles, the firm produced its own lines, with textured rugs being a speciality. Bénédictus*, Jean-Charles Moreux, Henri Gonse, Roger Valance, Georges Renouvin, Fernand Léger*, Jean Cocteau and Christian Bérard all designed for the firm. On Jean Lauer's death in 1960, his wife Irma succeeded him as president, assisted by Yves Bardou. Following her retirement, the company was run by a joint executive committee, and is now part of the Tai Ping Carpets Group, Hong Kong. **Sources:** Archives Nationales F12/8644; *Revue Professionnelle des Métiers d'Ameublement et de la Décoration*, no. 1, November 1982; Interviews with Irma Garance, José Michel; Tapis de Cogolin archives.

LAURENS, HENRI Paris 1885–Paris 1954
French sculptor. Self-taught, and a close friend of Braque, Picasso* and Juan Gris, Laurens is renowned for his Cubist sculptures of the female figure. Laurens was also a painter and engraver, set designer and occasional decorator. At least six rugs were produced from the thirties by the Maison Myrbor* from his studies of reclining nudes. **Source:** Mildred Constantine, Albert Châtelet, *An Exhibition of Contemporary French Tapestries*, Charles E. Slatkin Galleries, New York, 1965.

LÉGER, FERNAND Argentan 1881–Gif-sur-Yvette 1955

French painter and designer, trained at the Ecole des Beaux-Arts, the Ecole des Arts Décoratifs and the Académie Julian, Paris. Influenced by Futurist theories and his wartime experiences, Léger evolved from abstract to figurative painting, depicting movement and machines. A member of the Groupe de Puteaux, he later joined the Purist movement and collaborated with Le Corbusier and Ozenfant on the Pavillon de l'Esprit Nouveau at the 1925 Paris exhibition. Léger also designed film and ballet sets, book illustrations, murals, mosaics, tapestries and carpets. Five carpets were produced by the Maison Myrbor* from his brightly coloured paper collages. Léger's carpets were also retailed by the Compagnie des Arts Français*; post-war, the Tapis de Cogolin* wove his designs. **Sources:** Robert L. Delevoy, *Léger*, Skira, Geneva, 1962; *Rugs...*, World House Gallery, New York, 1962 (exhibition catalogue); *Tapis de Maîtres*, Galerie Weill-Seligman, Paris, n.d.

LEISCHNER, MARGARET
Bischofswerda, Germany 1907–Maplehurst, England 1970
German weaver, who studied at the School of Applied Arts in Dresden, then enrolled at the Bauhaus (1927–31). During the thirties, Leischner ran the weaving workshop at the Textil- und Modeschule in Berlin and designed textiles on a freelance basis for the Deutsche Werkstätten* and the Hablik-Lindemann* workshops. In 1938 she emigrated to England, where she worked as an industrial designer for several British textile manufacturers, including Irish Ropes, for whom she designed Brussels carpeting during the sixties. From 1948 to 1963 she headed the weaving department at the Royal College of Art in London. **Source:** Sigrid Wortmann Weltge, *Bauhaus Textiles. Women Artists and the Weaving Workshop*, Thames & Hudson, London, 1993.

LELEU, JULES Boulogne-sur-Mer 1883–Paris 1961
French sculptor and designer. Studied at the Académie des Beaux-Arts in Boulogne-sur-Mer, later in Brussels and the Ecole des Arts Appliqués, Paris. Upon inheriting their father's painting business in Boulogne-sur-Mer in 1909, Jules Leleu and his brother Marcel also set up an interior design department in Paris, which by 1924 had become one of the foremost furniture studios of the inter-war period. Important commissions included the United Nations headquarters in Geneva, French embassies, a dining room in the Elysée Palace (1948) and several liners, among them the *Ile-de-France*, the *Atlantique*, the *Pasteur* and the *Normandie*. Until the mid-thirties, Da Silva Bruhns* was chief rug designer; then Jules's daughter Paule Leleu (1906–87) took over, assisted by Anne Grattepain. Before the war, the rugs were hand-knotted by Lauer* and following the war, in India and Algeria; recent pieces have been made in the tufted technique. Paule Leleu's rugs feature symmetrical caisson arrangements and repeating geometric patterns with diamond or linear motifs, as seen in the piece exhibited in the Société des Artistes-Décorateurs pavilion at the 1937 International Exhibition. From 1940, she designed many circular compositions, with geometric and floral diaper patterns sculpted in relief. **Sources:** 'Leleu', *Mobilier et Décoration*, January 1940; René Chavance, 'La Rénovation du Tapis par Leleu', *Mobilier et Décoration*, December 1948; M. B. K., 'Une Exposition de Tapis chez Leleu', *Mobilier et Décoration*, December 1957; Viviane Jutheau, *Jules et André Leleu*, Vecteurs, Paris, 1989; Leleu archives.

LEPLAE, CHARLES Leuven 1903–Brussels 1961
Belgian sculptor. Leplae graduated in law, then studied art at the Leuven Academy, furthering his education in Paris as a student of Charles Despiau. Introduced to the Etikhove group by the Haesaerts* brothers, Leplae designed a series of carpets for the Studio de Saedeleer*. Decorated with stick-like figures, Leplae's carpets depict themes such as the ballet, jazz musicians or gods and goddesses.
Source: Albert Dasnoy, *Charles Leplae*, De Sikkel, Antwerp, 1950.

LÉVY, JANE Paris 1894–Auschwitz *c.* 1943
French painter. She trained at the Ecole des Beaux-Arts, Paris, under Fernand Sabatté and Paul Hannaux, and showed her pictures at the Salon des Artistes Français and the Salon des Indépendants. Lévy designed a series of brightly coloured carpets, either entirely geometric or overlaid with floral and animal motifs, particularly birds and butterflies. Braquenié*, Coupé* and Tabard* wove her designs.

LINDEMANN, ELISABETH see **HANDWEBEREI HABLIK-LINDEMANN**

LION CACHET, CAREL-ADOLPH Amsterdam 1864–Vreeland 1945
Dutch artist and decorator. A pioneer of Dutch Art Nouveau, Lion Cachet was the first Dutch artist to design batiks. In 1901 he set up the Atelier voor Versieringskunst (Decorative Arts Studio) in Vreeland. In addition to interiors, pottery and carpets, Lion Cachet designed postage stamps and banknotes. From 1899, he co-directed, together with Theodoor Niewenhuis* and Gerrit Willem Dijsselhof, the workshop of the Van Wisselingh firm in Amsterdam, which designed the interiors of several luxury liners, including the *Grotius*, *Prinses Juliana*, *J. P. Coen* and *Tjitjalenka*. He also designed the carpet exhibited in the Dutch pavilion at the 1925 International Exhibition. Surviving rugs woven by Kinheim* reveal a penchant for orientalism. **Sources:** Miep Spee, *Traditional and Modern Batik*, Kangaroo, Kenthurst, 1982; Titus M. Eliëns, Marjan Groot, Frans Leidelmeijer, eds. *Avant-Garde Design. Dutch Decorative Arts 1880–1940*, Philip Wilson, London, and V + K Publishing, Bussum, 1997.

LURÇAT, JEAN Bruyères (Vosges) 1892–Saint Paul de Vence 1966
French painter and designer of tapestry cartoons. A trainee in Victor Prouvé's workshop in Nancy, Lurçat moved to Paris to study painting at the Académie Colarossi. Lurçat made his name as a painter and decorator in the twenties but he is chiefly associated with the renaissance of the Aubusson tapestry industry after the Second World War, when he set up a studio in Saint Céré (Lot). His early rugs, commissioned during his Cubist period, not surprisingly recall his paintings; some are purely abstract, but others are peopled with fantastic creatures: mermaids, seahorses, centaurs and winged horses. Later pieces are decorated with the all-powerful sun and astrological symbols in a style reminiscent of his tapestries. From 1923 onwards he designed over twenty carpets for the Boutique Pierre Chareau*, the Maison Myrbor*, the Manufacture de la Savonnerie*, the Maison Jansen, Jacques Borker and the Cooperative des Tapis Marocains, as well as a line of powerloom carpeting for Saint Frères. **Sources:** Susan Day, 'Les Tapis de Jean Lurçat', in *Jean Lurçat. Le Combat et le Victoire. Aubusson 92, Centenaire*, exhibition organized by the Musée de la Tapisserie, Aubusson, 1992.

MÅÅS-FJETTERSTRÖM, MÄRTA Kimstad 1873–Båstad 1941
Swedish textile designer and weaver. Måås-Fjetterström left the Malmö craft society to set up her own weaving workshop, first in Vjittsjö, then Båstad (1919). She revived many forgotten weaving techniques and invented one of her own, named the MMF technique after her. Her designs were mostly drawn from Swedish folk art and the plant and animal life of the neighbouring countryside. At the same time, she was one of the first to break with graphical representation and focus on aesthetic effects achieved by using contrasting yarns and materials. Måås-Fjetterström's work was shown at numerous international events organized in Paris (1925, 1937), New York (1929), London (1931), Chicago (1933) and elsewhere, and won many awards. Rugs woven from the 662 designs she created during her lifetime bear the initials MMF, and after her death AB MMF, followed by a number of dots that identify the weaver. After Måås-Fjetterström died, the workshop became a limited company, directed by Barbro Nilsson. Models by Nilsson, Ann-Mari Forsberg, Marianne Richter and Barbro Sprinchorn have since been added to the studio catalogue. **Sources:** R. Stornsen, n.d.; Tyra Lundgren, *Märta Måås-Fjetterström och Väv-Verkstaden i Båstad*, Bonnier, Stockholm, 1968; Märta Måås-Fjetterström archives, Båstad.

MAES, KAREL Mol 1900–Koersel 1974

Belgian painter, a student of the Académie des Beaux-Arts in Brussels. A member of the avant-garde, Maes co-founded the magazine *7 Arts*, and was one of the first Belgian painters to endorse the school of abstract geometric painting. As director of the Ateliers Victor de Cunsel (1926–29), he also designed interiors. His carpet patterns, executed by the Studio de Saedeleer* and the Frères de Coene in Coutrai, are similar to his paintings. **Source:** Louis Frédéricq, 'Karel Maes', in Pierre Loze, Dominique Vautier, *Art Déco Belgique 1920–1940*, Musée d'Ixelles, Brussels, 1988.

MAISON MARTINE see Atelier MARTINE

MAISON MYRBOR, Paris and Algeria

French manufacturer and retailer of carpets. Marie Cuttoli, née Bordes (1879–1973), set up the first workshop in her home in Algiers (*c.* 1910), then in nearby Sétif. Local women made the carpets and embroideries, which were sold to Parisian *haute couture* houses. A patron of the avant-garde, Cuttoli commissioned the first modern carpet design from Jean Lurçat* in 1923, then opened a shop in Paris, designed by André Lurçat in 1926. The firm also sold embroidered dresses and ran a decoration department. Designs by Eileen Gray*, Francis Jourdain* and Da Silva Bruhns* were available, but the store eventually specialized in *tapis de maîtres*, woven from works by Picasso*, Léger*, Arp*, Miró*, Klee*, Laurens*, Joseph Csáky, Louis Marcoussis* and Nathalie Goncharova. From 1928, Cuttoli focused her efforts on reviving the moribund Aubusson tapestry industry; the Delarbre, Simon and Legoueix workshops wove tapestries for her and may also have produced rugs. In the mid-thirties, Cuttoli went into partnership with the Bucher gallery, and post-war, with fellow collector Lucie Weill. Rugs by Alexander Calder*, Max Ernst*, André Derain, Jean Cocteau, Ben Nicholson*, Roger Bissière and Maria Elena Vieira Da Silva, woven in India or Afghanistan, were added to the catalogue. Limited at the outset to six, the number of pieces woven from any one model was increased to one hundred, with the exception of Picasso. The name of the workshop and sometimes the designer is embroidered in block letters on the underside, generally on the border which is folded and stitched to the back. **Sources:** 'Notre Dame d'Aubusson, Patronne de l'Art Moderne', *Réalités*, no. 162, July 1959; Sarah B. Sherrill, 'Carpets of the Parisian Avant-Garde', *Hali*, no. 85, March–April 1995.

Atelier LA MAÎTRISE, Paris

Interior decoration department of the Galeries Lafayette department store, founded in 1921 with the aim of creating good-quality mass-produced furniture. Its first director was Maurice Dufrène*, who often hired his best students and allowed them to sign their work. The interiors were designed by a staff of around ten permanent or occasional collaborators. In 1925, the workshop presented a pavilion at the 1925 International Exhibition which was designed by a group of young architects, R. Hiriart, Tribout and Beau, with interiors by Suzanne Guiguichon*, Gabriel Englinger and Dufrène. Guiguichon, Jean and Jacques Adnet*, Jean Beaumont*, Fernand Nathan and Marguerite Dubuisson* were among those who designed rugs for the workshop, which were woven by Schenk, Coupé* or Lauer*. The studio also sold rugs by freelance designers, including Bénédictus*. Closed during the war, the workshop was directed by Dufrène until 1950, then by M. Gobion and Geneviève Pons until it closed permanently in 1972. **Source:** Pierre Kjellberg, *Le Mobilier du XXe Siècle. Dictionnaire des Créateurs*, Editions de l'Amateur, Paris, 1994.

MALLET-STEVENS, ROBERT Paris 1886–Paris 1945

French architect and decorator, trained at the Ecole Spéciale, Paris. A founder member and president of the U.A.M., Mallet-Stevens was a key figure on the French architectural scene between the wars. Until he endorsed the Modernist aesthetic, Mallet-Stevens's work showed pronounced Viennese influence. His designs, which recall the elegant severity of the De Stijl movement, include the carpeting in the hallway of his home in the rue Mallet-Stevens, the stairway of an apartment block on the rue Mechain, the Saint-Jean-de-Luz Casino, the Bally shoestore and the dining room of the Villa in Croix. He also used rugs by other designers, including Eileen Gray*, Djo-Bourgeois*, Jean Lurçat*, Fernand Léger* and Jean Burkhalter*, in his projects. **Source:** Dominique Deshoulières, Hubert Jeanneau, Maurice Culot, *Robert Mallet-Stevens, Architecte*, Archives d'Architecture Moderne, Brussels, 1980.

MANUFACTURE DE BÉARN, Pau

French carpet weaving workshop, established in the Château de Pau (1916–17) with a view to providing employment for the war-wounded. It was originally run by the daughters of the curator, Albert Pépin, with the backing of the local government and technical assistance supplied by Jean Coudyser*. He and Jallot* were among the decorators who had their rugs woven in the workshop, later known as Pépin et Berthier. **Source:** 'Le Tapis Français de Béarn', *Renaissance de l'Art Français*, 1922.

MANUFACTURE DE LODÈVE see MANUFACTURE NATIONALE DE LA SAVONNERIE

MANUFACTURE DE TAPIS DE COGOLIN see Ets. LAUER

MANUFACTURE FRANÇAISE DE TAPIS ET DE COUVERTURES, Beauvais

French carpet and blanket manufacturer. Founded by the brothers Gustave, Alfred and Victor Tétard in 1839; Henri Rupp and Edmond Lainé became partners in 1872, succeeded by Lucien Lainé. After merging with the Tourcoing firm of Wattel, and Rasson of Lys-les-Lannoy, the firm was reincorporated in 1920 under the name Manufacture Française de Tapis et de Couvertures. The firm wove various types of powerloom carpeting: chenille, tapestry carpets, Wilton and machine-made pile. Their in-house designers included Fernand Windels*, who left to set up his own company. Lainé also initiated a policy of acquiring models from freelance designers, among them Bagge*, Coudyser* and Crevel*. A handweaving workshop made hand-knotted carpets from designs by Bénédictus*, Boberman*, Kinoshita, Follot*, Solange Patry-Bié* and Georges de Feure*. The MFTC merged with Communeau et Cie in 1930, and in 1948 went into partnership with the Tourcoing-based firm of Lorthiois-Leurent to form a distribution network named France Tapis. From this date, handweaving was abandoned. A series of takeovers ensued, by Saint-Frères, Agache-Willot and Boussac, resulting in the liquidation of the Beauvais factory in 1982. **Sources:** *Cahiers de l'Ecomusée de Beauvaisis*, no. 6, November 1983; Jacques Dumont de Montroy, *Les No, Zentz, Communeau, Tétard, Lainé, MFTC, BSF, Industriels du Textile à Beauvais au XIX et XXe Siècle*, unpublished manuscript.

MANUFACTURE NATIONALE DE LA SAVONNERIE, Paris

French carpet-weaving workshop. Formerly under royal warrant, the carpet workshop was originally located in the Louvre Palace, where Pierre Dupont began weaving pile carpets using the symmetrical knot in 1608. In 1626 a second workshop was set up by Dupont's partner and former apprentice, Simon Lourdet, in a former soap factory at Chaillot (today part of Paris), hence the name 'Savonnerie'. The atelier was merged with the Louvre workshops in 1672, the Manufacture Nationale des Gobelins in 1825 and the Beauvais tapestry workshop in 1936. The designs were created by *artistes-cartonniers*, and overseen by an artist designated by royal appointment, of whom the first was Charles Lebrun. Less finely knotted than their oriental counterparts, modern Savonnerie rugs have woollen warps, linen wefts and a knot count of 800 to 1,000 knots per sq. dm, significantly lower than the 1,600 knots used in 17th-century pieces made with natural dyes. The number of strands composing each knot, which varies from a minimum of 4Z2S to 6Z2S, that is from 16 to 24 tufts, compensates for the relatively low knot count. Today, the weavers work with a range of 800 synthetic dyes,

a small number when compared to the 30,000 shades theoretically available in the late 19th century from the institution's dye laboratory. This, coupled with the use of chiné yarns and bevelled surfaces, allows the weavers to achieve subtle nuances in shading and relief. Today the workshops are run by the Mobilier National, the administrative body in charge of furnishing state institutions. The practice of commissioning designs from contemporary artists continues even today, with Vasarely, Pierre Soulages and Geneviève Asse figuring among those artists whose carpets have been produced recently. Set up in 1962 to provide employment for Algerian immigrants, the Lodève workshop has been run by the Mobilier National since 1964. **Sources:** Gustave Geffroy, *Les Musées d'Europe. Les Gobelins*, Paris, n.d.; Madeleine Jarry, *The Carpets of the Manufacture de la Savonnerie*, F. Lewis, Leigh-on-Sea, 1966; Jean Coural, 'Les Manufactures Royales', *Monuments Historiques*, no. 4, 1975; Pierre Verlet, *The Savonnerie, its History. The Waddesdon Collection*, Office du Livre, Fribourg, 1982; Nicole de Reyniès, 'Les ateliers des Gobelins', *Monuments Historiques*, no. 190, 1993.

MANUFACTURE SAINT JEAN see **HAMOT**

MANUFATTURA PARACCHI see **PARACCHI**

MANZANA-PISSARRO, GEORGES Louveciennes 1871–Menton (Alpes-Maritimes) 1961
French painter and decorator, born Georges Pissarro, son and student of Camille Pissarro. Trained at Ashbee's school in Whitechapel, Manzana-Pissarro and his wife set up a weaving workshop in Paris in 1913. An exhibition of his tapestries, carpets and decorative work was held at the Musée des Arts Décoratifs the following year. Interrupted by the war, the workshop's activities recommenced in the twenties. The last exhibition to include his carpets was held in 1927. The workshops probably closed in 1934, when he moved to Thiais. Signed 'Manzana', his carpets echo the subject matter of his paintings, particularly animals. **Sources:** Arsène Alexandre (pref.), *Exposition des Oeuvres de Manzana-Pissarro*, Paris, n.d. (1914); *Manzana-Pissarro*, Galerie Dario Boccara, Paris, 1973 (exhibition catalogue).

MARCOUSSIS, LOUIS Warsaw 1878–Cusset (Allier) 1941
French painter of Polish origin, trained at the School of Fine Arts in Krakow. Settled in Paris from 1903, Marcoussis was a Cubist and a member of the Section d'Or. During the twenties, at least four models were produced from his collages by the Maison Myrbor*. Two are abstract, the others decorated with stylized motifs suggesting leaves or the sky. In addition to Jacques Doucet's apartment, Marcoussis's carpets were used in an interior designed by André Lurçat and featured on Michel Dufet's stand at the 1930 Salon d'Automne. **Source:** *Amour de l'Art*, 1933, p. 233.

MARE, ANDRÉ Argentan 1885–Paris 1932
French painter and decorator trained at the Ecole des Arts Décoratifs and the Académie Julian, Paris. A member of the Groupe de Puteaux, Mare exhibited a 'Maison Cubiste' at the 1912 Salon d'Automne, designed in collaboration with Raymond Duchamp-Villon and a team of artists. In the period leading up to the First World War, Mare designed *Coloriste* interiors with coordinated carpets in floral and medallion motifs. In 1919 he formed the Compagnie des Arts Français* in partnership with Louis Süe*; the range of colourful floral carpets created by the firm are the epitome of Art Deco. **Sources:** Susan Day, *Louis Süe, 1875–1968, Architecte des Années Folles, Associé d'André Mare*, Institut Français d'Architecture, Paris; and Pierre Mardaga, Brussels, 1986 (exhibition catalogue); Florence Camard, *Süe et Mare et la Compagnie des Arts Français*, Editions du Regard, Paris, 1993.

Atelier MARTINE, Paris
French decorating firm, founded in Paris in 1911 by the couturier Paul Poiret (1879–1944). The Atelier Martine originally sold fabrics, carpets and wallpapers designed by the students of the Ecole Martine, a school for young girls located in Poiret's couture house. Production later expanded to include furniture and commissions for decorative schemes. The Atelier Martine designed the three luxury barges, *Amour*, *Délices* and *Orgues*, which served as the couturier's showcase at the Paris exhibition in 1925. Clients included Kees Van Dongen, Sacha Guitry and the Compagnie Générale Transatlantique, owner of the liner *Ile-de-France* (1927). The textiles were printed or woven by outside manufacturers, with the exception of the carpets, which were woven by the Ecole Martine. Inspired by events in the girls' daily lives, the designs were occasionally figurative or taken from nature: trees, broad leaves, tropical vegetation and, most famously, open flowers in bright colours. Poiret's business finally closed in 1934. **Sources:** Paul Poiret, *En Habillant l'Epoque*, Grasset, Paris, 1930; Léon Moussinac, 'L'Atelier Martine', *Art et Décoration*, vol. 46–2, 1924; *Poiret le Magnifique*, Institut de France, Paris, 1974 (exhibition catalogue).

McKNIGHT KAUFFER, EDWARD see **KAUFFER, EDWARD McKNIGHT**

METZ & CO., Amsterdam, The Hague
Department store specializing in quality home furnishings. Founded as a draper's store in the 18th century or earlier, Metz was bought out in 1900 by Joseph de Leeuw (1872–1944). He negotiated the exclusive rights to trade Liberty's fabrics in Holland, opened a branch in The Hague in 1934 and began a policy of commissioning ranges of furniture and textiles from independent progressive designers under the direction of Willem Penaat. Fabric designs were acquired from Sonia Delaunay* and carpets from Djo-Bourgeois*, Van der Leck*, Vantongerloo* and Pavel Mansurov, among others. Pile carpets were made in Aubusson and later in Rabat by the Société Africaine de Filature et Tissage, with several grades available. A line of reversible *moquette* mats made by the Veneta Company in Hilversum was issued in 1937. Metz was taken over by Liberty's in 1973. **Sources:** Petra Dupuits, *Metz & Co. 1900–1940. From Liberty towards Functionalism*, doctoral thesis, Vrije Universiteit Amsterdam, 1992; Interview with Gina de Leeuw, Grimaud.

Ets. MEUNIÉ see **BRUNET-MEUNIÉ**

MEYER-BERGNER, LÉNA see **BERGNER, LÉNA**

MFTC see **MANUFACTURE FRANÇAISE DE TAPIS ET DE COUVERTURES**

MIKLOS, Gustave Budapest 1888–Oyonnax 1967
Hungarian sculptor and designer, trained at the Decorative Arts School in Budapest, naturalized French. In 1909 Miklos settled in Paris, where he met up with Joseph Csáky and frequented the Cubists. Miklos designed jewelry, enamels, silver and carpets, including a set for Jacques Doucet's town house in Neuilly. A member of the U.A.M., Miklos showed his work in the society's pavilion at the 1937 Paris Exhibition. From 1940, he taught at Oyonnax and divided his time between sculpture and interior design. **Source:** Jean Selz, *Catalogue de l'Exposition Miklos*, Galerie L'Enseigne du Cerceau, Paris, 1974.

MIRÓ, JOAN Montroig 1893–Palma de Majorca 1983
Catalan painter, sculptor and designer, trained at the School of Fine Arts in Barcelona. From 1919, Miró divided his time between Barcelona and Paris, where he came into contact with the Surrealist movement. A master of abstract art, Miró also designed pottery, stained glass windows, textiles, ballet sets for Sergei Diaghilev's Ballets Russes and murals, including those for the UNESCO headquarters in Paris. The Maison Myrbor* produced at least five carpets from works by Miró, named *Flag*, *Mongoose*, *Spanish Dancer*, *Dream* and *Circus*. Another was commissioned by the Mobilier National. Like his paintings, they are peopled with dream-like figures and symbols and even Chinese characters. Individual models were executed in several colourways, in primary colours highlighted with black. **Sources:** Mildred Constantine,

Albert Châtelet, *An Exhibition of Contemporary French Tapestries*, Charles E. Slatkin Galleries, New York, 1965; *Tapis de Maîtres*, Galerie Weill-Seligman, Paris, n.d.

MOBILIER NATIONAL see **MANUFACTURE NATIONALE DE LA SAVONNERIE**

MONTEREAU, GERMAINE Sully-sur-Loire 1892–Paris 1959
French master weaver. Self-taught, Montereau set up an embroidery workshop in Beaugency in 1924 but turned to weaving when the American painter A. B. Davies asked her to execute his tapestry cartoons. Montereau was renowned for her experiments with synthetic fibres and unusual materials such as aloe, and for her monochrome carpets in various techniques, including bevelled, half-pile and shag rugs, which she exhibited from 1932. She collaborated with Jean-Michel Frank, Louis Sognot* and Emilio Terry. From 1936 to 1946 Montereau worked in Morocco, where she taught weaving and decorated homes in Mogador and Casablanca. Her last exhibition before retirement was held in 1947. **Sources:** Jean Gallotti, 'Les Tissages à la Main de Germaine Montereau', *Art et Décoration*, vol. 62, 1933; Renée Moutard-Uldry, 'Dictionnaire des Artistes-Décorateurs', *Mobilier et Décoration*, vol. 34, no. 5, 1954.

MORTON & CO., Darvel and Carlisle
British textile manufacturer. Founded by Alexander Morton (1844–1923) in 1867, the mill, located in Darvel, Scotland, initially made muslin and lace, then tapestry, printed fabrics and powerloom carpeting. In 1898, the first in a series of workshops weaving the 'Donegal' line, a prestige collection of hand-knotted carpets, was set up in Killibegs, Ireland. The carpets were created by in-house designers including Gavin Morton and freelance designers such as C. F. A. Voysey*. In 1905 the firm was reincorporated as Morton Sundour Fabrics Ltd with headquarters in Carlisle. Alexander's son, James Morton (1867–1943) continued his father's work, pioneering research into dyestuffs and directing the Edinburgh Weavers* from 1928. The firm remained in family hands until it was taken over by Courtauld's in 1964. The Victoria and Albert Museum, which inherited the company's archives, devoted an exhibition to Morton & Co. in 1973. **Source:** Jocelyn Morton, *Three Generations in a Family Textile Firm*, Weidenfeld & Nicolson, London, 1971.

MÜLLER-HELLWIG, ALEN Lauenburg 1902–Lübeck 1993
German embroiderer and master weaver, trained at the Schools of Applied Arts, Hamburg and Munich. From 1926 she ran a studio in Lübeck, specializing in textiles made from undyed handspun yarns, which were exhibited at Leipzig's Grassi Museum in 1927. Her work appealed to architects Hugo Häring, Philip Johnson and particularly Mies Van der Rohe, who used her rugs in the Haus Tugendhat at Brno, the 1929 Barcelona exhibition and his stands at the 1931 Berlin building exhibition and the Milan Triennale. Müller-Hellwig won many awards, including gold medals at the Barcelona and 1937 Paris exhibitions. **Sources:** *Alen Müller-Hellwig. Wandteppiche, Behänge, Gewebe*, St. Annen Museum, Lübeck, 1976; Alen Müller-Hellwig, *Weben, mein Leben*, St. Annen Museum, Lübeck, 1992 (exhibition catalogues).

MYRBOR see **MAISON MYRBOR**

NASH, PAUL London 1889–Boscombe, Hants 1946
British artist trained at the Slade School. A member of the London Group and the New English Art Club, Nash was a founder member of the avant-garde Unit One. He was involved with the Omega Workshops* and worked principally as a graphic artist, decorator and industrial designer before achieving renown as a painter. As well as designing pottery, crystal, furnishing fabrics and posters, Nash created *moquette* for London Transport and a range of carpets for the firm R. W. Symonds. **Source:** Mel Byars, *Design Encyclopedia*, Laurence King, London, 1994.

NEVEU BRUNET & CIE see **BRUNET-MEUNIÉ**

NICHOLSON, BEN Denham 1894–London 1982
British painter, printmaker and designer, son of Sir William Nicholson. Studied briefly at the Slade School of Fine Art, London, but turned to abstract painting in 1924. Nicholson was a member of several avant-garde groups, including the 7&5 Society, Unit One and Abstraction-Création, and was co-editor of *Circle: International Survey of Constructive Art*, a publication aimed at promoting the Modernist cause and lowering the barriers between art and design. Nicholson began designing textiles in 1934, when he exhibited a series of handpainted fabrics and four carpets with his second wife, the sculptor Barbara Hepworth. The Edinburgh Weavers* and the Maison Myrbor* wove carpets from his designs. **Source:** *The Nicholsons. A Study of Four People and their Designs*, York City Art Gallery, York, 1988 (exhibition catalogue).

NIEMEYER, ADELBERT Warburg 1867–Munich 1932
German painter, architect and decorator trained at the Düsseldorf and Munich Academies and at the Académie Julian in Paris. A founder member of the Munich Secession, Niemeyer was a leading Jugendstil designer of furniture, glass, porcelain and textiles. In 1902, he founded the Werkstätten für Wohnungseinrichtung with Karl Bertsch and Willy von Beckerath, which merged with the Deutsche Werkstätten* in 1907. At the 1910 Salon d'Automne in Paris, Niemeyer showed carpets patterned with geometric motifs and small stylized flowers which served as a source of inspiration to the first period of Art Deco. **Source:** Kathryn Bloom Hiesinger, ed., *Art Nouveau in Munich*, Philadelphia Museum of Art and Prestel, Philadelphia, 1998.

NIEUWENHUIS, THEODOOR Noord Scharwoude 1866–Hilversum 1951
Dutch painter and decorator trained at the School of Industrial Art, Amsterdam. A leading exponent of Dutch Art Nouveau, Nieuwenhuis designed interiors, metalwork, stained glass, posters, book illustrations, batiks, upholstery fabrics and carpets; he collaborated with Lion Cachet* and the Amsterdam decorating firm Van Wisselingh from 1908. His carpets, in floral and medallion designs of oriental inspiration, were woven by Kinheim*, the Deventer Tapijtfabriek and KVT*. **Source:** Reyer Kras, Petra Dupuits, Elinoor Bergvelt et al., *Industry and Design in the Netherlands 1850–1950*, Stedelijk Museum, Amsterdam, 1985.

A.B. NORDISKA KOMPANIET, Stockholm
Department store. The result of a 1902 merger of the K. M. Lundberg and Joseph Leja stores, the firm steadily expanded, opening branches in Gothenburg and Malmö. Following the example of its foreign counterparts, Nordiska established an interior decoration department and launched its own line of contemporary furniture and accessories. Upholstery fabrics by Karna Asker were shown at the 1930 exhibition. A newly set-up textile department, run from 1936 to 1972 by Astrid Sampe*, launched the 'Signerad Textil' (Signed Textiles) range, designed by Sampe and independent designers including the architects Sven Markelius and Alvar Aalto, and designers Olle Bonnier, Stig Lindberg and Theo Svedberg. **Sources:** Nils G. Wollin, *Svenska Textilier 1930. Swedish Textiles 1930. Textiles Suédois 1930*, Utställningsförlaget, Stockholm, 1930. Martin Eidelberg, ed., *Design 1935–1965. What Modern Was: Selections from the David and Liliane M. Stewart Collection*, St. Louis Historical Society, Montreal, and Harry N. Abrams, New York, 1991.

OMEGA WORKSHOPS, London
British interior decoration firm, founded in London in 1913 by Roger Fry (1866–1934) and members of the Bloomsbury Group. Artists associated with the workshops, modelled on Poiret's Atelier Martine*, included co-directors Vanessa Bell* and Duncan Grant*, Wyndham Lewis, Edward McKnight Kauffer*, Paul Nash*, Frederick Etchells and Mark Gettler. In 1914, several members, headed by Wyndham Lewis, left to found the Rebel Art Centre. The group designed furniture, screens, pottery, mosaics, stained glass, clothing and textiles and took part in exhibitions, including the Ideal Home

exhibition in 1913. Interiors included the Cadena Café, London (1914). Cubist-inspired carpets, some bearing the Omega monogram, were designed by Fry, Bell*, Grant*, Frederick Etchells and Roald Kristian. The workshop lost its impetus on the outbreak of war and was disbanded in 1919. **Sources:** Isabelle Anscombe, *Omega and After. Bloomsbury and the Decorative Arts*, Thames & Hudson, London, 1981; Judith Collins, *The Omega Workshops*, Secker & Warburg, London, 1984; Gillian Naylor, ed., *Bloomsbury, its Artists, Authors and Designers*, Pyramid, London, 1990.

ORAGE, JEAN
British weaver and designer. Orage wove fine tapestry for Morris & Co. (1905–16), then set up a craft studio in London. She made some hand-knotted rugs but specialized in flatweaves, including tapestries, upholstery and rugs from her own Modernist designs. Figurative tapestries entitled *The Forest* and *The Sea* were shown at the 1925 Paris exhibition and her carpets were shown at the Metropolitan Museum, New York, in 1929. She also wove rugs on commission for designers including Ronald Grierson*, Edward McKnight Kauffer* and Marion Dorn*.

OTTE, BENITA Stuttgart 1892–Bethel 1976
German textile designer, trained at the Bauhaus. Upon graduating in 1925, Otte headed the weaving workshop at the Decorative Arts School in Burg Giebichenstein, Halle-Saale, but was dismissed by the Nazis. After a brief stint in Prague as a freelance designer, she ran the weaving workshop of the Von Bodelschwinghschen-Anstalten, Bethel from 1934 until her retirement in 1957. **Source:** Arlette Barré-Despond, *Dictionnaire International des Arts Appliqués et du Design*, Editions du Regard, Paris, 1996.

Manufattura PARACCHI, Turin
Italian carpet manufacturer founded in 1901 in Turin by Giovanni Paracchi (1859–1940). The first Italian factory to produce carpets industrially, it originally made only Wilton carpeting, which always formed the bulk of the output. It also produced chenille carpeting (1924–52), and some Spool Axminster (1950–70). Two looms produced mechanically knotted pile carpets (1928–65). From 1955 the firm also made tufted carpeting. The patterns, both oriental and modern, are mostly the work of in-house designers. The firm wove rugs for Enrico Paulucci and executed the work of contemporary architects and designers to order. **Source:** Giovanni and Rosalia Fanelli, *Il Tessuto Art Deco e Anni Trenta. Disegno, Moda, Architettura*, Edizioni Cantini, Florence, 1986.

PATRY-BIÉ, SOLANGE
French designer active during the twenties. Patry-Bié collaborated with the Haviland porcelain company in Limoges, the Studium Louvre* and the Grands Magasins à la Place Clichy* in Paris, which produced two abstract carpets from her designs in 1928. **Sources:** A. G. (André Girodie), 'Tapis de Patry-Bié', *L'Art Vivant*, 15 January 1925; *Douze Tapis au Point Noué*, Paris, n.d.; *Renaissance de l'Art Français*, March 1928.

PECHE, DAGOBERT
St Michael im Lungau, Salzburg 1887–Mödling, near Vienna, 1923
Austrian artist, decorator and printmaker trained at the Vienna Academy. He began designing ceramics and carpets for industry in 1912 and after visits to England, France and Germany, settled in Vienna where he worked as a freelance for the Wiener Werkstätte*. His projects included the Austrian contribution to the 1914 International Exhibition in Rome. In 1915, he officially joined the Werkstätte, directing their Zurich branch from 1917 to 1919. His work includes furniture, objects, bookbindings, costumes, metalwork, theatre sets, toys and textiles. His colourful floral patterned carpets were manufactured by Max Schmidt, Backhausen*, Haas* and Flammersheim & Steinmann in Cologne. **Sources:** Max Eisler, *Dagobert Peche*, Gerlach & Wiedling,

Vienna and Leipzig, 1925. Werner J. Schweiger, *Wiener Werkstätte: Design in Vienna, 1903–1932*, Thames & Hudson, London, 1984; Backhausen archives.

PÉPIN & BERTHIER see MANUFACTURE DE BÉARN

PEPLER, MARIAN Sanderstead (Surrey) 1903–Eynsham (Oxfordshire) 1997
British designer, active between the wars. Trained at the Architectural Association, London, Pepler worked as a consultant for Gordon Russell's interior decoration firm and with her husband, the architect Richard Drew Russell (1903–81), on decoration schemes. She began designing carpets in 1930, for Russell and for firms including the Wilton Royal Carpet Factory* and Edinburgh Weavers*. Powerloom carpeting was made from her designs by Tomkinson's Ltd of Kidderminster. Her work, in a spare linear style in a palette of natural shades of greys, browns, blues and subdued reds, was shown at the Golden Gate Exhibition in San Francisco in 1939. She stopped designing handwoven carpets in the 1950s in order to focus on industrial design. **Sources:** *Design for Today*, February 1934; H. G. Hayes Marshall, *British Textile Designers Today*, F. Lewis, Leigh-on-Sea, 1939.

PETIT, PHILIPPE see D.I.M.

PICASSO, PABLO Malaga 1881–Mougins (Alpes-Maritimes) 1973
Catalan painter who spent most of his life in France. Unquestionably the most famous artist of the 20th century, Cubism's founding father remained a towering figure on the artistic stage throughout his life. Like others of his generation, Picasso was receptive to other media, expressing himself through the design of theatre sets, posters, pottery, glass, jewelry and textiles. He began designing tapestries for Marie Cuttoli in the mid-1920s, and carpets for the Maison Myrbor* from about 1928. The gallery subsequently wove some fifteen carpets from his works, the last during the sixties, in editions limited to seven. Some are abstract, some are stylized floral patterns and others are views of beaches or the sea, inspired by his life on the French Riviera, where he died. **Sources:** Mildred Constantine, Albert Châtelet, *An Exhibition of Contemporary French Tapestries*, Charles E. Slatkin Galleries, New York, 1965; *Tapis de Maîtres*, Galerie Weill-Seligman, Paris, n.d.

PINTON FRÈRES, Paris and Felletin
French manufacturer of fine tapestry and carpets. Granted a royal warrant in 1689, the workshop passed into the hands of Olivier Pinton in 1867. Production was diversified when a mill manufacturing powerloom carpeting was established in Tourcoing. Aubusson rugs from designs by Jacques Adnet*, Da Silva Bruhns*, Jean Picart-le-Doux, Lucien Coutaud and Anatole Kasskoff have been woven in the workshop. Now known as Pinton S.A., the Felletin workshop recently wove a set of tapestries for Disneyland Paris. Subcontracted for several decades to the Maison Hamot*, pile carpets and hand-tufted rugs are once again being made in the workshop. **Sources:** François Pinton, *Projets, Avant-Projets, Réalisations. Centre International de l'Architecture Tissée. Architecture Tissée Contemporaine*, Paris, n.d.; 'François Pinton, de Lissier en Lissier', *Le Moniteur, Architecture, AMC*, February 1991.

PISSARRO, GEORGES see MANZANA-PISSARRO

POINT SARRAZIN, Montrozier (Aveyron)
Weaving workshop founded as the Fabrication Familiale de Tapis au Point Noué by the philanthropist Maurice Fenaille, shortly before the First World War. The workshop provided training and was linked with weaving centres in the neighbouring villages of Lessac, Uimenet and Gabriac. Until the twenties, when Fenaille oriented production towards modern design, the workshops wove revival styles and Art Nouveau patterns, which were probably the work of the students. Bénédictus* and Yvonne Serac were among the designers whose carpets were woven by the

workshop, which was later taken over by France Tapis. **Sources:** *Catalogue de Tapis 'Le Point Sarrazin'*, Montrozier, Aveyron, n.d. (1913); Albert Crolard, *Le Tapis Savoyard. Essai d'une Organisation d'une Industrie Familiale en Savoye*, n.d.

POIRET, PAUL see Atelier MARTINE

Atelier POMONE, Paris
Decorating department of the Au Bon Marché department store directed from 1922 by Paul Follot*, succeeded by René Prou* and Albert Guénot. Pomone produced lines of carpets, but unlike La Maîtrise*, Primavera* or the Studium Louvre*, their designers generally remained anonymous. **Source:** Michael B. Miller, *The Bon Marché: Bourgeois Culture and the Department Store 1869–1920*, Princeton University Press, Princeton, 1981.

POOR, HENRY VARNUM Chapman (Texas) 1887–Rockland County (New York) 1970
American painter, designer and ceramicist. Poor was educated at Stanford University, the Slade School of Art, London, and the Académie Julian, Paris. Poor painted murals for the Department of Justice building, Washington, and Penn State College but specialized in pottery and tile decoration. A founder member of the American Designers' Gallery, he was president of the Skowhegan School of Painting and Sculpture, Maine. His carpets feature loosely drawn motifs, vaguely organic in origin.
Sources: *Who Was Who in America*, Chicago, 1973; Mel Byars, *Design Encyclopedia*, Laurence King, London, 1994.

PRAMPOLINI, ENRICO Modena 1894–Rome 1956
Italian painter, set and costume designer, writer and architect. Studied painting at the Academy of Fine Arts in Rome, where he met Giacomo Balla. Author of several Futurist manifestos, Prampolini was also linked with many international movements, including the Novembergruppe, Dada, De Stijl and Abstraction-Création. In 1918, together with art critic Mario Recchi, Prampolini founded the Casa d'Arte Italiana in Rome, the first of a series of interior design boutiques managed by the Futurists. In 1925, he organized the Futurist section at the Paris exhibition. Prampolini designed at least five carpets during the twenties, including those shown at the 1925 exhibition. Like his paintings, they attempted to represent movement or machines.
Source: Anna Maria Ruta, *Arredi Futuristi*, Edizioni Novecento, Palermo, 1985.

Atelier PRIMAVERA, Paris
French interior decoration studio founded by the Paris department store Le Printemps in 1912. The first of its kind, it was run by René Guilleré (1877–1932), founder and president of the Societé des Artistes-Décorateurs, assisted by his wife, the decorator Charlotte Chauchet-Guilleré (1878–1964), and Marcel Guillemard (1883–1932). The workshop called on the talents of young designers who were allowed to sign their work, among them Louis Sognot*, Claude Lévy, Jean Burkhalter*, Hilda Polsterer, Jean-François Thomas and Djo-Bourgeois*. A factory in Montreuil-sous-Bois manufactured the furniture and objets d'art, and another in Sainte-Radegonde, near Tours, made the ceramics. The MFTC* wove rugs for the store. After Guilleré's death in 1932, the studio was managed by his wife until 1939, when Colette Guéden took over until the closure of the department in 1972. **Source:** Pierre Kjellberg, *Le Mobilier du XXe Siècle. Dictionnaire des Créateurs*, Editions de l'Amateur, Paris, 1994.

PRINTZ, EUGÈNE Paris 1889–Paris 1948
French furniture designer and decorator. Printz was trained by his father, a cabinetmaker. He exhibited his own furniture from 1925, later setting up his own Paris workshop. Printz used rugs by other designers, including Léon Voguet* and particularly Evelyn Wyld*, in his projects until the early thirties. He then began to design his own carpets in abstract and textured patterns, which were woven by Lauer*.
Source: Guy Bujon, Jean-Jacques Dutko, *E. Printz*, Editions du Regard, Paris, 1986.

PROU, RENÉ Nantes 1889–Paris 1947
French designer trained at the Ecole Bernard Palissy. His first job was running the workshop of the Maison Gouffé, a furniture manufacturer. Between 1928 and 1932, Prou managed the Atelier Pomone*, as well as running his own Paris design studio. He designed the interiors of several hundred apartments, thirty banks, fifteen liners, including the *Paris*, *Ile-de-France*, *Atlantique*, *Normandie*, *Champlain* and *La Fayette*, and nearly 400 train compartments for the Compagnie Internationale des Wagons-Lits. Overseas assignments included the dining room of the Waldorf Astoria Hotel, New York, and the board room of the United Nations Headquarters in Geneva. The Prou studio did employ some freelance designers as consultants, including Da Silva Bruhns*, Gaudissart* and Vibert*, but most of its carpets were the work of in-house designers. Lauer* was among the manufacturers to whom Prou supplied fabric and carpet designs. Early floral Art Deco patterns were dropped for a geometric repertoire by 1928. Some are reminiscent of North African carpets or the graphic purity of De Stijl; others are linear or textured. By 1937, when Prou's son Jean-René became a partner, figurative patterns prevailed. **Sources:** Renée Moutard, 'Dictionnaire des Artistes-Décorateurs', *Mobilier et Décoration*, vol. 34, no. 2, 1954; Jean Porcher, 'René Prou', *Art et Décoration*, March 1929; *Atelier René Prou*, Paris, n.d. (c. 1933).

PRUTSCHER, OTTO Vienna 1880–Vienna 1949
Austrian architect and designer trained at the Decorative Arts School in Vienna under Hoffmann*. A member of the German and Austrian Werkbund, Prutscher designed furniture, porcelain, silverware, lighting fixtures, glass, bookbindings and textiles for the Wiener Werkstätte*. He also designed furniture for the Deutsche Werkstätten* and Thonet, a series of buildings for private clients in Vienna, and public housing. Prutscher's rugs were woven by Ginzkey*, Herrberger & Rhomberg, Haas* and Backhausen*, with over twenty different designs presently recorded. Prutscher evolved from a curvilinear and geometric repertoire to the intricate patterns recalling Islamic illumination or bookbindings that he adopted from 1909; he returned to a geometric vocabulary in the thirties. **Source:** Hans Wichmann, ed., *Deutsche Werkstätten und WK Verband 1898–1990. Aufbruch zum neuen Wohnen*, Prestel, Munich, 1992.

REEVES, RUTH Redlands (California) 1892–New Delhi 1966
American painter and textile designer educated at the Pratt Institute, Brooklyn, and the California School of Design in San Francisco. She furthered her studies at the Art Students' League in New York and in Paris, under Léger*. Upon her return to America, Reeves joined AUDAC and the American Designers' Gallery and took part in their first exhibition in 1928. She won several fellowships to study design, including assignments to Guatemala and India. Reeves created murals, furniture and wallpapers, but specialized in textiles, her best-known project being fabrics and carpeting for Radio City Music Hall, New York. The W. & J. Sloane department store, for whom she acted as consultant, organized an exhibition of her textiles in 1930. She also designed carpets in abstract and figurative patterns for Bigelow-Hartford* and Crawford Shops, New York. **Sources:** *Creative Art*, July 1931; Mel Byars, *Design Encyclopedia*, Laurence King, London, 1994.

REICHARDT, GRETE Erfurt 1907–Erfurt-Bischleben 1984
German textile designer and weaver. After graduating from the School of Applied Arts in Erfurt, Reichardt enrolled at the Bauhaus, where she specialized in weaving. She briefly established a workshop in The Hague before returning to Erfurt-Bischleben, where she set up a studio in 1934 and acquired teaching qualifications. A member of the German Union of Fine Arts, Reichardt won many awards, including a gold medal at the 1939 Milan Triennale. Towards the end of her life, the artist rewove some of the carpets created during her Bauhaus days. **Source:** Sigrid Wortmann Weltge, *Bauhaus Textiles. Women Artists and the Weaving Workshop*, Thames & Hudson, London, 1993.

RUHLMANN, EMILE-JACQUES Paris 1879–Paris 1933

French designer, painter and building contractor. Ruhlmann exhibited wallpaper and furniture at the Paris *salons* from 1910. Post-war, a partnership with Pierre Laurent left him free to devote most of his time to the decorating department of his Paris firm, which employed up to twenty young designers at a time, including Henry Stéphany, who specialized in textiles. Ruhlmann also consulted freelance designers including Ivan Da Silva Bruhns*, who created the carpet laid in the tearoom on the liner *Ile-de-France* (1927). The carpets for the sumptuous pavilion 'L'Hôtel du Collectionneur', designed by Studio Ruhlmann in collaboration with the architect Pierre Patout for the 1925 Paris exhibition, were made by Braquenié* from designs by Léon Voguet* and Emile Gaudissart*. After the decorator's death, Laurent retained the contracting side of the business, while Ruhlmann's nephew Alfred Porteneuve (1896–1949) inherited the decorating department. Studio Ruhlmann retailed a wide range of floral medallion and geometric designs. **Source:** Florence Camard, *Ruhlmann: Master of Art Deco*, Thames & Hudson, London, 1984.

SAARINEN, LOJA (LOUISE) Helsinki 1879–Cranbrook (Detroit) 1968

Finnish weaver and designer. In 1928, soon after her husband, the architect Eliel Saarinen (1873–1950), had completed the Cranbrook Foundation in Detroit, Loja Saarinen set up a weaving studio to provide furnishing fabrics and carpets for their home and the campus buildings, including the Art Academy, Cranbrook School, Science Institute and Kingswood School. In 1929 she was appointed head of the faculty's weaving department. The carpets were mainly woven from designs by Eliel and Loja Saarinen and Maja Andersson-Wirde, but the studio also wove on commission for architects and designers, among them Frank Lloyd Wright* and Charles Eames. In 1942, Marianne Strengell* succeeded Loja Saarinen as head of the weaving department. **Source:** Joan Marter, R. Craig Miller, Mary Riordan et al., *Design in America. The Cranbrook Vision 1925–1950*, Detroit Institute of Arts, Metropolitan Museum of Art, and Harry N. Abrams, New York, 1983.

Studio de SAEDELEER, Etikhove

Belgian weaving workshop, founded soon after the First World War by Elisabeth de Saedeleer, with the help of her father, painter Valérius de Saedeleer (1876–1942), and her sisters, Marie, Marie-Jozef, Monique and Godelief. The studio wove furnishing and clothing fabrics, household linen and tapestries, but specialized in carpets. The earliest designs were created by Valérius and Elisabeth de Saedeleer, Constant Montald, Henri Puvrez, Charles Leplae*, Anto Carte, Creten-Georges and Albert Saverys. In 1925, Paul Haesaerts* was appointed joint artistic director of the Société des Tapis d'Art de Saedeleer and designed many carpets. Albert Van Huffel* and Louis Herman de Koninck were among the architects and decorators who had their designs executed by the firm. The workshop wove various modern styles, from floral to abstract, created by Gustave de Smet, Rodolphe Strebelle, P G. Van Hecke, Fritz Van den Berghe, Jozef Peeters, Frans Masereel, Oscar Jespers, Sonia Delaunay*, Karel Maes* and Hans Polak. Several grades were available, woven on a jute foundation, with a knotting density varying from 10 to 30 knots per sq. dm. The number of carpets woven from each design was limited to six, and several different monograms were used. The studio, now the Centrum voor Kunst en Kunstambachten Valérius de Saedeleer, ceased to function as a weaving workshop in 1935, but Elisabeth de Saedeleer remained active until her death in 1972, establishing a workshop in her home in Brussels, as well as teaching at La Cambre design school and writing *Le Tissage à la Main*. **Sources:** Luc Haesaerts, 'De Tapijtkunst van de Gezusters de Saedeleer', *Onze Kunst*, vol. 42, 1925; Jean Teugels, 'Le Studio de Saedeleer', *Sélection, Chronique de la Vie Artistique et Littéraire*, vol. 5, January 1926; Jean Teugels, 'Les Tapis Modernes', *L'Art Vivant*, vol. 3, October 1927; Georges Marlier, 'Les Tapis de Saedeleer', *Art et Décoration*, September 1928; Elisabeth de Saedeleer,

Le Tissage à la Main, Atelier d'Art Elisabeth de Saedeleer, Brussels, 1974; Sibylle Valcke, 'Le Studio de Saedeleer', in Pierre Loze, Dominique Vautier, *Art Déco Belgique 1920-1940*, Musée d'Ixelles, Brussels, 1988.

SALLANDROUZE FRÈRES, Aubusson

French carpet manufacturer. The name of Sallandrouze has been connected with the tapestry-weaving industry in Aubusson* and nearby Felletin since at least the 16th century. Under the management of Jean-Jacques Sallandrouze (1791–1859) and his heirs Charles Sallandrouze Le Moullec and Théophile Sallandrouze (not to be confused with Sallandrouze de la Mornaix, another branch of the family who ran the rival Manufacture Royale des Tapis), a new factory was built in Aubusson in 1865. In 1867 powerlooms were installed, and various types of carpeting including *moquette*, tapestry carpets, chenille and later Axminster carpeting were produced. A loom for making mechanically knotted rugs, patented by the firm in 1889, was purchased by rival British and German manufacturers. Small quantities of handwoven rugs from designs by Félix Aubert, René Baucher* and Paul Follot* and recently by Daniel Riberzani, Paul Rich and Pol Gachon have been produced at the Aubusson plant. Still run by the same family, the firm became a limited company in 1925. **Sources:** Archives Nationales F12/8724; Amedée Carriat, *Dictionnaire Bio-Bibliographique des Auteurs du Pays Creusois et des Ecrits les Concernant, des Origines à Nos Jours*, Société des Sciences Naturelles et Archéologies de la Creuse, 1971; *Le Limousin de Paris*, 21 March 1937; *La Montagne*, 2 August 1988.

SAMPE, ASTRID Stockholm 1909–Stockholm 2002

Swedish textile designer. Sampe trained at the School of Industrial Art and the Technical School in Stockholm and later at the Royal College of Art, London. She founded a handweaving studio in Boras and sold her work through A.B. Nordiska Kompaniet*, then ran the textile department from 1936 to 1972. She founded her own studio in Stockholm in 1972. The abstract designs of her fabrics and carpets, some of which recall the works of Mondrian, are guided by the rationalist aesthetic, while some of her hand-knotted carpets recall those of the Maison Myrbor*. A consultant for the Wohlbeck and Kasthall rug factories in the 1950s, Sampe was major exponent of Swedish Modernism and one of the first to work with IBM on computer-aided textile design. Her work was the subject of an exhibition organized by the Nationalmuseum, Stockholm, in 1984. **Sources:** *Astrid Sampe, Svensk Industritextil*, Nationalmuseum, Stockholm, 1984 (exhibition catalogue); Mel Byars, *Design Encyclopedia*, Laurence King, London, 1994.

SAVONNERIE see MANUFACTURE NATIONALE DE LA SAVONNERIE

SCHOEN, EUGENE New York 1880–New York 1957

American architect and designer trained at Columbia University, New York. After meeting architects Otto Wagner and Josef Hoffmann* during a trip to Europe, Schoen returned to New York, where he founded an architectural practice in 1905 in partnership with Axel Hedman. His works include the RKO Center Theater and the British Empire Building, both in New York. In 1928 he founded Eugene Schoen Inc., an interior design studio, which sold his own custom-made furniture and foreign imports. He designed apartments, banks, stores, theatres, galleries and showrooms. Schoen's carpets, decorated with stylized or abstract motifs, reflect the spirit of French Modernism. **Sources:** Mel Byars, *Design Encyclopedia*, Laurence King, London, 1994; Jean Clair, ed., *Les Années Vingt. L'Age d'Or des Métropoles*, Musée des Beaux-Arts, Montreal, 1991 (exhibition catalogue).

SCHUMACHER Inc., New York

American textile manufacturer and retailer. The firm was founded in 1889 by Frederick Schumacher, a French immigrant and former employee of Passavant & Cie. Paul Gadebusch became a partner in 1893 and painter and designer Pierre Pozier in 1899.

The firm began manufacturing its own textiles in 1895, in its factory in Paterson, New Jersey, and began a policy of commissioning fabric designs from French and American designers. The carpet department, which sold models by Jules Bouy, dates from 1930. Today the firm sells reissues of Frank Lloyd Wright's* carpet designs. **Sources:** Marcia J. Wade, *A Century of Opulent Textiles. The Schumacher Collection*, 1989 (publicity brochure); Martin Eidelberg, ed., *Design 1935–1965. What Modern Was: Selections from the David and Liliane M. Stewart Collection*, St. Louis Historical Society, Montreal, and Harry N. Abrams, New York, 1991.

SOGNOT ET ALIX

French designer partnership. Louis Sognot (1892–1969) and Charlotte Alix (1897–1987) formed the Bureau International des Arts Français in 1928. Previously, Sognot had worked for Primavera* and Alix for Baron de Rothschild and Gaston Roussel. They showed their interiors at the annual salons, particularly the Salon d'Automne. Members of U.A.M., Sognot and Alix displayed a preference for new materials such as tubular metal, plate glass and moulded plastic, and sought new uses for traditional ones. Major commissions included the offices of the Laboratoires Roussel, Paris, and a bedroom for the Maharaja of Indore. Their carpet designs likewise conformed to Modernist principles. The couple made textured carpets their speciality, and in particular monochrome pieces with widely spaced rows of tufts, woven in the workshops of Hélène Henry* and Germaine Montereau*. The partnership lasted until the late thirties. **Sources:** Raymond Cogniat, 'Louis Sognot et Charlotte Alix', *Art et Décoration*, November 1930; *Mobilier et Décoration*, vol. 34, no. 4, 1954.

SOTAVALTA, IMPI 1885–1943

Finnish textile designer. A member of the Friends of Finnish Handicraft, which marketed her work, Sotavalta specialized in weaving *ryijy*. Her early designs, derived from folk art, are often composed of a series of animals arranged in the form of a flower and set off by a geometric border. By the thirties, she had evolved towards a Modernist vocabulary. **Source:** Arlette Barré-Despond, *Dictionnaire International des Arts Appliqués et du Design*, Editions du Regard, Paris, 1996.

STÉPHANY, HENRY see RUHLMANN, EMILE-JACQUES

STÖLZL, ADELGUNDE (GUNTA) Munich 1897–Zurich 1983

German textile designer and master weaver. She studied at the School of Applied Arts, Munich, then enrolled at the Bauhaus, where she specialized in weaving. Stölzl trained under Johannes Itten* and Paul Klee* (1919–25) and learned dyeing and weaving techniques at the Textile Industry School in Krefeld. She assisted Itten in setting up his Ontos workshop (1924), then ran the Bauhaus weaving workshop in Dessau from 1927 but was forced to resign in 1931. Stölzl then set up her own studio, S.P.H. Stoffe, in Zurich in partnership with fellow students Gertrud Preiswerk (b. 1902) and Hans-Otto Hürlimann. After the failure of S.P.H. Stoffe, she formed a new partnership with Hürlimann, S+H Stoffe. From 1937, she ran her own workshop, the Handweberei Flora, or Sharon-Stoffe (from the name of her husband). Stölzl later became a Swiss citizen after her divorce and remarriage to Willy Stadler. A member of the Swiss Werkbund, and the Society of Swiss Women Painters, Sculptors and Craftswomen, she showed her work regularly at international exhibitions, and remained active until 1969. **Source:** Sigrid Wortmann Weltge, *Bauhaus Textiles. Women Artists and the Weaving Workshop*, Thames & Hudson, London, 1993.

STRENGELL, MARIANNE Helsinki 1909–Wellfleet (Mass.) 1998

Finnish weaver and industrial designer. A graduate of the Helsinki Atheneum, Strengell began her career in Sweden, designing rugs and furnishing fabrics for the Swedish Society of Industrial Design before returning to Finland to work as art director for the AB Hemflit-Kotiahkeruus OY, a firm which specialized in exclusive ranges of textiles,

including rugs (1930–36). In 1934 she co-founded the interior design firm Koti-Hemmet, for which she designed furniture and textiles. In 1937, she took up a post teaching weaving, costume and textile design at the Cranbrook Academy in Detroit, heading the department after the retirement of Loja Saarinen* in 1942 until 1961. She also worked as a freelance designer and consultant for industry and extensively exhibited her work, winning several awards. Strengell focused primarily on effects achieved with texture, mixing natural and synthetic fibres; V'Soske* and Tai Ping are among the firms that sold carpets from her designs. **Sources:** Joan Marter, R. Craig Miller, Mary Riordan et al., *Design in America. The Cranbrook Vision 1925–1950*, Detroit Institute of Arts, Metropolitan Museum of Art, and Harry N. Abrams, New York, 1983; Martin Eidelberg, ed., *Design 1935–1965. What Modern Was: Selections from the David and Liliane M. Stewart Collection*, St. Louis Historical Society, Montreal, and Harry N. Abrams, New York, 1991.

STUDIO DE SAEDELEER see DE SAEDELEER, Studio

STUDIUM LOUVRE, Paris

Interior decoration department of the Grands Magasins du Louvre department store on the place du Palais Royal, founded and directed by architect and designer Etienne Kohlmann (1923–39), assisted by designer Maurice Matet. He was succeeded by Etienne-Henri Martin (1939–45), and later Roger Landault (1945–55). Designers associated with the Studium included Djo-Bourgeois*, André Fréchet and Max Vibert*, who designed most of the wallpapers, fabrics and carpets in the period leading up to the Second World War. **Source:** Pierre Kjellberg, *Le Mobilier du XXe Siècle. Dictionnaire des Créateurs*, Editions de l'Amateur, Paris, 1994.

SÜE, LOUIS Bordeaux 1875–Paris 1968

French architect, decorator and painter. From 1903 to 1912, Süe worked in partnership with fellow architect Paul Huillard. Increasingly drawn to the decorative arts, Süe began exhibiting interiors at the annual *salons* from 1910. A year later he founded the Atelier Français, modelled on similar lines to the Wiener Werkstätte*. From 1919 to 1928, Süe directed the Compagnie des Arts Français* with André Mare*. He then worked independently until 1947, when he formed a partnership with his nephew Olivier Süe. Noteworthy projects in the period subsequent to his collaboration with Mare include Jean Patou's summer home, an apartment for Helena Rubinstein, a stateroom on the liner *Normandie* and a stand in the pavilion of the Société des Artistes-Décorateurs at the 1937 International Exhibition. In his carpet designs, Süe continued to produce the luxuriant floral patterns perfected during his partnership with Mare, including the piece shown on the stand of the Mobilier National at the same event. He abandoned this style in the late thirties and moved towards a plainer style influenced by architectural composition and detailing. **Sources:** Susan Day, *Louis Süe Architectures*, Institut Français d'Architecture, Paris, and Pierre Mardaga, Brussels, 1986; Susan Day, *Louis Süe 1875–1968, Architecte des Années folles, Associé d'André Mare*, Institut Français d'Architecture, Paris, 1986 (exhibition catalogue).

Ets. TABARD, Paris and Aubusson

French tapestry and carpet workshop run by the Tabard family from 1637 to 1983. The firm was renowned for the quality of its tapestry, and for its role in reviving the industry in the 1940s, as a result of François Tabard's collaboration with Jean Lurçat*. Tabard also wove flatweave and pile carpets from designs by Raymond Subes, Maurice Dufrène*, Jules Coudyser* and Jane Lévy*. Two woven for Paul Follot* and Alfred Porteneuve were shown on the decorators' stands at the 1937 International Exhibition. The firm's archives are conserved by the Musée de la Tapisserie, Aubusson. **Source:** Amédée Carriat, *Dictionnaire Bio-Bibliographique des Auteurs du Pays Creusois et des Ecrits les Concernant, des Origines à Nos Jours*, Société des Sciences Naturelles et Archéologies de la Creuse, 1971.

TAEUBER-ARP, SOPHIE Davos 1899–Zurich 1943

Swiss painter, sculptor and textile designer, trained at the Gewerbeschule in St Gall, the Debschitz-Schule in Munich and the Gewerbeschule in Hamburg. A pioneer of abstract art, Taeuber was a founder member of Dada and was connected with the group Abstraction-Création. She designed the Café Aubette in Strasbourg (1926) in collaboration with Van Doesburg and her husband Jean Arp*. From 1916 to 1929, she headed the weaving department of the Ecole des Arts et Métiers in Zurich, where she began to reform the teaching of the applied arts. She also joined the Swiss Werkbund and was affiliated with the Zurich branch of the Wiener Werkstätte*. The fate of Taeuber-Arp's carpets, including the one shown in the Swiss pavilion at the 1925 International Exhibition, is presently unknown, and the intended use of certain drawings in the Arp Foundation in Bonn remains ambiguous. **Source:** *Sophie Taeuber*, Musée Cantonal des Beaux-Arts, Lausanne, 1990 (exhibition catalogue).

TEMPLETON AND CO., Glasgow

Scottish carpet manufacturer. Formerly a manufacturer of curtaining and Paisley shawls, James Templeton (1802–85) began manufacturing the 'Patent Axminster' carpeting which made his fortune, using a loom that he and an employee, William Quiglay, had invented in 1839. Based on the same technique as chenille fabric, Patent Axminster was adapted to the powerloom in the 1870s. When the patent expired in 1853, the firm diversified its production to include Brussels, Wilton and Spool Axminster carpeting. Under the management of his sons, James and John Stewart Templeton, the company began a short-lived venture into handloom weaving, which was less successful than that of their rivals Morton's*. A line of modern designs by Arts and Crafts designers was introduced in the 1890s. Between the wars, the company produced a wide range of Modernist designs created by in-house designers, as well as rugs by Brangwyn*, Bénédictus* and David Taylor. **Sources:** J. Neville Bartlett, 'James Templeton', 'John Stewart Templeton', in *Dictionary of Scottish Business Biography*, vol. 1, eds. Anthony Slaven and Sydney Checkland, Aberdeen University Press, Aberdeen, 1986; F. H. Young, *A Century of Carpet-Making: James Templeton & Co.*, Glasgow, 1944.

TÉTARD, LAINÉ ET RUPP see MANUFACTURE FRANÇAISE DE TAPIS ET DE COUVERTURES

TOMKINSON AND ADAM, Kidderminster

British carpet manufacturer founded by William Adam and Michael Tomkinson in 1869. The firm wove several types of powerloom carpeting, including chenille or machine-woven Axminster carpeting, once Adam had perfected the setting loom, patented in 1882. The firm purchased designs from several Arts and Crafts designers, particularly C. F. A. Voysey*, who supplied the firm under contract into the thirties. The firm also wove designs by George Sheringham, Maxwell Armfield, David Taylor, Ronald Grierson* and Marian Pepler*. **Sources:** C. E. C. Tattersall, *A History of British Carpets*, London, 1934, revised by Stanley Reed, F. Lewis, Leigh-on-Sea, 1966; H. G. Hayes Marshall, *British Textile Designers Today*, F. Lewis, Leigh-on-Sea, 1939.

TYTGAT, EDGARD Brussels 1879–Woluwe-Saint-Lambert 1957

Belgian painter, printmaker and writer, trained at the Académie Royale des Beaux-Arts under Constant Montald. Classed as a 'Flemish Neo-primitive', Tytgat rejected the formalism of academic painting for more cheerful and naïve subject matter, such as the theatre, the circus and the seasons, as well as festive scenes. His rugs were made by the Studio de Saedeleer*. **Source:** Maurice Roelants, *Edgard Tytgat*, De Sikkel, Antwerp, 1948.

URBAN, JOSEPH Vienna 1872–New York 1933

Austrian architect, set designer and decorator trained at the Academy of Fine Arts and the Polytechnicum, Vienna. A co-founder and president of the Hagenbund (1906–8), Urban's works include a spa in Baden and the Austrian pavilion at the 1904 World's Fair in St Louis. He designed theatre sets for the Vienna Hofburg and collaborated with the Wiener Werkstätte*, then emigrated to the United States, where he worked as Artistic Director of the Boston Opera. He settled permanently in New York, where he briefly managed a branch of the Wiener Werkstätte (1921–22) and pursued a career principally in the theatre and the cinema. Architect of the Ziegfeld Theatre (1927) and the New School for Social Research (1929–30), he was chief set designer of the Metropolitan Opera, New York (1918–33). Urban's early carpet patterns are typically Viennese; later they typify American Art Deco. **Sources:** Randolph Carter, Robert Reed Cole, *Joseph Urban*, Abbeville Press, New York, 1992; *Creative Art*, July 1931.

VALMIER, GEORGES Angoulême 1885–Paris 1937

French painter, decorator, illustrator, costume and set designer. Valmier began as an apprentice in a wallpaper and fabric design studio, and later trained at the Académie Humbert and the Ecole des Beaux-Arts, Paris, under Luc-Olivier Merson. He exhibited at the Salon des Indépendants (1913–14), at the Galerie de l'Effort Moderne (1921) and with the Surindépendants after the Second World War. His work, subject to Cubist influence, evolved towards total abstraction, particularly after he joined the group Abstraction-Création in 1932. Valmier is best known for his work as a costume and set designer for the Futurists and the Ballets Russes and for assisting Robert Delaunay with a set of murals for the SNCF pavilion at the 1937 International Exhibition in Paris. In 1929–30, Albert Lévy published a pattern book by Valmier, *Album No. 1 Collection Décors et Couleurs*; three of these designs were recently issued for the first time as hand-tufted carpets by the Galerie Artcurial, Paris. **Sources:** 'Georges Valmier 1885–1937', *Les Cahiers d'Art. Documents*, no. 35, 1956; Denise Bazetoux, *Georges Valmier, Catalogue Raisonné*, Editions Noème, Paris, 1993; Jeanine Warnod, *Valmier*, Galerie Seroussi, Paris, 1985 (exhibition catalogue).

VAN DER LECK, BART (ANTHONY) Utrecht 1876–Blaricum 1958

Dutch painter, printmaker and designer. A stained-glass craftsman, Van der Leck won a scholarship to the School of Arts and Crafts in Amsterdam. Briefly a member of De Stijl, he rejected the ideology of abstract art and by 1920 had broken all ties with the movement. In 1929 he was appointed as colour advisor to the interior decoration department of the Metz* department store, where he designed a range of handwoven and machine-made carpets similar to his series of *Mathematical Images*. Although he remained faithful to the principle of sparsely arranged, small geometric figures on light or dark grounds, Van der Leck later moved away from the mathematical precision of his early pieces, towards asymmetric designs and a softer palette of orangey-pinks, light blue and grey on a neutral field. His carpets have recently been reissued, hand-tufted by the Tapis de Cogolin* for the Galerie Artcurial. **Source:** R. W. D. Oxenaar, E. L. de Wilde, *Bart Van der Leck*, Rijksmuseum Kröller-Müller, Otterlo, 1976 (exhibition catalogue).

VAN DER MIJLL-DEKKER, KITTY (CATHERINE) Jakarta 1908–Nijkerk, Holland 2004

Dutch master weaver. Studied at the Hornsey School of Art in London and at the Bauhaus. In 1933 she founded a handweaving studio in Nunspeet, the Netherlands, in partnership with fellow students Greten Kähler and Hermann Fischer, and designed fabrics for industry, state buildings and the Dutch royal family. Between 1934 and 1979 she taught at the School of Applied Art in Amsterdam (formerly the Gerrit Rietveld Academy). She was awarded many prizes, including a gold medal at the 1935 Brussels exhibition. **Source:** Sigrid Wortmann Weltge, *Bauhaus Textiles. Women Artists and the Weaving Workshop*, Thames & Hudson, London, 1993.

VAN HUFFEL, ALBERT Ghent 1877–Brussels 1935

Belgian architect and decorator. Forced to cut short his architectural degree at the

Ghent Academy, Van Huffel worked as an interior decorator for several firms until he was assigned to architectural projects by De Wilde and Van Herreweghe. In 1912 he set up his own practice in Ghent, moving to Brussels in 1920 when he won a commission to build the Koekelberg Basilica. He also designed interiors, some in collaboration with Brussels firm A.D.C.D. (Art Décoratif Céline Dangotte). From 1926 he taught at La Cambre school of design in Brussels. Decorated with floral and chequered motifs, Van Huffel's early carpet designs, including those for the Behn house, Ninove, show a Viennese influence, but by 1923 he had developed his own style based on geometric motifs or highly stylized plant forms, exemplified in the rugs in the Van Gheluwe and Bruxelman houses in Ghent. In addition to designing carpets for the Studio de Saedeleer*, Van Huffel had designs for private commissions woven by the same workshop. **Sources:** Marc Dubois, *Albert Van Huffel 1877–1935*, Snoeck, Ducaju & Zoon, Ghent, 1983 (exhibition catalogue); Arlette Barré-Despond, *Dictionnaire International des Arts Appliqués et du Design*, Editions du Regard, Paris, 1996.

VANTONGERLOO, GEORGES Antwerp 1886–Paris 1965
Belgian artist, architect, interior decorator and writer. Trained at the Brussels and Antwerp Fine Arts Academies, Vantongerloo abandoned his early academic work for abstraction. Interned in Holland during the First World War, he met members of De Stijl and signed their manifesto, but broke off relations in 1921. Between 1919 and 1927, he lived in Menton, published *L'Art et son Avenir* and later settled in Paris, where he met Mondrian and Michel Seuphor. In 1931 he co-founded the group Abstraction-Création with Auguste Herbin, and served as their vice-president until 1937. In around 1930, Vantongerloo created a series of carpet designs for the Metz* department store, very similar to his mathematically precise abstract paintings. **Sources:** *Vantongerloo*, Kunsthaus, Zurich, 1949 (exhibition catalogue); *Macmillan Encyclopedia of Architects*, Macmillan, London, 1982.

VEREINIGTE WERKSTÄTTEN A.G., Munich
The Vereinigte Werkstätten für Kunst und Handwerk (United Workshops for Art and Handicraft) were founded in 1898 with a view to improving modern design. Early members of the workshop included Hermann Obrist, Peter Behrens, Richard Riemerschmid and Bruno Paul, all designers at the forefront of German Jugendstil. Reincorporated as the Vereinigte Werkstätten A.G. in 1907, the firm was part of the Werkbund and produced furniture, glass, metalwork and textiles. Fritz August Breuhaus and Sigmund von Weech designed carpets for the workshops between the wars. The firm finally closed in 1991. **Source:** Hans Wichmann, *Von Morris bis Memphis. Textilien der Neuen Sammlung Ende 19 bis Ende 20 Jahrhundert*, Birkhäuser, Basel, 1990.

VERGÉ, JACQUES
French designer, active between the wars. Vergé designed carpets in brightly coloured floral and abstract patterns for the Grands Magasins à la Place Clichy* and the Ets. Marcel Coupé*. **Sources:** André Girodie, 'Tapis de Jacques Vergé', *L'Art Vivant*, vol. 4, February 1928; *Douze Tapis au Point Noué*, n.d.

VIBERT, MAX (MAXINE) Séez (Savoie) 1905–Le Vaudoué (Seine-et-Marne) 1981
French designer, active *c.* 1920–40. Vibert designed murals, wall-hangings, textiles, wallpapers and numerous carpets for D.I.M.* and the Studium Louvre*. Easily recognizable, Vibert's style is composed of abstract motifs, including cross-hatching, grillwork or honeycomb patterning. In the mid-thirties, Vibert introduced 'Haï-Kaï' figures, drawn in a naive and ingenuous style, into her designs. Decorators who used her rugs in their decorative schemes included Maurice Matet, Etienne Kohlmann, Pierre-Paul Montagnac and René Prou*, who acquired several for his interiors on the liner *Atlantique*. **Sources:** Maurice Matet, *Tapis*, H. Ernst, Paris, n.d. (*c.* 1928);

Repertoire du Goût Moderne, vol. I, n.d. (*c.* 1929); Marcel Zahar, 'Les Haï-Kaï décoratifs de Max Vibert', *Art et Décoration*, January 1937.

VOGUET, LÉON born Paris 1879
French painter, designer and illustrator. Voguet showed his work at the Salon des Artistes-Décorateurs and the Salon d'Automne. He designed tapestries and carpets, illustrated books and painted murals, including those for the Paris restaurant Prunier, designed by the architect Louis-Hippolyte Boileau, and the chapel of the liner *Normandie*. His carpets, in abstract designs woven by Braquenié*, were laid in the study and bedroom of Ruhlmann* and Patout's 'Hôtel du Collectionneur' at the 1925 Paris exhibition. **Sources:** Edouard Joseph, *Dictionnaire Biographique des Artistes Contemporains*, Paris, 1934; *Allgemeines Künstlerlexikon*, vol. 34, 1940.

VOYSEY, CHARLES FRANCIS ANNESLEY Hessle 1857–Winchester 1941
British architect and designer. Apprenticed to the architect John Pollard Seddon, Voysey became a leading architect of the British Arts and Crafts movement. The early part of his career was devoted mainly to designing wallpaper and textiles. He was employed by many manufacturers and retailers, including Templeton's*, Tomkinson and Adam*, Morton's* (Donegal line), Yates & Co.*, Heal's department store, Liberty's and Ginzkey*. Towards the end of his life, when few architectural commissions came his way, Voysey returned to designing flat patterns. He was the first winner of the 'Designer for Industry' award in 1936. **Sources:** John Brandon Jones, *C. F. A. Voysey, Architect and Designer*, Lund Humphries, London, 1978; Stuart Durant, *The Decorative Designs of C. F. A. Voysey*, Lutterworth Press, Cambridge, 1990.

V'SOSKE, Grand Rapids (Michigan), Puerto Rico and New York
American designers and carpet manufacturers. Of Polish origin, Stanislav V'Soske (1899–1983) trained as a painter at the Pennsylvania Academy of Art and the Art Students' League in New York. In 1924 he and his brothers founded a carpet factory in Grand Rapids (Michigan) and a subsidiary in Puerto Rico in the late thirties. Though the firm began by making hooked rugs, V'Soske later developed the hand-tufted carpet and perfected the gun-tufting process, producing many textured and bevelled pieces from his own designs, three of which were shown at the Golden Gate Exhibition in San Francisco in 1939. He also made carpets designed by Robsjohn Gibbings, Donald Deskey*, Nelson S. Fink, Frank Lloyd Wright* and Gilbert Rohde. Prestigious commissions included the Green Room in the White House. In 1942, the company commissioned designs from ten contemporary artists and designers, including Marguerite Zorach, Irene Rice Pereira, John Ferren, Stuart Davis and Arshile Gorky. More recently, the firm has produced carpets from designs by Herbert Bayer, Charles Gwathmey, Richard Meier, Michael Graves and Robert Venturi. Since the closure of the Grand Rapids workshop, the rugs have been made in Puerto Rico and Ireland, under the trademark V'Soske Joyce. **Sources:** 'The V'Soske Rugmakers', *American Fabrics*, no. 51, autumn 1960; Mel Byars, *Design Encyclopedia* 1994.

WALTON, ALLAN Cheadle Hulme (Cheshire) 1891–Shotley (Suffolk) 1948
British painter, decorator and textile designer, who dropped architecture to study painting at the Slade, the Westminster School of Art and the Académie de la Grande Chaumière, Paris. His work as an industrial designer includes furniture, china, candlesticks, electric fires and textiles. In 1925 he founded Allan Walton Textiles, producing embroideries, carpets and printed fabrics from his own designs in addition to ranges commissioned from contemporary artists, including Duncan Grant*, Vanessa Bell*, Margaret Simeon and Frank Dobson. The company supplied the fabrics and carpets for several of the Orient Shipping Line's ocean liners, including *Orion* (1934) and *Orcades* (1937). Walton also decorated several restaurants. His carpet designs feature lively figurative motifs characteristic of Art Deco, or abstract motifs in a more sober vein. He was the director of the Glasgow School of Art from 1943 to 1945.

Source: Arlette Barré-Despond, *Dictionnaire International des Arts Appliqués et du Design*, Editions du Regard, Paris, 1996.

WARING & GILLOW, London and Paris

British interior decoration firm, born of a merger between the cabinetmakers Gillow's of Lancaster and Waring's of Liverpool. Waring & Gillow's interiors typified classical revival styles until 1929, when Lord Waring decided to create a modern art department, headed in London by Serge Chermayeff* and in Paris by Paul Follot*. The interiors of Claridge's Hotel and the Cambridge Theatre foyer figure among the prestigious commissions executed by the firm. Source: Barbara Tilson, 'The Modern Art Department, Waring & Gillow, 1928–1931', *Journal of the Decorative Arts Society 1890–1940*, no. 8, 1984.

WIENER WERKSTÄTTE, Vienna

Austrian interior decoration and design firm. Founded in 1903 by Josef Hoffmann* and Koloman Moser with banker Fritz Wärndorfer acting as commercial director, the Werkstätte promulgated the ideas of the Viennese Secession. The workshop undertook architectural design, furniture and accessories, and later expanded to include textile and fashion departments. The Werkstätte built and decorated the Palais Stoclet in Brussels, regarded as an Art Deco landmark and representative of the transition from Art Nouveau. During the twenty-nine years of its existence, the workshop employed some two hundred artists and designers, most of whom were members of the Secession, including Carl Otto Czeschka, Eduard Josef Wimmer-Wisgrill, Dagobert Peche* and Joseph Urban*. Some of the textiles were handmade on the Werkstätte's premises, but the majority, including the pile and strip carpeting, were woven by Backhausen*. Source: Werner J. Schweiger, *Wiener Werkstätte: Design in Vienna, 1903–1932*, Thames & Hudson, London, 1984.

WILTON ROYAL CARPET FACTORY Wilton, Wiltshire, England

British carpet manufacturer, probably founded in the 17th century when drugget, a cheap type of napless carpet, was made. Impressed by the quality of Savonnerie* carpets, the Earl of Pembroke, whose family seat is in Wilton, smuggled in two Huguenot weavers, hidden according to legend in wine barrels. Pierre Jemaule and Antoine Defosse invented the Wilton loom for making cut-pile strip carpeting using the *moquette* technique, patented in 1741. In 1835, the firm was bought out by Henry and Humphrey Blackmore, a rival firm in Wilton, who mechanized production methods and acquired the pile-weaving looms and the services of workers of the former Axminster workshop, which had been destroyed in a fire. The looms remained in active use until 1957. The firm passed into the hands of Lapworth in 1860, succeeded by Yates & Wills (later Yates & Co.) from 1871 to 1905, when the Earls of Pembroke and Radnor saved it from bankruptcy. A royal warrant was granted in 1910, when the firm assumed its present name. Wilton Royal wove rugs for the Omega Workshops* and during the twenties issued the 'Wessex line' from designs by McKnight Kauffer*, Marion Dorn*, Marian Pepler*, Serge Chermayeff* and Sheila Walsh. Today, the firm is part of the Coates Viyella group. Sources: Bertram Jacobs, *Axminster Carpets (Hand-Made) 1755–1957*, F. Lewis, Leigh-on-Sea, 1970; Wilton Royal Carpet Factory, *The History of Wilton Royal*, n.d. (publicity brochure).

WINDELS, FERNAND born Namur, Belgium 1893

Belgian carpet designer and manufacturer, active between the wars. Windels worked as a designer for the MFTC* prior to establishing his own factory, named L'Industrie du Tapis, in Bourganeuf (Creuse) with showrooms in Paris. Author of *Le Tapis, un Art, une Industrie*, devoted in part to the MFTC's production, Windels designed a few floral carpets, but the majority are striking abstract patterns. The firm also wove on commission for decorators, including Jean Goulden. Sources: Jean du Bercel, 'Les Tapis de Fernand Windels', *Art et Industrie*, March 1931; Fernand Windels, *Le Tapis, un Art, une Industrie*, Editions d'Antin, Paris, 1935.

WOODWARD GROSVENOR, Kidderminster

British carpet manufacturer, founded by Benjamin Grosvenor in 1790 to make ropes and cordage. Production was automated from 1864, when Henry Woodward took over, and the firm made chenille, Wilton, Brussels, Spool and Gripper Axminster carpeting. A new loom named the Grosvenor Picking, a variant on the Wilton loom, was invented in 1923 by employee William Picking. On John Grosvenor's retirement after the Second World War, the business was sold to W. C. Gray & Sons, which was in turn taken over by the Guthrie Corporation in 1970. It is now a part of British Carpets Ltd. The company produces powerloom carpeting designed by Marion Dorn* but its production is mainly limited to traditional patterns by in-house designers. The firm maintains an important design archive and recently reissued two designs by William Morris. Sources: C. E. C. Tattersall, *A History of British Carpets*, London, 1934, revised by Stanley Reed, F. Lewis, Leigh-on-Sea, 1966; publicity brochures supplied by the Woodward Grosvenor Company.

WRIGHT, FRANK LLOYD Richland Center (Wisconsin) 1867–Phoenix 1959

American architect and designer trained at the University of Wisconsin, Madison. Wright was unusual in remaining at the forefront of the architectural scene from his Arts and Crafts beginnings until the fifties, when he built his architectural *tour de force*, the Guggenheim Museum in New York. In his decorative schemes, Wright never diverged from his penchant for geometry, evolving from the strictly rectilinear compositions of the carpets in his Prairie Houses to the circles that decorate the rugs in his own home in Taliesin and several other houses, including one for his son in Phoenix, Arizona. In the thirties, the Studio Loja Saarinen* wove his textiles, including those for the office of Edgar Kaufmann, director of the Pittsburgh department store (now reassembled at the Victoria and Albert Museum). Edward Field Inc., a firm which collaborated with Wright's Taliesin Foundation, produced his designs during the forties. Wright later had his fabrics woven by Schumacher*; in 1955, this firm launched a range of fabrics and wallpapers named the 'Taliesin Line', which was extended in 1968 to include his pile carpets, woven in Tibet. Sources: David Hanks, *The Decorative Designs of Frank Lloyd Wright*, E. P. Dutton, New York, 1979; Bruce Brooks Pfeiffer, *Frank Lloyd Wright Drawings. Masterworks from the Frank Lloyd Wright Archives*, Harry N. Abrams, New York, Frank Lloyd Wright Foundation, and Phoenix Art Museum, Phoenix, 1990 (exhibition catalogue).

WYLD, EVELYN London 1882–1973

British weaver who spent her adult life in France. After learning the rudiments of weaving in North Africa and receiving further instruction in England, where she purchased the necessary looms, Wyld returned to France and set up a weaving workshop in Paris with Eileen Gray* in 1910. Wyld only began designing herself in the mid-twenties, when one of her designs was shown on the stand of H. and A. Barberis at the 1925 International Exhibition. In 1927, Gray withdrew and Wyld formed a new partnership with Eyre de Lanux*. From this time, Wyld was chief carpet designer, and decorators Jean Dunand, Albert Fournier and particularly Eugène Printz* used her works in their interiors. In 1932, after the closure of their rue Visconti workshop, Wyld and de Lanux ran *Décor*, a short-lived interior decoration shop in Cannes. After her muse left her to live in Rome, Wyld became a market gardener, although she continued to show her rugs at international events, including exhibitions held in New York in 1937 and San Francisco in 1939. Her archives are maintained by the Royal Institute of British Architects, London. Sources: Isabelle Anscombe, 'Expatriates in Paris. Eileen Gray, Evelyn Wyld and Eyre de Lanux', *Apollo*, February 1982; Christie's auction catalogue, New York, 13 December 1966.

YATES & CO. see WILTON ROYAL CARPET FACTORY

 JEAN and JACQUES ADNET

 ERNEST BOICEAU

 JACQUES ADNET

 FRANK BRANGWYN

 ANDRÉ ARBUS

 MARCEL BREUER

 ART DÉCORATIF CELINE DANGOTTE BRUSSELS and GHENT

 SERGE CHERMAYEFF

 AUX FABRIQUES D'AUBUSSON

 COMPAGNIE DES ARTS FRANÇAIS

 JOHANN BACKHAUSEN UND SÖHNE, VIENNA

 JULES COUDYSER

 ERIC BAGGE

 CRANBROOK ACADEMY

 SIGVARD BERNADOTTE

 RENÉ CREVEL

 VLADIMIR BOBERMAN

 EMIL DANIELSSON

IVAN DA SILVA BRUHNS
(MANUFACTURE DE SAVIGNY)

ATELIER DE LA DAUPHINE

SONIA DELAUNAY

J. H. DERCHE

DONALD DESKEY

D.I.M.
(Décoration Intérieure Moderne)

DJELO (Society for the Promotion
of the Decorative Arts, Zagreb)

MARION DORN

PAUL DUMAS

GUSTAVE FAYET

GEORGES DE FEURE

EMILE GAUDISSART

JAAP GIDDING

JEAN GOULDEN

RONALD GRIERSON

SUZANNE GUIGUICHON

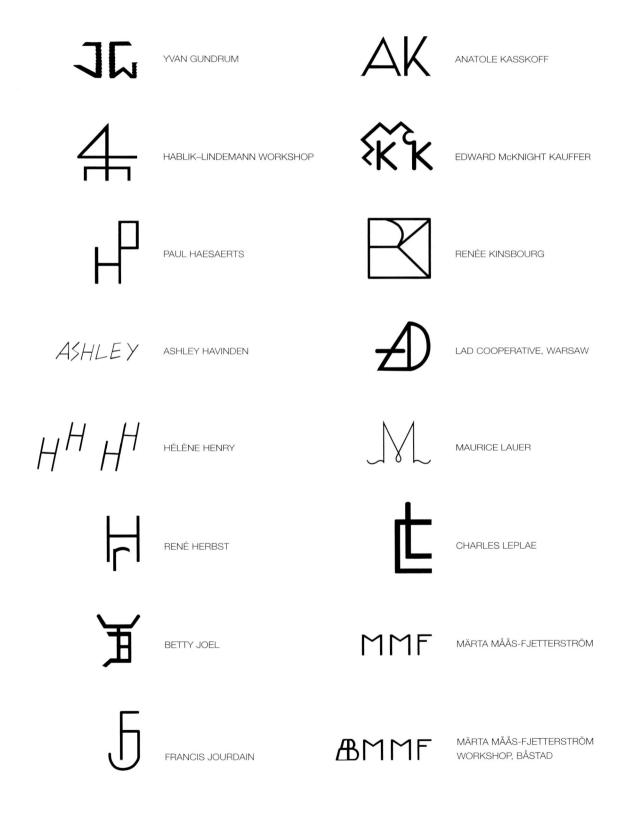

YVAN GUNDRUM

HABLIK–LINDEMANN WORKSHOP

PAUL HAESAERTS

ASHLEY HAVINDEN

HÉLÈNE HENRY

RENÉ HERBST

BETTY JOEL

FRANCIS JOURDAIN

ANATOLE KASSKOFF

EDWARD McKNIGHT KAUFFER

RENÉE KINSBOURG

LAD COOPERATIVE, WARSAW

MAURICE LAUER

CHARLES LEPLAE

MÄRTA MÅÅS-FJETTERSTRÖM

MÄRTA MÅÅS-FJETTERSTRÖM
WORKSHOP, BÅSTAD

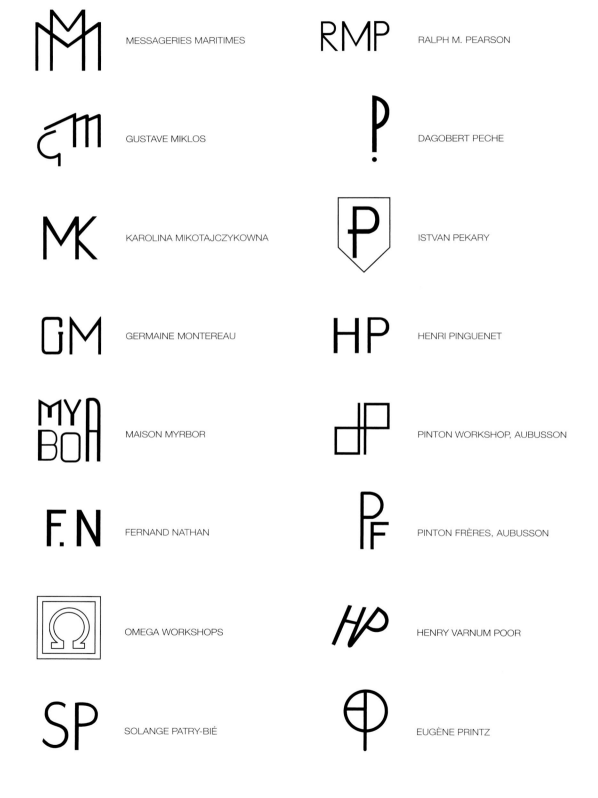

MESSAGERIES MARITIMES

RALPH M. PEARSON

GUSTAVE MIKLOS

DAGOBERT PECHE

KAROLINA MIKOTAJCZYKOWNA

ISTVAN PEKARY

GERMAINE MONTEREAU

HENRI PINGUENET

MAISON MYRBOR

PINTON WORKSHOP, AUBUSSON

FERNAND NATHAN

PINTON FRÈRES, AUBUSSON

OMEGA WORKSHOPS

HENRY VARNUM POOR

SOLANGE PATRY-BIÉ

EUGÈNE PRINTZ

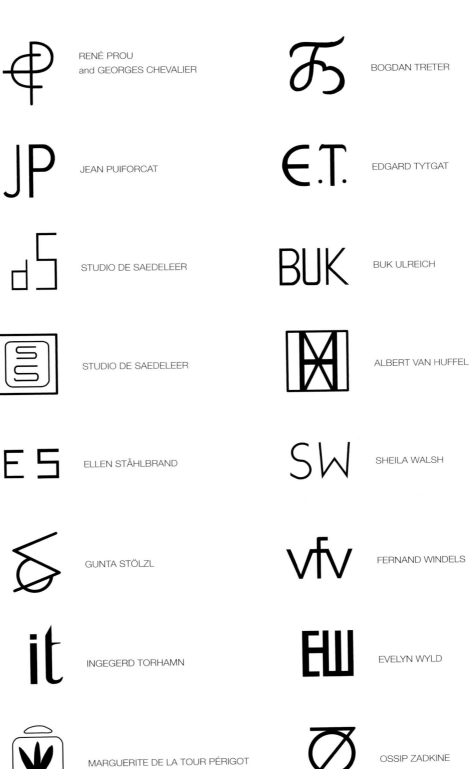

RENÉ PROU
and GEORGES CHEVALIER

JEAN PUIFORCAT

STUDIO DE SAEDELEER

STUDIO DE SAEDELEER

ELLEN STÅHLBRAND

GUNTA STÖLZL

INGEGERD TORHAMN

MARGUERITE DE LA TOUR PÉRIGOT

BOGDAN TRETER

EDGARD TYTGAT

BUK ULREICH

ALBERT VAN HUFFEL

SHEILA WALSH

FERNAND WINDELS

EVELYN WYLD

OSSIP ZADKINE

GLOSSARY

Words in **bold** type have separate entries in this section.

artificial silk – a term used in the early 20th century for rayon and acetate fibres; in 1925 the term was banned as being misleading.

asymmetrical knot – To tie an asymmetrical knot, the weaver takes two warps, passing the yarn behind so that it emerges between them to encircle one and reappear between them. Synonyms: Senneh knot, Persian knot.

Aubusson carpet – napless carpet made in the **tapestry weave**, from the name of the French town known for its production of fine tapestry. The quality of the Aubusson tapestry weave is measured by the number of warp threads, expressed in terms of the *portée* and the *lame*. A *portée* represents twelve warps and a *lame* is equivalent to 40 cm. Therefore, the more *portées* there are to a *lame*, the higher the number of warp threads and the finer the tapestry. Tapestry-weave carpets are normally more coarsely woven than wall tapestries. A standard Aubusson carpet made in the 19th century normally had ten *portées* to the *lame* (i.e. three warps per cm). Synonyms: **flatweave, tapestry weave, Gobelins**.

Axminster – The aristocrat of English hand-knotted carpets, Axminster takes its name from the town in Devon, England, where Thomas Whitty began weaving pile carpets using the **Turkish knot** in 1755, shortly after visiting Peter Parisot's factory in Fulham. In 1836 some of the Axminster looms were moved to Wilton, where they remained in use until 1957. Today the name is synonymous with quality **hand-knotted carpets**, as well as various types of powerloom carpeting, namely **Spool Axminster, Gripper Axminster**, and **Chenille** or Patent Axminster.

Body Brussels – synonym for **Brussels carpeting**.

bouclé – looped weave obtained by means of additional warp threads drawn up into long or short loops.

bouclé yarn – yarn of uneven thickness.

broadloom – a particularly wide loom.

Brussels carpeting – Formerly handmade, Brussels *moquette* was the first type of carpet to be adapted to the powerloom. Patented by the American manufacturer Erastus Brigham Bigelow in 1846, Brussels, or Body Brussels carpeting, like its sister technique **Wilton carpeting**, has three sets of warps: the chain warps which form the foundation, the stuffer warps to supply body and the pile warps, raised into loops around steel rods or wires to form looped pile. The number of rods is 35 per dm. The chain and stuffer warps are made of cotton or bast fibres and the pile warps of worsted woollen yarns. The number of colours does not normally exceed six.

canvas – a fabric generally made of bast fibres or cotton, used for the foundation of hooked, tufted and embroidered rugs.

carpeting – metered fabric, or strip carpeting, normally made to fit a room, as opposed to a carpet or rug in a predetermined format. See also *moquette*, Kidderminster, Brussels, Wilton, chenille, Gripper Axminster, Spool Axminster.

cartoon – the life-sized model on squared paper used as a guide by weavers in the execution of mural tapestries and fine tapestry. Since weavers work from the back, the cartoon image is woven back to front. Often erroneously used as a synonym for **point-paper**.

chenille carpet – Patented by James Templeton of Glasgow in 1839, the manufacture of chenille carpeting was adapted from a traditional technique used in the textile trade for making shawls. The furlike fabric is made in two stages. Woollen cloth is woven with widely spaced groups of warp threads and wefts coloured according to the pattern. The resulting fabric is cut in strips lengthwise along the warps, which are then folded to form strips of V-shaped tufts. The strips of chenille 'fur' (*chenille* is French for 'caterpillar') attached end-to-end are inserted into the **shed** of a second loom, and bound in with catcher warps. The number of rows varies from three to sixteen to the inch. As the tufts are attached only to the catcher warps, the carpet is stabilized with a jute backing, sized for extra strength. Templeton's adapted chenille carpeting to the powerloom, when a machine was invented which performed both processes in the 1870s. Other European manufacturers purchased the rights to manufacture chenille carpeting on payment of royalties. Production declined by the mid-20th century, this somewhat laborious technique being superseded by the invention of the **Spool** and **Gripper Axminster** looms in the 1890s. The technique found only brief acceptance in America after it was introduced in 1910. Synonyms: Chenille Axminster, Patent Axminster.

chiné – yarn patterned before it is woven. European weavers generally tie knots with two to five yarns, each of which may be composed of two to four plied yarns. By combining coloured yarns, say 2/2 or 1/3, it is possible to achieve finely graduated shades. The technique may have originated in the Gobelins tapestry workshop and is used by the **Savonnerie** weavers for making carpets.

Cornély stitch – a semi-mechanized embroidery technique invented in 1865 by Frenchman Emile Cornély (1824–1913). The technique consists of attaching tightly twisted yarn, juxtaposed in rows forming the pattern, to a fabric backing. It was adapted to carpet-making by Ernest Boiceau during the 1920s.

Deventer rug – hand-knotted rug of Dutch origin. The term is derived from the name of the Deventer Tapijtfabriek, a manufacturer in the town of Deventer which wove the best quality rugs in the Netherlands.

directional design – a pattern which may be correctly viewed from one angle only.

double cloth – synonym for **Kidderminster** carpeting, with two interwoven layers of cloth.

embroidered carpet – carpet worked in yarn sewn with a needle onto a cloth backing. Synonyms: needlework carpet, **needlepoint carpet**.

fibranne – spun rayon yarn. See rayon.

filling weft – yarn which is woven from **selvedge** to selvedge at right angles to the warp. Each yarn of the filling is called a **pick, shoot** or shot.

flat cord – a means of reinforcing the **selvedge** by weaving extra threads around the warps nearest the edge of the fabric.

flatweave – napless fabric. Synonyms: **tabby weave, tapestry weave**, weft-faced plain weave.

flossa – Swedish term for a short-pile rug. See also *rya*.

Ghiordes knot – synonym for **Turkish** or **symmetrical knot**.

glesrya – a variant on the *rya*, the *glesrya* consists of a **tabby weave** interspersed with one very long row of knots after every ten to fifteen **shoots**.

Gobelins – synonym for **tapestry weave**, from the name of the Manufacture Royale des Gobelins, a tapestry workshop set up by Colbert in the Hôtel des Gobelins, Paris, in 1662. The Gobelins family were originally dyers from Rheims. Synonym: **Aubusson** tapestry, **flatweave, tabby weave**, weft-faced plain weave.

Gripper Axminster – Patented by Thomas Greenwood and John Brinton of Kidderminster in 1890, based on an invention by Halcyon Skinner in Yonkers, New York in the 1860s, the Gripper Axminster differed from the **Spool Axminster** loom in using a **Jacquard mechanism** to feed the yarn drawn from creel frames behind the loom, and a beak-like gripper attachment to insert the tufts between the warp threads.

halvflossa – Swedish term for the **half-pile** technique.

half-pile – a technique in which designs are created partly by weaving the pile and partly by leaving the wefts visible in the manner of Genoese velvets. Half-pile carpets may be woven with two or more levels of pile, but may also stand out from a ground woven in the **bouclé** technique. Synonym: voided pile.

hand-hooked rugs – see **hooked rugs**

hand-knotted carpet – generally woven on a high-warp loom. The weaver works from the front of the carpet, attaching the knots in rows of upright tufts. In European carpets, the **symmetrical** or **Turkish knot** is more common than the **asymmetrical** or **Persian knot** but both are used. In both cases the weaver ties a whole row of knots, cutting each one individually and changing the skeins in accordance with the pattern. The rows of knots are fixed in place by two or more weft **shoots**, beaten down with a comb, in order to ensure the stability of the weave. The number of shoots varies according to the culture or even the individual weaver, but generally does not exceed two. The fineness of the weave is determined by the **knot count**.

heddle – assembly of leashes and rods required to lift the warps, thereby opening the **shed** for the passage of the weft.

high-warp loom – upright loom, also called a vertical loom.

hooked rugs – worked face-up with a crochet hook on burlap, monk's cloth or an existing canvas foundation using strips of fabric or woollen yarns.

ingrain – synonym for **Kidderminster** or **double cloth**.

interlocked technique – a method for linking up the different blocks of coloured yarn in a tapestry. It consists of encircling the single warp with two differently coloured weft yarns, while the weaving is still on the loom.

Jacquard mechanism – Named after the Lyons weaver Joseph-Marie Jacquard (1752–1834), the invention mechanized the weaving of patterned textiles. It represented an improvement on earlier experiments. Basile Bouchon invented the punched card system, resembling a Barbary organ, that is used to separate the warp threads and Jacques de Vaucanson devised a terminal mounted on the top of the loom, operated by a treadle, which causes a row of hooks attached to a metal bar to move forward and lift the warp threads to allow insertion of the weft. The Jacquard loom was first adapted for carpet manufacture at Kidderminster in 1825.

Kidderminster – a napless reversible fabric made by interweaving two or three separate webs of cloth. Woven in standard widths of 36 inches, the pattern is formed by the interwoven yarns and has a characteristic speckled effect when different colours are used. Woven on a drawloom at Kidderminster since 1735, the double cloth underwent an improvement at Kilmarnock in 1824, when the insertion of an extra web resulted in triple cloth. Adapted to the powerloom in 1839, Kidderminster carpeting was woven in quantity in the town of Kidderminster, England, during the 19th century. Synonyms: ingrain, multiple cloth, **double cloth**, triple cloth, Scotch and Kilmarnock.

kilim – synonym for **weft-faced fabric**, **tapestry weave** carpet.

Kilmarnock – synonym for **Kidderminster**.

knot count – the number of knots over a given surface of a hand-knotted carpet, measured in inches or decimetres.

knotted carpet – see **hand-knotted carpet**, **mechanically knotted carpet**

knotting density – synonym for **knot count**.

loop-pile Brussels – **Brussels** carpeting, with uncut loops.

low-warp loom – a loom with the warps in a horizontal position, used for making fine tapestry and **tapestry-weave** carpets. The **cartoon** is generally placed underneath the weave as a guide for the weaver.

mechanically knotted carpet – Using a **Jacquard mechanism** and special grippers, the yarn is wrapped around the two foundation warps in a manner indistinguishable from the **symmetrical knot**. Unlike most mechanically made carpets, the pile is solidly attached to the warp rather than the weft, with the result that the pattern is clearly visible on the back. Several grades were made, the finest virtually indistinguishable from a **hand-knotted carpet**. A loom of this type was patented by Sallandrouze Frères in 1889, in itself an improvement on an earlier model. Later patents include the one taken out by the Manufacture du Renard in Saint-Lubin-de-Jonchères (Eure et Loire) in 1910.

moquette – a French term used to describe a metered pile fabric made by raising the warps into loops around rods (or wires) introduced during the weaving process. Similar to velvet, *moquette* production is recorded in France in the 17th century and by the 18th it was made in quantity in Flanders. When the rods are equipped with a shearing device at one end, the resulting product is known as the **Wilton** weave, and when the loops are left uncut, it is known as **Brussels**. Woven in rolls of a standard width (usually 69–70 cm/27 in. or 92 cm/36 in.), *moquette* strips are sewn together for large carpets or used in single widths for halls, stairways or as individual throw rugs if the pattern unit is suitable. Today the term *moquette* is used to describe wall-to-wall strip **carpeting** made on mechanical looms.

needlepoint carpet – stitched onto a fine canvas foundation with a needle using a variety of stitches, but most frequently a small slanting stitch. Needlework carpets were made in large quantities in **Aubusson** until the First World War. Synonym: **embroidered carpet**.

nylon – the first yarn made from entirely chemical sources. Invented by Wallace Hume Carothers in 1932, polyamide was produced commercially from 1938 by DuPont of Delaware, under the trade name Nylon.

Patent Axminster – synonym for **chenille** carpet.

pattern unit – a complete single section of the design in a repeating pattern.

Persian knot – synonym for the **asymmetrical knot**; **Senneh knot**.

pick – a pass of the weft through the **shed**. Synonym: **shoot**, shot.

pile – the tufted surface of a carpet, formed by loops of yarn, cut or left uncut, as opposed to a napless fabric. Techniques used to achieve a piled surface include **hand-knotted**, **hooked** or **tufted** carpets, in addition to a variety of machine-made carpets.

pitch – pile thickness.

point de Cornély – see **Cornély stitch**.

point de Savonnerie – see **Savonnerie**.

point noué – French term for **hand-knotted** pile rug.

point-paper – a system whereby the pattern of a pile carpet is prepared for the loom by being translated onto graph paper, each square corresponding to a knot. The number of points, or squares, on the paper generally varies from 16 to 36 points to the square inch (or 25 to 55 per sq. dm).

powerloom carpeting – From the mid-19th century, carpeting made on looms operated by steam power began to supplant the craft of handweaving. **Brussels** and **Wilton** were the first types of carpeting adapted to the powerloom in 1846. Since that date, a wide variety of new looms have been invented, including the **Chenille** Axminster, **Spool Axminster**, **Gripper Axminster**, tapestry velvet, tapestry Brussels, and the **mechanically knotted** carpet.

pre-tinted warp carpeting – synonym for **tapestry velvet**.

rag rug – A folk craft, the rag rug is made from old clothing torn into strips. Rag rugs may be made by weaving or braiding the strips to form rectangular, circular or oval shapes. In 20th-century rugs, the strips of fabric may occasionally be tied in knots.

rayon – Made from regenerated cellulose fibres, the earliest type of rayon, nitrocellulose rayon, was first produced industrially by Hilaire de Chardonnet in 1884, based on earlier discoveries by Audemars and Schwabe. The use of nitrate was soon abandoned. Invented by English chemists Cross, Bevan and Beadle in 1892, the viscose process was more successful. Rayon viscose textiles were commercialized from the 1890s, after Topham had invented a method for spinning the yarn. Yarns produced according to the viscose process may have continuous filaments (rayon) or short fibres (spun rayon). Known as *fibranne,* spun rayon was discovered by Paul Girard in 1911. Synonym: **artificial silk**.

rölakan – Swedish term for a **weft-faced fabric** (low-warp tapestry), hung on the wall above a bench as a means of protection from draughts. Derived from *rygglakan*, a 'back cover'.

Royal Axminster – synonym for **Spool Axminster**.

rya – Swedish word designating a bedcover or sleigh blanket. The term has only been applied to rug-making since the 1920s. With warps and wefts of linen, the *rya* is characterized by a large number of **shoots**, generally ten to fifteen, between the knots. The woollen pile may be very long, particularly in modern rugs. *Rya* are made all over Scandinavia. See also *flossa, glesrya.*

ryijy – Finnish term for *rya.*

Savonnerie – a term used to describe the pile rugs made in the Manufacture Nationale de la Savonnerie, the carpet weaving workshop established by the French crown during the 17th century. Two methods are used: the knots may either be tied and cut individually as in the **symmetrical knot** or made in rows with a single length of yarn wrapped around the pairs of warps and a *tranche-fil* (a rod equipped with a shearing device at one end) placed in front of the weave. When the rod is removed, the yarn is cut and the resulting pile is indistinguishable from the symmetrical knot. To reduce the risk of accidents, scissors are now used in place of the *tranche-fil* to trim the pile. The fine quality of the carpets produced by the workshop has meant that the term Savonnerie has become a synonym for a superior grade of **hand-knotted carpet** made by commercial manufacturers elsewhere in France, particularly in **Aubusson**. The commercial Savonnerie grade should have a **knot count** of 400 knots per sq. dm.

Scotch carpeting – synonym for **Kidderminster**.

seamless Wilton – a technique invented in America in around 1930. Patterns were created by joining separate pieces of the design, invisibly held together on a webbed backing.

sedan loom – patented by the engineer Adrien Duquesne in 1878 for his factory in Sedan, known originally as 'Le Tapis Parisien' and today as the 'Point de Sedan'. Duquesne adapted the **Jacquard mechanism** so that the woollen pile warps are wrapped around the linen foundation warps. The pile resembles the **asymmetrical knot**, except that it is attached to one warp rather than the two characteristic of Persian knotting. The **knot count** is 75 per sq. dm; wefts are also in linen and the loom permits a maximum of five colours.

selvedge – the longitudinal edge of a cloth, which is generally reinforced, either by being oversewn after the fabric has been taken off the loom, or during the weaving process. See also **flat cords**.

Senneh knot – synonym for the **Persian** or **asymmetrical knot**.

shed – opening between rows of warp threads through which the weft is passed.

shoot, shot, shute – yarn used as filling in weaving. Synonym: **pick**.

slit-tapestry technique – a structure in **weft-faced tapestry weave** in which vertical slits occur between areas of different coloured yarns. They may be left open or stitched together once the weaving has been removed from the loom.

Smyrna carpet – term used in Germany, Austria and Holland to describe **hand-knotted carpets**. Taken from the name of the Turkish port, Smyrna, from which vast quantities of hand-made pile carpets were exported. In German-speaking countries, the term is sometimes used to describe **Gripper Axminster** carpeting.

Spool Axminster – a pile carpet woven on a loom developed by Halcyon Skinner, an employee of the Alexander Smith Carpet Company in Yonkers, New York, patented in 1874. Multicoloured pile yarns on spools, corresponding to the exact width of one row of tufts, are fed to the foundation from the spools, arranged in rotation on carriages above the loom. The yarns are guided to the loom through tubes attached to a mechanical bracket which inserts them through the warps to form loops held in place by one of three double **shoots** of weft. The warps and wefts were of cotton or jute, then later of synthetic fibres. This type of loom had advantages over **Wilton carpeting** in that it allowed an unlimited choice of colours and ensured that no worsted yarn once hidden in the foundation was wasted.

spun rayon yarn – also known as *fibranne*. See **rayon**.

strip carpeting – see **carpeting**.

stuffer warps – extra warps which reinforce the foundation of mechanically woven carpets. The pile is not attached to these warps.

symmetrical knot – To tie a symmetrical knot, the weaver takes two warps, passing the yarn behind both warps so that the tufts of yarn emerge between them. Synonym: Ghiordes knot, Turkish knot.

tabby weave – synonym for weft-faced plain weave or **flatweave**.

tapestry Brussels – made in the same technique as **tapestry velvet**, but the loops are left uncut.

tapestry velvet – First patented by Richard Whytock of Edinburgh in 1832, the technique had been perfected by 1855. The term is confusing, as the tapestry velvet technique is totally unrelated to the true **tapestry weave**. The pile of tapestry velvet carpeting, analogous to cut velvet, is formed by wrapping warp threads around a rotating drum, below which a moving mechanism colours sections of the threads which are then used to create the pile. The weaving process is similar to **Brussels carpeting**, but obviates the need for the **Jacquard mechanism** and allows an unlimited range of colours. A slight blurred effect is characteristic of this type of weave. Synonyms: velvet carpeting, printed warp carpeting, pre-printed warp carpeting, tinted-warp carpeting.

tapestry technique – see **tapestry weave**.

tapestry weave – a **weft-faced fabric** generally made on a **low-warp loom**. The weaver works from the back, inserting the weft yarn in blocks of colour corresponding to the pattern area. The weft is then tightly packed down with a comb beater to cover the warps. The most common methods for linking up the different blocks of colour are the **interlocked technique** or the **slit-tapestry technique**. It is possible to make tapestry weaves perfectly reversible, but generally loose ends are to be found on the underside. Synonyms: **Gobelins**, kilim, weft-faced fabric.

tinted-warp carpeting – synonym for **tapestry velvet** or **tapestry Brussels** carpeting.

Tournay – German term for **Wilton** carpet.

triple cloth – synonym for **Kidderminster** carpeting with three interwoven layers of cloth.

tufted carpets – The term 'tufted' is often used to denote a weaving with raised pile. In the 20th century, it has come to denote a particular technique, derived from the technique used for making candlewick bedspreads. To make a hand-tufted carpet, the weaver stands behind a jute or cotton foundation stretched onto a frame and inserts loops of wool from the back. The American Stanislav V'Soske may have been the first to adapt this technique for use in carpet-making, probably during the 1930s. The small wooden tool resembling a crochet hook initially used in making hand-tufted rugs has since been replaced by a single-needle tufting gun resembling an electric drill. Different grades of needles permit the use of yarns of varying thicknesses. The loops may be cut or left uncut. Early carpets were sized to ensure stability; now they are coated with a latex backing. Mechanical tufting, an adaptation of the sewing machine stitch, also an American invention, was developed by the Bigelow-Hartford Carpet Company after 1950 and had been introduced into Europe by the end of the decade.

Turkish knot – synonym for **symmetrical knot**.

velvet carpeting – see **tapestry velvet**.

velvet-pile Wilton – synonym for **Wilton carpet**.

voided pile – see **half-pile**.

warp – rows of threads of equal length attached to each end of a horizontal frame or the crossbeams of a loom.

weft – the transverse threads of a fabric which pass over and under the warps to create a fabric or the foundation of a carpet.

weft-faced fabric – synonym for **tabby weave**, **flatweave**, weft-faced plain weave.

Wilton carpeting – A warp-pile weave patented in Wilton in 1741 by a workshop which was the forerunner of the Wilton Royal Carpet Factory. Adapted to the powerloom in 1846, the structure of mechanically made Wilton carpeting is identical to **Brussels carpeting** except that the pile is cut and the weave is finer, with 39 rods per dm.

worsted wool – fine grade of yarn with long fibres made from combed wool.

SELECT BIBLIOGRAPHY

GENERAL WORKS

Marianne Aav, Nina Stritzler-Levine, *Finnish Modern Design: Utopian Ideals and Everyday Realities 1930–1997*, Bard Graduate Centre for Studies in the Decorative Arts, New York, and Yale University Press, New Haven, 1998

Jean Babonneix, *La Crise d'une Vieille Industrie. Le Tapis et la Tapisserie d'Aubusson*, Librairie Technique et Economique, Paris, 1935

Arlette Barré-Despond, *Dictionnaire International des Arts Appliqués et du Design*, Editions du Regard, Paris, 1996

Louis-Charles Bary, *Les Textiles Chimiques*, Presses Universitaires de France, Paris, 1978

Cornelia Bateman Faraday, *European and American Carpets and Rugs*, Dean Hicks Co., Grand Rapids, 1929 (repr. Antique Collectors Club, Woodbridge, 1990)

Luc Benoist, *Les Tissus, la Tapisserie, les Tapis*, Rieder, Paris, 1926

Thérèse Bonney and Louise Bonney, *A Shopping Guide to Paris*, Robert McBride, New York, 1929

Frederick R. Brandt, *Late 19th and Early 20th Century Decorative Arts. The Sydney and Frances Lewis Collection in the Virginia Museum of Fine Arts*, Virginia Museum of Fine Arts, Richmond, VA, 1985

Yvonne Brunhammer, Suzanne Tise, *The Decorative Arts in France 1900–1942*, Rizzoli, New York, 1990

Mel Byars, *Design Encyclopedia*, Laurence King, London, 1994

Mel Byars, Russell Flinchum, *Fifty American Designers 1918–1969*, Preservation Press, Washington, 1994

Richard Cork, *Art Beyond the Gallery in Early 20th-Century England*, Yale University Press, New Haven and London, 1985

David Crowley, *National Style and Nation-State. Design in Poland from the Vernacular Revival to the International Style*, Manchester University Press, Manchester, 1992

Fernand David, Léon Deshairs, *L'Art Décoratif Français 1918–1925*, Albert Lévy, Paris, n.d. (c. 1925)

Sonia Delaunay, *Tapis et Tissus*, Charles Moreau, Paris, n.d. (1929)

Alastair Duncan, *American Art Deco*, Thames & Hudson, London, 1999

Stuart Durant, *Ornament from the Industrial Revolution to Today: A Survey of Decoration since 1830*, Macdonald, London, 1986

Titus M. Eliëns, Marjan Groot, Frans Leidelmeijer, eds., *Avant-Garde Design. Dutch Decorative Arts 1880–1940*, Philip Wilson, London, and V + K Publishing, Bussum, 1997

Enciclopedia delle Moderne Arte Decorative Italiani, vol. V: *Le Stoffe d'Arte e l'Arredamento della Casa*, Edizioni Ceschina, Milan, 1928

Giovanni and Rosalia Fanelli, *Il Tessuto Art Deco e Anni Trenta*, Cantini, Florence, 1986

Simon Garfield, *Mauve. How One Man Invented a Colour that Changed the World*, Faber and Faber, London, 2000

Gustave Geffroy, *Les Musées d'Europe. Les Gobelins*, Nilsson, Paris, n.d.

H. G. Hayes Marshall, *British Textile Designers Today*, F. Lewis, Leigh-on-Sea, 1939

Irena Huml, *Polska Sztuka Stosowana XX Wieku*, Wydawnictwa Artystyczne i Filmowe, Warsaw, 1978

Madeleine Jarry, *The Carpets of Aubusson*, F. Lewis, Leigh-on-Sea, 1969

Madeleine Jarry, *The Carpets of the Manufacture de la Savonnerie*, F. Lewis, Leigh-on-Sea, 1966

Pierre Kjellberg, *Art Déco. Les Maîtres du Mobilier. Le Décor des Paquebots*, Editions de l'Amateur, Paris, 1990 (2nd ed.)

Pierre Kjellberg, Guillemette Delaporte, *Le Mobilier du XXe Siècle. Dictionnaire des Créateurs*, Editions de l'Amateur, Paris, 1994

R. L. Leonard, C. A. Glassgold, eds., *Modern American Design by the American Union of Decorative Artists and Craftsmen*, Acanthus Press, New York, 1992 (1st ed. 1930)

Lennart Lindkvist, ed., *Design in Sweden*, Swedish Institute, Stockholm, 1977

Fiona MacCarthy, *British Design Since 1880. A Visual History*, Lund Humphries, London, 1992

David Revere McFadden, ed., *Scandinavian Modern Design, 1880–1980*, Harry N. Abrams, New York, 1982

Oli Mäki, ed., *Taide ja Työ. Finnish Designers of Today*, Werner Söderström Osakeyhtiö, Helsinki, 1954

J.-J. Marquet de Vasselot, Roger-Armand Weigert, *Bibliographie de la Tapisserie, des Tapis et de la Broderie*, Armand Colin, Paris, 1935

Edna Martin, Beate Sydhoff, *Swedish Textile Art*, Liberförlag, Stockholm, 1979

M. Matet, *Tapis*, H. Ernst, Paris, n.d. (c. 1928)

Frederick J. Mayers, *Carpet Designs and Designing*, F. Lewis, Benfleet, 1934

Ann Lee Morgan, Colin Naylor, eds, *Contemporary Designers*, Macmillan, London, 1984

Jocelyn Morton, *Three Generations in a Family Textile Firm*, Weidenfeld & Nicolson, London, 1983

R. Craig Miller, *Modern Design in the Metropolitan Museum of Art, 1890–1990*, Harry N. Abrams, New York, 1990

Léon Moussinac, *Tapis*, Albert Lévy, Paris, n.d. (c. 1926)

Anna-Maja Nylén, *Swedish Handcraft*, Van Nostrand Reinhold, New York, 1988

Gustave Quénioux, *Les Arts Décoratifs Modernes*, Larousse, Paris, 1925

Steen Eiler Rasmussen, *Danish Textiles*, F. Lewis, Leigh-on-Sea, 1956

Georges Rémon, pref., *Serge Gladky. La Voie Céleste. Tapis Astraux. Quinze Compositions en Couleur*, Editions de Quatre Chemins, Paris, 1929

Repertoire du Goût Moderne, Albert Lévy, Paris, n.d. (1928–29)

Ingeborg de Roode, Marjan Groot, *Amsterdamse School. Textile 1915–1930*, Uitgeverij Thoth, Nederlands Textielmuseum, Bussum, 1999 (summary in English)

Helene Rosenstiel, *American Rugs and Carpets from the Seventeenth Century to Modern Times*, Barrie & Jenkins, London, 1978

Anna Maria Ruta, *Arredi Futuristi*, Edizioni Novecento, Palermo, 1985

Elisabeth de Saedeleer, *Le Tissage à la Main*, Atelier d'Art Elisabeth de Saedeleer, Brussels, 1974

Mary Schoeser, Kathleen Dejardin, *French Textiles from 1760 to the Present*, Laurence King, London, 1991

Werner J. Schweiger, *Wiener Werkstätte: Design in Vienna, 1903–1932*, Thames & Hudson, London, 1984

Joan Scobey, *Rugs and Wall Hangings. Period Designs and Contemporary Techniques*, Dial Press, New York, 1974

E. A. Seguy, *Suggestions pour Etoffes et Tapis. Soixante Motifs en Couleurs*, Paris, n.d. (1925)

Sarah B. Sherrill, *Carpets and Rugs of Europe and America*, Abbeville Press, New York, London & Paris, 1996

Charles Singer, E. J. Holmyard, A. R. Hall and Trevor Williams, eds., *A History of Technology*, vols. III, IV, V, Clarendon Press, Oxford, 1958

Françoise Siriex, Jacques Sirat, *Tapis Français du Vingtième Siècle, de l'Art Nouveau aux Créations Contemporaines*, Editions de l'Amateur, Paris, 1993

Maj Sterner, *Homecrafts in Sweden*, F. Lewis, Leigh-on-Sea, 1939

R. Stornsen, intro., *Tapis de Pologne, Lithuanie, Yougoslavie*, H. Ernst, Paris, n.d. (c. 1927)

C. E. C. Tattersall, *A History of British Carpets*, London, 1934, rev. ed. by Stanley Reed, F. Lewis, Leigh-on-Sea, 1966

Anne Thackeray, *Leisure in the 20th Century: History of Design*, Design Council Publications, London, 1977

Henri Verne, René Chavance, *Pour Comprendre l'Art Décoratif Moderne*, Hachette, Paris, 1925

Angela Völker, *Textiles of the Wiener Werkstätte 1910–1932*, Thames & Hudson, London, 1994

Georges Warchalowski, *L'Art Décoratif Moderne en Pologne*, J. Mortkowicz, Warsaw, 1928

Eva Weber, *Art Deco in America*, Crescent Books, New York, 1992

Jeanne G. Weeks, Donald Treganowan, *Rugs and Carpets of Europe and the Western World*, Chiltern Book Co., Philadelphia, 1969

Erik Wettergren, *The Modern Decorative Arts of Sweden*, Malmö Museum, Malmö, and American-Scandinavian Foundation, New York, 1926

Hans Wichmann, *Von Morris bis Memphis. Textilien der Neuen Sammlung Ende 19 bis Ende 20 Jahrhundert*, Birkhäuser, Basel, 1990

Hans Wichmann, ed., *Design Contra Art Deco. 1927–1932 Jahrfünft der Wende*, Prestel, Munich, 1993

Hans Wichmann, ed., *Deutsche Werkstätten und WK-Verband 1898–1990. Aufbruch zum Neuen Wohnen*, Prestel, Munich, 1992

Fernand Windels, *Le Tapis, un Art, une Industrie*, Editions d'Antin, Paris, 1935

Nils G. Wollin, *Svenska Textilier 1930. Swedish Textiles 1930. Textiles Suédois 1930*, Utställningsförlaget, Stockholm, 1930

Jonathan M. Woodham, *Twentieth-Century Ornament*, Rizzoli, New York, 1990

Sigrid Wortmann Weltge, *Bauhaus Textiles. Women Artists and the Weaving Workshop*, Thames & Hudson, London, 1993

EXHIBITION CATALOGUES

American Federation of Arts, *Contemporary Glass and Rugs*, Metropolitan Museum of Art, New York, 1929

Art Déco en Europe. Tendances Décoratives dans les Arts Appliqués vers 1925, Palais des Beaux-Arts, Brussels, 1989

Sigrid Barten, *Textilkunst 1950–1990*, Museum Bellerive, Zurich, 1991

Centre de Création Industrielle, *Textile du Nord. Culture et Industrie*, Centre Georges Pompidou, Paris, 1984

Mildred Constantine, Albert Chatelet, *An Exhibition of Contemporary French Tapestries*, Charles E. Slatkin Galleries, New York, 1965

Decorative Arts. Official Catalog. Department of Fine Arts, Division of Decorative Arts. Golden Gate International Exhibition, San Francisco, 1939

Douze Tapis au Point Noué... édités par les Grands Magasins à la Place Clichy, Grands Magasins à la Place Clichy, Paris, n.d. (1928)

Magdalena Droste, *Gunta Stölzl. Weberei am Bauhaus und aus eigener Werkstatt*, Bauhaus Archiv, Berlin, 1987

Magdalena Droste, Manfred Ludewig, *Der Bauhaus Webt: die Textilwerkstatt am Bauhaus*, Bauhaus Archiv, Berlin, 1988

Exposition Internationale de Paris 1937. Catalogue Officiel des Classes 38 Ensembles Mobiliers 41. Tissus d'Ameublement, Tapisseries et Tapis, Le Décor d'Aujourd'hui, Paris, n.d.

Finlande. Tradition et Formes Nouvelles. Tapis Rya et Rétrospective A. W. Finch, Palais des Beaux-Arts, Brussels, 1967

Johannes Itten und die Höhere Fachschule für Textile Flächenkunst in Krefeld, Deutsches Textilmuseum, Krefeld, 1992

J. Stewart Johnson, *American Modern 1925–1940. Design for a New Age*, Metropolitan Museum of Art, New York, 2000

Reyer Kras, Petra Dupuits, Elinoor Bergvelt et al., *Industry and Design in the Netherlands 1850–1950*, Stedelijk Museum, Amsterdam, 1985

Stefania Krzysztofowicz-Kozakowska, *Art Deco w Polsce (Art Deco in Poland)*, Muzeum Narodowe, Krakow, 1993

Edmond Labbé, *Exposition Internationale des Arts et Techniques dans la Vie Moderne (1937). Rapport Général*, Imprimerie Nationale, Paris, 1939

Jacqueline Lafargue, *Meubles 1920–1937*, Musée d'Art Moderne de la Ville de Paris, Paris, 1986

Jocelyne Le Bren, Alain Demachy, *Tapis du XXe Siècle*, Galerie Camoin-Demachy, Paris, 1999

Paul Léon, *Exposition Internationale des Arts Décoratifs et Industriels dans la Vie Moderne, Paris 1925. Rapport Général. Section Artistique et Technique*, vol. 6, *Tissus et Papier*, Larousse, Paris, 1927–31

Pierre Loze, Dominique Vautier, *Art Déco Belgique 1920–1940*, Musée d'Ixelles, Brussels, 1988

Fiona MacCarthy, Patrick Nuttgens, *Eye for Industry. Royal Designers for Industry 1936–1986*, Royal Society of Arts, London, 1986

Joan Marter, R. Craig Miller, Mary Riordan et al., *Design in America. The Cranbrook Vision 1925–1950*, Detroit Institute of Arts, Metropolitan Museum of Art, 1983

Francis Mathey, Yvonne Brunhammer, Chantal Bizot et al., *Cinquantenaire de l'Exposition de 1925*, Musée des Arts Décoratifs, Paris, 1976

Ingrid de Meûter, *Kleur voor Wand en Vilder. Het Weefatelier Elisabeth de Saedeleer 1902–1972*, Stadhuis Lakenhalle, Oudenaarde, 1993

Ministère du Commerce et de l'Industrie, des Postes et des Télégraphes, *Catalogue Général Officiel. Exposition Internationale des Arts Décoratifs et Industriels Modernes, Paris, avril–octobre 1925*, Paris, 1925

Jacqueline Pruskin, *British Carpets and Designs. The Modernist Rug 1928–1938*, Royal Pavilion Art Gallery and Museums, Brighton, 1975

Quatre Siècles de Tapis Français XVIIe–XXe Siècles, Musée des Arts Décoratifs, Paris, 1949

David Revere McFadden, ed., *Scandinavian Modern Design 1880–1890*, Cooper-Hewitt Museum and Harry N. Abrams, New York, 1982

Rugs: Arp, Calder, Cocteau, Max Ernst, Laurens, Léger, Miró, Picasso, World House Galleries, New York, 1987

Rugs and Carpets, an International Exhibition of Contemporary Industrial Art, Metropolitan Museum of Art, New York, 1937

Astrid Sampe, *Svensk Industritextil*, Nationalmuseum, Stockholm, 1984

Suomalaisia Ryijymalleja. Finska Ryemönster. Some of the Latest Models of Finnish Rugs, Neovius, Helsinki, 1938

Le Tapis. Ière Exposition. Europe Septentrionale, Musée des Arts Décoratifs, Paris, 1927

Les Tapis au Printemps, Printemps, Paris, n.d (c. 1930)

Tapis de Maîtres, Galerie Lucie Weill-Seligmann, Paris, n.d.

Le Tapis Moderne. Esthétique, Laines, Teintures, Manufacture de Tapis d'Art de la Côte d'Argent, Bordeaux, 1926

Teppiche. Arp, Bissière, Calder, Ernst, Vieira Da Silva, Klee, Laurens, Léger, Galerie Beyeler, Basel, 1961

La Tessitura del Bauhaus 1919–1933, Palazzo Ducale, Pesaro, 1985

Thirties. British Art and Design Before the War, Arts Council of Great Britain; Victoria & Albert Museum, London, 1979

M. P. Verneuil, *Exposition des Arts Décoratifs, Paris 1925. Etoffes et Tapis Etrangers*, Albert Lévy, Paris, n.d.

Le Vingtième Siècle au Tapis, Musée de la Tapisserie, Aubusson, 1991

ARTICLES

Harry V. Anderson, 'Contemporary American Designers', *Decorators' Digest*, March 1935, pp. 42–45, 59, 68, 74, 80, 82, 90

Isabelle Anscombe, 'Tapis d'Europe', in *Rugs and Carpets of the World*, ed. Ian Bennett, Quarto, London, 1977

'Les Beaux Tapis', *Art et Décoration*, 1947–2, no. 5, pp. 1–12

Charles Bricker, 'Art Deco Rugs', *Architectural Digest*, September 1987, vol. 44, no. 9, pp. 160–65

Marcel Brion, 'Tapis de Peintres Abstraits', *Graphis*, November–December 1962, vol. 18, no. 104, pp. 576–81

(Carpets) *L'Art International d'Aujourd'hui*, no. 15, n.d. (*c.* 1929)

(Carpets) *Domus*, December 1928, p. 80; February 1930, pp. 40, 57; October 1930, pp. 60–61

'Centenaire W. H. Perkin', *Cahiers CIBA* 1958, no. 66, October 1956

René Chavance, 'Les Tapis', *Echos des Industries d'Art*, January 1927, pp. 19–28

René Chavance, 'Les Tapis Modernes', *La Demeure Française*, Winter 1924–25, no. 4, pp. 53–60

René Chavance, 'Tapisserie et Tapis', *Echos des Industries d'Art*, January 1929, pp. 13–19

Henri Clouzot, 'Le Tapis Moderne', *Renaissance de l'Art Français et les Industries de Luxe*, April 1928, no. 4, pp. 157–61

Raymond Cogniat, 'Technique et Esthétique des Tapis Nouveaux', *Art et Décoration*, vol. 60, October 1931–32, pp. 105–24

'Les Décorateurs Modernes et l'Art du Tapis', *Art et Industrie*, October 1929, pp. 37–41

Léon Deshairs, 'Tapis de l'Europe Septentrionale et Orientale', *Art et Décoration*, November 1927, vol. 52, pp. 135–52

Léon Deshairs, 'Tapis Modernes', *Art et Décoration*, vol. 38–2, 1920, pp. 75–84

'Fine Craftsmanship', *The Studio (London Studio)*, vol. 106, September 1933, pp. 177–180a

Theo Van Doesburg, 'Oude en Nieuwe Textiel-Kunst/L'Art Textile Jadis et Aujourd'hui', *Interieur* (Amsterdam), vol. 47, 1930–31, pp. 1651–57, 1695–97, 1783–87, 1826–33, 1867–74; vol. 48, 1931–32, pp. 17–21, 65–70

Edmée, 'Les Tapis Modernes', *L'Art Vivant*, April 1925, pp. 31–33

G. Ferraris, M. Marabelli, 'Come Erano Belli Quei Tappeti', *Casa Vogue*, October 1985, no. 167, pp. 200–3

Ewa Frys-Pietraszkowa, 'Dywany Pany Tchórzewskiej', *Polska Sztuka Ludowa*, vol. XLI, 1987, pp. 201–6

'German Knotted Smyrna Rug by Wilhelm Poetter; English Knotted Axminster Rug by Da Silva Bruhns', *Design*, vol. 35, February 1934, pp. 10–11

L. Goodenough, 'Rugs from the Looms of Luxury', *Arts and Decoration*, vol. 43, October 1935, p. 36ff

Chantal Humbert, 'L'Influence de l'Art Nègre sur la Reliure, les Tapis et les Tissus Art Déco', *La Gazette*, no. 37, 21 October 1988, pp. 48–49

'L'Industrie Textile et la Fabrication des Tapis en Algérie', *L'Industrie Textile*, September 1924, vol. 40, no. 460, pp. 407–8

Guillaume Janneau, 'Tapisseries et Tapis', *Echos des Industries d'Art*, January 1928, pp. 5–14

Lucien Lainé, 'De la Tente du Nomade au Palais de Ciment', *Renaissance de l'Art Français et des Industries de Luxe*, May 1929, pp. 246–62

Lucien Lainé, 'Tapis en Relief', in Michel Dufet, *Meubles, Ensembles, Décors*, Editions du Décor d'Aujourd'hui, Paris, 1945, pp. 232–40

Hans Lassen, 'A Novel Branch in Art: the Modern Danish Knotted Rug', *Haandarbejdets Fremme*, no. 2, 1962–63, pp. 35–45

Jean Lauer, 'Le Rôle des Tapis dans les Intérieurs', *Art et Industrie*, April 1935, n.p.

Georges Marlier, 'Les Tapis de Saedeleer', *Art et Décoration*, September 1928, vol. 54–2, pp. 81–88

A. H. Martinie, 'Le Tapis Moderne', *ABC Artistique et Littéraire*, July 1931, no. 79, pp. 175–78

'Moderne Fussbodenteppiche', *Deutsche Kunst und Dekoration*, August 1931, pp. 319–23

'Notre Dame d'Aubusson, Patronne de l'Art Moderne', *Réalités*, no. 1962, July 1959, pp. 40–46, 97

Georges Oprescu, 'Tapis et Tentures Roumains', *Demeure Française*, Autumn 1925, no. 23, pp. 28–36

Georges Pascal, 'Le Tapis Moderne', *Beaux-Arts*, March 1931, p. 15

Nicolaus Pevsner, 'Designer in Industry: Carpets', *Architectural Review*, vol. 79, April 1936, pp. 185–90

'Quelques Nouveaux Tapis', *Art et Industrie*, October 1933, pp. 40–43

'Quelques Tissus Nouveaux Présentés par Brunet, Meunié et Cie', *Echos d'Industrie d'Art*, June 1926, p. 19

Charles Risler, 'Les Objets d'Art à l'Exposition des Arts Décoratifs. Etoffes, Tapis, Papiers Peints', *L'Architecture*, December 1925, pp. 413–24

Gabrielle Rosenthal, 'Les Tapis Nouveaux', *Amour de l'Art*, vol. 7, 1926, pp. 280–82

H. Sneyd, 'Developpement et Fabrication des Tapis *Tufted*', *Revue de l'Ameublement et des Industries du Bois*, March 1960, vol. 48, no. 3, pp. 135–37; April, pp. 159–63; May, pp. 151–53; June–July, p. 111

Fabien Sollar, 'Tapis, Tapisseries (Beaumont)', *Les Echos d'Art*, no. 66, January 1931, pp. 13, 16–18

Walter Rendell Storey. 'American Rugs for the Modern Age', *Creative Art*, vol. 9, July 1931, pp. 42–51

'Le Tapis', *Ce Temps-Ci. Cahiers d'Art Contemporain*, no. 6, October 1929

'Tapis en Relief. L'Aspect Fourrure, le Bouclé-Laine', *Maison et Jardin*, December 1959, no. 65, pp. 130–33

'Tapis Mécaniques', *Revue de l'Ameublement*, May 1964, vol. 52, no. 5, pp. 179–80

'Tapis Modernes', *Art et Industrie*, October 1927, no. 10, pp. 19–22

'Tapisseries et Tapis', *Amour de l'Art*, vol. 29, 1949, pp. 60–65

'Les Techniques de l'Art Décoratif: le Tapis', *Beaux-Arts*, April 1938, p. 45

Jean Teugels, 'Les Tapis Modernes', *Art Vivant* (3) 1927, p. 812

('Tufted Carpets'), *Textile Art*, 1986, no. 18, pp. 22–25

A. Varron, 'Le Tapis Européen. Le Tapis Symbole de Puissance. Le Tapis Façon de Turquie. Les Tapis de la Bourgeoisie. La Fabrication Moderne des Tapis en Europe. Le Tapis dans l'Art Populaire', *Cahiers CIBA*, July 1950, no. 30, pp. 1026–50

Jennifer Wearden, 'Europe', in David Black, ed., *World Rugs and Carpets*, Country Life, London, 1985

Fernand Windels, 'Tapis d'Aubusson', in Michel Dufet, *Meubles, Ensembles, Décors*, Editions du Décor d'Aujourd'hui, Paris, 1945

Edward Woroniecki, 'Les Kilims et les Tissus de Lin Modernes en Pologne', *Art et Décoration*, February 1930, pp. 61–64

The author would like to offer her profound thanks to all those who have helped in various ways to bring this book to fruition.

Special thanks are due to Maurice Culot, Maïté Hudry, Yves Mikaeloff and Olivia and Armand Deroyan for their faith in the project and to Anne Lajoix, whose idea it was in the first place and who kindly gave me her documentation.

Thanks also to Sarah B. Sherrill and Suzanne Tise-Isoré, for reading the manuscript and providing useful pointers, and to the staff at Thames & Hudson.

Among those who have generously shared their knowledge with me are Barbro Hovstadius, curator, Nationalmuseum, Stockholm; Eris Erlandsson, curator, Textile Museum, Sandviken, Sweden; Charlotte Paludan, curator, Kunstindustrimuseet, Copenhagen; Nadine Gasc, Marie-Noëlle de Gary, Evelyne Possemé, curators, Musée des Arts Décoratifs, Paris; Brigitte Lainé, Archives Départementales de la Seine; Martine Mathias, curator, Musée de la Tapisserie, Aubusson; Catherine Giraud, Laurence de Lamaestre, Centre de Documentation du Musée de la Tapisserie, Aubusson; Bernard Brillon, Manufacture Nationale des Gobelins; Jean-François Pinchon, assistant lecturer at the Université de Montpellier; Marie-Laure Crosnier-Leconte, Marie-Madeleine Massé, Musée d'Orsay; Greta Stroeh, Fondation Arp, Clamart; Danièle Giraudy, curator, Musée Picasso, Paris; Emmanuel Bréon, Afsaneh Girardo, Musée des Années Trente, Boulogne-Billancourt; Jane Adlin, Christina Carr, curators, Metropolitan Museum of Art, New York; Meg Smith, Gail Davidson, curators, Cooper-Hewitt Museum, New York; Leanne Pudick, Tina de Carlo, Museum of Modern Art, New York; Frederick R. Brandt, curator, Virginia Museum of Fine Arts, Richmond (VA); Emilie Norris, Busch-Reisinger Museum, Harvard University, Cambridge (MA); Gregory M. Wittkopp, Cranbrook Academy of Art Museum; Penny Fowler, Frank Lloyd Wright Foundation; Marianne Lamonaca Loggia, Brooklyn Museum; Dena S. Katzenberg, consultant curator, Baltimore Museum of Art; MaryAnn Wilkinson, associate curator, Detroit Institute of Arts; Gillian Coveney, curator, Wilton Royal Carpet Factory; Gillian Varley, National Art Library, London; Liz Arthur, Glasgow Museums & Art Galleries; Dr Magdalena Droste, Sabina Hartmann and Barbara Stolle, Bauhaus Archives, Berlin; Luise Schier, Bauhaus, Dessau; Liesbeth Crommelin, Agnes Splinter, Ingeborg de Roode, Stedelijk Museum, Amsterdam; Dr Maryan Boot, A. A. A. Blankesteÿn, Erna Onstenk, Gemeentemuseum, The Hague; Dr Evert Van Straaten, Toos Van Kooten, curators, Rijksmuseum Kröller-Müller, Otterlo; Walter Swagemakers, Jan Esman and Marijke Andriese, Nederlands Textielmuseum, Tilburg; Françoise Bellis-Dumont, Musée Van Buuren, Brussels; Marijke Detremmerie, Design Museum, Ghent; Dr Michael Eissenhauer, Germanisches Nationalmuseum, Nuremberg; Ingrid Pfeiffer, Museum des Kunsthandwerks, Leipzig; Dr Brigitte Herrbach, Badisches Landesmuseum, Karlsruhe; Dr Agnieszka Lulinska, Fondation Jean Arp and Sophie Taeuber-Arp, Bonn; Dr Elisabeth Fuchs Beltrami, Wenzel Hablik-Museum, Itzehoe; H. Dauer, Kunstsammlung zu Weimar; Dr Sigrid Barten, Museum Bellerive, Zurich; Howard Shubert, assistant curator, Canadian Architecture Centre, Montreal; Dr Angela Volker, Blanda Winter, Österreichisches Museum für angewandte Kunst, Vienna; Prof. Giandomenico Romanelli, Centro Studio di Storia del Tessuto e del Costumo, Venice; Riccardo Passoni, curator, Museo Civico, Turin; Fiona Leslie, curator, Victoria & Albert Museum, London; David Peyceré, Guillaume Marchand, Frédéric Chèvre, Institut Français d'Architecture Archives, Paris; Marie-Hélène Guelton, Centre International de l'Etude des Textiles Anciens, Lyons; Piet Blondeel, Cultural Office, Oudenaarde; Marie-Christine Veilex, Mairie de Séez; Sonia Parmentier, Mairie de Namur.

Warm thanks are also extended to:

Germaine d'Abbadie, Berdj Achdjian, Peter Adam, Geneviève d'Andoque, Jean-Pierre André, Henri Bacaud, Peter Backhausen, Louis Baucher, Doris Blau, Olivier Bosquillon, Brian Brace Taylor, Bracquenié et Cie., Fanny Brennan, Florence Camard, Claude and Françoise Cardinaël, Lison de Caunes, Jean Coudyser, M. Cretenet, Mireille Cuttoli, Jacques Damase, Philippe Dautzenberg, M. Dumont de Montroy, Luigi Durante, Elisabeth Erlevint, Eyre de Lanux, France Faure Seligman, Sonia Ganne, Mme Irma Garance, Katherine and Steven Gottlieb, M. and Mme Jacques Gournay, Denise Grail, Joseph Hakimian, M. and Mme Philippe Hamon, René Hamot, Ellen Herzmark, Gilles Jorrand, Zoë and John Kurtz, Eddy Lainé, R. C. Ledford V'Soske, Gina de Leeuw, Peter J. Lepage, Alain Lesieutre, Simone Lurçat, Eva Mahn, P. Mathiot, Evelyne Meurice, José Michel, Ian Millmann, Matteo de Monti, Alen Müller-Hellwig, Linda Parry, Gilles Peyroulet, Eric Philippe, Pinton S.A., François Pinton, Mme Jean Pinton, Mme Félix Pissarro, Perrine Poiret de Wilde, Fatima Raoui, Ninon Roques, Anna Maria Ruta, Godelief de Saedeleer, Heinz Spielmann, Peter Uyttenhove, Anne Van Loo, Anne and Philippe Van Melle, Eric Vène, J. Verheust, Louis-René Vian, Mercé Viñas de Samaranch.

PICTURE CREDITS

1 Georges Valmier, *Outremer (Overseas)*, detail. 1929–30. Wool, gun-tufted, 197 x 241 (77⅝ x 94⅞). Courtesy Artcurial, Paris. © ADAGP, Paris and DACS, London 2002. 2 Art Nouveau carpet in the style of Georges de Feure, *c.* 1900. Wool pile, 405 x 297 (159½ x 116⅞). Collection Yves Mikaeloff, Paris. Photo Sebert. © DACS 2002. 3 Jean Arp, carpet design for the Maison Myrbor, *c.* 1928. © DACS 2002. 4 Sonia Delaunay, *Tondo*, carpet design, 1937. Gouache. Collection Jacques Damase, Paris. © L & M SERVICES B.V. Amsterdam 20020303. 5 Carpet in a Constructivist pattern, possibly woven by the Wilton Royal Carpet Factory, *c.* 1925. Wool pile, 187 x 240 (73⅝ x 94½). Christie's London, 2 May 1996, lot 186. Photo © Christie's Images Ltd. 6 André Lhote, *Rugby*. Hand-knotted wool pile carpet, 208 x 217 (81⅞ x 85⅜), based on the 1917 painting in the Musée de l'Art Moderne, Paris. Courtesy Galerie Berdj Achdjian. © ADAGP, Paris and DACS, London 2002. 7 Paul Klee, *Blue-Red Abstraction (Abstraction Bleu-Rouge)*, *c.* 1930. Wool pile, 150 x 195 (59 x 76¾). Galerie Lucie Weill-Seligmann. © DACS 2002. 8 Set for Marcel L'Herbier's film *Le Vertige*, designed by Robert Mallet-Stevens, with a carpet by Jean Lurçat. Photographic service of the Cinémathèque Française. © ADAGP, Paris and DACS, London, 2002 (Lurçat and Mallet-Stevens). 9 Jean Lurçat, *La Sirène (Mermaid)*, 1925. Hand-knotted, wool pile, diameter 250 (98⅜). Musée Départemental de la Tapisserie, Aubusson, Coupé archives. Photo R. Godrant. © ADAGP, Paris and DACS, London 2002. 10 Jeanne Rij-Rousseau, *La Cité Eclatée*, 1915–20. Hand-knotted, wool, 127 x 107 (50 x 42⅛). Courtesy Galerie Berdj Achdjian, Paris. 11 Carpet based on *Composition* by Georges Braque, *c.* 1925. 415 x 280 (163⅜ x 110¼). Auction Hôtel Drouot, Etude Pierre Cornette de Saint Cyr, 23 November 1989. © ADAGP, Paris and DACS, London 2002. 12 Carpet based on a Cubist still life by Pablo Picasso, *c.* 1928. Hand-knotted, wool pile, 205 x 118 (80¾ x 46½). Produced by the Maison Myrbor. Oxford Decorative Arts, Oxford. © Succession Picasso / DACS 2002. 13 Illustration of tapestry weave. 14 Illustration of the Turkish or symmetrical knot. 15 Illustration of the Persian or asymmetrical knot. 16 Photograph of a hand-knotted carpet being woven on a vertical loom. 17 Photograph of *moquette* being woven in the Studio de Saedeleer, Etikhove, Belgium. 18 Photograph of the Jacquard mechanism. 19 Ernest Boiceau, rug in the Cornély stitch, detail. Courtesy Galerie Eric Philippe, Paris. 20 Hand-tufting a carpet designed by Stanislav V'Soske in the V'Soske factory, Puerto Rico, 1939. Courtesy V'Soske, New York. 21 Photograph of the design studio of a French manufacturer in the 1930s. 22 Franz Delavilla, medallion carpet, 1909–10. Hand-knotted, wool, 551 x 351 (217 x 138¼). Woven by Backhausen und Söhne, Vienna. Courtesy F. J. Hakimian, Inc., New York. Photo John Bigelow Taylor, NY. 23 Exhibition of the Wiener Werkstätte's work in Berlin, 1904, designed by Josef Hoffmann. Archives J. Schweiger, Vienna. 24 Dining room of the Palais Stoclet, Brussels, 1905–11. Designed by the Wiener Werkstätte under the direction of Josef Hoffmann. Mosaics by Gustav Klimt. Photo Studio Minders. 25 Study of the pile carpet woven for the dining room of the Palais Stoclet, designed by the Wiener Werkstätte and woven by Backhausen und Söhne, Vienna. Backhausen Archive, Vienna. 26 Josef Hoffmann, *Glockenblüme (Campanula)*, Wilton carpeting designed for the Palais Stoclet, 1910. Backhausen Archive, Vienna. 27 Otto Prutscher, study for a circular carpet, 1910. © Otto Prutscher Archiv. 28 Leopold Bauer, carpet, *c.*1907. Hand-knotted, wool, 403 x 263 (158⅝ x 103½). Musée d'Orsay, Paris. © Photo RMN – H. Lewandowski. 29 Josef Hoffmann, preparatory study of the carpet for the Villa Skywa, Vienna, 1913. Backhausen Archive, Vienna. Photo Susan Day. 30 Dagobert Peche, design for Wilton carpeting, 1913. Backhausen Archive, Vienna. 31 The Wiener Werkstätte stand at Werkbund Exhibition, Cologne, 1914, designed by Josef Hoffmann, with carpeting by Dagobert Peche. Photo Bibliothèque Forney, Paris. 32 Theodor Veil, reception room shown at the Salon d'Automne, Paris,

1910. Photo Bibliothèque Forney, Paris. 33 Richard Riemerschmid, carpet for the Thieme residence, Munich, 1903. Wool pile, 400 x 300 (157½ x 118⅛). Stadtmuseum, Munich, T 86/295. © DACS 2002. 34 Geometric ornament analysed by Eugène Grasset in *Méthode de Composition Ornementale*, published in 1905. 35 Ecole Martine, pile carpet showing a tree hung with magic lanterns. 230 x 187 (90½ x 73⅝). Musée des Arts Décoratifs, Paris, inv. 987.945. Photograph Laurent Sully-Jaulmes. 36 Louis Süe, pile carpet designed for the firm of André Groult, shown at the Salon d'Automne, 1911. Photo Bibliothèque Forney, Paris. © ADAGP, Paris and DACS, London 2002. 37 Interior of the 'Maison Cubiste' by André Mare and Raymond Duchamp-Villon, shown at the 1912 Salon d'Automne. Carpets by Marie-Thérèse Lanoa (foreground) and Jean-Louis Gampert (rear). Photo Bibliothèque Forney, Paris. © DACS 2002 (Mare). 38 Robert Mallet-Stevens, sample of strip carpeting displayed on the Laplante stand at the 1913 Salon d'Automne. Photo Bibliothèque Forney, Paris. © ADAGP, Paris and DACS, London 2002. 39 André Groult, carpet exhibited at the Salon d'Automne, 1911. Photo Bibliothèque Forney, Paris. © ADAGP, Paris and DACS, London 2002. 40 Jeanne Lanvin's stand at the 1925 International Exhibition, Paris. Photo Bibliothèque Forney, Paris. 41 Fur rug displayed on Jeanne Lanvin's stand at the 1925 International Exhibition. 154 x 154 (60⅝ x 60⅝). Courtesy Galerie Cheska Vallois, Paris. 42 Carpet by an unknown designer. Flatweave, wool on cotton foundation, 220 x 150 (86⅝ x 59). Courtesy Collection Blondeel-Deroyan, Paris. 43 Gustave-Louis Jaulmes, section of a carpet design made by the Maison Hamot, 1925. Gouache, 27.3 x 47.2 (10¾ x 18⅝). Musée Départemental de la Tapisserie, Aubusson. 44 Fernand Nathan, pile carpet, *c.* 1925. Hand-knotted, wool pile, 300 x 193 (118⅛ x 76). Collection Yves Mikaeloff, Paris. 45 Camille Cless-Brothier (attr.), pile carpet, *c.* 1925. 342 x 252 (134⅝ x 38⅝). Sotheby's Monaco, 21 April 1991, lot 442. 46 Carpet designed and/or produced by Paul Dumas. Hand-knotted, wool pile, 400 x 480 (157½ x 189). Courtesy Collection Blondeel-Deroyan, Paris. Photo © Hughes Dubois, Brussels-Paris. 47 Pile carpet woven by the Ecole Martine, *c.* 1925. 457 x 255 (180 x 100⅜). Courtesy Galerie Berdj Achdjian, Paris. 48 Paul Poiret, bedroom on the barge *Amours*, decorated by the couturier, 1925. © DACS 2002. 49 Süe et Mare Compagnie des Arts Français, pile carpet woven by the Maurice Lauer workshop, Aubusson, 1924. Hand-knotted, wool, 490 x 260 (192⅞ x 102⅜). Private collection. Collection Yves Mikaeloff, Paris. © ADAGP, Paris and DACS, London 2002. 50 Süe et Mare Compagnie des Arts Français, circular carpet, *c.* 1925. Hand-knotted, wool pile, diameter 213 (84). Oxford Decorative Arts, Oxford. © ADAGP, Paris and DACS, London 2002. 51 André Mare, carpet design in gouache, *c.* 1925. André Mare Archives IMEC, Rouen, Courtesy Cabinet Camard, Photo Jean-Pierre Bourret. © ADAGP, Paris and DACS, London 2002. 52 Paul Follot, rug, 1920s. Hand-knotted wool pile, 116.2 x 185.5 (45¾ x 73). Christie's London, 2 May 1996, lot 165. Photo © Christie's Images Ltd. 53 Maurice Dufrène, bedroom designed for La Maîtrise, exhibited at the Salon des Artistes-Décorateurs, Paris, 1923. Institut Français d'Architecture Archives. 54 Maurice Dufrène, carpet produced by La Maîtrise, 1923. Hand-knotted, wool, 290 x 205 (114⅛ x 80¾). Courtesy Cabinet Camard, Paris. 55 Suzanne Guiguichon, carpet in the style of Maurice Dufrène, probably for La Maîtrise, *c.* 1925–27. Hand-knotted, wool. 304.8 x 152.4 (120 x 60). Victoria and Albert Museum, London, inv. T.393.1977. V&A Picture Library. 56 Emile Gaudissart, central fragment of the pile carpet exhibited in 'L'Hôtel du Collectionneur' at the 1925 International Exhibition, Paris. Hand-knotted, wool pile; fragment 405 x 301 (159½ x 118½), original carpet 650 x 750 (236¼ x 295¼). Photograph courtesy Galerie Berdj Achdjian, Paris. 57 'L'Hôtel du Collectionneur', stand by Emile-Jacques Ruhlmann and Pierre Patout at the 1925 International Exhibition, Paris,

with a carpet woven by Braquenié from a design by Emile Gaudissart. 58 Interior designed by Raymond Quibel for Mercier Frères at the 1925 International Exhibition, featuring glass by René Lalique, metalwork by Jean Puiforcat, and a carpet by Jules Coudyser. © ADAGP, Paris and DACS, London 2002 (Lalique). 59 Jules Coudyser, *Les Liserons (Convolvulus)*, *c.* 1925. Hand-knotted, wool, 300 x 300 (188⅛ x 118⅛). Courtesy Collection Blondeel-Deroyan, Paris. Photo © Hughes Dubois Brussels-Paris. 60 Edouard Bénédictus, pile carpet made by Aux Fabriques d'Aubusson for the pavilion of the Société des Artistes-Décorateurs at the 1925 International Exhibition. Hand-knotted, wool pile, 830 x 435 (327 x 171¼). Musée des Arts Décoratifs, Paris, dépôt du Mobilier National, GMT 28119. Photo Laurent Sully-Jaulmes. 61 Henri Rapin and Pierre Selmersheim, reception room of 'Une Ambassade Française', the pavilion of the Société des Artistes-Décorateurs at the 1925 International Exhibition. Carpet and textiles by Edouard Bénédictus. 62 Edouard Bénédictus, carpet design, 1929. Gouache on paper, 49.5 x 35 (19½ x 13¾). Courtesy Collection Blondeel-Deroyan, Paris. Photo © Hughes Dubois, Brussels-Paris. 63 Interior of Gustave Fayet's weaving workshop, rue Dauphine, Paris, *c.* 1920. Photo Bibliothèque Forney, Paris. 64 Gustave Fayet, pile carpet, 1920. Hand-knotted, wool pile, 163 x 128 (64⅛ x 50⅜). Musée des Arts Décoratifs, Paris. inv. OAO 274. Photo Laurent Sully-Jaulmes. 65 Léon Voguet, carpet design for the Studio Ruhlmann, 1925. Gouache on cardboard. 66 René Joubert (attr.), carpet, *c.* 1920. Flatweave, wool, 376 x 320 (148 x 120). Courtesy F. J. Hakimian, Inc., New York. 67 Albert-Armand Rateau, pile carpet for the bedroom of Aline and Charles Liebman, New York, *c.*1926. Hand-knotted, wool pile, 414 x 346 (163 x 136¼). Courtesy Galerie Cheska Vallois, Paris. © ADAGP, Paris and DACS, London 2002. 68 The Studio Ruhlmann, circular carpet in a vermicular pattern, *c.* 1920. Hand-knotted, wool pile, diameter 360 (141½). Courtesy Collection Blondeel-Deroyan, Paris. Photo © Hughes Dubois Brussels-Paris. 69 Henry Stéphany (attr.), *Circles and Waves*, *c.* 1927. Hand-knotted, wool pile, 534 x 414 (210¼ x 163). Courtesy Galerie Cheska Vallois, Paris. 70 Ivan Da Silva Bruhns, carpet with an African-inspired motif, *c.* 1920–25. Hand-knotted, wool pile, 215 x 118 (84⅝ x 46½). Courtesy Cabinet Camard, Paris. 71 Ivan Da Silva Bruhns, carpet, *c.* 1927. Hand-knotted, wool pile, 540 x 330 (212⅝ x 129⅞). Courtesy Collection Blondeel-Deroyan, Paris. 72 Jules Leleu's stand at the 1925 International Exhibition, Paris. Carpet by Ivan Da Silva Bruhns. 73 Ivan Da Silva Bruhns in front of one of his creations, *c.* 1930. Fonds Thérèse Bonney, Arch. Photo © C.M.N., Paris, BNN 1622N (35623). 74 Robert Bonfils, pile carpet commissioned by the Mobilier National for the French Ministry of War, 1922–24. Hand-knotted, wool pile, 296 x 231 (116½ x 91). Collection du Mobilier National, Paris. Photo Mobilier National/Philippe Sébert. 75 Marie Laurencin, pile carpet for the director of a music salon, Paris, 1925. Hand-knotted, wool pile, 325 x 350 (129 x 137¾). Virginia Museum of Fine Arts, Richmond. Gift of Sydney and Frances Lewis, inv. 85.340. Photo Katherine Wetzel © Virginia Museum of Fine Arts. © ADAGP, Paris and DACS, London 2002. 76 Pile carpet decorated with a galloping horse in the style of Jean Lurçat, woven by the Maison Myrbor, *c.* 1925–30. Hand-knotted, wool pile, 200 x 190 (78¾ x 74¾). Courtesy Collection Blondeel-Deroyan, Paris. © ADAGP, Paris and DACS, London 2002. 77 Pierre Leconte, pile carpet for La Maîtrise, 1925. Hand-knotted, wool pile. Christie's Monaco, 6 December 1987, lot 236. Photo © Christie's Images Ltd. 78 *The Three Graces*, carpet design for D.I.M., 1928. Photo Bibliothèque Forney, Paris. 79 Léon Sneyers, fragment of a carpet design, *c.* 1910. Photo © Archives d'Architecture Moderne, Brussels. © ADAGP, Paris and DACS, London 2002. 80 The de Saedeleer sisters seated before a high-warp loom, *c.* 1922–23. From left to right, Elisabeth, Marie-Jozef and Monique. Photo courtesy Stad

Oudenaarde, Belgium. 81 Albert Van Huffel, *Springtime*, carpet for the Van Gheluwe House, 1923. Hand-knotted, wool-pile, diameter 295 (116⅛). Courtesy Galerie Camoin-Demachy, Paris. 82 Albert Van Huffel, carpet decorated with parrots, 1923. Hand-knotted, wool pile, 268 x 268 (105 x 105). Woven by the Studio de Saedeleer, Belgium. Oxford Decorative Arts, Oxford. 83 Exhibition of Studio de Saedeleer carpets at the Museum voor Sierkunst, Ghent, 1926. On the wall, from left to right: 1. unidentified, 2. *Circus*, by Paul Haesaerts, 3. untitled, attr. Valérius de Saedeleer, 4. *Remous*, by Albert Van Huffel, 5. untitled, attr. Jules Boulez. On the floor: 6. Charles Leplae(?) © DACS 2002, 7. attr. Jules Boulez © DACS 2002, 8. unidentified. 84 Edgard Tytgat, *The Hunt*, 1925. Woven by the Studio de Saedeleer, Etikhove, *c.* 1925. Hand-knotted, wool pile, 260 x 260 (102⅜ x 102⅜). Collection René Van Blerk, Brasschaat. © DACS 2002. 85 Charles Leplae, *Musicians*, *c.* 1925. Hand-knotted, wool pile, 78 x 120 (31¾ x 48). Woven by the Studio de Saedeleer, Etikhove. Spinks, London, 5 December 1989, lot 223. © DACS 2002. 86 Paul Haesaerts (attr.), carpet woven by the Studio de Saedeleer, Etikhove, *c.* 1925. Hand-knotted, wool pile, 427 x 300 (158⅛ x 118⅛). Courtesy F. J. Hakimian, Inc., New York. 87 Paul Haesaerts, carpet woven by the Studio de Saedeleer, Etikhove, 1925. Hand-knotted, wool pile, 350 x 255 (137¾ x 100⅜). Courtesy Galerie Camoin-Demachy, Paris. 88 The Omega Workshops, Post-Impressionist room at the Ideal Home Exhibition, London, 1913. Photo Eileen Tweedy. 89 Duncan Grant, pile carpet for the Omega Workshops shown at the Ideal Home Exhibition, London, 1913. Hand-knotted, wool pile, 174 x 116 (68½ x 45⅝). Victoria & Albert Museum, London. inv. 193.1958. V&A Picture Library. © 1978 Estate of Duncan Grant, Courtesy Henrietta Garnett. 90 Frederick Etchells, carpet design, 1913. Pencil, watercolour and body colour, 44.5 x 40.6 (17½ x 16). Victoria & Albert Museum, London. E730.1995. V&A Picture Library. 91 Roger Fry, design of a circular rug for Arthur Ruck, 1916. Ink, gouache and *papier collé* on paper, 43.2 x 60.6 (17 x 23⅞). Victoria & Albert Museum, London. E722.1955. V&A Picture Library. 92 Vanessa Bell, carpet for the 'music room' of the Lefevre Gallery, 1932. Wool. 365.5 x 249.5 (143¾ x 98¼). Sotheby's London, 29 March 1996, lot 298. © 1962 Estate of Vanessa Bell, Courtesy Henrietta Garnett. 93 Music room of the Lefevre Gallery designed by Vanessa Bell and Duncan Grant, 1932. Photo Royal Pavilion, Art Gallery and Museums, Brighton and the Lefevre Gallery, London. 94 Frank Brangwyn, chenille Axminster carpet manufactured by Templeton's of Glasgow, 1930. 367 x 270 (183⅞ x 106¼). Christie's London, 16 November 1994, lot 67. Photo © Christie's Images Ltd. Courtesy David Brangwyn. 95 Sir William Nicholson and Elizabeth Drury (Edith Nicholson), *The Zodiac*, *c.* 1925. Carpet in a looped ribbon technique, 278.1 x 227.3 (109½ x 89½). Victoria & Albert Museum, London, inv. T-11-1954. V&A Picture Library. Reproduced by permission of Elizabeth Banks. 96 Theodoor Nieuwenhuis, carpet executed by Kinheim of Beverwijk, *c.* 1910–20. Hand-knotted, wool pile, 244 x 140 (96½ x 55⅛). Stedelijk Museum, Amsterdam, KNA 1814. 97 Carel-Adolph Lion Cachet, carpet woven by Kinheim of Beverwijk, *c.* 1910–20. Hand-knotted, wool pile, 170 x 115 (66⅞ x 45¼). Stedelijk Museum, Amsterdam, KNA 21. 98 Hildo Krop, machine-made carpet for the Polak-Krop home, 1915. Wool pile, 320 x 254 (126 x 100). Gemeentemuseum, The Hague. © DACS 2002. 99 Jacob Van den Bosch, carpet woven for 't'Binnenhuis by Kinheim, Beverwijk, 1924. Hand-knotted, wool pile, 386 x 297 (152 x 116⅞). Gemeentemuseum, The Hague, MW-2-1979. 100 Theodoor C. A. Colenbrander, *Hovenierskunst (The Art of Gardening)*, 1910. Design for a carpet in the batik style, gouache, 57 x 44 (22½ x 17⅜). Gemeentemuseum, The Hague. 101 R. N. Van Dael, pile carpet, *c.* 1930. Hand-knotted, wool pile, 282 x 195 (113 x 78). Oxford Decorative Arts, Oxford. 102 Jaap Gidding, pile carpet woven by the KVT, Rotterdam,

c. 1920. Wool pile, 138 x 74 (54³/8 x 29¹/8). Christie's Amsterdam, 23 May 2000, lot 220. Photo © Christie's Images Ltd. **103** Carpet by an anonymous designer in the batik style, *c.* 1900–25. Embroidered in wool on a cotton backing, 260 x 130 (102³/8 x 51¹/8). Courtesy Collection Blondeel-Deroyan, Paris. **104** Lobby in the Tuschinski Theatre, Amsterdam, 1918–21. Carpeting by Jaap Gidding. Gemeente Archief, Amsterdam, photo Ivan Dijk, no. 1946/22. Photo John Bigelow. With the permission of Eva Brummer. **105** Ellen Ståhlbrand, flatweave carpet in a traditional design, *c.* 1900. Wool, 249 x 388 (98 x 152³/4). Courtesy F. J. Hakimian, Inc., New York. **106** Eva Brummer, carpet, *c.* 1930. Hand-knotted, wool pile, 269 x 208 (105⁷/8 x 81⁷/8). Courtesy F. J. Hakimian, Inc., New York. With the permission of Eva Brummer. **107** Agda Österberg, carpet with a repeating tulip design, 1930. Hand-knotted, wool pile, 495 x 380 (197⁷/8 x 149⁵/8). Courtesy Eric Philippe, Paris. **108** Märta Måås-Fjetterström, *Black Garden*, *c.* 1925. Wool pile, 340 x 221 (134 x 87). Courtesy F. J. Hakimian, Inc., New York. With the permission of A.B. Märta Måås-Fjetterström. **109** Carpet made *c.* 1990 by the Tapis de Cogolin for the Galerie Artcurial, Paris from *Balfiore*, a design by Giacomo Balla dating from the 1920s. Gun-tufted, wool pile, 252 x 232 (99¹/4 x 78³/4). Courtesy Artcurial, Paris. © DACS 2002. **110** Giacomo Balla, Futurist interior, 1918. Photo Bibliothèque Forney, Paris. © DACS 2002. **111** Enrico Prampolini, *Fish*, pile carpet, 1925. Fonds Thérèse Bonney, Arch. Photo © C.M.N., Paris. no. BNN 2804 P (35798). **112** Enrico Prampolini, interior of a carpet, *c.* 1924. Private collection. **113** Enrico Paulucci, *Tiger*, 1933. Wool pile, 195 x 118 (76³/4 x 46¹/2). GAM, Galleria Civica d'Arte Moderne e Contemporanea di Torino. Photo Gonella Foto S.n.c. **114** Paolo Bevilacqua, pile carpet depicting wrestlers, *c.* 1930. Photo Bibliothèque Forney, Paris. **115** The Director's office at the Palazzo delle Poste (Central Post Office), Palermo, with a rug by Paolo Bevilacqua. Photo courtesy Anna Maria Ruta, Terme Vigliatore, Italy. **116** Tomàs Aymat, *Diana the Huntress*, 1924. Wool pile, 252 x 232 (99¹/4 x 91³/8). Private collection. **117** Yvan Gundrum, flatweave carpet woven by Djelo, Zagreb, 1927. Wool, 142 x 186 (55 ⁷/8 x 73¹/4). Courtesy Galerie Berdj Achdjian, Paris. **118** Flatweaves made by the Kilim Polski craft society, Warsaw, shown in the Polish pavilion at the 1925 International Exhibition, Paris. On the walls: Bogdan Treter, Joseph Czajkowski and Bogdan Treter. On the floor: Wojciech Jastrzebowski (beneath table), Bogdan Treter (foreground) and a matching pair by Joseph Czajkowski. Photo Bibliothèque Forney, Paris. **119** Edward Trojanowski, carpet made by the Kilim Polski craft society, 1925. Flatweave, wool, 156 x 198 (61³/8 x 78). Courtesy Galerie Berdj Achdjian, Paris. **120** Runner made in the Kilim Polski workshop, Warsaw, possibly designed by Adalbert (or Wojciech) Jastrzebowski. Flatweave, wool, 98 x 273 (38⁵/8 x 107¹/2). Courtesy Galerie Berdj Achdjian, Paris. **121** Frank Lloyd Wright, pattern unit for the hand-knotted carpets designed for the Banquet Hall of the Imperial Hotel, Tokyo, 1915. Pencil and coloured pencil on tracing paper, 115 x 115 (45³/4 x 45³/4). Frank Lloyd Wright Foundation, inv. 1509.044. The drawing of Frank Lloyd Wright is Copyright © 1965, 1990, 1994, 2001 The Frank Lloyd Wright Foundation, Scottsdale, AZ. **122** Donald Deskey, bathroom rug design, *Sea Horse, Starfish, Coral, Conch Shell and Jellyfish*, 1930–35. Brush and gouache, graphite traces on grey paperboard, 25.9 x 25.8 (10¹/4 x 10¹/4). Cooper-Hewitt, National Design Museum, Smithsonian Institution/Art Resource, NY. Gift of Donald Deskey 1975.11.49. Photo Matt Flynn. **123** Marguerite Zorach, cartoon sketch for *Coral Sea Rug*, 1942. Watercolour on paper, 106 x 241 (41³/4 x 94⁷/8). Brooklyn Museum of Art. 77.126. Gift of Mr and Mrs Tessim Zorach. **124** Loja Saarinen, pile carpet for the headmistress's office, Kingswood School, Cranbrook, 1931. Wool pile on a linen warp, 262 x 204 (103 x 80¹/2). Cranbrook Academy of Art Museum. Photo © 1983 The Detroit Institute of Arts. **125** Ruth Reeves, carpet design, *Musical Instruments*, for Radio City Music Hall, New York,

1932. Brush and gouache, graphite traces on cream paper, lined, 18.6 x 14.1 (7³/8 x 5¹/2). Cooper-Hewitt, National Design Museum, Smithsonian Institution/Art Resource, NY. Gift of Donald Deskey 1975.11.73. Photo Matt Flynn. **126** Donald Deskey, interior of the Radio City Music Hall, with carpeting by Ruth Reeves and sculpture by William Zorach, *c.* 1931. **127** Weavers at a broadloom in Loja Saarinen's weaving studio, Cranbrook, May 1935. Photo Richard Askew, Cranbrook Archives. **128** Maja Andersson-Wirde and Studio Loja Saarinen, *Animal Carpet*, 1932. Wool and linen, 385 x 274 (151¹/2 x 108). Collection of Cranbrook Art Museum (CAM 1972.28) © Estate of Maja Andersson Wirde. Photograph © 1983 Dirk Bakker. **129** Carpet designed and executed by the Fetté-Li Co., Beijing, *c.* 1930. Baltimore Museum of Art, inv. 1987-295. **130** Benita Otte, carpet, 1923. Wool pile. Kunstsammlung zu Weimar, inv. 146/55. Photo Roland Dressler **131** Johannes Itten, point paper design of a carpet, *c.* 1923. Itten Archiv, Zurich. © DACS 2002. **132** Gunta Stölzl, Meisterin am Bauhaus Dessau/Master of the Bauhaus Dessau, design of a runner executed in knotted pile, 1923. Gouache on paper, 12 x 41.8 (4³/4 x 16¹/2). Bauhaus-Archiv, Berlin, inv. 1976, gift Paul Häberer. Photo Markus Hawlik. © DACS 2002. **133** Ida Kerkovius, *Animal Carpet*, 1923. Woven partly in weft-faced plain weave and partly in relief. Bauhaus-Archiv, Berlin. On behalf of the Ida Kerkovius Estate, E. Krause, Marburg. **134** Grete Reichardt, cloth and carpet design, 1929. Watercolour over pencil sketch with collage elements. Stiftung Bauhaus Dessau. Photo Kellerhoff, Kelly, Berlin. © Gisela Kaiser, Johannesstraße 178, 99084 Erfurt. **135** Anni Albers, design for Smyrna rug, 1925. Watercolour, gouache and graphite on paper, 20.6 x 16.7 (8¹/8 x 6¹/2). The Museum of Modern Art, New York. Gift of the designer. Photograph © 2002 The Museum of Modern Art, New York. © ARS, NY and DACS, London 2002. **136** Walter Gropius's office at the Bauhaus, Weimar, 1923. Carpet by Gertrud Hantschk-Arndt. Bauhaus-Archiv, Berlin. Photo Lucia Moholy. © DACS 2000 (Moholy) **137** Gertrud Hantschk-Arndt, design for a carpet, *c.* 1923. Watercolour on paper. On loan to Bauhaus-Archiv, Berlin. **138** A room in the Haus am Horn, the house designed by Georg Muche for an exhibition on the model home, Weimar, 1923. Bauhaus-Archiv, Berlin. **139** Martha Erps, carpet for the Haus am Horn, 1923. Wool pile. Hochschule für Architektur und Bauwesen, Weimar. **140** Students in the weaving workshop, Dessau. Top row, from left to right: unidentified, Margarete Heymann, Gertrud Hanschk-Arndt, Kurt Wanke (technical advisor), Gunta Stölzl, Gertrud Preiswerk-Dirks. Middle row: three unidentified students, Léna Meyer-Bergner, Lis Beyer-Volger, unidentified. Foreground: Ruth Hollós-Consemüller, Grete Reichardt, Anni Fleischmann-Albers. Bauhaus-Archiv, Berlin. **141** Otti Berger, flatweave carpet, *c.* 1930. Bouclé wool on a hemp foundation. Bauhaus-Archiv, Berlin. Photo courtesy Barry Friedman Gallery, New York. **142** Gunta Stölzl, Meisterin am Bauhaus Dessau/Master of the Bauhaus Dessau, carpet design, 1926. Watercolour and gouache on cardboard. Private collection. Photo courtesy Barry Friedman Gallery, New York. © DACS 2002. **143** Anni Albers, rug design for child's room, 1928. Gouache on paper, 34.1 x 26.5 (13⁷/8 x 10¹/2). The Museum of Modern Art, New York. Gift of the designer. Photograph © 2002 The Museum of Modern Art, New York. © ARS, NY and DACS, London 2002. **144** Grete Reichardt, carpet design, *c.* 1930. Watercolour over pencil, 12.1 x 9.2 (4³/4 x 3⁵/8). Stiftung Bauhaus Dessau. Photo Kellerhoff, Kelly, Berlin © Gisela Kaiser, Johannesstraße 178, 99084, Erfurt. **145** Wenzel Hablik, carpet design, 1932. Tempera and water colour on Chinese rice paper, 23.6 x 15 (9¹/4 x 5⁷/8). Wenzel-Hablik-Museum, Itzenhoe. **146** Alen Müller-Hellwig, *Kleine Mühle (Little Mill)*, 1928. Flatweave rug woven in natural undyed wools. **147** Ludwig Mies Van der Rohe, interior of the Haus Tugendhat, Brno, 1929. © DACS 2001. **148** Friedrich von Berzeviczy-Pallavicini, pile rug, woven by Anna Truxa, 1929. Looped rayon ribbon, 96 x 171 (37³/4 x 67³/8). University of Applied Arts, Vienna.

149 Lady's boudoir shown at the exhibition commemorating the 60th anniversary of the Kunstgewerbeschule (University of Applied Arts), Vienna, 1929. University of Applied Arts, Vienna. Photo J. Scherb. **150** Lois Resch, carpet, *c.* 1930. Hand-knotted, wool pile, 213.4 x 123.2 (84 x 48¹/2). Christie's New York, 12 December 1992, lot 459. Photo © Christie's Images Ltd. **151** Knotted carpet woven by Mila Hoffmannlederer from a design by Johannes Itten, *c.* 1925. Badisches Landesmuseum, Karlsruhe, inv. 76/182. © DACS 2002. **152** Sonia Delaunay, pile carpet for the living room of Dr Charles Viard, *c.* 1925. Formerly Galerie Félix Marcilhac, Paris. Whereabouts presently unknown. © L & M SERVICES B.V. Amsterdam 20020303. **153** Sonia Delaunay, interior shown at the U.A.M. (Union des Artistes Modernes) exhibition at the Musée des Arts Décoratifs, Paris, 1930. On the wall is Robert Delaunay, *Hommage à Blériot*, 1914. © L & M SERVICES B.V. Amsterdam 20020303. **154** Marguerite Dubuisson, carpet in a 'simultaneous' design of chromatic contrasts, *c.* 1930. Wool pile, 358 x 270 (141 x 106¹/4). Sotheby's London, 4 March 1988, lot 313. **155** Eileen Gray, study for a carpet, *c.* 1922. Gouache and collage on cardboard, 19.1 x 9.2 (7¹/2 x 3¹/2). Private collection, Paris. Courtesy Gilles Peyroulet. Eileen Gray Archive, London. **156** Eileen Gray, *Black Magic*, designed *c.* 1923. 280 x 225 (110¹/4 x 88⁵/8). Reissued in the tufted technique by Ecart International, Paris. Photo courtesy Ecart International © Deidi Von Schaewen. Eileen Gray Archive, London. **157** Eileen Gray, 'Monte Carlo Room', a bedroom design shown at the Salon des Artistes-Décorateurs, Paris, 1923. The carpet is *Black Magic*. Photo courtesy of the Lewis Archives, Virginia Museum of Fine Arts, Richmond. Eileen Gray Archive, London. **158** Staircase in Jacques Doucet's studio in Neuilly-sur-Seine, *c.* 1926–29. Banisters by Joseph Csáky, carpet by Louis Marcoussis. © ADAGP, Paris and DACS, London 2002 (Marcoussis). **159** Louis Marcoussis, pile carpet for Jacques Doucet's studio, Neuilly-sur-Seine, *c.* 1926. Wool pile, 252 x 140 (99⁵/8 x 55¹/8). Virginia Museum of Fine Arts, Richmond. Gift of Sydney and Frances Lewis, inv. 85.343. Photo Katherine Wetzel. © Virginia Museum of Fine Arts. © ADAGP, Paris and DACS, London 2002. **160** Jean Lurçat, *Garden*, carpet design for the Maison Myrbor, 1925. © ADAGP, Paris and DACS, London 2002. **161** The hallway of Jacques Doucet's studio with paintings by Joan Miró and Francis Picabia. The carpet is *Garden* by Jean Lurçat. © ADAGP, Paris and DACS, London 2002 (Miró, Picabia and Lurçat). **162** Gustave Miklos, 'collage' rug with an irregular shape, *c.* 1925. Hand-knotted, wool pile, 144 x 85 (56³/4 x 33¹/2). Musée des Arts Décoratifs, Paris, inv. 38160. Photo Laurent Sully-Jaulmes. © ADAGP, Paris and DACS, London 2002. **163** Gustave Miklos, carpet from Jacques Doucet's studio, Neuilly-sur-Seine, wool and metallic thread, 190 x 81 (74³/4 x 31⁷/8). Musée des Arts Décoratifs, Paris, inv. 38159. Photo Laurent Sully-Jaulmes. © ADAGP, Paris and DACS, London 2002. **164** René Herbst, furniture and pile carpet, *c.* 1929. Fonds Thérèse Bonney, Arch. Photo © C.M.N., Paris, BNN 0383-N (36.688). **165** Philippe Hosiasson, carpet design for the Boutique Pierre Chareau, *c.* 1930. © ADAGP, Paris and DACS, London 2002. **166** Elise Djo-Bourgeois, carpet design, *c.* 1928. **167** Jean Burkhalter, *Les Dalles*, *c.* 1930. Hand-knotted, wool pile, 215 x 147 (84⁵/8 x 57⁷/8). Courtesy Cabinet Camard, Paris. **168** Fernand Windels, Modernist design woven in Windels's own workshops, Bourganeuf (Creuse), *c.* 1930. Wool, 170.2 x 256.5 (67 x 101). Virginia Museum of Fine Arts, Richmond. Gift of Sydney and Frances Lewis, inv. 40433. Photo Ron Jennings © Virginia Museum of Fine Arts. **169** Francis Jourdain, carpet design, *c.* 1928. **170** Jean Goulden, textured carpet, *c.* 1930. Wool pile, 250 x 170 (98³/8 x 66⁷/8). Courtesy Collection Blondeel-Deroyan, Paris. © ADAGP, Paris and DACS, London 2002. **171** Jacques Adnet, circular rug in a Modernist design, *c.* 1930. Hand-knotted, wool pile, diameter 220 (86⁵/8). Courtesy Collection Blondeel-Deroyan, Paris.

Photo © Hughes Dubois Brussels-Paris. © ADAGP, Paris and DACS, London 2002. **172** Eric Bagge (attr.), pile carpet, *c.* 1930. Hand-knotted, wool pile, 300 x 205 (118¹/8 x 80³/4). Courtesy Galerie Berdj Achdjian, Paris. **173** Renée Kinsbourg, pile carpet, *c.* 1925–30. Hand-knotted, wool pile, 295 x 195 (116¹/8 x 76³/4). Courtesy Galerie L'Arc en Seine, Paris. **174** Ivan Da Silva Bruhns, pile carpet for the palace of the Maharaja of Indore, 1933. Hand-knotted, wool pile, 345 x 250 (135⁷/8 x 98³/8). Courtesy Cabinet Camard, Paris. **175** Eckhart Muthesius, foyer of the Palace of the Maharaja of Indore, 1933. Portrait of the Maharaja by Bernard Boutet de Monvel, carpets by Da Silva Bruhns. © DACS 2002 (Boutet). **176** Eileen Gray and Jean Badovici, living room of the E1027 villa in Roquebrune, 1929. Photo Bibliothèque Forney, Paris. Eileen Gray Archive, London. **177** Eileen Gray, design for *Centimètre*, originally made in pile for the living room of E1027, 1926–29. Gouache on paper, 17.8 x 15.5 (7 x 6¹/8). Sotheby's London, 4 November 1999, lot 422. Eileen Gray Archive, London. **178** André Lurçat, advertising poster for the Maison Myrbor, 9 December 1926. Photo IFA/DAF. © ADAGP, Paris and DACS, London 2002. **179** Interior of the Maison Myrbor, rue Vignon, Paris, designed by Jean Lurçat. Rugs by Jean Lurçat, Louis Marcoussis and Pablo Picasso. Fonds Thérèse Bonney, Arch. Photo © C.M.N., Paris, BNN 2115N (37247). © ADAGP, Paris and DACS, London 2002 (Lurçat and Marcoussis). © Succession Picasso / DACS 2002. **180** Fernand Léger, *Red 9*, *c.* 1927. Hand-knotted, wool pile, 230 x 155 (90¹/2 x 45¹/4). Photograph courtesy Cabinet Camard, Paris. © ADAGP, Paris and DACS, London 2002. **181** Robert Mallet-Stevens, interior of the architect's home on the rue Mallet-Stevens. Fabrics by Hélène Henry, carpet by Fernand Léger. © ADAGP, Paris and DACS, London 2002 (Mallet-Stevens and Léger). **182** Donald Deskey, hall of Helena Rubinstein's apartment, New York, *c.* 1935. Carpets by Jean Lurçat (foreground) and Picasso (background). Photo Bibliothèque Forney, Paris. © ADAGP, Paris and DACS, London 2002 (Léger). © Succession Picasso / DACS 2002. **183** Jean Arp, *Red Circle*, *c.* 1930. Wool pile, 200 x 155 (78³/4 x 61). Courtesy Cabinet Camard, Paris. © DACS 2002. **184** Joán Miró, *Spanish Dancer*, *c.* 1930. Wool pile, 200 x 155 (78³/4 x 61). Designed for the Maison Myrbor, Paris, rewoven 1980s. Galerie Lucie Weill-Seligmann. © ADAGP, Paris and DACS, London 2002. **185** Interior designed by Pierre Chareau, with a tapestry by Joan Miró and *Odalisque*, a carpet by Henri Laurens. Photo Bibliothèque Forney, Paris. © ADAGP, Paris and DACS, London 2002 (Miró and Laurens). **186** Hélène Henry, pile carpet, *c.* 1930. Monochrome wool with mixed straight and bouclé yarns, 500 x 600 (197 x 236). Christie's London, 11 May 2000, lot 145. Photo © Christie's Images Ltd. **187** Evelyn Wyld and Eyre de Lanux, stand at the Salon des Artistes-Décorateurs, 1929. The carpets displayed are *Romana* (on the floor), *Storm* (on the wall behind) and *Antennae* (on wall to right). British Architectural Library, RIBA, London. **188** Evelyn Wyld, design for *Storm*, 1929. Design for pile carpet with varying pile lengths shown at the Salon des Artistes-Décorateurs, Paris, 1929. British Architectural Library, RIBA, London. **189** Eileen Gray, runner, *c.* 1927. Hand-knotted, mixed wool and sisal pile in the chenille technique, 90 x 289 (35³/8 x 113³/4). Private collection, Paris. Eileen Gray Archive, London. **190** Eugène Printz, pile carpet in a bevelled design, *c.* 1930–35. Wool pile, 365 x 215 (143³/4 x 84¹/4). Sotheby's Monaco, 22 April 1990, lot 582. **191** Maurice Dufrène (attr.), carpet with a sprig motif, *c.* 1935. Hand-knotted, wool pile, 387 x 309 (152³/8 x 121⁵/8). Courtesy Galerie Camoin Demachy, Paris. **192, 193, 194** Ivan Da Silva Bruhns, set of three carpet designs in a linear pattern, *c.* 1935. Hand-knotted, wool pile, smaller two 185 x 84 (72⁷/8 x 33¹/8), larger one 320 x 135 (126 x 53¹/8). Courtesy Collection Blondeel-Deroyan, Paris. **195** Max Vibert, carpet designed for the Studium Louvre, *c.* 1930. Courtesy Galerie Anne-Sophie Duval, © photo Zarko Vijatovic. **196** Music room in the 'Demeure en Ile-de-France', designed by André Arbus for

the pavilion of the Société des Artistes-Décorateurs at the 1937 International Exhibition, Paris. Archives André Arbus / Editions Norma, Paris. © ADAGP, Paris and DACS, London 2002. **197** Louis Süe, carpet design made in the Savonnerie workshops displayed on the stand of the Mobilier National at the 1937 International Exhibition. Photo IFA/DAF. © ADAGP, Paris and DACS, London 2002. **198** Henri Gonse, *Spanish Carpet*, *c*. 1940. Tufted wool carpet in the *moquette* technique, 665 x 325 (245 1/2 x 132). Christie's London, 8 November 2001. Photo © Christie's Images Ltd. **199** André Groult, *La Mer (The Sea)*, carpet, 1942. Collection du Mobilier National. Photo Mobilier National / Philippe Sébert. © ADAGP, Paris and DACS, London 2002. **200** Jean Hugo, carpet embroidered by Frosca Munster, Maria de Gramont, François Hugo, Jean Bourgoin and Boris Kochno, 1934. 245 x 198 (96 1/2 x 78). Sotheby's Monaco, 4–6 September 1992, lot 418. © ADAGP, Paris and DACS, London 2002. **201** Dominique, carpet design with neo-Directoire motifs, *c*. 1935. Gouache. Archives Manufacture de Tapis, Cogolin. Photograph Susan Day. **202** André Arbus, carpet with architectural motifs, *c*. 1940. Hand-knotted, wool pile, 500 x 350 (196 7/8 x 137 3/4). Courtesy Collection Blondeel-Deroyan, Paris. Photo © Hughes Dubois, Brussels-Paris. © ADAGP, Paris and DACS, London 2002. **203** Lucien Coutaud, *Unicorn*, 1942. Flatweave woven by the Atelier Pinton, Aubusson, 250 x 140 (98 3/8 x 55 1/8). Musée Départemental de la Tapisserie, Aubusson, Archives Braquenié. © ADAGP, Paris and DACS, London 2002. **204** Paule Leleu, carpet, *c*. 1936. Hand-knotted, wool pile, 450 x 270 (177 1/8 x 106 1/4). Courtesy Cabinet Camard, Paris. **205** First-class lounge of the liner *Normandie*, designed by Roger-Henri Expert and Pierre Patout, 1935. Carpet by Emile Gaudissart. IFA/DAF. **206** Emile Gaudissart, *Cornucopia*, carpet design for the first-class lounge of the liner *Normandie*, 1935. Manufacture de Tapis, Cogolin. Photo Susan Day. **207** Ernest Boiceau, *Tulips*, 1929. Embroidered in wool in the Cornély stitch, 800 x 400 (315 x 157 1/2). Courtesy Galerie Eric Philippe, Paris. **208** Karel Maes, carpet in a Modernist design, *c*. 1930. Hand-knotted, wool pile, 200 x 111 (78 3/4 x 43 3/4). Sotheby's London, 4 June 1993, lot 370. © ADAGP, Paris and DACS, London 2002. **209** Albert Van Huffel, *Remous, or Les Fleurs Irisées sur l'Eau*, 1925. Wool pile, 215 x 220 (84 5/8 x 86 5/8). Sotheby's New York, 26–27 November

1993, lot 551. **210** Marcel-Louis Baugniet, design of a carpet, 1924. Watercolour. Photo © Archives d'Architecture Moderne, Brussels. © DACS 2002. **211** L. H. De Koninck, design of a carpet for the Gobert Villa, Stockel, 1927. Pencil and gouache on tracing paper. Photo © Archives d'Architecture Moderne, Brussels. **212** Maurice Gaspard, rug from the apartment of Charles Dekeukeleire, 1928. Hand-knotted, wool pile, 226 x 293 (89 x 115 3/8). Photo © Archives d'Architecture Moderne, Brussels. **213** L. H. De Koninck, rug for a bedroom, *c*. 1923. Hand-hooked, wool, 143 x 80 (56 1/4 x 31 1/2). Photo © Archives d'Architecture Moderne, Brussels. **214** Ben Nicholson, *Project*, *c*. 1939–44. Pile carpet. Courtesy Galerie Lucie Weill-Seligman, Paris. © Angela Verren-Taunt 2002. All rights reserved, DACS. **215** Francis Bacon, pile carpet, 1929. Hand-knotted, wool pile, 200 x 115 (78 3/4 x 45 1/4). Collection Félix Marcilhac, Paris. © Estate of Francis Bacon 2002. All rights reserved, DACS. **216** Roy de Maistre, *Interior*, 1930. Oil on canvas, 61.2 x 50.8 (24 x 20). © Manchester Art Gallery. **217** Serge Chermayeff, *Compass*, 1932. Hand-knotted, wool pile, diameter 283 (111 3/8). Sotheby's London, 25 October 1991, lot 263. Collection Ivan Chermayeff. **218** Betty Joel, rug. *c*. 1930. Tufted pile, woven in T'ien-Tsin, China, 121 x 206.5 (47 5/8 x 81 1/4). Christie's London, 2 May 1996, lot 176. Photo © Christie's Images Ltd. **219** Marion Dorn, tufted rug, 1930s. 135 x 195 (53 x 77). Oxford Decorative Arts, Oxford. **220** Marian Pepler, *Boomerang*, rug woven by Wilton Royal Carpet Factory, 1929–30. Hand-knotted rug, 203 x 325 (80 x 128). Victoria and Albert Museum, London, inv. circ. 568.1969. V&A Picture Library. **221** Lobby of Claridge's Hotel, London. Carpets by Marion Dorn, *c*. 1935. **222** Syrie Maugham's all-white drawing room at her home in Chelsea, furnished with matching carpet in the half-pile technique by Marion Dorn, 1933. Photo Philippe Garner. **223** Edward McKnight Kauffer, pile rug woven by Wilton Royal Carpet Factory, *c*. 1935. 127 x 179 (50 x 70 1/2). Christie's London, 2 May 1996, lot 190. Photo © Christie's Images Ltd. **224** Sheila Walsh, *Warrior*, *c*. 1930. Hand-knotted, wool pile, 211 x 189 (83 1/8 x 74 3/8). Sotheby's London, 30 October 1992, lot 326. **225** John Tandy, carpet manufactured by Wilton Royal Carpet Factory, *c*. 1937–38. Hand-knotted, wool pile, 180 x 122 (70 7/8 x 48). Christie's London, 13 May 1998, lot 459. Photo © Christie's Images, London. **226** Ashley

Havinden, carpet, *c*. 1935. Hand-knotted, wool pile, 255 x 200 (100 3/8 x 78 3/4). Courtesy Cabinet Camard, Paris. **227** Rex Whistler, *Neptune*, *c*. 1932. Oil on canvas board. 73.5 x 49.5 (29 x 19 1/2). Christie's West Dean House, 2–6 June 1986, lot 2029. Photo © Christie's Images Ltd. © Estate of Rex Whistler 2002. All Rights Reserved, DACS. **228** Interiors designed by Vilmos Huszár, illustrated in *L'Architecture Vivante*, Autumn 1924, pl. 10-1. Photo Institut Français d'Architecture Archives, Paris. © DACS 2002. **229** Vilmos Huszár, pile carpet woven for the Bruynzeel House, 1921. Wool pile, 203 x 107 (79 7/8 x 41 1/8). Gemeentemuseum, The Hague. © DACS 2002. **230** Georges Vantongerloo, reversible mat in the *moquette* technique produced by Metz & Co., Amsterdam, 1937. Private collection. © DACS 2002. **231** Bart Van der Leck, carpet design, L2, 1918. Produced by Metz & Co., Amsterdam, 1929. Gouache and pencil on paper, 37.9 x 28 (14 7/8 x 11). Private collection. © DACS 2002. **232** Metz & Co. stand at the U.A.M. exhibition, Paris, 1930. Furniture by Gerrit Rietveld, carpets by Bart Van der Leck. Photo Bibliothèque Nationale, Paris. © DACS 2002 (Rietveld and Van der Leck). **233** Jaap Gidding, Modernist carpet woven by the Studio de Saedeleer, *c*. 1930. Present location unknown. Photo Stedelijk Museum, Amsterdam 12594/2. **234** Jan Gompertz, pile carpet executed by Kinheim, Beverwijk, *c*. 1930. Wool pile, 195 x 240 (76 3/4 x 94 1/2). Gemeentemuseum, The Hague. **235** Kitty Van der Mijll-Dekker, carpet, 1936. Wool, mixed half-pile, looped and weft-float technique. Stedelijk Museum, Amsterdam, inv. KN 686. **236** Agda Österberg, flatweave runner, 1930s. 950 x 74 (374 x 29). Courtesy F. J. Hakimian, Inc., New York. **237** Märta Måås-Fjetterström, *Silverryan (The Silver Rug)*, 1923. Hemp in the warp and cowhair in the weft, 250 x 153 (98 3/8 x 60 1/4). © The Röhsska Museet, Gothenburg. With the permission of A.B. Märta Måås-Fjetterström, www.artrug.com. **238** Märta Måås-Fjetterström, rag rug, detail, 1934. Knotted in linen yarn and strips torn from surplus overalls, made in her workshop in Båstad, 200 x 100 (78 3/4 x 39 3/8). Textilmuseet i Högbo © Nordiska Museets Bildbyrå. With the permission of A.B. Märta Måås-Fjetterström, www.artrug.com. **239** Märta Måås-Fjetterström, wool rug in the voided or half-pile technique, *c*. 1934. 406 x 310 (160 x 122). Courtesy F. J. Hakimian, Inc., New York. Photo John Bigelow Taylor, New York.

With the permission of A.B. Märta Måås-Fjetterström, www.artrug.com. **240** Ingegerd Torhamn, hand-hooked *flossa* rug, 1930. Wool, 190 x 115 (74 3/4 x 45 1/4). Statens Konstmuseet, Stockholm, inv. NM 51/1967. Photo Alexis Daflos. © DACS 2002 (Torhamn). **241** Sven Markelius, living room exhibited at the Exhibition of Decorative Arts and Industrial Design, Stockholm, 1930. Carpet by Ingegerd Torhamn. Fonds Thérèse Bonney, Arch. Photo © C.M.N., Paris, BNN 2222 N (37109)5. © DACS 2002. **242** Barbro Nilsson, carpet, *c*. 1940. Wool pile on linen warp, 559 x 343 (220 1/8 x 135). Courtesy F. J. Hakimian, Inc., New York. Photo John Bigelow Taylor, New York. **243** Sigvard Bernadotte, *Hourglass*, *c*. 1940. Flatweave, 371 x 249 (146 x 98). Courtesy F. J. Hakimian, Inc., New York. **244** Ilonka Karasz, carpet designed for a child's nursery, 1928. Cotton and wool, 273.1 x 271.8 (107 1/2 x 107). The Metropolitan Museum of Art, Purchase, Theodore R. Gamble, Jr. Gift in honour of his mother, Mrs Theodore Robert Gamble, 1983. (1983.228.2). Photograph by Mark Darley. Photograph © 1989 The Metropolitan Museum of Art, New York. **245** Interior by Harriet E. Brewer, *c*. 1930. Photo Eileen Tweedy. **246** Stanislav V'Soske, *Marco Polo* carpet, *c*. 1939. Courtesy V'Soske, New York. **247** Man's den furnished with a carpet in a zig-zag pattern designed by Joseph Urban for the 1929 exhibition 'The Architect and the Industrial Arts', at the Metropolitan Museum of Art. The Metropolitan Museum of Art, New York. **248** John Ferren, carpet in an abstract design, 1942, woven by V'Soske, New York. 274.3 x 200.7 (108 x 79). The Museum of Modern Art, New York, Edgar Kaufmann, Jr. Fund. Photograph © 2002 The Museum of Modern Art, New York. Courtesy Katharina Rich Perlow Gallery, New York. **249** Arshile Gorky, *Bull in the Sun*, 1942. Tufted technique, wool, 215.9 x 295.9 (85 x 116 1/2). The Museum of Modern Art, New York. Gift of Monroe Wheeler. Photograph © 2002 The Museum of Modern Art, New York. © ADAGP, Paris and DACS, London 2002. **250** Stuart Davis, *Flying Carpet*, 1942. Wool rug, woven by V'Soske, 216 x 366 (85 x 144 1/8). The Museum of Modern Art, New York. Edgar Kaufmann, Jr. Fund. Photograph © 2002 The Museum of Modern Art, New York. © Estate of Stuart Davis / VAGA, New York / DACS, London 2002.

Figures in *italics* refer to illustration numbers.

7 Arts 149–51
7&5 Society 155, 197
De 8 163

Aalto, Alvar 197
Aaltonen, Hilma 78
Abstraction-Création 111, 155, 183, 197, 199, 202, 203
Adam, William 202
A.D.C.D. (Art Décoratif Céline Dangotte) 65, 203, 205
Adnet, Jacques 114, 123, 125, 183, 186, 195, 198, 205, *171*
Adnet, Jean 125, 183, 195, 205
Afzelius, Märta 191
Ahlmann, Lis 173
Ahrèn, Uno 78
Alavoine (Maison) 193
Albers, Anni (née Fleischmann) 102, 103, 105, 107, 108, 120, 178, 183, *135*, *140*, *143*
Albers, Josef 100, 102, 184
Alix, Charlotte 136, 139, 201
Alix, Yves 67
American Designers' Gallery 192, 199
Andersson-Wirde, Maja 78, 92, 200, *128*
Apollinaire, Guillaume 114
Arbus, André 141, 143, 147, 183, 191, 205, *196*, *202*
Armfield, Maxwell 202
Armory Show 87, 89
Arndt, Gertrud (Hantschk-Arndt) 102, *136*, *137*, *140*
Arp, Jean (Hans) 12, 111, 114, 133, 135, 159, 163, 183, 191, 195, 202, *3*, *183*
L'Art Décoratif 11, 37
L'Art Libre 149
Art Nouveau 11, 12, 27, 31, 34, 36, 63, 188, 194, 197, 204, *2*; *see also* Jugendstil, Nieuwe Kunst
Arts and Crafts 11, 34, 35, 63, 65, 67, 68, 69, 72, 88, 188, 202, 203, 204
Asker, Karna 78, 170, 175, 197
Asplund, Gunnar 172
Asplund, Signe 168
Asse, Geneviève 196
Aubert, Félix 200
Au Bon Marché 42, 189, 199
Aubusson, France 19, 34, 35, 42, 131, 147, 149, 165, 183, 185, 186
AUDAC 175, 188, 192, 199
Aufseeser, Hans 160
Aux Fabriques d'Aubusson 51, 184, 187, 205
Aymat Martinez, Tomàs 82–84, 183, *116*

Backhausen, Johann 183
Backhausen, Karl 183
Backhausen und Söhne 27, 31, 110, 183–84, 192, 198, 199, 204, 205
Bacon, Francis 157, 184, *215*, *216*
Badovici, Jean 116, 130, 190, *176*
Baeckman, Arno 78
Bagge, Eric 114, 123, 125–27, 184, 185, 187, 195, 205, *172*
Balla, Giacomo 81, 199, *109*

Banzer, Greta 108
Bardou, Yves 193
Bardyère, Georges de 187
Baucher, René 151, 184, 200
Bauer, Leopold 28, *28*
Baugniet, Marcel-Louis 151, 152, 184, *210*
Bauhaus 11, 14, 31, 84, 99–108, 110, 111, 120, 136, 155, 159, 163, 175, 178, 183, 184, 187, 189, 192, 193, 194, 198, 199, 201, 202, 203
Baumann, Henny 173
Bayer, Herbert 203
Beadle, Clayton 18, 212
Béarn (Manufacture de) 187, 195
Beaumont, Jean(-Georges) 42, 149, 184, 185, 186, 187, 191, 195
Becher, Ilse 108
Bell, Clive 68, 184
Bell, Vanessa 68, 69, 157, 184, 190, 197, 203, *92*, *93*
Bénédictus, Edouard 17, 36, 38, 42, 51–53, 184, 186, 187, 188, 190, 193, 195, 198, 202, *60*, *61*, *62*
Benton, Thomas 89
Bérard, Christian 193
Berger, Otti 105, 107, 108, 184, *141*
Bergner, Léna (Meyer-Bergner) 107, 108, 184–85, *140*
Bernadotte, Sigvard 172, 185, 205, *243*
Bernheim, Hélène 122
Bertsch, Karl 32, 197
Berzeviczy-Pallavicini, Friedrich von 110, *148*, *149*
Bevan, Edward 18, 212
Bevilacqua, Paolo 82, *114*, *115*
Beyer-Volger, Lis 105, *140*
Biddle, George 89
Bigelow, Erastus Brigham 22, 185, 210
Bigelow, Horatio N. 185
Bigelow Hartford Company 175, 185, 199
Bijvoët, Bernard 122, 186
Billing, Hermann 32
Bing, Siegfried 185, 189, 192
Bissière, Roger 136, 195
Björn, Acton 185
Blaue Reiter, Der 183, 193
Boberman, Vladimir 60, 62, 185, 186, 188, 191, 195, 205, *78*
Bohn, René 18
Boiceau, Ernest 23, 24, 41, 42, 54, 147, 185, 205, 210, *19*, *207*
Boileau, Louis-Hippolyte 203
Bonfils, Robert 58, *74*
Bonney, Thérèse 51, 54, 122, 123, 127, 133, 135, 175
Bonnier, Olle 197
Borker, Jacques 194
Börner, Helene 100, 105
Bouchon, Basile 22, 211
Boulez, Jules 67, 152, *83*
Bourgeois, Georges *see* Djo-Bourgeois
Bourgeois, Victor 151
Bourgoin, Jean 146
Bouy, Jules 94, 200
Bracquemond, Félix 185
Bracquemond, Marie 185
Bracquemond, Pierre 42, 53, 185, 191
Brandt, Paul 188

Brangwyn, Frank 69–70, 185, 202, 205, *94*
Braque, Georges 17, 113, 170, 193, *11*, *240*
Braquenié et Cie 34, 149, 183, 184, 185–86, 187, 190, 193, 194, 200, 203
Braquenié, Alexandre 185
Braquenié, Henri-Charles 185
Breuer, Marcel 104, 155, 205
Breuer, Robert 32
Breuhaus, Fritz August 203
Brewer, Harriet E. *245*
Brinton, John 211
Bromberg, Paul 165
Broner Ullmann, Bella 108
Brummer, Eva 78, 186, *106*
Brunet-Meunié 34, 51, 184, 186
Brzozowski, Kasimir 87
Bukowska, Helena 87, 193
Bulhakowa, Karolina 87
Burkhalter, Jean 120, 122, 127, 165, 186, 195, 199, *167*
Burne-Jones, Edward Coley 63

Cahiers d'Art 133
Calder, Alexander 131, 135, 136, 186, 195
Calder, Louisa 186
Cambelotti, Duilio 82
Carothers, Wallace Hume 19, 211
Carte, Anto 200
Cézanne, Paul 68, 69
Chagall, Marc 67
Champion, Georges 187
de Chardonnet, Hilaire 18, 212
Chareau, Pierre 41, 60, 117, 120, 121–22, 139, 186, 187, 191, 192, 194, *185*
Chauchet-Guilleré, Charlotte 199
Chavance, René 14, 117
Chermayeff, Serge 116, 157, 175, 186, 204, 205, *217*
Chessa, Gigi 82
Chevalier, Georges 141, 209
Chevreul, Michel-Eugène 35, 114, 176
de Chirico, Giorgio 133
Christiansen, Hans 190
Cless-Brothier, Camille 42, 186, *45*
Clouzot, Marianne 125, 149, 186
Cocteau, Jean 136, 189, 193, 195
Cogolin *see* Tapis de Cogolin
Colenbrander, T. C. A. 72–75, 186, 193, *100*
Compagnie des Arts Français 45, 123–25, 183, 186–87, 188, 194, 196, 201, 205, *49*, *50*
Compagnie Générale Transatlantique 188, 196
Constructivism 13, 103, 120, 121, 155, 160, 165, 170, 184, 189
Le Corbusier (Charles-Edouard Jeanneret) 14, 62, 103, 112–13, 116, 120, 121, 130, 190, 194
Cornély, Emile 24, 210
Coudyser, Jules 41, 42, 48–51, 122, 186, 187, 192, 195, 201, 205, *58*, *59*
Coulon, René 183
Coupé, Marcel 183, 186, 187, 189, 191, 194, 195, 203
Coutaud, Lucien 147, 198, *203*
Cranbrook Academy/Foundation 92, 127, 172, 178, 200, 201, 205
Creten-Georges 200
Crevel, René 60–62, 187, 191, 195, 205
Croc, Pierre 187

Croc & Jorrand 34, 187
Cross, Charles Frederick 18, 212
Csáky, Joseph 120, 133, 195, 196, *153*
Cubism 12, 13, 34, 36, 37, 40, 47, 54, 69, 87, 89, 100, 112, 113–14, 116, 117, 122, 127, 129, 136, 137, 151, 152, 155, 157, 163, 184, 187, 188, 189, 193, 194, 196, 197, 198, 202
Cuttoli, Marie 131, 133, 135, 136, 195, 198
Czajkowski, Joseph 87
Czeschka, Carl Otto 27, 28, 31, 204

Da Cono, Francesco 82
Dada 37, 111, 135, 149, 183, 189, 199, 202
Damase, Jacques 187
Danielsson, Emil 78, 205
Danish Handicraft Guild (Haandarbejdets Fremme) 172
Da Silva Bruhns, Ivan 41, 54, 56, 127, 143, 147, 159, 175, 186, 187, 193, 194, 195, 198, 199, 200, 206, *70*, *71*, *72*, *73*, *174*, *175*, *192*, *193*, *194*
Dauphine, Atelier de la 53, 189, 206, *63*
Davies, Arthur B. 197
Defosse, Antoine 204
Delacroix, Eugène 101
Delaunay, Robert 12, 100, 101, 114, 127, 157, 176, 187, 193, 202, *153*
Delaunay, Sonia 12, 114, 120, 121, 151, 163, 187, 196, 200, 206, *4*, *152*, *153*
Delavilla, Franz 28, *22*
Delville, Jean 184
Démy, Pierre-Antoine 185
Démy, Pierre-Jean 185
Derain, André 133, 136, 195
Design for Today 157
Design in Industry 157
Deskey, Donald 89, 92, 94, 133, 175, 176, 177, 186–87, 203, 206, *122*, *126*, *182*
Despiau, Charles 194
Despierre, Jacques 191
Dessarteaux, Jacques 183
Deutsche Textil Kunst 108
Deutsche Werkstätten 188, 197, 199, 203
Deventer Tapijtfabriek 22, 186, 193, 197, 210
Diaghilev, Sergei 35, 1969
Dijsselhof, Gerrit Willem 194
D.I.M. (Décoration Intérieure Moderne) 41, 62, 114, 120, 123, 184, 185, 186, 188, 202, 206
Dinclau, Hildegard 78
Djelo 206, *117*
Djo-Bourgeois (Georges Bourgeois) 54, 120, 123, 165, 188, 195, 196, 199, 201
Djo-Bourgeois, Elise 120, 123, 188, *166*
Dobson, Frank 203
Domin, André 188
Dominique 48, 147, 187, 188, 191, 193, *201*
Dorn, Marion 157–58, 160, 175, 188, 189, 198, 204, 206, *219*, *221*, *222*
Doucet, Jacques 117, 131, 196, *158*, *161*
Dresdner Werkstätten für Handwerkskunst 188
Drury, Elizabeth 95
Dubuisson, Marguerite 114, 186, 188, 195, *154*
Duchamp, Marcel 114
Duchamp-Villon, Raymond 37, 196, *37*
Dufet, Michel 196
Dufrène, Maurice 42, 47–48, 120, 125, 143, 183, 186, 187, 188, 191, 193, 195, 201, *53*, *54*, *191*

Dufy, Raoul 36, 133, *48*
Dumas, Fernand 53, 189
Dumas, Paul 42, 206, *46*
Dunand, Jean 137, 204
Dupont, Pierre 195
DuPont company 19, 211

Eames, Charles 200
Eberson, L. H. 186
Echos des Industries d'Art 14
Eckmann, Otto 191
Edinburgh Weavers 160, 188–89, 191, 197, 198
Ehrlich, Franz 107
Ehrmann, Marli 178
Ekman, A. 188
Englinger, Gabriel 191, 195
Ernst, Max 131, 133, 189, 195
Erps, Martha 101, 104, 120, *138*, *139*
L'Esprit Nouveau 112
Etchells, Frederick 68, 69, 197, 198, *88*, *90*
Expert, Roger-Henri *205*
Eyre de Lanux 129, 137, 189, 204

Fauvism 12
Favory, André 67
Fayet, Gustave 41, 42, 53, 189, 206, *64*
Feininger, Lionel 100, 103
Fenaille, Maurice 198
Ferren, John 178, 203, *248*
Féron, Sylvie 151, 184
Fetté, Helen 94, 189, *129*
Feure, Georges de 189, 195, 206, *2*
Fink, Nelson S. 203
Fischer, Hermann 168, 202
Fischer, Louis 188
Flouquet, Pierre-Louis 151, 184
Follot, Félix 189
Follot, Paul 38, 42, 47, 48, 53, 54, 142, 147, 183, 186, 187, 188, 189, 191, 195, 199, 200, 201, 204, *52*
Föreningen för Svensk Hemslöyd (Society of Swedish Homecraft) 79
Föreningen Handarbetets Vanner (Society of Manual Textile Art) 78
Forsberg, Ann-Mari 194
Fourgeaud, Yvonne 42, 185, 189, 190
Fournier, Albert 204
Frank, Jean-Michel 197
Frank, Josef 110
Frankl, Paul T. 87, 175
Fréchet, André 201
Fréchet, Paul 186
Fressinet, J. 186
Friedrich Bayer company 99
Fry, Roger 68–69, 184, 197, *91*
Frykholm, Annie 78, 79
Futurism 12, 69, 81–82, 114, 194, 199, 202

Gabo, Naum 155
Gabriel, René 149, 189
Gachon, Pol 200
Gadebusch, Paul 200
Gahn, Greta 170
Gahn, Märta 78, 79, 170
Galeries Lafayette 42, 47, 125, 183, 186, 188, 195
Gallen-Kallela, Akseli 77

Gampert, Jean-Louis 38, *37*
Garance, Irma 193
Gaudissart, Emile 42, 48, 147, 189–90, 193, 199, 200, 206, *56*, *57*, *205*, *206*
Genevrière, Marcel 188
Gettler, Mark 197
Giauque, Elsi 111–12
Gibbings, Robsjohn 203
Gidding, Jaap 75, 167, 190, 193, 206, *102*, *104*, *233*
Ginzkey 84, 190, 192, 199, 203
Ginzkey, Ignatius 190
Girard, Paul 19, 212
Girodie, André 51
Gladky, Serge 36
Gleizes, Albert 114
Gobelins, Manufacture Nationale des 21, 35, 48, 53, 149, 181, 185, 192, 195, 210
Gobion, M. 195
Gompertz, Jan 167, 193, *234*
Goncharova, Nathalie 195
Gonse, Henri 147, 193, *198*
Gorky, Arshile 178, 203, *249*
Gould, Frank J. 183
Goulden, Jean 123, 204, 206, *170*
Graebe, Carl 18
Grafström, Thyra 168
Gramont, Maria de *200*
Grands Magasins à la Place Clichy 42, 184, 186, 187, 189, 192, 198, 203
Grands Magasins du Louvre 42, 121, 201
Grant, Duncan 68–69, 184, 190, 197, 203, *88*, *89*, *93*
Grasset, Eugène 36, 189, *34*
Gråsten, Viola 170–72, 190, 191
Grattepain, Anne 194
Graves, Michael 203
Gray, Eileen 41, 72, 116–17, 120, 121, 129–30, 136, 137, 138, 139, 186, 189, 190, 195, 204, *155*, *156*, *157*, *176*, *177*, *189*
Greenwood, Thomas 211
Grierson, Ronald 157, 190, 196, 202, 206
Gris, Juan 193
Grodecka, Julie 193
Gropius, Walter 14, 99, 102, 103, 104, 106, 155, *136*
Grosvenor, Benjamin 204
Grosvenor, John 204
Groupe de Puteaux 37, 113–14, 194, 196
Group X 192
Groult, André 37, 38, 39, 116, 143, 190, 193, *39*, *199*
Guéden, Colette 199
Guénot, Albert 199
Guévrékian, Gabriel 120
Guiguichon, Suzanne 48, 125, 186–87, 191, 195, 206, *55*
Guillemard, Marcel 199
Guilleré, René 199
Guitry, Sacha 196
Gullberg, Elsa 168, 175, 191
Gundrum, Yvan 84, 207, *117*
Gwathmey, Charles 203

Haas, Philipp 110, 191, 198, 199
Hablik, Wenzel 108–9, 191, 194, *145*
Hablik-Lindemann workshop 191, 194, 207

Haesaerts, Luc 65, 194
Haesaerts, Paul 65, 67, 151, 191, 194, 200, 207, *83*, *86*, *87*
Hamot (Maison) 34, 149, 183, 184, 187, 188, 191, 192, 198
Hamot, Georges 191
Hamot, René 191
Handelsman, Jadwiga 87
Hankar, Paul 63
Hannaux, Paul 194
Harang, Raoul 42
Häring, Hugo 109, 197
Havinden, Ashley 160, 189, 191, 207, *226*
Hedman, Axel 200
Heim, Jacques 114, 187
Heine, Thomas Theodor 32
Henning, Gerda 173
Henry, Hélène 120, 122, 123, 136, 138, 139, 149, 188, 191, 201, 207, *181*, *186*
Hepworth, Barbara 197
L'Herbier, Marcel 187, *8*
Herbin, Auguste 203
Herbst, René 120, 121, 139, 187, 191, 207, *164*
Heymann, Margarete *140*
Hoffmann, Josef 11, 27, 31, 3, 63, 72, 109, 190, 192, 199, 200, 204, *23*, *24*, *26*, *29*, *31*
Hoffmann, Pola 175
Hoffmann, Wolfgang 175
Hoffmannlederer, Mila 101, 110, 192, *151*
Hofmann, August Wilhelm 18
Hofmann, Hans 176
Hollós-Consemüller, Ruth *140*
Hölzl, Adolf 192, 193
Horta, Victor 63
Hosiasson, Philippe 122, 165, 186, 192
Hoste, Huib 151
Hugo, François *200*
Hugo, Jean 147, *200*
Hugo, Victor 186
Huillard, Paul 39, 201
Hunter, Edmund 69, 189
Hürlimann, Hans-Otto 201
Huszár, Vilmos 163, 165, *130*, *228*, *229*

Ingrand, Paule and Max *196*
Iribe, Paul 141
Itten, Johannes 12, 14, 100–1, 102, 104, 105, 110, 111, 183, 192, 193, 201, *131*, *151*

Jacobs, Bertram 8
Jacobsen, Arne 173
Jacquard, Joseph-Marie 21, 22, 211
Jallot, Léon 192, 195
Jallot, Maurice-Raymond 192
James, Edward 163
Jansen (Maison) 193, 194
Jastrzebowski, Wojciech (or Adalbert) 87, 193, *118*, *120*
Jaulmes, Gustave-Louis 37, 38, 42, 149, 191, 192, *43*
Jeanneret, Pierre 112
Jemaule, Pierre 204
Jespers, Floris 152
Jespers, Oscar 200
Joel, Betty 157, 192, 207, *218*
Joel, David 157, 192
Johansson, Gurli 78

Johnson, Philip 197
Jones, Owen 9
Jorrand, Adolphe 187
Jorrand, Antoine 183, 187
Joubert, René 41, 123, 188, *66*
Jourdain, Francis 42, 54, 113, 120, 121, 123, 125, 139, 186, 188, 189, 190, 192, 195, 207, *169*
Jourdain, Frantz 192
Jouvet, Louis 189
Joyce, James 189
Jugendstil 11, 31–32, 188, 191, 197, 203
Jungnickel, Hedwig 120

Kachinsky, Alexander *245*
Kaerling, Suzanne 190
Kähler, Greten 168, 202
Kahn, Ely Jacques 89
Kandinsky, Vasily 9, 14, 17, 100, 103, 184
Karasz, Ilonka 87, 175, 192, *244*
Karasz, Mariska 192
Karpinska, Halina 87, 193
Karttunen, Laila 78
Kasskoff, Anatole 198, 207
Kauffer, Edward McKnight 68, 157, 159, 188, 192–93, 197, 198, 207, *223*
Kaufmann, Edgar 204
Kerkovius, Ida 100, 101, 102, 104, 193, *133*
Kilham, Teresa 175
Kinheim 72, 193, 194, 197
Kinoshita 186, 196
Kinsbourg, Renée 123, 127, 193, 207, *173*
Klaarhamer, P. J. C. 165
Klee, Paul 14, 100, 101–2, 131, 133, 163, 183, 184, 193, 195, 201, *7*
Klein, Jacques 42, 187, 193
Kleinhempel, Gertrud 191
de Klerk, Michel 72
Klimt, Gustav 27, 28, 109, *24*
Koch, Ea 173
Koch, Mogens 173
Kochno, Boris *200*
Koch-Otte, Benita *see* Otte, Benita
Kohlmann, Etienne 201, 203
de Koninck, Louis Herman 151, 152, 200, *211*, *213*
Kossecka, Wanda 87
Kozma, Lajos 84–87
Kramer, Piet L. 72
Kreis, Wilhelm 32
Kristian, Roald 69, 198
Krop, Hildo 72, *98*
Kunst und Kunsthandwerk 11
KVT (Koninklijke Verenigde Tapijtfabrieken) 75, 190, 193, 197
Kybal, Antonín 87
Kybalová, Ludmila 87
Kysela, Frantisek 84

Lad Artists' Cooperative 84, 87, 193, 207
Laeuger, Max 31
Laglenne, Jean-François 133
Lainé, Edmond 195
Lainé, Lucien 15, 195
Lalique, René *58*
Landault, Roger 201
Lanoa, Marie-Thérèse 38, *37*

de Lanux, Eyre *see* Eyre de Lanux
Lanvin, Jeanne 40, 42, *40, 41*
Laplante 39, 192
Larsen, Jack Lenor 178
Lauer, Etablissements Maurice 34, 141, 183, 186, 193, 194, 195, 199, 207
Lauer, Jean 193
Lauer, Jean-Philippe 193
Lauer, Maurice 193, 207
Laurencin, Marie 58, 113, 114, *75*
Laurens, Henri 136, 193, 195, *185*
Laurent, Pierre 199–200
Lebrun, Charles 195
Leconte, Pierre 58, *77*
de Leeuw, Joseph 165, 196
Léger, Fernand 114, 116, 131, 133, 135, 178, 193, 194, 195, 199, *180, 181*
Lehmann, Gustav Karl 108
Leischner, Margaret 105, 155, 157, 194
Leleu, Jules 54, 58, 187, 193, 194, *72*
Leleu, Marcel 194
Leleu, Paule 143, 147, 194, *204*
Le Lorrain, Louis-Joseph 183
Le Même, Henry-Jacques 54
Leplae, Charles 65, 67, 194, 200, 207, *83, 85*
Lévy, Albert 202
Lévy, Claude 199
Lévy, Jane 42, 186, 194, 201
Lewis, Wyndham 68, 197
Lhote, André, 13, 67, *6*
Liberty's 165, 196, 203
Liebermann, Carl 18
Li Meng Shu 94, 189
Lindberg, Stig 197
Lindemann, Elisabeth 108–9, 191
Lindgren, Armas 77
Lion Cachet, Carel-Adolph 72, 193, 194, 197, *97*
Loos, Adolf 11, 28, 109, 113, 163
Lord and Taylor's 89
Lorthiois-Leurent et Cie 149, 189, 195
Lourdet, Simon 195
Lucien Bouix (firm) 34, 184, 185, 187
Lurçat, André 133, 195, 196, *178*
Lurçat, Jean 15, 60, 117, 120, 122, 125, 131, 133, 186, 194, 195, 201, *8, 9, 76, 160, 163, 179, 182*
Lux, Raoul 187

Måås-Fjetterström, Märta 78, 79, 168–70, 172, 175, 194, 207, *108, 237, 238, 239*
Macy's 89, 175
Maes, Karel 151, 184, 195, 200, *208*
Mage, Pierre 183
Maharaja of Indore 129, 191, 201
Mairet, Ethel 69, 157, 189
'Maison Cubiste' 37, 196, *37*
Maison Hamot *see* Hamot
Maison Myrbor *see* Myrbor
de Maistre, Roy *216*
La Maîtrise (atelier) 42, 47, 48, 58, 183, 184, 187, 188, 191, 193, 199
Malevich, Kazimir 9, 116
Mallet-Stevens, Robert 38, 120, 122–23, 136, 139, 188, 191, 195, *38, 181*
Malmsten, Carl 78
Mansurov, Pavel 165, 196

Manufacture Française de Tapis et de Couvertures (MFTC) 48, 123, 149, 184, 185, 187, 189, 195, 199, 204
Manufacture du Renard 23, 211
Manufacture de Tapis, Cogolin *see* Tapis de Cogolin
Manzana-Pissarro, Georges 58, 196
Marcoussis, Louis 114, 117, 120, 133, 195, 196, *158, 159, 179*
Mare, André 34, 37–38, 41, 42, 45, 114, 125, 186, 192, 193, 196, 201, *37, 49, 50, 51*
Margold, Emmanuel 108
Markelius, Sven 197, *241*
Marrot, Paule 147, 191
Martin, Etienne-Henri 201
Martine (Atelier/Ecole) 37, 42, 60, 68, 196, 197, *35, 47, 48*
Marx, Enid 160
Masereel, Frans 200
Matet, Maurice 121, 201, 203
Mathieu-Lévy, Mme 117
Matisse, Henri 189
Maugham, Syrie 157, 159, 188, *222*
Mayer, Adolf 193
Meier, Richard 203
Meier-Graefe, Julius 189
Mendelsohn, Eric 186
Mercier Frères 123, 184
Mère, Clément 42, 187
Merson, Luc-Olivier 202
Metz & Co. 165, 196, 202, 203, *232*
Meyer, Hannes 106–7, 108, 184
Mies Van der Rohe, Ludwig 108, 109, 197, *147*
Miklos, Gustave 120, 196, 208, *162, 163*
Mikotajczykowna, Karolina 196, 212
de Mille, Cecil B. 89
Miller, Duncan 191
Miró, Joan 131, 133, 135, 195, 196, *161, 184, 185*
Mobilier National 48, 58, 142, 183, 185, 190, 196, 201
Mögelin, Else *136*
Moholy-Nagy, László 100, 103, 184
Mondrian, Piet 9, 17, 163, 165, 200, 203
Montagnac, Pierre-Paul 143, 186, 187, 203
Montald, Constant 200, 202
Montereau, Germaine 136, 138, 139, 197, 201, 208
Montessori, Maria 100
Moreux, Jean-Charles 193
Morris, William 7, 11, 63, 76, 84, 99, 185, 198, 204
Morton & Co./Morton Sundour Fabrics Ltd 160, 188–89, 199, 197, 202, 203
Morton, Alastair 189
Morton, Alexander 197
Morton, Gavin 197
Morton, James 170, 188, 197
Moser, A. 188
Moser, Koloman 11, 27, 109, 192, 204
Mottheau, Jacques 185
Mouveau, Georges 188
Muche, Georg 100, 101, 103, 104, *138*
Müller-Hellwig, Alen 108, 109, 197, *146, 147*
Munster, Frosca *200*
Munthe, Alfe 191
Muthesius, Eckhart 129, *175*

Muthesius, Hermann 11, 99
Myrbor, Maison 9, 17, 60, 102, 117, 131–36, 138, 183, 189, 192, 193, 194, 195, 196, 197, 198, 200, 208, *178, 179*

Nash, Paul 189, 197
Nathan, Fernand 42, 187, 195, 208, *44*
Navellier, Edouard 184
Neo-plasticism 123, 125, 163–67; *see also* De Stijl
New Age Artists and Workers Association 94
Nicholson, Ben 12, 136, 155, 189, 195, 197, *214*
Nicholson, Sir William 70, 197, *95*
Niemeyer, Adelbert 32, 197
Nieuwe Bouwen 163
Nieuwe Kunst 11, 72
Nieuwenhuis, Theodoor 72, 193, 197, *96*
Nilsson, Barbro 170, 172, 194, *242*
Nilsson, Eva 78
de Noailles, Vicomte Charles 120, 188
Nordiska Kompaniet 78, 172, 190, 197, 200
Novembergruppe 199

Obrist, Hermann 203
Olbrich, Josef 31
Omega Workshops 68–69, 155, 184, 190, 192, 197–98, 204, 208, *88*
Opbouw 163
Orage, Jean 69, 188, 190, 198
Ornament and Crime (Loos) 11, 28, 113
Orry de Fulvy, Jean-Henri-Louis 183
Österberg, Agda 78, *107*
Otte, Benita 101, 102, 103, 198, *130*
Ottolenghi Wedekind, Herta 81
Oud, J. J. P. 163
Ozenfant, Amédée 112, 116, 141, 194

Palais de Marbre 123, 125, 184
Palais Stoclet 27–28, 34, 38, 63, 192, 204, *24, 25, 26*
Paquet, René 192
Paracchi (Manufattura) 198
Paracchi, Giovanni 198
Parigot, Yvonne 116, 188
Pascaud, Jean 193
Patou, Jean 201
Patout, Pierre 200, 203, *57, 205*
Patry-Bié, Solange 123, 195, 198, 208
Paul, Bruno 31, 32, 203
Paulsson, Gregor 168
Paulucci, Enrico 82, 198, *113*
Peacock, Elizabeth 69
Pearson, Ralph M. 94, 176, 208
Peche, Dagobert 27, 31, 109, 191, 198, 204, 208, *30, 31*
Peeters, Jozef 151, 200
Pekary, Istvan 208
Pembroke, Earl of 204
Penaat, Willem 165, 193, 196
Pépin, Albert 195
Pepler, Marian 157, 160, 189, 198, 202, 204, *220*
Perkin, William 18
Permeke, Constantin 65
Perriand, Charlotte 113
Perrot, Pierre-Josse 183
Pestalozzi, Johann Heinrich 100
Petit, Philippe 41, 123, 188

Pevsner, Antoine 155
Pevsner, Nikolaus 160, 163
Philipp Haas und Söhne 110, 191, 198, 199
Picart-le-Doux, Jean 192, 198
Picasso, Pablo 9, 17, 113, 114, 131, 133, 136, 189, 193, 195, 198, *12, 179, 182*
Picking, William 204
Pinguenet, Henri 187, 208
Pinton/Pinton Frères 149, 183, 187, 198, 208
Pinton, Olivier 198
Pissarro, Camille 58, 198
Plutynska, Eleonora 87, 193
Poetter, Wilhelm 108
Poggenbeck, Tom 193
Point Sarrazin 187, 198
Poiret, Nicole 190
Poiret, Paul 34, 36–37, 42, 68, 149, 190, 196, 197, *35, 47, 48*
Polak, Hans 151, 168, 200
Pollitzer, Louise 108
Polsterer, Hilda 199
Pomone (Atelier) 42, 47, 185, 189, 199
Pons, Geneviève 195
Poor, Henry Varnum 94, 199, 208
Popova, Liubov 120
Porteneuve, Alfred 54, 143, 201, 201
Pouchol, Paul 125, 186
Pozier, Pierre 200
Prampolini, Enrico 81–82, 199, *111, 112*
Preiswerk(-Dirks), Gertrud 201, *140*
Prentice, Terence 160
Primavera 36, 42, 186, 199, 201
Le Printemps 36, 42, 192, 199
Printz, Eugène 123, 129, 136, 139, 193, 199, 204, 208, *190*
Prou, Jean-René 199
Prou, René 123, 136, 147, 184, 193, 199, 204, 209
Prouvé, Victor 194
Prutscher, Otto 28, 199, *27*
Puiforcat, Jean 188, 209, *58*
Purism 112, 113, 194
Puvrez, Henri 200

Quibel, Raymond *58*
Quiglay, William 202

Radnor, Earl of 204
Rahlson, Lydia 175
Raito, A. W. 78
Ramah, Henri 65
Rapin, Henri *61*
Rateau, Albert-Armand 42, 54, 186, *67*
Ray, Man 129, 189
Recchi, Mario 81, 199
Redon, Odilon 53, 189
Reeves, Ruth 92, 175, 178, 185, 199, *125. 126*
Reich, Lilly 108, 184
Reichardt, Greta 102, 107, 199, *134, 140, 144*
Reiss, Emily 176
Reiss, Henrietta 185
Reiss, Winold 89
La Renaissance de l'Art Français et des Industries de Luxe 15, 39
Renouardt, Jane 45
Renouvin, Georges 193
Resch, Lois 110, *150*

Ribemont-Dessaignes, Georges 37
Riberzani, Daniel 200
Rice Pereira, Irene 203
Rich, Paul 200
Richard, Charles H. 175
Richter, Marianne 194
Riemerschmid, Richard 31, 32, 203, *33*
Rietveld, Gerrit 165, 202, *228*
Rij-Rousseau, Jeanne *10*
Rizzo, Pippo 81
Rockefeller, John D. 187
Rodier 184
Roghé, Agnes 104
Rohde, Gilbert 89, 176, 203
Rossbach, Ed 178
Rosso, Giulio 82
Rothschild, Baron de 201
Roussel, Gaston 201
Ruaud, Paul 120
Ruhlmann, Emile-Jacques 34, 38, 41, 45, 48,
 54, 58, 143, 186, 187, 189, 199–200, 203
 57, 68
Rubinstein, Helena 17, 60, 133, 187, 201, *182*
Ruck, Arthur 69
Rupp, Henri 195
Ruskin, John 11
Russell, Gordon 157, 198
Russell, Morgan 176
Russell, R. D. 198

Saarinen, Eliel 72, 77, 94, 175, 200
Saarinen, Loja 92–94, 178, 200, 201, 204, *124,*
 127
Sabatté, Fernand 188, 194
Saddier Frères 187
Saedeleer, Studio de 63–67, 187, 190, 191, 194,
 195, 200, 202, 209, *20, 81, 82, 83, 84, 85,*
 86, 87
de Saedeleer, Elisabeth 63, 67, 200, *80*
de Saedeleer, Godelief 200
de Saedeleer, Marie 200
de Saedeleer, Marie-Jozef 200, *80*
de Saedeleer, Monique 200, *80*
de Saedeleer, Valérius 63, 65, 200
Sailors, Robert D. 178
Sakowska-Wanke, Wanda 193
Sallandrouze Frères 23, 34, 183, 200, 211
Sallandrouze, Jean-Jacques 200
Sallandrouze, Théophile 200
Sallandrouze Le Moullec, Charles 200
Samaranch, Miguel 183
Sampe, Astrid 170, 172, 197, 200
Saverys, Albert 200
Savonnerie, Manufacture de la 21, 35, 56, 63,
 143, 147, 183, 187, 190, 194, 195–96, 204,
 210, 212
Schenk 48, 190, 195
Schiele, Egon 109
Schlemmer, Oskar 100, 103
Schmidt, Karl 188
Schmidt, Max 198
Schoen, Eugene 89, 200
Schumacher Inc. 200–1, 204
Schumacher, Frederick 200
Seddon, John Pollard 203
Sedeyn, Emile 39
Séguy, Emile-Alain 36

Selmersheim, Pierre 189, *61*
Serac, Yvonne 198
Seuphor, Michel 203
Sheringham, George 70, 202
Shopping Guide to Paris (Bonney) 51, 133
Simeon, Margaret 203
Sjöstrom, Maja 78
Skoczylas, Wladyslaw 87
Sluyters, Jan 67
de Smet, Gustave 67, 200
Sneyers, Léon 63, *79*
Société Africaine de Filature et Tissage 165, 196
Société de l'Art Pour Tous 192
Société des Artistes-Décorateurs 11, 34, 51, 58,
 117, 120, 141, 149, 184, 187, 188, 189, 192,
 194, 201
Society of Industrial Design, Sweden 201
Society of Industrial Design, UK 157
Society of Industrial Designers (SID), USA 188
Sognot, Louis 136, 139, 191, 197, 199, 201
Sotavalta, Impi 78, 201
Soulages, Pierre 196
Spanjaard, Frits 167, 195
Spinoza, Baruch 184
Sprinchorn, Barbro 194
Stadler, Willy 201
Ståhlbrand, Ellen 78, 209, *105*
Stein, Gertrude 189
Stepanova, Varvara 120
Stéphany, Henry 38, 42, 54–56, 200, *69*
De Stijl 103, 114, 116, 120, 138, 149, 163–67,
 184, 188, 190, 195, 199, 202, 203
Stile Liberty 11
Stoclet, Adolphe 27
Storrs, John 176
Stölzl, Gunta 100, 101, 104, 105, 106, 107, 108,
 110, 120, 168, 183, 184, 192, 201, 209, *132,*
 140, 142
Strebelle, Rodolphe 152, 200
Strengell, Marianne 78, 170, 172, 178, 200, 201
Stryjenska, Zofia 87
The Studio 11, 157, 159
Studium Louvre 42, 121, 123, 143, 188, 198,
 199, 201, 203
Subes, Raymond 201
Süe, Louis 34, 37, 39, 41, 42, 45, 125, 141,
 143, 147, 186, 192, 193, 196, 201, *36, 49,*
 50, 197
Süe, Olivier 201
Surrealism 135, 155, 159, 183, 186, 187, 189,
 193, 196
Svedberg, The 197
Sveinsdottir, Juliana 173

Tabard, Etablissements 187, 194, 201
Tabard, François 201
Taeuber-Arp, Sophie 110, 111, 114, 163, 183,
 201–2
Taipale, Martta 78, 193
Tandy, John 160, 189, *225*
Tapis de Cogolin 147, 163, 183, 184, 185, 188,
 189, 190, 193, 194, 202; *see also* Lauer
Tassinari et Chatel 51, 184
Taylor, David 202
Templeton, James 23, 202, 210
Templeton, John Stewart 202
Templeton's 17, 70, 184, 202, 203

Terry, Emilio 147, 197
Tétard, Alfred 195
Tétard, Gustave 195
Tétard, Louis 188
Tétard, Victor 195
Thomas, Auguste 185
Thomas, Jean-François 199
Thorn, Li 100
Tomkinson, Michael 202
Tomkinson and Adam 198, 202, 203
Topham, Charles 18, 212
Torhamn, Ingegerd 170, 209, *240, 241*
de la Tour Périgot, Marguerite 136, 139, 209
Towarzystwo Polska Sztuka Stosowana (Polish
 Society of Applied Arts) 87
Town and Country 189
Treter, Bogdan 87, 209, *118*
Trock, Paula 173
Trojanowski, Edward 87, *119*
Truxas, Anna 110, *148*
Tytgat, Edgard 65, 67, 152, 202, 209, *84*

Ulbrich, Franz 108
Ulreich, Buk and Nura 89, 209
Union des Artistes Modernes (U.A.M.) 113,
 120–1, 123, 139, 165, 186, 187, 190, 191,
 192, 195, 196, 201
Unit One 197
Urban, Joseph 27, 87, 89, 202, 204, *247*

Valance, Roger 193
Valentin, Ruth 100
Valmier, Georges 17, 202, *1*
Van Buuren, David 48, 167
Van Dael, R. N. 75, 193, *101*
Van den Berghe, Fritz 200
Van den Bosch, Jacob 75, 193, *99*
Van der Leck, Bart 163, 165, 196, 202, *231, 232*
Van der Mijll-Dekker, Kitty 105, 168, 202, *235*
Van der Velde, Henry 11, 99, 108
Van de Woestijne, Gustave 65, 67
Van Doesburg, Theo 12, 103, 111, 114, 120,
 163, 183, 202
Van Dongen, Kees 196
Van Gogh, Vincent 68
Van Hecke, Paul-Gustave 200
Van Huffel, Albert 65, 151, 200, 202–3, 209, *81,*
 82, 83, 209
Van Ravesteyn, Sybold 120
Van Sluijters, George *see* de Feure, Georges
Vantongerloo, Georges 163, 167, 196, 203, *230*
Van Wisselingh 72, 194, 197
Varda, Jean 160, 189
Vasarely, Victor 196
de Vaucanson, Jacques 22
Veil, Theodor 32, 39, *32*
Venturi, Robert 207
Véra, André 37
Véra, Paul 37
Vereinigte Werkstätten für Kunst und Handwerk
 188, 203
Vergé, Jacques 187, 190, 203
Verneuil, Adam 36
Verneuil, Maurice (M. P.) 36, 39
Viard, Charles 114
Vibert, Max 123, 143, 199, 201, 203, *195*
Vieira Da Silva, Maria Elena 136, 195

Villon, Jacques 114
Vionnet, Madeleine 189
de Vlaminck, Maurice 67
Voguet, Léon 54, 199, 200, 203, *65*
Vollmer, Philip 187
von Baeyer, Adolf 18
von Beckerath, Willy 197
von Runge, Philipp Otto 101
von Weech, Sigmund 203
Vordemberge-Gildewart, Friedrich 138
Vorticism 69, 192
Voysey, C. F. A. 69, 190, 197, 202, 203
V'Soske Company 201, 203, *20*
V'Soske, Stanislav 24, 177–78, 203, 213, *246*

Wadsworth, William 68, 69
Wagner, Otto 109, 192, 200
Waldemar-George 141
Walsh, Sheila 204, 209, *224*
Walton, Allan 70, 184, 190, 203
Wandel, H. 108
Wanke, Kurt 107, *140*
Waring & Gillow 69, 186, 189, 204
Wärndorfer, Fritz 204
Wedel, Inga 170
Weill, Lucie 195
Wendingen 72
Werkbund
 Austrian 192, 199
 German 11–12, 31, 32, 34, 99, 108, 113,
 157, 168, 199, 203
 Swiss 111, 192, 201, 202
Whistler, Rex 163, *227*
Whitty, Thomas 210
Whytock, Richard 23, 213
Wiener Werkstätte 11, 27–31, 35, 87, 184, 192,
 198, 199, 201, 202, 204, *23, 24, 25, 31*
Wiesemann, Margarethe 32
Wilton Royal Carpet Factory 22, 69, 157, 160,
 184, 188, 190, 191, 204, 213
Wimmer-Wisgrill, Eduard Josef 110, 191, 204
Windels, Fernand 123, 183, 195, 204, 209, *168*
Witzmann, Karl 28
Woodward, Henry 204
Woodward Grosvenor 188, 204
Woolf, Virginia 68, 184
Wright, Alexander 185
Wright, Frank Lloyd 72, 88, 89, 92, 200, 201,
 203, 204, *121*
Wurzener Teppichfabrik 108
Wyld, Evelyn 41, 116, 120, 123, 129, 136,
 137–38, 139, 170, 175, 189, 190, 199, 204,
 209, *187, 188*
Wynants, Sander 152

Yates & Co. 203, 204; *see also* Wilton Royal
 Carpet Factory

Zadkine, Ossip 67, 151, 209
Zorach, Marguerite 89, 178, 190, 203, *123*
Zorach, William 175, *126*
Zwart, Piet 163